SILHOUETTES
A History and Dictionary of Artists

PLATE 1

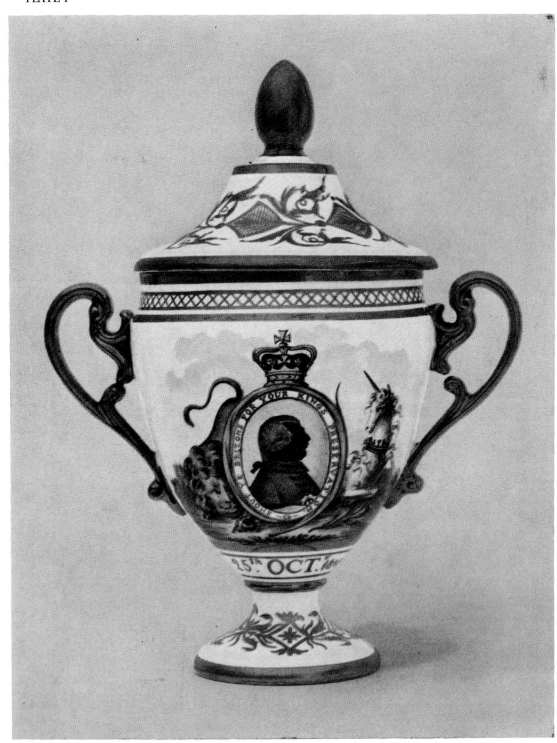

VASE WITH LID, MADE AT THE ROYAL PORCELAIN FACTORY, WORCESTER,
IN COMMEMORATION OF THE JUBILEE OF GEORGE III, 1809
In the Royal Collection of Windsor Castle (By gracious permission of H.M. the King)

SILHOUETTES
A History and Dictionary of Artists

by
Mrs. E. Nevill Jackson

DOVER PUBLICATIONS, INC.
NEW YORK

This Dover edition, first published in 1981, is an unabridged re-publication of the work originally published in 1938 by Methuen & Co. Limited under the title *Silhouette: Notes and Dictionary*. Plates 1, 2, 3, 20, 21, 22, 37, 38, 51 and 62 appeared in color in the original edition.

International Standard Book Number: 0-486-24210-2
Library of Congress Catalog Card Number: 81-68487

Manufactured in the United States of America
Dover Publications, Inc.
180 Varick Street
New York, N.Y. 10014

DEDICATED

BY GRACIOUS PERMISSION

TO

HER MAJESTY

QUEEN MARY

A ROUNDEL

A Slender Art, yet eloquent,
Light intercepted, sun-kiss't Shade.
Compact of Charm and Sentiment
Shadow proclaims Life's accolade.

Black, bronzed with gold, ruffles, brocade,
Beneath a crystal bubble bent
A Slender Art, yet eloquent,
Light intercepted, sun-kiss't Shade.

In Shadow land, impermanent,
Clarissa's Profile, Saucy Jade !
Children flit ghost-like play-intent,
The Beau be-wigged, a gallant Blade :
A Slender Art, yet eloquent.

<div align="right">E. J.</div>

Child, cut by Edouart.

PREFACE

NOWADAYS, few of the minor arts exercise a wider appeal than that of the Silhouette. These shadows from the past—the term is by no means inexact—are valued as much for their revelation of bygone features, costumes, manners and customs, as for the decorative value which is theirs in a pronounced degree. Not infrequently they form the sole pictorial records of individuals in every phase of society ; and even when portraits in other media exist, it is to the ' shades ' that we often refer for interesting or amusing sidelights which have entirely escaped more orthodox portraitists.

To be a ' speaking likeness ', a silhouette must be a true profile. And that many shades are in fact excellent portraits can be gauged by comparing with other sources of information, when such are available.

Our shadows are with us always. Only ' When the tree falls, the Shade is gone ' as the Chinese proverb has it. Who shall belittle the gentle art which concerns itself with permanently recording the fleeting shadows, of the great with fine artistry, the less great with humble effort but no less interesting result.

Not only in Britain is keen interest evident in this handmaid of the great art of portraiture. In other countries, notably Germany and the United States of America, enthusiasm is very apparent, and I have included the names of many exponents in the art in those countries. Moreover, I have added a few names of those associated with the subject, such as art collectors, engravers, and antiquaries.

Thirty years ago, few took an interest in shadow portraiture. Silhouettes were still made, but the art had fallen on evil days. It was thought to be ' cheap ', and save for such individuals as cherished family collections, few regarded them otherwise than tolerantly—for decorative purposes.

Many years ago the late Viscount Northcliffe (then Sir Alfred Harmsworth) had advised me : ' Find a subject no one else has touched, and master it.'

In 1906 a copy of Edouart's little ' Treatise on Silhouettes ', published in 1835, was sent to me. Its perusal spurred me on to find all I could about the producers and processes of this gentle art in old biographies and social histories ; to search the cabinets of fine art collectors, and hunt up the scrap-books of the world.

Thus it happened that after five years' intensive study in 1911 my *History of Silhouettes*—the first general history of its kind—was given to the world. I little guessed what a wave of enthusiasm would break over the first collector's book on the subject.

Immediately after its publication, letters poured in upon me, together with offers of authenticated specimens for examination, besides details of trade labels and additional facts of value. How this influenced my researches is shown by the following figures.

In the *History* (1911), I gave a list of 242 artists, with details of their methods of work, dates, places of origin, prices, etc., all based on my personal research. By 1913, the 242 names had increased to 270 ; by 1914 to 320 ; by 1921 to 339 ; by 1923 to 345 ; and so on. In the present volume, I am able to present my readers with no fewer than 800 names : a total which I can claim to be unique.

As to the scope of the notes in this volume it may be objected that the names of artists have been inserted who have left little that merits remembrance, but after all, it is not only the important workers, of whom there are already ample records, but of those who are obscure and in danger of being forgotten that information is desirable. In some cases a single fact, a date, a name are all that is available to save an artist from oblivion ; but at any time facts may be forthcoming, supplied by a hitherto undiscovered example. Exact spelling is given and punctuation in labels and advertisements, dates, and provenance when possible for the assistance of owners.

Since the result of my study has become known our Museums recognize the importance of the subject, and in the Victoria and Albert Museum there has been founded a distinct department where, in filled cases, labelled examples may be studied, the work of the eighteenth century and later.

Shortly after this I was honoured by the Command of King George V to describe and catalogue the Royal Collection of Silhouette pictures, china and jewels at Windsor Castle and Buckingham Palace.

I acknowledge with very cordial thanks my indebtedness to many informants : to Dr. Beetham, descendant in the fourth generation of that eminent silhouettist, Mrs. Beetham (*née* Isabella Robinson) ; Mr. J. A. Field, for the loan of the Field portraits ; Sir Henry Miers, descendant of the great John Miers, of Leeds ; Mr. G. Kruger Gray, a descendant of Carl Rosenberg, Silhouettist to King George III and Queen Charlotte ; Mr. O. F. Morshead ; Mr. Gordon Roe ; Sir Henry Sutcliffe Smith ; Miss Mary Martin ; the Rev. Glenn Tilley Morse ; Mr. Henry W. Erving ; collectors of English or American examples ; Mr. Lumb ; Mr. Buckley ; the late Mr. Basil S. Long, Keeper of the Department of Engraving, Illustration and Design, Victoria and Albert Museum ; Mr. Martin

Hardie, formerly Keeper of the same ; Sir James Caw, of the National Gallery, Edinburgh ; Mr. Cursiter ; the late Mr. D. L. Milner, F.S.A., formerly Director of the National Portrait Gallery, London ; Mr. Rogers, Assistant in the Library of Congress, Washington, D.C. ; the Director of the Public Library, New York ; the Trustees of the Public Library, Newark, New Jersey ; Herr Martin Knapp ; Herr Julius Leisching, Director, Mährisches Gewerbe-Museum ; Herr Anton Kippenberg ; and Dr. Bräuning-Oktavio, Ph.D., for data concerning German, Austrian and Russian silhouettists ; Dr. Conrad Höfer, for permission to reproduce examples from the *100 Silhouettes of Anthing* ; and to the *Illustrated London News*, for permission to reproduce illustrations from their interesting pages. I have endeavoured to acknowledge all copyright in my illustrations. If I have in any case overlooked this I hope I shall be pardoned. My grateful thanks are due to those who have afforded me information either by correspondence, display of their specimens, or through the medium of their published writings : the latter are specially mentioned in the appropriate portions of my text. I hope that one and all will accept my sincere acknowledgment for their valued help.

E. NEVILL JACKSON

KENSINGTON

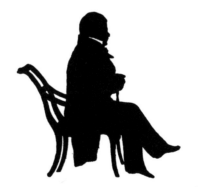

Sir Walter Scott, by Edouart,
in the Scottish National Portrait Gallery,
Nevill Jackson Collection.

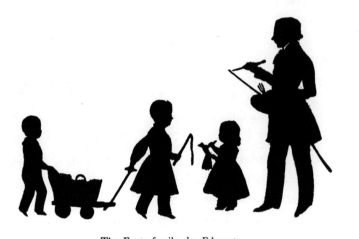

The Foote family, by Edouart.
Taken in New York, 1839.

ABBREVIATIONS

B.	*born*
Bolton, Mrs. E. S. .	*' Wax portraits and Silhouettes', 1873*
Bolton, T. . .	*Theodore Bolton. ' Early American Portrait Painter in Miniature', 1921*
Brit. Mus. . .	*British Museum*
Buckley . . .	*Notes from information by F. & G. B. Buckley*
Carrick . .	*Mrs. Van Leer Carrick, ' Shades of our Ancestors', 1928*
Catherine II . .	*La Cour de L'Impératrice Catherine ; ses Collaborateurs et son Entourage. St. Petersburg, 1899*
Conn. Vol. . .	*' Connoisseur Magazine', Volume X*
D. . . .	*died*
Dic. Nat. Bio. .	*' Dictionary of National Biography'*
Fl. . . .	*Flourished or was working*
Foster, J. J. . .	*Miniature Painters, British and foreign*
	Samuel Cooper and the English Miniature Painters of the XVII Century, 1914–16
Graves, Algernon, R.A.	*A Dictionary of Artists who have exhibited Works in the principal London Exhibitions.*
Kippenberg . .	*Katalog der Sammlung Kippenberg*
Knapp, M. . .	*Deutsche Schatten- und Scherenbilder aus drei Jahrhunderten, Munich*
Leisching, J. . .	*Julius Leisching. Die Silhouette. Mährisches Gewerbe-Museum*
Mantle, Fielding .	*' Dictionary of American Painters, Sculptors, and Engravers', 1926*
Martin . .	*The Physionotrace in France and America, ' Connoisseur'*
Miniaturists, B. Long	*' British Miniaturists', Basil Long, 1929*
MSS. . . .	*Manuscripts*
Nat. Port. Gal. London	*Edinburgh, Dublin, &c.*
Nevill Jackson, ' Ancestors'	*Ancestors in Silhouette, 1919*
Nevill Jackson, ' History'	*History of Silhouettes, 1911*
Old Col. . .	*Newspaper Cutting Volumes in the Library of Victoria and Albert Museum*
P. . . .	*page*
Redgrave . .	*Samuel Redgrave, ' A Dictionary of Artists of the English School', 1878*
Rep. . . .	*Reproduction ; reproduced*
See Dic. . .	*See Dictionary under this name*
Strickland . .	*Walter G. Strickland, ' A Dictionary of Irish Artists', 1913*
Thieme and Becker .	*' Allgemeines Lexikon der Bildenden Künstler', 1907*
Wellesley . .	*' One Hundred Silhouette Portraits from the Collection of Francis Wellesley, 1912*

A vertical mark indicates a division into lines, e.g. John Briers | Painter would mean that on the label John Briers occurs on one line and Painter on the next.

CONTENTS

Bath tin-ware pedlar.
Cut by Edouart.

PLATES

INDEX TO ILLUSTRATIONS

(Artists are described fully in the Dictionary)

CHAPTER I

ORIGINS, PRIMITIVES AND GENERAL HISTORY

THE European countries most concerned with black profile portraits were England, Germany, and France.

As all types in art work have each their individual hall-mark, it is useful before writing details of general history to describe the origin, inspiration, and to analyse the influences which affected the work in the several countries.

Lay portraits beginning in Europe in the fourteenth century with the painting of donors in early ecclesiastical pictures, became popular through the later examples of work by the great masters in the sixteenth and seventeenth centuries.

Portraits 'in little' came, apart from missal decoration, in the fifteenth century; these miniatures less cumbersome and more intimate than those hitherto known were at once popular; men wore small portraits as ornaments in their hats, and women had miniatures on chains. Small pictures of the wealthy aristocracy and their friends were used, worn as *gages d'amours*, as keepsakes, as half-secret inspiration in the inside lids of snuff-boxes, while kings, princes and patrons decorated the outer case, framed in diamonds and pearls.

The fashion in portraits-in-little spread; individuality and self-expression, born of the Renaissance, had waxed and seeped downwards, till, insidiously, cheap portraiture had become a necessity, and Daguerre, the French pioneer in photography, was not yet at work.

Then nimble fingers in ENGLAND cut with sharp scissors, shapes, faces, or figures out of a piece of cloth or paper—scissors or knife had already been used sparingly on vellum—and thus arrived cheap outline profiles.

Gifted and high-spirited amateurs amused themselves with cutting, as we read in old biographies and diaries; Swift and other wits of the early eighteenth century laughed at its exponents.

Inevitably some of the light-hearted silhouettists were more expert than others; besides cutting or life-size shadow outlining, there were those who drew and painted, and it is at this cross-road in silhouette history that ENGLAND took that path, which enabled her to outdistance competitors.

Though a profile portrait is often taken from the actual shadow, caused

by a solid body intercepting light, the mind, hand and eye of the artist still comes between the sitter and the finished portrait, because of the manner of setting down.

Herr Max von Boehn [1]—scholarly and critical, has pointed out that the English Miniature painting in colour of the eighteenth century excels that of any other country, therefore English shadow portraiture shares this praise, for profile shades, at their finest, are miniature painting in monochrome. It was through the unique excellence of the English school of Miniature painters that our silhouette workers achieved so high a standard. Had not the artists the advantage of access to the work of men such as Hilliard, Oliver, Bone, Cooper, Engleheart, Cosway, Smart and Plimer? Mrs. Beetham, a great silhouettist, worked under Smart. Foster's coloured miniatures are of finest quality.

In GERMANY the birth of the shadow portrait and the influences which modified it were widely different. There was no luxurious central court, where miniaturists might flourish. In semi-obscurity, a painter here and there gained a precarious livelihood in some small Grand Ducal court, and amateurs cut and reduced shadows with enthusiasm.

A German school of miniaturists can hardly be said to have existed. These facts are shown in the work of their silhouettists, which is rigid and severe ; the craze came to Germany, as to other European countries, in fact it swept over the land with great severity, but its origin was Heraldic or inspired by primitive ornamentation of missals, incunabula and woodcuts ; this can be traced from the lines of the prints of Dürer and Cranach.

The sober realism of the reformation, together with the scientific theories and physiognomical experiments of the Swiss divine Gaspard Lavater, the friend of Goethe, also influenced silhouette work in Germany, turning it towards scientific experiment, rather than life and gaiety, for Germany has no sense of humour. Lavater's volumes are chiefly illustrated with shadow portraits of men, animals and lunatics. I once had a serious offer from Germany of silhouette portraits of twenty-four congenital idiots, in exchange for a copy of my History ; medical evidence in silhouette does not attract me, though it is interesting to know that such workers value the precision of shadow outline.

In FRANCE, though the shadow portrait is alluring in its restricted size, and suggestive of an intimate tenderness, which we seek in vain in large portraits, the technique never really acquired popularity, rich colouring was demanded of the court painters of the eighteenth century in France. One cannot associate the quaint restraint of shadow decoration with bibelots for the courtiers of Louis XV, Louis XVI, and the age of gallantry. When Etienne de Silhouette, himself an amateur cutter, rose to the ministry, he was laughed out of office in eight months ; his austerities did not accord with the spendthrift splendour of the court circle.

[1] *Miniatures and Silhouettes*, Max Von Boehn.

It was not until shortly before the Terror, that French professional silhouettists came to do serious work; we find Gonord with his booth in the Palais Royal, cutting the portraits of the aristocrats as they mounted the steps of the guillotine, and painting on ivory for setting in rings and brooches. Sideau and Edouart, the most important and prolific of the French shadow artists, worked chiefly away from their own country. As to origin and its influence, we have but to look at the exquisite miniatures in a French Book of Hours or to examine the work of Petitot, Drouais, Isabey and Guérin, to realize beauty and gaiety supreme, but not to be expressed in black.

At the end of the eighteenth century, there were other influences at work in France, besides economy and delight in a new pastime for amateurs. Excavation was being seriously undertaken, in Italy and Greece. Paestum and Pompeii were being explored, classical knowledge was becoming not only the possession of the savant, but the study of the man of fashion and the blue-stocking.

A classical taste must be acquired, or at any rate affected, in order to be in the mode. What more easy than to give a turn to the scissors and recall classical drapery, snipping Greek patterns and groups so that the fascinating jugs, bowls and vases of the third century B.C. were suggested, with their decoration of flat black figures, brought to light by the pick of the excavator.

There was refreshment in the simple lines after the redundancy of detail at the time of the Roi Soleil; it was pleasant to get rid of rococo absurdities; the new simplicity affected architecture, furniture, and all textile decoration, till the fashions of the First Empire became pseudo-Classic.

As might be expected of the six or more different processes in which silhouette work is done, to be described later, it is the *verre églomisé* technique, in which the French chiefly excelled, in small sized examples, quite distinct from the large gold glass wall productions of Germany.

These small French pieces are often in charming settings, as French *Jouailliers*, above all others, know how to achieve; the untouched black lies on its rich gold background, in perfect simplicity, sometimes set as a personal ornament, sometimes enriching cabinet work.

In other European countries, Italy, Spain, Russia, Holland and in America also, examples are often found to have been done by visiting artists of English, French or German nationality; if there is native work, it is generally machine made, having no special marked character, except perhaps in Russia.

Briefly: In *England* the shadow portrait was greatly in demand, as cheap portraiture, and the fine school of English miniature work was there to raise it to beauty and refinement.

In *France* the miniaturists were at work, but the silhouette was too cold and simple for the taste of the French court, except as an amateur toy, a jest or ornament in cabinet work.

In *Germany* heraldic or missal ornament, and woodcuts inspired the silhouette

workers ; domestic, mutual admiration, parochial or court adulation, and scientific
necessity for cheap physiognomical research, generated the craze, which caught
on and raged, in its cruder manifestations, with an intensity unequalled else-
where. So much for regional influences.

There are so many different ways of making a silhouette that it will be well
to write briefly of the methods which can be studied more fully in the Dictionary
of Artists and their work. Some artists used several of the different techniques :

(1) On prepared slabs of plaster, generally 2½ by 3½ inches, portraits were
painted with dense black mixture, such as Indian ink, pine soot and beer or
tallow smoke. The portrait was all dense black or black thinned, but not light-
ened with body colour ; or it was bronzed. This method was used by John
Miers, Field, Lovell and others.

(2) Painting was done on ivory, card, silk or vellum, by Charles, Hamlet
of Bath, Torond, etc.

(3) Painting the portrait dense black with no relief, at the back of flat glass,
by the brothers Jorden and by Rosenberg, court silhouettist to George III and
Queen Charlotte.

(4) Painting at the back of convex glass, usually with much detail, was
filled in with wax, composition, or red pigment, by Thomason, Forberger,
Spornberg and Beetham.

(5) Painting on porcelain, dense black and also with detail, afterwards fired,
chiefly at Sèvres, Dresden, Copenhagen, Gotha, Fürstenberg and Royal Worcester
factories ; rarely is a silhouette to be found in enamel.

(6) Cutting hollow by machines of various kinds from the simple boxlike
contraption of Moses Chapman, to the elaborate machines of Chrétien or
Schmalcalder (see Plates 63, 65, chapter 5, on machines).

(7) Freehand cutting, when two folds of paper are generally used for stability ;
thus there are duplicate original cuttings. It was in this freehand method that
Edouart worked. Hubard, Dempsey and W. H. Brown ; the two latter painted
details afterwards in subdued colour or whitish grey, on the cut, after pasting
down.

(8) The *églomisé* process, flat glass being painted on the reverse ; gold and
silver foil, and occasionally coloured wax were used as background, as in the work
of Forberger (Plate 35) and Zeuner, &c.

Of all types the all-black shadow, nature's own flat outline presentment, is
the most forceful, and whatever the process used by the artist to catch this fleeting
phenomenon, and render it permanent, there remains a simplicity and fervour
which moves us beyond our craving for colour, or demand for extraneous detail.

In silhouette, the individuality of the sitter is dominant. Undisturbed by
modelling, we forget the black face anachronism, as we forget it in a dancing
life shadow ; we sense the flesh and blood, and feel the warmth of the sun in
which the painter stood in order to sketch the profile projected on the board.

The technique is so simple, here is no calculation necessary for picture making. Those eighteenth-century miniaturists in monochrome saw the beauty, appreciated the value of the delicate accessories, and more than likely exaggerated their effect, or possibly invented them ; their only rule, that there should be sufficient restraint to prevent any overshadowing with detail, the main individuality. Meissonier tells us that 'harmony of parts, unity of impression make up the charm of small things'.

Above all, 'rapidity of workmanship', emphasized by all silhouettists, 'makes for correct portrayal' again to quote that master of accurate notation—'Portraits should be finished at once ; never be allowed to drag on, for it is impossible to take them up again, people always modify or alter in appearance . . . My touch is very rapid, my sketches are written notes.' [1]

Glass, plaster, ivory, card, Indian ink, a brush, pen or scissors, as described above ; could tools be more meagre ?

There is no sequence in the use of different processes ; some of the earliest silhouettes were cut ; primitive examples in subject rather than portraiture, demonstrate the first yet known. Cutting was most usual in medieval times, and cutters are still with us.

Shadow tracing on glass, ivory, plaster, smoke staining, Indian-ink drawing, all were used throughout the ages, and many artists worked equally in a variety of media ; even the minute work to be set as jewels, was undertaken by the same artist in differing methods.

Black only—yet in fine examples, perfection of line inspires a joy in careful craftsmanship, which we seek in vain amongst more complex studies. There is a gaiety in the transparencies, the fluttering hair, in wisps of muslin, that one fears to stir, by a breath on the picture ; all this enhances the opacity of the dense black profile, and shows us the silhouette artist's skill in appreciating different textures.

Later, towards the end of the eighteenth century,[2] while the restraint of the shadow portrait was retained, we begin to find examples in which there is enough laxity to break down the barrier of too sober conventionality, and the slightest deviation appears. A fleck of gold, or as it was called 'bronzing', subdued and dingiest colour, has a magical effect, an excitement quite beyond its merit, if taken in contrast with other canons of art.

Doubtless patrons demanded this new thrill in the new century (nineteenth), ignoring the anomaly that a shadow having no colour should have barred gold chains and combs and coral ear-rings to deck it out. But public demand must be supplied, and only Edouart protested against the innovation, and resisted its decoy ; so the charm of the coloured shadow being undeniable, a new factor in silhouette work had to be reckoned with. Exponents such as Phelps appeared, while Dempsey, Beaumont and others were not far behind him in allure.

[1] *Meissonier.* Gréard (Heinemann, 1897). [2] W. Phelps used colour in 1787.

The sketch above, brought practically to the present day, has purposely been made brief. Now let us get down to corroboration with historical evidence.

Apart from legendary shadow portraiture to which I have alluded elsewhere, the earliest concrete examples of ornamental silhouette at present known are of cut work, reminding us of the shadow theatre and stage. There are curious puppets of the old shadow theatre, which were discovered by Dr. Paul Kahle in the Nile Valley, having been used in the performance of plays of the eleventh to the thirteenth century in an Islamic Puppet Show (Plate 5).

These figures, objects and groups are made of leather, specially prepared and imported from India. They are cut in intricate geometrical patterns, the transparencies being sometimes filled in with thinner leather or brightly stained fabric. They are mounted on sticks (as are the Javanese shadow puppets we can study in the Louvre and elsewhere), so that the body of the showman may remain hidden.

All the limbs of these human figures from Egypt are movable. Thus action could well be simulated in the romantic plays, just as I have seen them in Sicily to-day, with the rounded puppets, which are worked with suspension wires instead of sticks.

These early shadow puppets were shown on a brightly lighted screen ; the plays lasted from early evening till the following morning. For further details see Chapter III.[1]

The near East had its Guild of Paper Cutters. A fine piece ' A Pavilion and flower-beds ' was presented to the Sultan at Constantinople. This is set down in the report of a feast in the sixteenth century.

In early cutting we sometimes find the use of script as pattern, clearly indicating Eastern origin.

There is a leaf from a German album of shadow cuttings, dated 1631, the name on it is Johannes David Schaffer [2]—whether this is the signature of the cutter or the name of the individual to be fêted, there is no means of judging.

The subject is a triumphal car with angels, animals, symbols and heraldry, and is obviously intended as a commemorative subject. It is in the Tafel Collection, Stuttgart.

In the museum at Linz there are two Ex-Voto sheets, which serve as links between missal painting and cut silhouette work. One dated 1708 is a painting on parchment of the Flight into Egypt, its border is a medley of birds, including the imperial eagle, a stag hunt with vine tendrils of finest cutting. It is in white, and is mounted on black resembling the Jewish manuscript shown on Plate 5. The other example, at Linz, is a dedication to the State Deputation of the province of Nymwegen. Angels and trophies surround the figure of Justice.

[1] *Islamische Schattenspiel Figuern am Egypten Indie Islam*, Dr. Paul Kahle, Vol. 1, 1910.
[2] Rep. M. Knapp.

PLATE 2

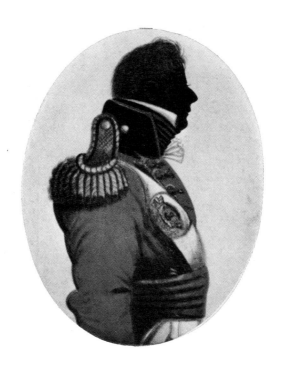

OFFICER OF THE 60TH RIFLES (ROYAL AMERICANS)
BY J. BUNCOMBE, OF NEWPORT, ISLE OF WIGHT
Formerly in the Nevill Jackson Collection

The heraldry of the province and rich floral decoration are all cut in parchment and mounted on red. It is dated 1710, but unsigned.

In another example St. Francis of Assisi is preaching to the birds. Twenty-seven different kinds are distinguishable in a small section : cocks, cranes, parrots, eagles, swans, geese, turkeys, etc. This is probably convent work. These early examples are reproduced in Herr Knapp's volume. At Cambray as late as the eighteenth century a very fine piece of cut work was made by a nun ; an achievement of arms is decorated with *œil de pedrix* and other lace motif patterns, signed ' by a nun of Cambray, cut with scissors 1787 '. This example is at the Museum and Fine Art Gallery, Bristol.[1]

In very early work there are also elaborate hunting and hawking scenes. It is interesting to note that some of the effects are gained by folding, thus achieving a positive and a negative with one cutting ; this genre is well shown by an exquisite little Gethsemane, reproduced by Herr Knapp. In modern times Hans Andersen the Dane amused himself by this method. His silhouette cuttings are shown at his house, which is now a museum [2] (Plate 49).

It is to the Tudor period that the Megellah or Book of Esther belongs, which I am able to illustrate. It is one of the most interesting primitives, a decorated strip, mounted on a turned block of wood, probably of later date.

The vellum roll, on which the words are written in Hebrew, has egg-shaped medallions, surrounded by cut and pierced work. Animals, human figures in groups, show scenes such as Jacob's dream of the ladder reaching Heaven. The scenes are united with floral arabesques ; dogs, lions, crocodiles, winged dragons and many kinds of birds. The roll is $6\frac{1}{2}$ inches wide and about 4 yards long ; it is mounted on red silk and has a handmade *passement* edging of the eighteenth century. The figures are dressed in the style of the Tudor period.[3]

Another of these cut borders surrounds an Italian marriage certificate, dated 1780. In this case painting is used, as well as cutting ; men, women and children are dancing in formal groups, and a cut chequer background, like the lacis of the needlepoints of the period, gives a rich effect. At the corners are medallions, in which scenes from the Hebrew records are depicted. The certificate is written in Aramaic Hebrew, the language of the Talmud of Babylonian origin (Plate 6).

The government stamp is of Verona ; the document measures 12 by 14 inches and was shown at the exhibition of Jewish Art, held at Whitechapel, together with several other examples less ornate.

Enough has been said to prove that cutting and flat profile portraiture have come down to us from earliest ages, and that cutting predominated over other processes in medieval times.

Quaint handwork of the early eighteenth century is shown in a dressed picture. The profile in black is set on a body of black lines, cut away to show

[1] See Dictionary and Scrap-Book chapter. [2] See Chap. III.
[3] In the possession of the Mayor of Richmond.

silk corsage, brocade, skirt, and panniers of a lady.[1] The man, forming the companion picture, has a profile in black silhouette, figured linen is used for his jacket and hose. These figures, probably German, were found amongst the effects dispersed on the death of a German nobleman, and are dated 1745 (Plate 6).

With such specimens the primitives of the art may be said to cease ; from the mid-eighteenth century, the portrait shade took its place practically in its present form.

Those who had no skill in cutting, obtained an outline of the shadow and reduced it to the required size, by the use of some simple kind of stork's bill or pantograph, of which there were several kinds, adapted from the more delicately adjusted and expensive mathematical instrument.

Books and pamphlets appeared with instructions for the amateur ; one is entitled : *The Physiognomical Cabinet, a Detailed Treatise on Silhouettes, their Drawing, Reduction, Ornamentation and Reproduction.* This little book, published by Perrenon, is dated 1780, and has twelve illustrations. It specified various implements, such as the pantograph and the Camera Obscure, great stress is laid on the proper arrangement of the light.

Paper and pencil are exactly prescribed and the suggestion is made, that as women's head-dresses are so enormous (Plate 15), two sheets of paper shall be glued together. For finishing and filling in, Chinese or Indian ink are recommended, or pine soot mixed with brandy, gum or beer. Two portraits should be cut out, and when reduced one is ready for the album, the other to be hung on the wall. White, green, red and blue cuttings or backgrounds are considered in bad taste.

The process of making glass-painted silhouette portraits is also touched upon, together with a method of pressure from the back of card or paper, to produce the effect of contour. Stencil reproductions, wood cuts and copper plates are described.

A second book soon appeared in Germany, and much later one was published in England ; the latter was entitled : *The Art of Cutting out Designs in Black Paper*, by Barbara Ann Townend, 1815. There is a short Instruction and fifteen pages of designs which were sold separately at 1s. each. The book in paper covers cost 5s. My copy is bound with leather back, I have only heard of one other copy complete. That cheapness was in the minds of everyone is proved when the paper process was nicknamed *à la silhouette* (a word hitherto unknown in France or England) in allusion to the parsimonious methods of the Controller General of Finance in France in 1759. When his economies began to touch the incomes of the very large class of pensioners and court holders of sinecures, the popularity of the minister waned. It is said that a joke may kill a policy : the Parisians' wit as to wooden snuff-boxes and paper portraits *à la silhouette*, certainly scotched the Finance Minister's methods. He retired to his château at Brie-sur-Marne to decorate his rooms cheaply with home-made paper

[1] Rep. *History of Silhouette*, Nevill Jackson, 1911.

cuttings and to cultivate the farm he had received, through the patronage of the Pompadour. His name remained in France long after he himself was forgotten and though black Profile Shades and Shadows were spoken of in England and Germany, later on the French name was introduced into England by Edouart, and now is also adopted in Germany.

Edouart was a stickler in small matters and thought the word 'shade' derogatory to his art. So paramount was his influence and so prolific his work and business organization, that the word silhouette seems to have been almost universally adopted.

John Caspar Lavater, the Zurich divine, published in 1775–8 his 'Essays on Physiognomy, calculated to extend the Knowledge of the Love of Mankind'; incidentally it popularized the practise of silhouetting. I have before me the translation of Rev. C. Moore, LL.D., F.R.S., printed in 1793 at No. 12 Red Lion Street, Holborn.

It is illustrated by several hundreds of engravings, which vary from sketches of butterflies and apes to profiles of men, women, children and idiots. Countenances of 'men in excess of rage', 'the fury of a fool', the panic of terror, amazement, meanness, and other degrees of emotion are analysed and it is the silhouette which Lavater prefers above all other styles of delineation, for showing delicate shades of character. 'It is the justist and most faithful when the light is placed at a proper distance, when the shade is drawn upon a perfectly smooth surface, and the face is placed in a perfectly parallel position, to that surface . . . it is then the immediate impress of nature and bears a character and originality, which the most dexterous artist could not get to the same degree of perfection, in a drawing from the hand.' One wearies of his many pages of adulation of the silhouette; he seems never tired of singing its praises. With his draughtsman Schmoll he travelled widely in Germany, taking profile portraits of important people and incidentally obtaining subscriptions for his book, where the portraits would *perhaps* be published. Thousands more portraits were sent to him by amateurs, who hoped to hear of the charm of their character, or see their face in the great work. The Goethe family were taken, and a quarrel as to their reproduction in the book is something of an anticlimax; at any rate the poet was bitten with the craze, like all the rest, and with his friend Höfner, devised improvements in the silhouette chair. He declares that only a shadow portrait full life-size can be called an original. He remained enamoured of the 'slender art' long after he had abandoned Lavater's theories, and continued to practise it on his friends and intimates for many years. In old age he collected the profiles of well-known persons, and placed them in the inevitable album of that period.

The portrait of his sister Cornelia has a curiously modern look, on account of a hat, small for those days, worn tilted forward, doubtless to minimize the effect of the 'rounded forehead, black eyebrows and prominent eyes' with which

Goethe supplies her in his personal description ; he continues in his *Truth and Fiction*, ' although my sister was unusually intelligent, she was incredibly blind and stupid in this matter. She knew to her sorrow that she was far below her companions in outward beauty, without taking comfort from the fact that she was far above them, in beauty of mind and spirit.'

There are many allusions to the taking of life-size portraits in old diaries in Germany. We seldom find life-size examples in England ; three interesting examples were shown at the Lansdowne House Loan Exhibition of superb furniture, pictures, silver and enamels in 1929, by Hon. Claud Willoughby. The shadow portraits were full length, cut out of fawn paper or card and mounted on linen, dated 1766. Mr. E. V. Lucas, writing in a *Wanderer's Notebook*, 3 March 1929, asks himself the question, ' What amongst all those treasures made the greatest impression on my mind ? ' And answers himself thus : ' I carried away from all that abundance of splendour and ingenuity the memory of the three life-size shadow portraits in Room XI. They represent Robert, fourth Duke of Ancaster and his two sisters, one of whom was Lady Priscilla Burrell, a little demure creature, with rounded cheeks, holding a nosegay in her hand.'

In the Townley Museum, Burnley, Lancs., there are two life-size shades dated 1777. These are cut hollow from buff paper, they are laid on card of a darker shade ; on one is the name Colonel Wryton.

While much silhouette cutting was going on in Germany, Anthing the French silhouettist, q.v., was touring the courts of Europe, practising his profession, generally with pen and ink. Starting from Gotha, he built up page by page those albums of sentiment, philosophy, and portraiture, naming and dating each of the pages, and often obtaining the signatures of his august sitters. Cavalry officers in Brunswick, notabilities in Berlin ; then after a journey by sea, he arrived in Russia, and at the court of St. Petersburg silhouetted no fewer than 158 of the most illustrious personages of the court circle.

Forty-four of these are included in the collection of 100 published in folio,[1] from which by special permission our examples are reproduced.

Anthing ornamented snuff- and patch-boxes with his painted portraits, besides rings, brooches and pins, just as Mrs. Beetham, Miers, Spornberg and Rosenberg of Bath were doing, and it is a delightfully human touch to note that he wished he had been paid in jewels and land by the Imperial family rather than in roubles.

Anthing returned to Gotha, and in 1787, started off to Copenhagen, Stockholm, Vienna, Prague, Strasburg and Paris, where our Earl of Ashburnham appears in his record. In the following year this indefatigable traveller came to London, and for two months practised his profession.

The Prince of Wales was taken by him. Surely his wife, the lovely Mrs.

[1] Collection de Cent Silhouettes des Personnes illustres et célébres dessinées d'après les originaux par Anthing.

Fitzherbert, who had her own silhouette gallery at Brighton, was also taken by Anthing ? but I have been unable to find a record of it.

Frederick, Duke of York, the Duchess of Devonshire, and many others sat to him. Of his return to St. Petersburg, his fall from the favour of the Imperial family, his devotion to General Suwarow and his death in poverty, we need not write here.[1]

Another traveller was François Gonord, whose industry and success again proves how widespread in Europe was the taste for the black profile. Gonord had invented a machine or more likely improved on that made by Chrétien (musician to King Louis XVI, and a skilled engraver). There is a drawing of this machine in the Bibliothèque Nationale reproduced in Chapter IV. It was 5 feet in height and an exact life-size portrait could be traced in a few minutes. Gonord sold these machines, and, using one himself, made silhouettes in large numbers, his sitters flocking to his studio. His beautifully designed and engraved mounts, which are sometimes hand painted, in colour, increased the charm of his work. I have before me, three of these profiles, done in Vienna. One is of Niccolo Foscarini, Venetian ambassador to Vienna, and his wife. They are surrounded by a garland of laurel, above is a Greek vase with flowers ; the whole is enclosed in an elaborate frame with rope-pattern border.

The doctor and naturalist, G. B. Retter Scotti has a more sombre frame, with palm-branches, manuscript rolls and a ponderous tome ; while Marchese de Circello, the Neapolitan Ambassador has a sword and plumed helmet ; on one side, a cupid pulls a cord which withdraws a curtain, revealing the profile.

The ballerina Navarro has only a rose wreath ; her beautifully and elaborately dressed head, her shapely shoulders, stand out in chaste and restrained black, amongst the lovely blooms.

Who will deny the charm of such accessories in which Gonord is supreme, even though his portraits are machine made ? A few other artists attempted these mounts, but none with success ; occasionally a Frenchman shows some delicacy of execution, but the German gives little but laboured and ponderous dullness in such designs, except perhaps in the cases of one or two artists. At his best, Gonord leaves all behind him in fine mounting.

Sideau was another Frenchman who itinerated in northern Europe, and took a great number of portraits, mostly in St. Petersburg. They are found in volumes or on album sheets and in every case the name, date and social position of the sitter, is written at the back in French. Thus the three great French silhouettists Gonord, Sideau and Edouart, besides the Swiss Lavater, have alone bequeathed to the world, not only fine black profile portraits, but have enriched posterity with authentic pictorial documents, by their businesslike methods in naming and dating. It was so easy to jot down particulars at the time, yet how few took the trouble to confer this priceless gift on future generations.

[1] See Dictionary.

The most important collection of Sideau's work is in the Library of the Hermitage Museum at St. Petersburg, or was, before chaos reigned in Russia. There are four volumes ; each has fifty pages ; on each page are two cut portraits facing each other. At the bottom of the page are the names of the subjects in French.

The Empress Catherine II sat to Sideau several times and his silhouettes of her have been reproduced in various histories of the Imperial family.

The popularity of the black profile portrait was not a restricted cult, created by a few professionals and affected by some amateurs. Its success became assured amongst royal and aristocratic patrons, who commanded pictures, in *verre églomisé*, and miniature jewels in rings and snuff-boxes. Amongst the middle classes were those who filled albums with the profiles of their friends in shadow form. The lower orders delighted in engraved reproductions of their stage favourites in silhouette, and were supplied with scenes and portraits in their newsheets, another branch of the silhouette craze.

Loeschenkohl of Vienna was an artist who made topical silhouette pictures, and also single portraits of singers, actors and social celebrities. So realistic was his silhouette picture of the death-chamber of the Empress Maria Theresa,[1] 1780, with doctors, chamberlains and other high officers of the court, all in black profile, that all thought he must have been present. Gonord produced the scene when the Pope met his Imperial Majesty in Vienna, and another silhouettist went one better and produced a picture of a topical event which had been cancelled. The picture, however, came out, and was eagerly bought.

We are told in our chronicle that ' even the market women wore bracelets of brass and pinchbeck, with profiles of their lovers, and only removed them when they sold fish.'

Some of the peasant cutting is extremely interesting, much of it is landscape and flower work, rather than portraiture ; wherever it was done, the workers declared it was a new art, nor were the professionals backward in using novelty as an extra inducement for the purchase. In nearly every advertisement of black profile work, the assertion is made that the invention is entirely new. The claims of originality and superiority are about equal.

We cannot argue the matter with these people as they are all dead, we can only assure the living that their claims were quite without foundation.

Charles of Bath, always a boaster, declares himself to be the inventor of painting at the back of glass. Bingham of Manchester paints on plaster and reduces ' in a manner entirely new '. Jones in 1752 makes shade profiles on an entirely new plan, he also advertises newly invented reflecting mirrors. Mrs. Lightfoot ' reduces her profiles on a plan entirely new, which preserves the most exact symmetry and animated expression. It is much superior to any other plan,' and so on.

[1] J. Leisching.

An advertisement of Master Hubard late in his life runs thus :

The curious and much admired art of cutting out likenesses with common scissors (without drawing or machine) originated in this establishment in 1822. Master Hubard was the first youth known to possess the extraordinary talent of delineating profile likenesses with scissors, and his works consisting of military, architectural and other subjects are still considered the finest specimens of Papyrotomic art.

As the originator of this new and curious art, Master Hubard was, in 1823, presented with an expensive silver palette by the Glasgow Philosophical Society, and by that Society his exhibition was first designated the 'Hubard Gallery'.

Enough has been said to refute foolish claims to originality. Germany and Austria have always excelled in gold glass pictures, which are perhaps technically the most difficult to achieve ; the painting must first be done on the back of the glass, and gold leaf or silver put on the spaces left free. To avoid contact with the air the back is generally covered in with wax.

Occasionally the wax is coloured, as in a memorial plaque by Forberger, an 8-inch oval, where both gold and silver are used, and blue wax filling greatly enhances the richness of effect (see Plate 35). An instrument like a fine etching needle is used for hair, lace gauze and foliage.

Sometimes the portrait is painted and a wreath of flowers or swags of fruit are indicated as a framing on the same piece of glass. A well authenticated piece by Schmid of Vienna, who at the time was working in Bohemia, has two portraits facing each other (as on the snuff-box at the Metropolitan Museum, New York). The black profiles are on a green ground and are surrounded by black sprigs of flowers and leaves, the signature is 'Fecit Schmid de Vienna 1797, Toeplitz, Aug. 24'.

Two portraits presented to the Victoria and Albert Museum, of similar technique,[1] are painted on glass and have green backgrounds. They measure $3\frac{11}{16}$ inches and are portraits of the Count and Countess Van Suchtele. This indicates Dutch origin, but unfortunately there is neither signature nor trade label.

Such work, mostly framed for lockets, rings, patch- and snuff-boxes, was occasionally used for panels, to let into the sides of caskets ; there are such examples of Tudor period at Kensington, but unsigned. Catermeyer is a name found on one exhibited specimen, and at the Arts and Crafts Museum, Gratz, 'Josef Mayer fecit' is on a fine example of a lady in feathered hat with frame of wheat ears.[2]

The Jorden brothers who, in England, painted on flat glass, never put colour behind in the continental manner, nor have I seen their work with gold or silver backing. Both Richard and William Jorden painted in a bold and solid manner, which in their trade labels they liken to the effect of stone ; there is little detail, and the result is unusual and fine (Plate 97).

[1] Desmond Coke Collection. [2] J. Leisching.

At any moment a large wall or 'conversation' picture by one of these brothers may be discovered, but I have not yet seen such an example.

These 'conversations', as they are called in the trade labels, are quite distinct from the pictures of public occasions, made to commemorate national events and described below with bombastic dedication. Family life is the drama represented and comfortable circumstances are suggested by delicate silver tea or coffee equipage, writing materials, work-baskets, poodles, cage-birds, flowers and shady avenues. These properties indicate homely and pleasant environment, such as Torond gives us (see Plates 39–41).

Even with urns, tombs and weeping ladies, there is a decorous upper middle-class serenity. Goethe cuts portraits of his family, indicating their occupation with a coffee table. Torond shows a dessert table in a garden, with three figures enjoying fruit and wine. Beaumont poses 'The Sisters' contemplating a nosegay of primroses, and Edouart cuts ladies playing cards.

Dempsey's enormous Liverpool Exchange gives us men in the pursuit of their business (Plate 86), but differs from the domesticity of the Wellings ladies and gentlemen at table at the Victoria and Albert Museum (Plate 40).

William Henry Brown of America, though showing to the length of 6 feet firemen with the implements of their craft, does not suggest any immediate necessity for their use. This is not a picture of action.

Edouart, another maker of these rare large silhouette examples, places his 90th Regiment on the parade ground, rather than a battlefield, though none knew better than this cutter how to express violent action in his work: as his folio of men and animals in rare small pictures abundantly prove, many of these being used as his full-page illustrations in the *Treatise*; he drew doubtless on his personal observation during his service in the Napoleonic Wars (Plate 14).

I have never seen any but one single life-size bust portrait by Miers, but his partner Field exhibited a large picture with twenty-five grouped figures in silhouette which was hung in the Royal Academy. Captain Coke owned one of Field's rare full-length figures, now at the Victoria and Albert, $7\frac{1}{2}$ inches. Most numerous of all in silhouette history were the single portraits, either three-quarter or full-length, about $7\frac{1}{2}$ inches or bust only $2\frac{1}{2}$ inches, which were the chief business of all silhouettists in England.

Mrs. Lightfoot painted dainty ladies in the great Gainsborough hats of her day; hats on curling wigs, and her characteristic shadow line enhances their charm. Like Charles and Phelps, she puffed their kerchiefs and fichus out to keep the balance of line (Plate 11). Slim gentlemen in many caped overcoats, and officers in uniform, sometimes sat for Rosenberg at Bath or to Buncomb at Newport, Isle of Wight; so that these eighteenth-century men and women from shadowland come before us in professional and out-door dress, as well as in the court wigs and finery of the home, the court and the ballroom.

In the National Portrait Gallery in London we can see in silhouette how

PLATE 3

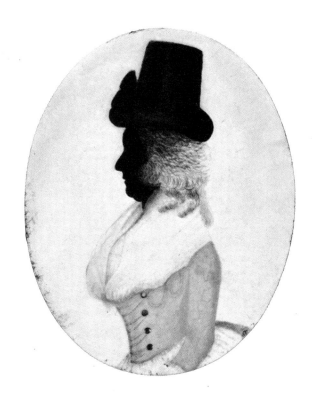

PORTRAIT OF A LADY
PAINTED ON PLASTER BY W. PHELPS, *fl.* 1788

Queen Charlotte appeared in her feather-trimmed petticoat, and court train. Mrs. Harrington's machine-made hollow white-cuts have the hard and lifeless line of the machine made, but are pure and lovely in restraint, and make us realize how becoming were the 'heads', how chic the hats, worn at Brighthelmstone, Bath, Bristol, Hot Wells, Vauxhall, and Ranelagh (Plate 64).

When Mrs. Pyburg, a somewhat mythical figure, exercised her talent at court, the mantle of her originality and genius fell upon many other women-workers.

Amongst them in England, Mrs. Beetham's portraits make us feel that we really have had a peep at the Prince of Wales, the handsome Florizel, in his suit for the King's birthday reception, and that we really are acquainted with a few of the young bloods, who lounged in the windows of Brooks's and White's, or danced at Almacks and sought adventure at Astley's. One almost sees the plumes nodding with shocked agitation over the diamond necklace affair of poor beautiful Marie Antoinette, while over a dish of tay—the turban-wreathed beauties would relax at the mention of fascinating Mr. Lunardi's balloon ascent, with Mrs. Sage—the baggage.

In that Fleet Street studio, the modern-minded Isabella Beetham of old days worked at her profession, a most daring thing to do in the eighteenth century, when Dr. Johnson declared portraiture was 'most indelicate for a woman, necessitating the peering into the faces of men'. Nevertheless, both he and his wife were painted in shadow, but by whom I do not know.

Mrs. Beetham helped her husband in his inventions, bore four children, and brought them all up—not an easy task in those times of elementary hygiene. She also used her social gifts, entertained her husband's relations, on those long visits when no one thought of moving on under two months. She reigned over a household consisting of many servants, workmen, and warehousemen, all to be fed.

Such was the life of one of our best miniaturist's in monochrome, and in one priceless specimen in colour which I own (see Plate 32), her cuttings, which are very rare, are fine. She seems to have discontinued scissor-work on leaving her Cornhill address. She had lessons in miniature painting from Smart, who was an intimate of the family, and whose work some of her best resembles. The hair on the authenticated example above is the exact technique of Smart, I am told, by an expert in miniatures.[1] Her work on convex glass is of supreme beauty. She is the Holbein amongst shadow painters, in that she can give elaborate detail in dress without weakening the interest in the face.

On card or glass every collector should strive to possess an example of Mrs. Beetham's work, it is the high-water mark of perfection.

Hamlet of Bath, at his best, runs her close. His studio was in the same street as that of Gainsborough, and his fair sitters had not far to walk, in Old

[1] The late Mr. Basil Long, formerly Keeper, Victoria and Albert Museum.

Bath's muddy roads, to find themselves in either place. One almost hears the click-clack of the pattens that Maria Edgeworth tells us of, on those rainy days in that rainy city (Plates 93, 95).

It is the work of John Miers, 1758–1821, which is best known to all English silhouette lovers, not only on account of its beauty, but also because there is a comparatively large number of portraits, both on card, plaster, and a few on ivory, which remain in excellent condition. Miers signed freely J. Miers, Miers, or Miers and Field, and often gives an address as well (Plates 8, 16, 32).

His labels also are generally on the back of his portraits, unless the old black lacquer frame has been broken open, by a too industrious housewife, and clean backing alas replaces the precious original label. A word of warning is necessary, as his labels are being forged. Examine the technique, that alone is the final test; for a faker who can paint a passable Miers, need not hide his identity behind fraud. He will earn better money under his own name, for what is badly wanted just now is a silhouettist who can paint as well as did John Miers.

Itinerating first in the north of England, Miers painted on card and plaster fine all-black profiles, taking the original shades, and reducing them to $2\frac{1}{2}$-inch size; the forcible, virile simplicity of the profile, the delicate appreciation of texture, in hair and lace and cambric or feather, make his portraits of men, women and children notable in artistry.

In 1788 he came to London, when his labels state ' Late of Leeds '. Soon after this date, bronzing appears on his portraits, giving relief to the shadow. The greyish yellow is as superbly well done as his all-black work, though to the true lover of shadow portraiture, they may not be so admirable. It is a matter of taste. From this time on, Miers' work was sometimes all-black, as the purists would have it, sometimes bronzed, so that except in the first eight or nine years of Leeds endeavour, in which I have never found bronzing, that addition comes after 1788.

Miers died in 1821. His sometime assistant, later partner, John Field, continued to use the Miers and Field label for several years after Miers's death, which is confusing to those who would date their portraits.

Field's work is equally fine, in bronzed specimens. He signed Field or J. Field beneath the bust-line. His work in all-black is rare.

Miers used fourteen labels as far as I have been able to discover—their differences and dates are all set forth under his name in the Dictionary, so that even if a fragment remains at the back of a portrait, its date may be assigned.

An item in the Watson Bequest at the National Portrait Gallery in Edinburgh, is a silhouette portrait of Robert Burns, taken about a year before Miers moved from Leeds to London. In the Library of the Gallery is a letter written by the Poet numbered 1144A. ' Miers lately in Edinburgh now in Leeds, has the original shade from which he did mine. However, if His Lordship wishes it, he shall have

to get it copied.' What of the breast-pin—for Clarinda taken by Miers, the subject of two of those letters between Burns and Mrs. MacLehose, letters 33 and 34?

'I shall go to-morrow forenoon to Miers alone, 'tis quite a usual thing I hear. . . . What size do you want it about? O Sylvander, if you wish my peace, let Friendship be the word between us. I tremble at more. Talk not of Love, etc. To-morrow I'll expect you. Adieu. Clarinda' (Plate 30).

Then 'I want it for a breast-pin to wear next my heart, Sylvander.'

I have examined upwards of twelve thousand silhouette portraits and jewels during the last twenty-five years. I have seen only two of such breast-pins. There are three known silhouette portraits of Robert Burns, two are in the Scottish National Portrait Gallery. I found a third, a beautiful half-length on plaster by Edward Bruce, who was a jeweller and frame-maker in Edinburgh, as well as a shadow painter ; he worked during the last quarter of the eighteenth century, and was at one time in partnership with Houghton (see Dictionary). His address in Edinburgh was South Bridge Street, a district easily accessible for the poet.

This portrait is now in the Burns Cottage Museum, having been purchased by the Burns Federation.

Miers must have had many assistants besides Field. Lovell was one of his pupils ; his work is generally all-black. It is hard to find, or at any rate to identify, owing to the label-destroying fiends—for he does not sign (Plate 98).

In the British Isles, as in other parts of Europe, it was not only professional silhouettists who worked, but amateurs as well.

The wistfulness of a shade, found in an old scrap-book, is undeniable ; so many were given as love tokens, as pledges of friendship, or kept as family records.

In early days, much fun was made of the craft. Swift in his Miscellanies shows us, in ridicule, the popular pastime of his day. 'To fair Lady Betty, Dan sat for his Picture' ; the rhymster lets slip the fact that it was 'cut in silk'.

'Lady Betty observed it then pulls out a pin, and varies the grain of the stuff to his grin' and so on.

Another versifier tells us that likeness was sometimes achieved with the addition of embroidery. 'One slooping cut made forehead, nose and chin. A nick produced a mouth, and made him grin', &c.

Swift died in 1745, and ceased writing some years before that date. Simultaneously there were amateurs in old Philadelphia, making merry with amateur skill. Major André, the handsome, the brilliant, and well-beloved, was cutting portraits out of black paper, and fragile profiles of Washington, Horatio Gates, Benjamin Franklin, and others of that famous crowd in fashion circles in America, can be seen to this day, silent witnesses of talent and light-hearted gaiety, before the great tragedy of the War of Independence deprived the world of that ardent spirit, under supremely tragic circumstance.

Amateur work in other countries in Europe is touched upon elsewhere ;

its fine quality is often remarkable, having as guide the real shadow ; dexterity only was needed to produce good results.

An amusing deception, though advertised quite openly, was the habit of many professional artists to supply the elaborate head dressing so essential for modish presentment. As we look at Mrs. Lightfoot's great hats, or those of Mrs. Harrington's machine-made ladies, reminiscent of Sir Joshua Reynolds and Romney's pictures of the same day, we smile, for the artist advertises that if folks have home-made shadow-on-the-wall outlines, they can be sent to her ' for reduction and dressing in perfect taste without need of a sitting '. W. Phelps evidently kept a cap and wig head-dress in his studio, for it appears in several of his portraits (Plate 11).

Welling, not to be outdone, advertises that he will take a shade and dress it as any theatrical character—' Theatrical portraits finished in any character required on a few days' notice '.

If the ladies of the day proclaimed the ' Beggar's Opera ' vastly entertaining, and fell in love with Macheath, although he was acted then by a woman, so could their profile be dressed as Pretty Polly, or, did Sheridan's ' Trip to Scarborough ' fascinate a sitter, then could the profile be turned out as one of the characters.

Was Allan Ramsay's ' Gentle Shepherd ' a favourite pose in silhouette ? or was Mr. Welling requested to make up his subject as the incomparable Miss Farren in ' The Disbanded Officer ' ?

Until the end of the eighteenth century, all English shadow artists, with the exception of Phelps, whether with brush or scissors, avoided colour, but after that time insidious bronzing began, and later faintly suggested hues, in the dress of the ladies, and uniforms, as stated above. Edouart writes in his treatise, published 1835, ' profiles with gold hair drawn on them, coral ear-rings, blue necklaces, white frills, green dresses, are ridiculous ; the representation of a shade can only be executed by an outline.'

Notwithstanding this or any other argument, the art of silhouette, as it was in the past, must be described with truth. An historian should hold no brief on either side; private taste is inevitable, but my business is to record facts. I only admit that charm makes audacity to be condoned.

With incessant recurrence, incongruity ceases to shock, and pleasure remains. In this disorganization of a highly conventional theme, we are wafted away from logic, but not from beauty.

The desire for colour in Germany was satisfied by the use of brightly tinted backgrounds, and in the cutting of figures and landscapes in varicoloured papers. I know of no foreign silhouettist who painted in colours as did Dempsey, Beaumont, Foster, and Phelps.

Spornberg, the Swede, with his black and red technique, supplied the colour variant in glass painting, and the gold and silver glass pictures of Forberger,

Zenner and others, provided another colour variety, especially in France, where Napoleon encouraged the art ; there are several examples to be seen at Malmaison ; he is said to have had a series done of his generals.

Foster, the Englishman, was a veritable stalwart at silhouette work, going his own way whether in gold flecked black, brown or vivid colouring, from his early youth till the mature age of 103. No canons of art or common sense could stop him, and if he uses his strange three dot gold work, or the more extended palette, his work has the charm of individuality, vigorous and rich.

The machine as an aid to silhouette cutting was already a fact, even with Mrs. Harrington in 1786. She cut shadow portraits with her ' patent contrivance '.

With insidious rapidity, machine cutting increased—here one manifestation, there another, until it practically killed the art of fine freehand silhouette work which was revived only by Edouart, the matchless freehand cutter, and in America, in a minor way, by W. H. Brown.

Contemporary with Mrs. Harrington, was one Mr. Jones of 32 Ludgate Street, who, as early as 1783, advertised ' Striking Likenesses in Miniature Profile on an entirely new plan, and executed in such a manner as to represent the whole drapery and particularly the headdress ; to imitate the finest lace, &c., taken in one minute at Mr. Jones artist and drawing master . . . also teaches the art of painting on glass.' Two years later, this artist is advertising ' Likenesses of certainty, taken with Royal Patent Instruments. Reflecting Mirrors, at one guinea each, at 7 Coventry Street and 168 Strand. He has an Exhibition. Admission one shilling.'

The reflectors do not seem to have been part of a machine for cutting, more probably they were akin to the camera lucida, used later by Bly of Brighton, which obviated the necessity for reduction of the size of the shadow. This was probably founded on Benoist's general camera lucida (Plate 68).

In 1789 Chrétien was working his Physionotrace in Paris, and combined reproduction and engraving. This machine traced the life-sized portrait which was then reduced by a special lens, and either filled in with black, or with colour. I have seen examples of each in Paris. This was engraved by Chrétien on a steel or copper plate, the engravings being done in black, blue or carmine. Some of these plates are still in existence (Plate 63).

Then came the Schmalcalder pencil or knife, fixed on an instrument. Where rods passed over the profile, the outline was inevitably correct, except that such sensitive features as the lips would surely be distorted by pressure ; but these matters are more fully described in Chapter III. Enough in this general sketch to add that the machine was an important factor (Plate 65).

Machine cutting had but one step lower to fall in order to reach the lowest depths of folly. In the automaton, the work of the great silhouettists was mocked and debased by trickery.

Now Exhibiting in apartments over the shop of Mr. Liddell, show maker, corner of the Market Place, Huddersfield, PROSOPGRAPHUS, the Automaton Artist. This splendid little figure possesses the extraordinary power of drawing by mechanical means, the Likeness of any Person, that is placed before it, in the short space of One Minute. It is hoped that the Inhabitants of Huddersfield, will come forward with their usual spirit, to encourage a piece of ingenuity at once novel and curious. A likeness in Black, for one shilling. Coloured from 7. 6. upwards. Open from Ten till Eight.

This clap-trap affair prepares us for the bad work at fairs and street-corner booths of 1820 to 1840.

Cheaper and cheaper, more tawdry, more futile. Mrs. Beetham, Charles, Rosenberg, Jorden and Miers are forgotten, the beauty and dignity of their work imitated by ignorance and trickery.

It remained for Edouart, the finest freehand cutter the world has ever seen, to raise the fallen art, by his matchless work, using no machines, except his own hands, sharp scissors his only tool (Plates 87–91).

His training of eye and hand was severe, he worked for many years at hair pictures, when sometimes it was necessary to split his material in order to get the right line. He studied his subject from every aspect ; in his treatise he reasons with regard to height, bulk, poise ; the proportions calculated by length of head he holds unreliable, on account of variations in structure. All the minutiae of his craft were thought out and reduced to a scientific formula; his facility for catching a likeness crowned that gift which training could only assist and not create. He obtained his marvellous outline through sheer hard work and study; his superb power of recording with simple implements alone what he saw before him, was perfected by his training to the width of a split hair.

The late Captain Desmond Coke has said : 'Where Edouart was quite supreme was in his sense of character. This accounts for his success in studies of child life. He had the first gift of a portraitist, he could portray ; and explain in a single illuminating moment. We know an Edouart subject as we know a Sargent ; the soul is there, no less than the mere skill. Edouart had a fine control of the scissors, but he had more than that, he had an eye for important feature.' And again this understanding writer on art matters writes : 'The exquisite fineness of the profiles of Mrs. Beetham, the dignity of Rosenberg, the character of Edouart.'

Like his fellow-countrymen Gonord, and Sideau, Edouart did most of his work away from his native land; first leaving it after fighting in the Napoleonic wars, he joined the great crowd of *émigrés* in England. Accidentally, after strenuous art training in other branches, he discovered his gift for catching a likeness, and using it with individuality. So almost under protest, and through stress of poverty, he began to practise that profession which has resulted in a great harvest of pictorial documentary evidence. He itinerated all over England, Scotland and Ireland, taking thousands of portraits, in doubled paper, and

PLATE 4

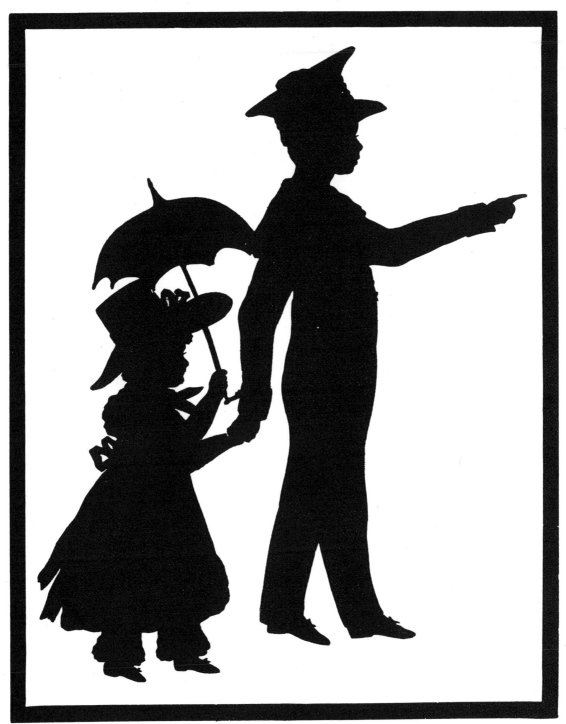

THE ARTIST'S CHILDREN

EMILIE ADELA EDOUART,
AGED 2¼ YEARS
Cut June, 1828

AUGUSTIN GASPARD EDOUART, WHO BECAME VICAR OF
LEOMINSTER, HEREFORDSHIRE, AND WROTE A HISTORY
OF THE PARISH CHURCH AND DISTRICT
Cut June, 1828

PORTRAITS CUT BY AUGUST EDOUART, 1789–1861

PLATE 5

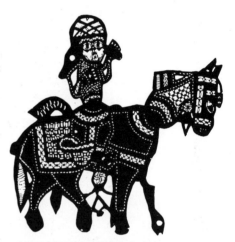

STYLISTIC CUTTING IN LEATHER
FOR THE SHADOW THEATRE IN
EGYPT
MAMELUKE HEROES OF THE XI TO XIII
CENTURY
Found in Lower Egypt by Dr. Paul Kahle

CUT WORK DECORATION ON A ROLL OF THE LAW
BOOK OF ESTHER IN HEBREW. GROUPS OF FIGURES IN TUDOR DRESS,
BIRDS, BEASTS, SHIPS. XVI CENTURY. 5½ INCHES WIDE
Owned by Mr. A. Hewett, Mayor of Richmond

PRIMITIVES. CUT WORK IN LEATHER AND VELLUM

PLATE 6

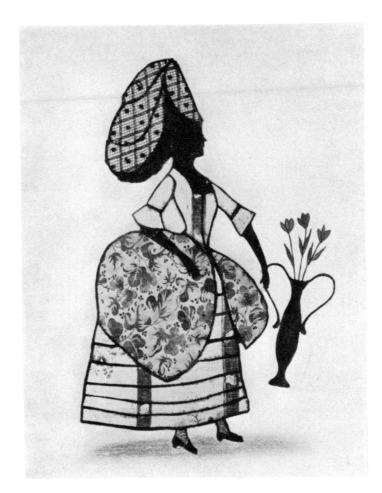

RARE DRESSED PICTURE IN SILHOUETTE
ONE OF FOUR OWNED BY DR. BEETHAM, PROBABLY GERMAN, DATED 1745

EXAMPLE SHOWING CUTWORK AND PAINTING USED TOGETHER IN THE ORNAMENTATION OF
A MARRIAGE CONTRACT, ITALIAN, VERONA, 1780

From the Jewish Art Exhibition, Whitechapel

PRIMITIVES

PLATE 7

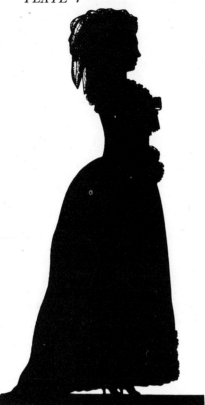

GRAND DUCHESS LUISE, 1757

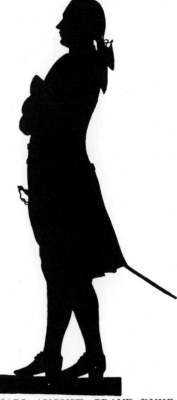

KARL AUGUST, GRAND DUKE
OF SAXE-WEIMAR, 1757–1828
From the Palace, Weimar

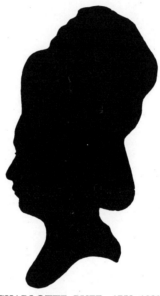

CHARLOTTE BUFF, 1753–1828
THE ORIGINAL OF LOTTE IN
WERTHER'S KESTNER
From the Archives, Dresden

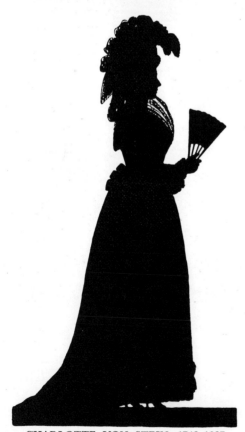

CHARLOTTE VON STEIN, 1742–1827
AT SCHLOSS GROSS-KOCHBERG

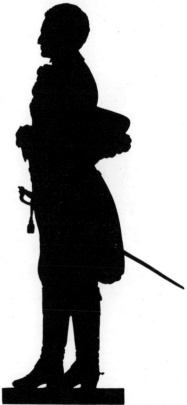

GOETHE IN COURT DRESS
Hirzel Collection, University Library, Leipzig

PLATE 8

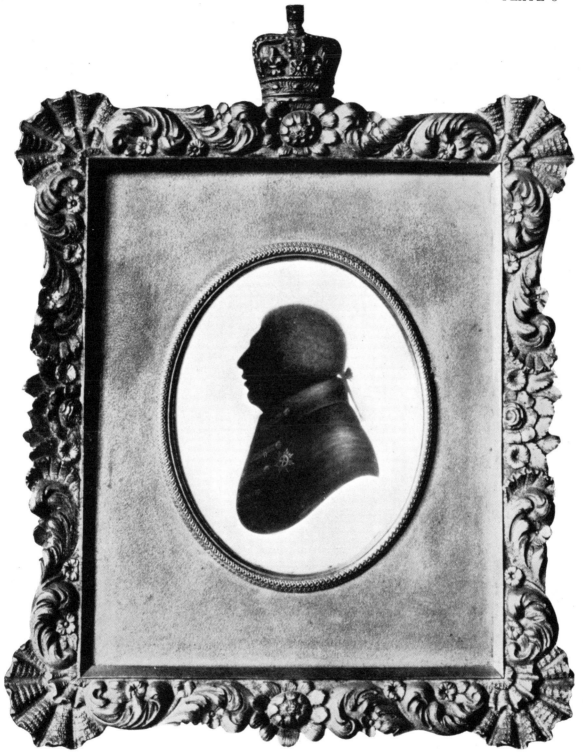

KING GEORGE III BY MIERS AND FIELD
PAINTED ON PLASTER, BLACK, WITH PROFUSE BRONZING. 3¼ INS. × 3¼ INS.
In the Royal Collection at Windsor Castle
(Reproduced by gracious permission of H.M. the King)

PLATE 9

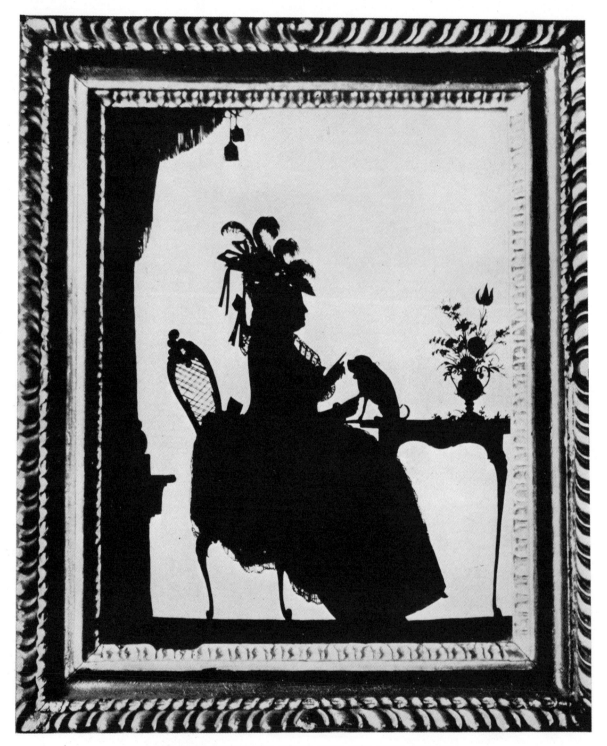

QUEEN CHARLOTTE WITH HER PET DOG BADINE
PAINTED BY WALTER JORDEN ON BACK OF FLAT GLASS
In the Royal Collection at Windsor Castle (By gracious permission of H.M. the King)

PLATE 10

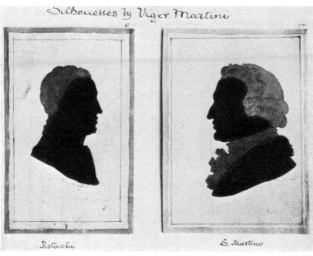

TWO OF THE SERIES OF ACTORS BY
THE FRENCHMAN, VIGER MARTINI

*In the Library of the National Portrait Gallery,
London*

THE FATHER OF GOETHE THE POET

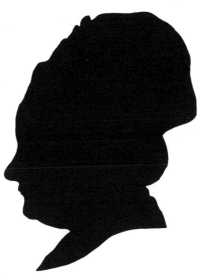

KATHARINE ELIZABETH TEXTOR, 1731–1808
THE MOTHER OF GOETHE

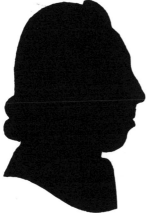

*Heinrich der XXVIII. Graf Reuß.
nat. 30. August 1725.*

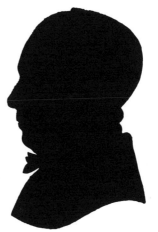

*Agnes Sophia Gräfin Reuß.
geb. Gräfin von Promnitz.
nat 14. May 1720*

PLATE 11

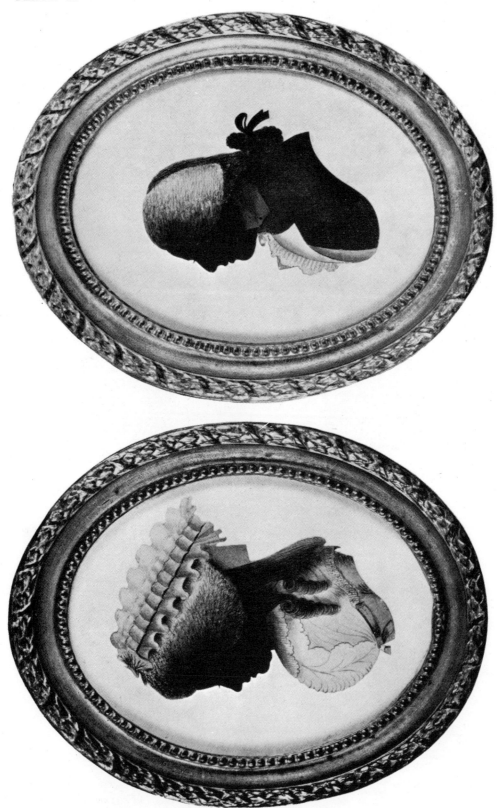

PORTRAIT OF A GENTLEMAN
CUT IN BUFF PAPER

PORTRAIT OF A LADY
CUT IN BUFF PAPER AND DELICATELY COLOURED

BY WILLIAM PHELPS, *fl.* 1788
Nevill Jackson Collection

PLATE 12

CHA.TE Q.N of G.T BRITAIN

Pub.d by W. Turner opposite the Chu.h Snow-Hill. 1782

QUEEN CHARLOTTE

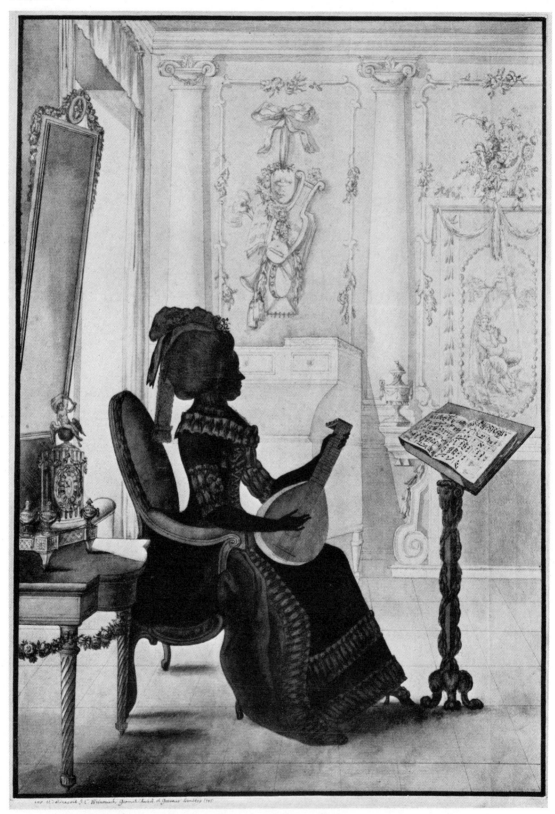

PLATE 13

INTERIOR WITH A LADY PLAYING A GUITAR. LINE AND WASH
'INV. ET DELINEAVIT I : C : WEINRAUCH GEOMET : ARCHOB : ET GRAVEUR : BAMBERG 1786'

PLATE 14

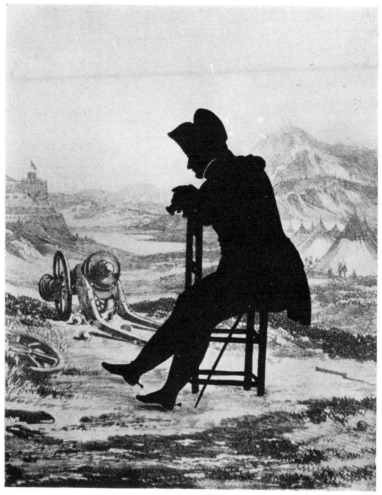

NAPOLEON

FROM THE TREATISE ON SILHOUETTES BY AUGUST EDOUART, ON LITHOGRAPH
MOUNT. THE ARTIST FOUGHT IN THE NAPOLEONIC WARS AND WAS DECORATED

VOLTAIRE BY M. HERBERT, *fl.* 1761
GENEVA

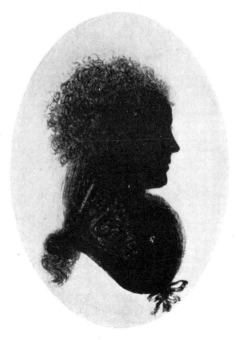

'PERDITA' ROBINSON

Portrait from the Collection of Francis Wellesley

PLATE 15

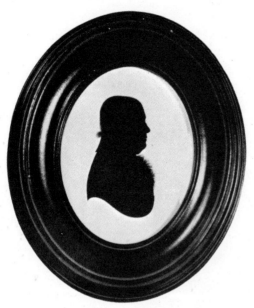

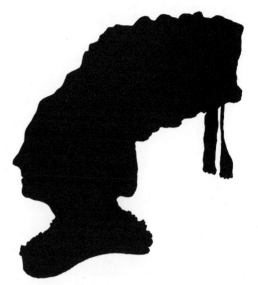

PROFILE SHADE, BY S. HOUGHTON
PAINTED BLACK ON PLASTER PEARWOOD
FRAME
Miss Martin's Collection

SPECIMEN OF ENORMOUS HEAD-DRESS
EARLY WRITERS IN GERMANY ADVISED TWO
SHEETS OF PAPER TO ACCOMMODATE THEM
Dr. Beetham's Collection

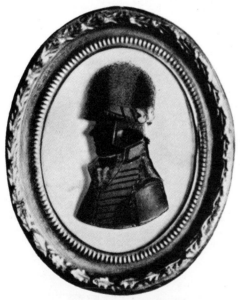

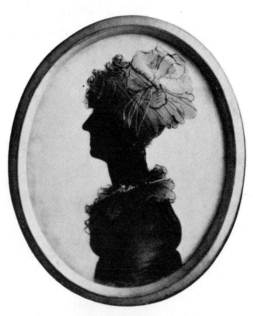

PORTRAIT OF AN OFFICER, BY ISABELLA
BEETHAM, 1780
PAINTED ON CONVEX GLASS
Nevill Jackson Collection

PORTRAIT OF A LADY, BY I. THOMASON
PAINTED ON GLASS, BACKED WITH WAX
Nevill Jackson Collection

PLATE 16

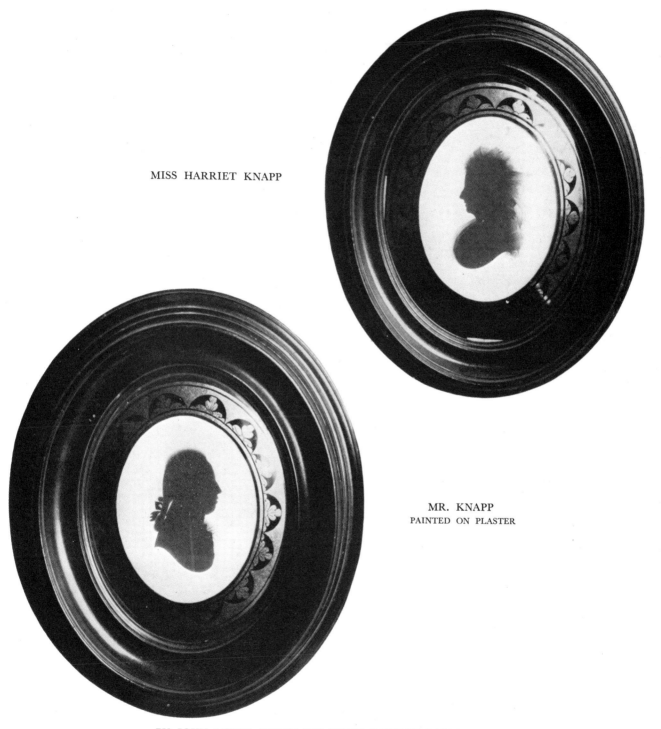

MISS HARRIET KNAPP

MR. KNAPP
PAINTED ON PLASTER

BY JOHN MIERS, USING HIS FIRST LONDON LABEL, 1788
ORIGINAL PEARWOOD FRAMES AND BLACK AND GOLD ORNAMENTED GLASS MOUNTS. 4 INS. × 5¼ INS.
Nevill Jackson Collection

PLATE 17

A LANDSCAPE, ROEHAMPTON LANE
PAINTED ON PLASTER BY JOHN FIELD (SIGNED)
*For many years in succession the artist sent such work
to the Royal Academy. 2½ ins. × 3½ ins.*

PORTRAIT OF A YOUNG MAN
PAINTED AT THE BACK OF CONVEX GLASS, BY
ISABELLA BEETHAM
*The mount has elaborate white and gold ornament, by
Edward Beetham, who learnt in Venice the art of
making such mounts for his wife's work. Sight measure
5 ins. × 4¾ ins. (Nevill Jackson Collection)*

PLATE 18

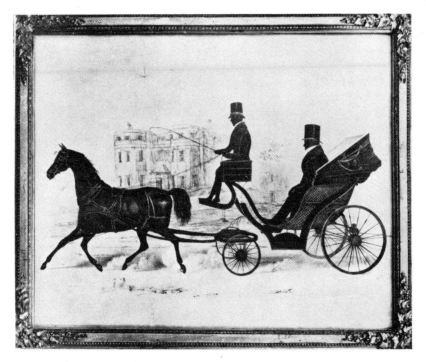

LITHOGRAPH OF DR. JEPHSON
WHO POPULARIZED THE WATERS OF LEAMINGTON, CURING THE GOUTY AND FAT
BY TAKING THEM OUT DRIVING AND INSISTING ON THEIR WALKING BACK, THUS
GIVING THEM THE FRESH AIR AND EXERCISE THEY NEEDED (19 INS. × 15 INS.)
Nevill Jackson Collection

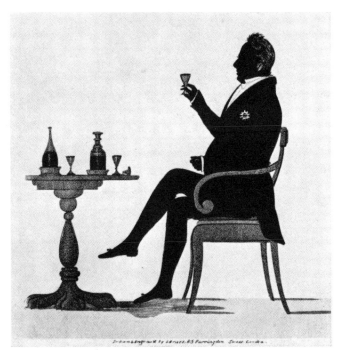

PORTRAIT OF KING WILLIAM IV
ONE OF A SERIES OF FAMOUS MEN ENGRAVED BY L. BRUCE, 85 FARRINGDON
STREET, LONDON
Nevill Jackson Collection

PLATE 19

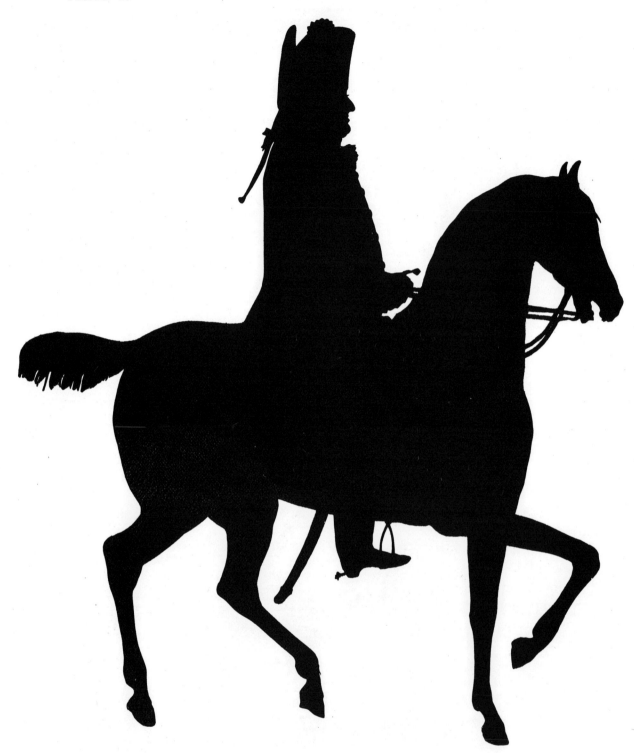

WILLIAM MACDOWALL, ESQR., M.P. OF GARTHLAND, LORD LIEUT. OF RENFREWSHIRE
DIED APRIL 1810
SILHOUETTED BY EDOUART FROM A DRAWING BELONGING TO LORD WESTMORLAND

retaining the original duplicate for reference and exhibition purposes ; pasting each portrait, carefully named and dated in a reference folio ; and indexing them for future use.

Through this meticulous care, the National Portrait Galleries all over the world have obtained authentic contemporary full-length portraits of the ut-most value. Men, women and children famous in after life crowd every page. The Bourbon Exiles, Charles X, living at Holyrood in 1832, employed the French artist to enliven the dull evenings of their exile, and to-day the Biblio-thèque Nationale values the result of Edouart's industry in making excellent likenesses of 78 members of the Court entourage ; of Charles X, his confessor, his valet, the Dauphin, the Dauphine, even the court chef. Sir Walter Scott's likeness by Edouart is in the London National Portrait Gallery, from this collec-tion ; another of the novelist is at the Scottish National Portrait Gallery; and dozens of other eminent Scotsmen wandered into Edouart's studio, with their wives and families ; all were named and dated, even addresses and quaint particulars of relationships noted.

Descendants find their ancestors amongst Edouart's 5,000 authentic silhouette portraits. Many delight in tracing in my folios the features, the pose they recognize in their children.

Of Edouart's further wanderings to ' the Americas ' and elsewhere, details are given in the Dictionary, and in my American chapter. The artist returned to his native land, visited Birmingham and Nottingham professionally and eventually died at Guines in 1861, having cut at least 100,000 likenesses in all-black paper, with never a touch of gold or colour, for he was faithful to his principles. Everyone was named and dated, almost we can look upon the outlines of the world's grandparents. Unfortunately, he has not been succeeded by many other brilliant cutters, and even painstaking painters in monochrome are few. There are plenty of wooden likenesses in black portraits, but where are the charm and spirituality, the quality of the old time shade ?

No wonder specimens of early silhouette work are becoming more and more valuable, and hard to find. In this volume twice mention is made of fires, answerable for the destruction of at least 200 of the choicest specimens; the George and Martha Washington, life size at Boston, and the entire collection of Captain Coke, warehoused during the Great War ; while how many machine cuts were burnt when the American Museums blazed so frequently, we shall never know. So these frail treasures disappear, as a shadow vanishes when a cloud passes before the sun, and those shades that remain become more precious.

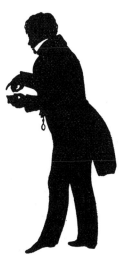

Liston, Comedian.
By Edouart.

CHAPTER II

CHINA, GLASS, JEWELLERY, BOXES

AS one of the earliest known types of black profile representation is connected with the decoration of pottery, it is interesting to note that when silhouette making was at the height of its popularity in the eighteenth century, a return was made to the style of the antique.

We see Greek wine-jars of the third century B.C. ornamented with black shadow pictures, stalwart figures bending over work at a forge, ships guided by sailors in profile, women spinning, carrying water-jars, children playing. What are they but the forerunners of the simpler profile porcelains of comparatively modern times?

The silhouette portrait of a friend on a cup or vase pays a delicate tribute to personality. Floral ornament, landscape, masonic and commemorative emblems, all suggest places or events, but for direct charm and compliment, the uncompromising black of a shadow portrait on the china of Worcester, Bristol, Sèvres, Dresden, Berlin, Gotha, Copenhagen or Vienna, is an inspiration.

How simple to paint a silhouette on china; so many of the artists at the factories were connected with miniature painting. Fanny Charin of Lyons was a pupil of the great French miniaturist Augustin, and painted at the Sèvres porcelain works, at the same time that she undertook those charming miniatures in the manner of Isabey.

Isabey himself was sometimes employed at Sèvres, and Jorge Gylding the Dane was a painter of porcelain before he became Danish court portraitist. We may be sure many of the minor miniaturists were working at both trades in the neighbourhood of the important factories. Queen Mary has a fine mug [1], from a Danish factory, $5\frac{3}{4}$ inches high; it is decorated in gold on the lip; in a medallion framed in black is a silhouette portrait of Princess Louisa of Denmark, daughter of Queen Caroline Matilda, sister of King George III; on a label in the handwriting of Her Majesty are the words: 'Married the Duke of Augustenburg.' Small sprays of roses in natural colours also decorate this cup (Plate 28).

I have seen two fine centre-pieces made at the Copenhagen porcelain works; they stand 16 inches in height, swags of flowers on a white ground enrich the vases; cupids ornament the lids and hold a shield, where on rose-pink ground

[1] Royal Collection, Windsor.

the silhouettes of the King and Queen of Sweden show with good effect ; this at one time was in the Knole Collection. At the Royal Copenhagen factory, founded in 1770, plaques with the silhouette portraits of successive Kings and Queens of Denmark have been made, beginning with King Christian IX and Queen Louise ; our own Queen Alexandra, wife of King Edward VII, is naturally in this series [1] amongst the latter-day Royalties (Plate 23).

The fine chocolate pot (see Plate 23) was made after Franz Heinrich Müller had re-established the Copenhagen factory about 1780. Foreign artists were employed and the varied designs, magnificent colouring with rich gold, combined to perfect work on a level with the best European factories. With the exception of the collection at Rosenborg Castle there are few examples of this period left in Denmark [2].

The decoration of china with profile portraits synchronizes not only with the wave of silhouette popularity, from the second half of the eighteenth century to the first quarter of the nineteenth, but also with the founding of many of the European soft-paste factories ; hence cups, plates or vases, bearing portraits of the original founders, are occasionally to be found. Amongst these is an English example, a mug made at Bristol ; this was included in the Trapnell Collection now dispersed. It is painted with bouquets of flowers in colour (Plate 23), and is of the valuable hard-paste porcelain. Round the lip is a border irregular in depth, one inch wide at the narrowest, in fish-scale pattern painted in red. Surrounded by a laurel wreath frame is the shade of Richard Champion, founder of the factory ; the mark is the crossed swords.

Another valuable founder's piece with silhouette decoration comes from Worcester and is closely connected with the management, the portrait is of Dr. John Wall, so long in command of the Royal works.

Flower and fruit decoration in [3] natural colours show with great effect on the canary yellow ground of the mug. This piece is considered by experts to be one of the best examples of the work of a Worcester artist in 1769 (Plate 20). A mug from the same source is now in the British Museum. The Wall mug bears the date 1759, and initials J.W. It was formerly in the collection of the late Mr. Drane of Cardiff, and is now owned by Mr. Wallace Elliot. Mr. Drane believed the piece to have been made to commemorate the twentieth anniversary of Wall's marriage or possibly to his having a degree at Oxford conferred upon him. I regret to add that Mr. Elliot died while this book was in proof, 1938.

The Royal Warrant was bestowed on the Worcester factory in 1788, after the visit of King George III, who in the selfsame year was attacked by his first serious mental illness.

It was a few months before the King's Jubilee in 1809 that those important pieces were made in preparation for the patriotic demand for the King's portrait

[1] Miss Martin's collection. [2] *Old Copenhagen Porcelain*, by E. Reuter.
[3] See colour plate.

in the Jubilee year, when on October 25 His Majesty entered the fiftieth year of his reign.

Such an occurrence had not taken place since the reign of Edward III 1327–77, so that general festival, distinct from all party politics, was celebrated with enthusiasm.

There were Chamberlain Worcester vases in white and gold on which the black shadow showed with fine effect; vases with decoration of green and blue and gold with ornate handles. Besides the portrait and motto, 'A Present from Cheltenham,' occurs on a ribbon frame surrounding the silhouette of the King all-black; the decoration of the piece is in three colours. A smaller example is very similar, but the words are 'Happy Jubilee 1809'. On another Worcester vase, 13 inches high, the motto is 'An Honest man's the noblest Work of God'. This last example is in the Knole Collection (Plates 26, 28).

A small specimen of very fine quality in The Royal Collection consists of a stand raised on three gilt lion's paws. 'The Nation's Hope' is in gold lettering with jewel work in porcelain above; on this stand there is a jardinière with gilt mask handles and gold arabesque ornament. In the front is the silhouette of the King, the face black, the hair, Garter Star on the breast lightish grey. This portrait was taken from the silhouette drawn, engraved and published by H.W.H., 24 Clerkenwell Green, London (see Dictionary), I have recently been able to identify it. Besides such specimens there were hot-water jugs; mugs of the village harvest drinking type, provided for bucolic admirers of the Farmer King; plates, saucers, cups and porringers, all with the silhouette of the King and patriotic mottoes such as 'Long May He Reign', 'Glorious Jubilee', 'The Nation's Hope', and so on. There are two Jubilee Commemoration pieces at the London Museum presented by Queen Mary. I have several fine jardinières in Chamberlain Worcester, with the motto. Examples such as these are very rare; it is only by careful search that one is able to find specimens. It is certain that no silhouette collection approaches fulfilment without an example of such a ceramic rarity.

From the other European factories which produced such unusual souvenirs,[1] perhaps the most costly specimen recorded is a coffee cup and saucer in *Viennese* porcelain. The chief decoration consists of rayed lines in colour; in the centre of the saucer is a palm-leaf. On the cup is a shadow portrait of the Archduke Charles, in a double-line frame, with inscription.

The specimen formerly in the collection of Karl Meyer was sold in Vienna in 1928 for £200 (Plate 25).

At Dresden, in the period when Count Marcolini, Minister to the Elector Frederick Augustus, was director, 1796–1814, the examples made were most interesting and valuable. During these eighteen years the style of manufacture underwent a great change. Ornate floral decoration disappeared, and classical

[1] See *Royal Collection, Connoisseur*, Nov. 1932.

PLATE 20

PORTRAIT OF A MAN
BY A. FORBERGER, PARIS
SIGNED AND DATED 1791. BACKED WITH GOLD FOIL

PORTRAIT OF LORD MANSFIELD
PAINTED ON GLASS BY A. FORBERGER, PARIS
1762–1865

forms and ornaments with profile medallions took their place (hence the opportunity for silhouette portraits) ; the plinths of vases were square ; laurel and husk wreathing was used, angular shaped handles were made for cups and mugs. A beautiful Marcolini Dresden cup and saucer is a rich dark blue in colour, with gold ornaments and black portraits on a cream yellow ground.[1]

This severe style inspired by the French first Empire influence, in dress and furniture, pseudo-Classic, is shown in a cup and saucer in the British Museum. It is of black glaze with red bordering lines ; on the cup is a square panel in gold with a black silhouette of a female bust. In the saucer a similar panel is inscribed ' Homanage de l'amitie ' (mark R-g and number 2 in blue). There is also a fine Austrian or Russian Royal portrait on a cup in the Museum. The silhouette medallion is on ermined mantling, and above is an imperial crown ; the date is the end of the eighteenth century. On the saucer is the same crown and entwined initials. A beautiful Fürstenberg china coffee-cup is 3 inches high. A man's portrait is framed in a gold laurel-wreath suspended like a locket, to a gold border at the edge. A similar cup has a wreath of forget-me-nots in colour. On the back is the inscription ' In Remembrance of Your Affectionate Grandmother N.J.T.'. Such a piece would probably be made for a wedding or birthday gift.

A saucer from the Gotha factory has no fewer than five silhouette portraits in a border alternating with a wheel device. Above are lines of gold and green ivy trails. The portraits are most distinctive ; the ages of the men range from about 10 to 60 years. All wear tied wigs and frilled shirts. They are probably members of some ducal family (Plate 27 (6)).

A large dessert plate is of French porcelain with bouquets of coloured flowers, and within a husk wreath, the silhouette of a man of about the year 1790, whose name I have not yet found (Plate 27 (1)).

In the Hohenzollern Museum, Monbijou Castle, there is a coffee service of Berlin manufacture. The silhouette of Frederick the Great appears on the coffee-pot, and six female and three male heads, presumably members of the Royal family, decorate milk-jug, bowl, sugar-basins and cups. The finest cup with cover I have seen is richly ornamented with portraits, and was in the possession of Captain Desmond Coke, and is now in my cabinet (Plate 25).

Mirabeau's portrait in silhouette was painted at Sèvres (Plate 28), possibly on a whole service; or perhaps his was amongst the portraits of other notabilities of his day. This relic can be seen at the Musée Carnavalet, Paris. A somewhat similar example of a famous man whose popularity would quicken the sale, is the cup and saucer, lettered at the base Revil ; a silhouette portrait of Benjamin Franklin is on the cup. The profile is wreathed with pink and blue flowers with gold ornament ; its date, 1780–5, synchronizes with the visit of Franklin to Paris. It was purchased at that date by the Russian Ambassador to France and in 1917

[1] Nevill Jackson collection.

was brought back to Paris by a descendant of the family, from whom it was bought.[1] Nyon, Lake of Geneva, also produced shadow portrait decoration on its hard paste. Other factories in Europe likely to yield specimens of Silhouette china are *Gotha*, oldest of the Thuringian group, dating approximately from 1763.

Fulda in Hesse, where the fine white paste with handsome decoration was made with the mark double *ff* or *x* cross. This make is difficult to find, for little attempt was made to trade it.

Fürstenberg in Brunswick, where the plaques similar to those of Copenhagen were made. Its date 1750 coincides with the cursive, or running-horse mark.

Höchst on the Main now in Nassau, once belonged to the Electors of Mainz. Its wheel-mark dates it from 1746 when Johann Frederick Karl, Archbishop of Mainz, was in power.

Nymphenburg at Neudeck produced a good deal of this personally decorated china. Its interlaced mark C or mystic double triangle mark declares the origin of the paste, but much of the decoration was done at Munich.

Coming to comparatively modern times the late Lady Sackville, a notable collector, confessed to having had made a very fine toilet set with beautiful flower wreath framed silhouettes, after those in her own collection of Royalties and personal friends. Bowls and jugs complete form an interesting and unique series from Knole.[2]

During the first decade of the nineteenth century some of the designs of Louise Duttenhofer (see Dictionary), the cutter, were used as decoration on porcelain.

Occasionally one may find silhouette heads on china pipe bowls made in the German manner.

'Seven cups and saucers (silhouette)' is an intriguing entry in the catalogue of the Miniature Exhibition under the auspices of the Maryland Society of the Colonial Dames of America, held 18 January 1911, in Baltimore. Unfortunately our cousins over the water do not catalogue in the usual manner. There is no description of the china, nor note of its provenance, nor name of the present owner, so that I must end my list with a mystery.

JEWELLERY AND BOXES

A locket said to be a keepsake given by the unfortunate Marie Antoinette to one of her ladies shows a portrait of the lovely Queen, black on white porcelain on one side, and her initials entwined on the other.

In describing a brooch as another example on porcelain, this time of a British officer in uniform of the date 1800, we are led definitely to the subject of shadow portraits of small size set as jewellery.

The fashion of wearing small portraits as ornaments goes back to the beginning of the sixteenth century, when portrait miniatures set with jewels were worn by men and women. Besides this a chain with medallion portrait attached

[1] Miss Mary Martin's collection. [2] Now in the possession of Rev. Glenn Tilley Morse.

was often given as a reward for special service. Such a gift would be an honour as well as payment.

The custom persisted on account of convenience in recognizing service in not too obvious a manner; the farewell gift to a trusted ambassador, or to a friend, would be a gem set portrait of the donor. In old wardrobe accounts one reads of large sums being paid for miniatures set with jewels to be used as discharge for debts.

Later the habit penetrated to a lower stratum of society, still touching the souvenir mode. Ladies wore the miniatures of their betrothed husbands and of their children attached to a chain or as a clasp to a bracelet; men wore frill brooches and rings with silhouettes of their lady loves. Even portrait breast-pins are known, though rare. One well authenticated contained the head of the lovely Clarinda; Burns, in his character of Sylvander, the lover of this lady, urges her to have her portrait taken by Miers. One of his published letters runs :

'I thank you for going to Miers. Urge him, for necessity calls, to have it done by the middle of next week; Wednesday the latest day. I want it for a breast-pin to wear next my heart.'

Silhouette heads of men, women and children were set in diamonds, pearls, turquoise, amethyst and gold as charming tokens of remembrance.

The mourning ring must not be forgotten. What more suitable than the black shadow portrait of the departed on the bezel, an oval or oblong set in gold and inscribed on the back. I have a dozen varieties, the collection of twenty-five years. If one example is found by Miers, the half-inch shade will probably be signed. Field also signs, and the J.D. of Dempsey is on a few rare specimens found in the wake of his Liverpool itinerary (Plates 32, 33, 34).

Though I have no reason for thinking that mourning rings were often distributed as lavishly, yet the extent of the custom may be gauged by the list given in Wheatley's edition of the *Diary of Samuel Pepys*, 1923, Vol. 1, when Sir Richard Hoare, Banker, instructed goldsmiths Richard Moore of Stark Court or Edward Chowne to make memorial rings to be distributed on the occasion of Pepys' death and funeral, to relatives, dependants and friends, representatives of the Admiralty, the Royal Society and the Universities of Oxford and Cambridge.

Moreover, the rings were of three denominations—*45* at a cost of twenty shillings each; *62* priced at fifteen shillings each, and *16* at ten shillings each.

In wills up to the end of the last century five pounds or more was frequently left to a friend 'to buy a mourning ring'.

Some of the mourning rings in my collection have a swivel bezel so that either the inscription or the shade can be exposed; one in black enamel with white lines has the words 'Not lost, but gone before'; on the reverse, a beautiful portrait of an officer in blue uniform with gold embroidered collar.

One ring has a bezel which can be opened or shut. On the tiny lid is a

pansy in mauve and white enamel with green stalk and leaf. One lifts the lid to find a minute Dempsey portrait of a man.[1]

Considering the small space at the disposal of the silhouettist who undertakes a ring portrait, one would expect to find no satisfactory result as to likeness, but strangely this is not so. 'The likeness', as Miers says on his label, 'is preserved, however small.'

Nearly all the important silhouettists mention on their labels, their miniature work for jewels; on *Miers* first Leeds label 1781 'N.B. Profile Shades in Miniature'. On his first London label 'Profiles on ivory set in Rings, Lockets, Bracelets, &c.'

Charles in his Newspaper advertisements 'Miniature for Lockets, Rings, &c.'. Mrs. Beetham's jewel-work is very rare. I have found no mention of it on her labels, though I have some examples.

Field 1824. 'Character even in the minute sizes for Rings, Brooches, Lockets, &c.'

Queen Mary owns a fine memorial ring, a portrait by Miers of George Brudenell, Duke of Montagu. This was made to the order of his daughter, the Duchess of Buccleuch, and gives the only portrait at Windsor of the Duke of Montagu, who was Governor of the Prince of Wales 1776, Master of the Horse, Governor of Windsor Castle, Privy Councillor, and Lord Lieutenant of Huntingdon. The ring was ordered from Miers by the Duchess of Buccleuch who has left the record engraved on a bezel ring, containing some of her father's hair and her own entwined, as was the custom of the day (Plate 34).

A quaint memorial ring is uncommon in holding two portraits by Dempsey, painted in black and gold; the lady has a charming cap and tippet. A snake, tail in mouth, symbol of eternity, forming the frame in gold, rests on a bezel of black enamel. Another Dempsey ring is in memory of William Colborn, who died in 1795, aged 77, painted from description. This has the familiar J.D. Sometimes the ring of an older generation was supplied by the owner, and the silhouette worked to fill the space allotted.

There are two superb rings with portraits of a man and a woman respectively, each signed S. Furt. They are eighteenth-century works in the *églomisé* process. The gold framing is an inch and a quarter long; an inside line of black octagonal shape makes a second frame. These were lent to the Victoria and Albert Museum for a year and are now once more in my cabinet (Plate 32).

Another ring once in my possession has an interesting history, showing the efficiency of English staff work just before the Great War. Of the tiny cut portrait on satin I can tell no story earlier than 1912 when I bought it in London, and sent it, together with many other samples of silhouette work, in answer to a request from the Loan Exhibition at Leipzig in 1914. Great was my anxiety as to the

[1] In the magnificent collection of rings sold at Sotheby's in December, 1937, belonging to the late Monsieur C. Guiltron, was a gold ring with a carefully concealed silhouette of Louis XVI, in coloured papers, set in the bezel.

PLATE 21

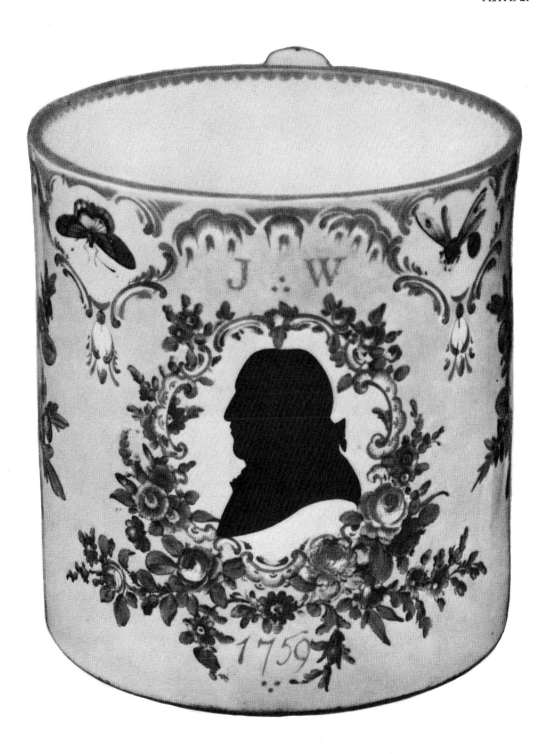

MUG, WITH PORTRAIT AND INITIALS OF DR. JOHN WALL
WORCESTER, DATED 1759
Ex Wallace Elliot Collection (sold, May 1938, for £660)

fate of my property when war was declared on the outraging by Germany of Belgian neutrality; then I read in *The Times* :

No confirmation has been received at the Exhibition Branch of the Board of Trade of the reported destruction of the British Pavilion, at the International Book Exhibition at Leipzig, together with the French and Russian sections, but there seems unfortunately little reason to doubt the accuracy of the report. It will allay the fears of those private owners who generously contributed to the British Loan Collection to know that practically all these exhibits were safely removed by Mr. E. Wyldbore Smith, the British Commissioner, and his staff immediately before their hurried departure.

At the conclusion of the war in 1919 I recovered all my property.

At the time when the silhouette jewel was popular—the last quarter of the eighteenth and the first of the nineteenth century—hair decoration was fashionable, and coils, plaits, twists, flat chequers, pearl strewn knots and flowers, landscapes and urns were made. These were generally on the obverse of a locket or ring. In a locket in my collection, also a memorial piece, a hair plait oval has on it a smaller enamel plaque on which is the portrait of a woman. The obverse has a beautifully worked inscription in brown silk on primrose satin : ' Maria White born May 15th, 1799, died August 21st, 1825.' A fine oval has the head of a man, all-black, early Miers work ; the signature beneath the bust-line. He is very handsome with ribbon-tied wig and shirt frill.

A fine Miers portrait of a man on ivory is in the clasp of a flat agate bracelet set in gold. Another lovely clasp has a cut-out head of a child on satin ; to this is still attached the band of black velvet which our grandmothers knew so well would show off the fairness of the skin (Plate 33).

In 1779 a traveller passing through Paris commented on the fact that the market women bore their lovers' portraits in bracelets. Such trifles might be framed in pinchbeck, the rich looking but inexpensive amalgam invented by our Christopher Pinchbeck in the eighteenth century.

I have a beautiful pair of 2-inch wide pinchbeck bracelets with silhouette clasps, with portraits of ladies, and another with a silhouette portrait as centre-ornament. This latter has a copper fastening with an adjustable rachet which makes it suitable for either a thick or a slender arm (Plate 33).

Not only were the miniature shades mounted as rings, bracelets and lockets, but seals were made to open and reveal the profile of the owner or donor. I have only seen three of these so-called secret seals—one in the Victoria and Albert, bequeathed by Captain Desmond Coke, one in the collection of the late Mr. Stoner, and one in my own cabinet.

When we consider what a much used and important item was the fob seal, in the first half of the nineteenth century, it is no wonder that its decoration was made to conform to the fashion.

Not less important was the snuff-box in the equipment of a gentleman, and here the silhouette again appeared.

The gorgeous gifts of jewelled and painted snuff-boxes offered when money reward was inconvenient were in vogue up to the end of the First Empire, and it is amusing to find that there are many authentic records of their return to the maker for a cash equivalent.

In my own cabinets on a tortoiseshell box mounted in gold, is a fine portrait of a lady in a hat, with gold background (Plate 31). More minute is a charming lady's portrait mounted in a gold stopper of a perfume bottle; the glass of the bottle is curved and in the centre there rises a little Vauxhall spyglass, the opera glass in embryo. This is a most valuable silhouette toy, probably French.

Quaint mottoes were freely used on Palais Royal snuff-boxes, many in snake skin or shagreen, with lid portraits inside or out. 'Il ne me reste que l'ombre'; on another were portraits of Louis XVI, Marie Antoinette and the Dauphin on gold ground; this box is in the collection of Rev. G. T. Morse.

I have several ivory patch-boxes and tooth-pick cases with Miers's portraits in the lid; a snuff-box mounted in tortoiseshell and gold has a charming young lady with ringlets painted by Dempsey (Plate 31).

Also painted, though I do not know by whom, is a lovely lady in black and gold with a lace cap and frill. I have several full-length figures, the size of a sixpence, mounted in horn boxes; these are by Dempsey, found at Liverpool, where he worked for a long time. Very charming is an ivory and gold patch-box with a beautiful cut spray of moss rosebuds an inch high, probably amateur work.

A French card box with old packs and some engraved counters remaining in it, has inset in the lid a little black portrait, probably of the owner, with high dressed hair. The box is of satin wood studded with steel pins in patterns in the French manner. Another box has needlework implements in it, measuring 6 inches; it has on the outside a silver plate 'to our Incomparable Maman'; inside is the shadow portrait of the incomparable one, in a charming high cap. The fittings of the box are in silver repoussé.

A pearl and gold fitted box has outside under glass a quaint little cut-out figure, obviously amateur work. Such examples as these are very rare, but charming for varying a collection.

GLASS

An account of glass in connection with silhouette work would be incomplete without eulogy of the work of Karl Rosenberg, H. Gibbs, the Jorden brothers, Mrs. Beetham, Spornberg, Hamlet of Bath, Thomason, Bouttat, Gross, Forberger, Zenner and many others, whose lovely portraits painted on flat or convex glass fill us with pleasure.

Infinite variety is achieved, and individuality shown, in minor details. Rosenberg's dense black, and the hint of faded colour background; Gibbs's wax-filling at the back, and his airy treatment of dress detail; Hamlet's full-length

method ; Spornberg's beautiful red pigment ; each of these and many others are described in detail under the artist's name in the Dictionary.

Nor should we, while treating of glass method, omit to mention the fine gold and opaque white borders of the inner framing of Mrs. Beetham's work, provided by Edward Beetham, her husband, who went to Venice in order to learn the art of making such mounts ready for his wife's work (Plate 17).

Of supreme importance also is the *églomisé* process in connection with glass.

GOLD GLASS SILHOUETTE PORTRAITS

The art of gold ornament is much older than the term *verre églomisé*, often used to describe it. That refers back to an eighteenth-century Frenchman, J. B. Glomy, who popularized glass, coloured and gilt on the reverse, as a border for frames.[1]

In a French dictionary of art terms by Larousse : 'Eglomisé ée (de Glomie n pr) adj. *Se dit d'en objet en verre décoré au moyen d'une dorure intérieur suivant le procédé de l'encadreur Glomie, qui paraît en avoir été l'inventeur au XVIII siècle.*'

The art of gold-leaf ornament under glass was known in early Christian times. Medallions are in existence engraved with gold leaf adhering to the underside of a thick sheet of glass, which is protected by a covering of fused glass. There is an Italian example of the fourteenth century, another of the fifteenth in the Victoria and Albert Museum. Elsewhere there is a half-inch thick slab of glass on which an indentation, the head of a doge, has been made, and the cap and gown decorated with gold. This moulding before gilding is rare.

Early examples exist of the gold leaf being put on in patterns and then backed only with a coating of paint as in the ordinary gold glass silhouettes, so that we need not think the omission of glass backing is a sign of decadence ; it exists side by side with the glass backing process, and was done in all countries in Europe. There are Italian specimens of the fourteenth and fifteenth century where the gold leaf, after being engraved, is seen to be backed only with paint.

A crucifixion of North Italy, fourteenth-century, done at the back of flat glass is an oval, measuring about 10 inches. Above are small medallions ; two prophets and a pelican in her piety carried out in the same process.

A Dutch fifteenth-century gold glass picture shows men in a wood with a lamp ; this is a 3-inch size, backed only with paint. A century later, a writer Mathesius wrote : ' The ready wit of man is always finding something new ; some have on the white glass painted all kinds of pictures and mottoes and burnt them in, in the annealing oven.'

A Russian or Greek paint-backed sample shows a head of John the Baptist ; this was made in the eighteenth century. A French eighteenth-century example shows Neptune in his chariot, trident in hand. Again, a fourteenth-century Italian

[1] *Connoisseur*, F. Sydney Eden, LXXXIX ; W. B. Honey, XCII.

plaque of the school of Niccolo da Bologna, measuring 7 by 5 inches, is simply backed with paint.

So highly decorative was this process that gold glass pictures were used in conjunction with the finest specimens of the silversmith's art. There is an Elizabethan silver casket among recent acquisitions in one of our National Museums which is profusely decorated with panels in *verre églomisé*. In the superb collection of Mr. Eumorfopoulos there is a fine ecclesiastical example, the subject the enthronement of the Virgin ; it measures 3½ by 2½ inches.

South German panels or plaques are used to ornament a cabinet of the late sixteenth century. The glass is flat, backed with gold foil, etched with subjects from the Old Testament. Religious subjects were generally chosen for these pictures. Mrs. Whittaker at Palermo has a fine series of this type which may possibly have been used as the Stations of the Cross.

Perrenon in his book of instructions for silhouette workers which appeared in 1780 gives rules for making glass silhouettes. He directs that—' The glass must be cleaned with powdered chalk to remove all grease and dirt, then cover one side with fine ground white lead mixed with gum water. When this has dried take the profile cut out of strong paper, lay it on the glass, trace round it the outline of the portrait, with a needle. Scrape away all the white within the drawing ; a transparency is thus obtained. It may be made black by layingon a piece of black velvet, cloth, paper or taffeta, one can stick on the paper cutting, using the gum to cover the white ground, as well, or one can put foil, gold or silver.'

Another process is described as consisting in ' painting the back of a flat piece of glass black, drawing the outlines of the head or figure in this, and putting gold leaf under the space left free. To avoid air and damp getting in and prevent the black from rubbing. A layer of wax should be put over the whole of the back.' (This takes the place of the gum in above process.)

Fine lines on hair, lace, etc., were done with an etching needle, also wreaths, patterns and emblems were marked on in black to form a frame. Often blue, grey or rose colour were used as well, and the gold, silver and subdued colour had a very beautiful effect.

Schmid of Vienna 1796 made a good many gold glass trinkets; a black spray beneath the portrait is a favourite device; he uses it on a portrait of Landgrave Joachim Fürstenberg, 1749–1827, which is in the Gratz Museum of Arts and Crafts. On the back of this silhouette is inscribed : ' *Quoique dans l'ombre on reconnait pourtant le tendre epoux, le bon pere et l'amie prudent.*'

A green ground was used frequently by him; several examples are mentioned with the fine signature ' Fecit Schmid de Vienna ' with the date. The companion picture to the Fürstenberg above, is on green. In the distance is a tiny landscape, drawn on the glass, and the lines of water in a brook are made with hair.

Johann Mildner of Gutenbrunn in Austria used colour freely in his profile portraits in drinking glass decoration ; and the Mohns, father and son, though

PLATE 22

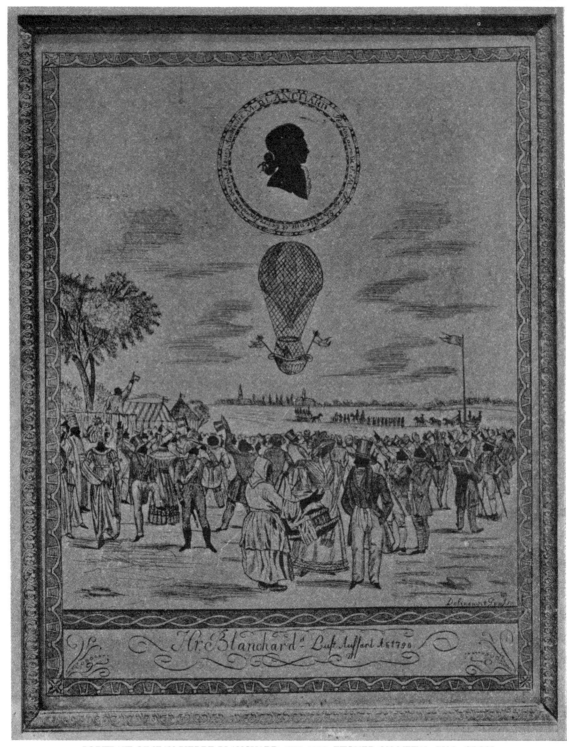

PORTRAIT OF JEAN PIERRE BLANCHARD, 1783–1809, ETCHED ON METAL, BY L. GROSS
OF VIENNA
THE DRESS OF THE CROWD INDICATES THAT THE PICTURE WAS MADE MANY YEARS AFTER THE BALLOON
ASCENT TOOK PLACE
Presented to the Victoria and Albert Museum by Major Desmond Coke

faithful to the black shade convention, bronzed buttons and decorations and used colour sparingly, in ornament.

It is said that in Silesia, objects like glass goblets, preserve and sweetmeat holders, were decorated with the profiles of the reigning family and other notabilities, and examples were kept ready for the addition of the silhouette of the purchaser which was put on and rendered permanent in a few hours by blowing glass over it.

At Bohemian and French factories the practice of adorning the base of a drinking glass, salt-cellar or basin with coloured pictures, belongs to this period, and later in England the white profile portraits enclosed in glass by Ashley Pellat appeared.

Gold decorated glasses were often given away to departing guests or as wedding presents. These were made at Nuremberg, and often had the profile portrait of the donor ; one has inscribed round the rim : 'With best wishes for your welfare, your faithful wife presents you with this. L.W.V.R. August 6, 1795.' For obvious reasons the goblet has a glass-fused backing, as the paint would be soaked off by the fluid. These glasses were being reproduced in dozens a few years ago, and a modern example might be mistaken for an antique by the unwary.

A fine beaker is decorated with rose garlands in colour, beneath are three portraits measuring 2 by 1½ inches of Goethe, Schiller and Lavater.

Larger pictures in the *églomisé* process are more numerous in Germany than in England.

In the Linz Museum is a picture of eight musicians about to perform. They wear knee-breeches and cocked hats of the period, some have musical instruments in their hands, others sheets of music, which are also strewn on a table. Two medallion portraits hang on the wall, a clock and cabinets are in the room and the correctly drawn floor-covering in squares appears as usual in work of this period in Germany.

Herr J. Leisching mentions a series of ten family portraits by Occolowitz, in gold glass, signed and dated ; others are full-length portraits in the same process, and a small example in a locket.

'Fec. Slauzell', 'G. Schroll fec' are two others described by Herr J. Leisching, as being in an Industrial Museum at Mehren.

Large wall pictures date from about 1740; the flat glass sheet with painted black decorations, was sometimes mounted on a coloured ground, instead of the gold or silver foil. In the Linz Museum is such a picture, an officer and lady in First Empire dress ; another, a lady reading, seated at a writing-table ; both these are mounted on red with good effect.

In an example belonging to Dr. Strauss of Vienna, two men are drinking coffee ; a mirror behind them reflects the room, which is in Empire style. On the wall above hangs the silhouette of an ancestor, in *verre églomisé*. This formula of representing a deceased member of a family, in a picture, persisted to the time of Edouart, who used it frequently in his interiors.

Our Blanchard picture may be studied at the Victoria and Albert Museum.

It measures $8\frac{1}{4}$ by $10\frac{5}{16}$ inches and is by Gross. A crowd of men and women, tents and fruit-sellers in the foreground suggest a country fair; the dress indicates the date about 1830. Above is a balloon with one occupant in the carrier; at the top of the picture is a medallion with silhouette portrait of Mr. Blanchard, one of the early aviators whose ascents took place in the second half of the eighteenth century. The process is etching in black on gilt metal (Plate 22).

Another picture of the more intimate conversation type and in the gold glass *églomisé* process is by Bouttat. It measures 8 by $9\frac{1}{2}$ inches. In a richly furnished room a lady, Jane, Countess of Harrington, is seated with her two children, Lord Viscount Petersham and the Honourable Lincoln Stanhope. The date is 1795; the signature and full details given in one with the glass of the picture make this a valuable example.[1]

Of other less important examples of the use of silhouette decoration one may note that when the fashion prevailed for the wearing of enormous pictured buttons on men's coats, shadow portraits were used.

One man is described as having portraits of Roman Emperors all down his coat. A lovely gold glass button in my possession recalls this amusing mode.

Isabey, the miniaturist, painted buttons with names, portraits, flowers, &c. The fashion would thus be set, the shadow in *verre églomisé* would follow.

It is recorded that in the possession of Frederick the Great was an étui with a silhouette portrait of the Duchess of Brunswick on white enamel. This process is very rare. I have a portrait in a locket, I know, of one of the ordinary $2\frac{1}{2}$-inch size, but I have seen no others; in the advertisement of two silhouettists, enamel is mentioned as one of their processes.

A curious example of silhouette work in glass commemorates Queen Victoria's coronation. It is one of the usual millefiori paper-weights, but varying in that it holds no fewer than twenty-two silhouettes of the young Queen. The largest is in the centre surrounded by a wreath, and in each starred floret or coloured mosaic flower, a tiny portrait is held (Plate 36). On the underside of the weight is another silhouette of the Queen. The weight was made either at Bristol or Stourbridge in 1837.

Those who have visited Murano's famous glass works on the island near Venice can easily realize how this piece was made.

The rods in different coloured glass were arranged in a vertical position, then heated to fuse. The bunch of rods was then pressed laterally to exclude all air bubbles; and the combined rod drawn out lengthwise so that the colour combination remained the same however attentuated. Thus the surprisingly small centre portrait of the Queen would be correct, however diminutive. These were cut into sections and the pieces wound into bouquets. Lastly a bubble ball of molten glass was blown round the bouquet, the pontil being filled up with sections of rods.

[1] Nevill Jackson collection.

PLATE 23

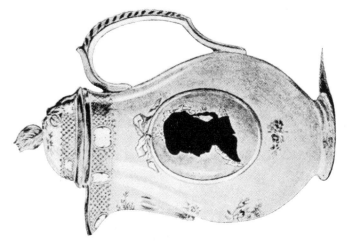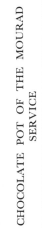

CHOCOLATE POT OF THE MOURAD
SERVICE

OF GREAT ARTISTIC MERIT, MADE AT THE ROYAL
COPENHAGEN FACTORY AFTER ITS RE-ESTAB-
LISHMENT ABOUT 1780 BY F. H. MÜLLER

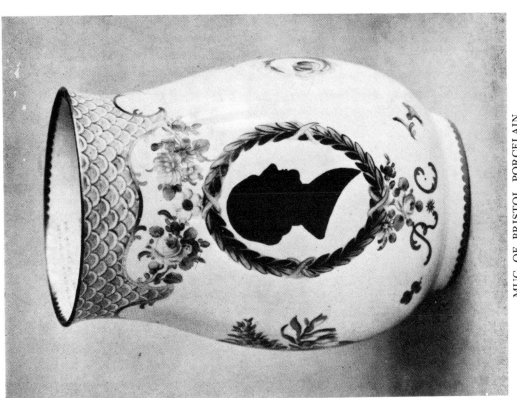

MUG OF BRISTOL PORCELAIN

DECORATED WITH COLOURED FLOWERETS, RIBBONS AND HUSK WREATHING.
THE SCALE PATTERN IS IN RED. THE PORTRAIT IS OF RICHARD CHAMPION,
DIRECTOR OF THE BRISTOL FACTORY

Formerly in the Trapnell Collection

SHADOW PORTRAIT OF QUEEN
ALEXANDRA ON PORCELAIN

MADE AT THE ROYAL COPENHAGEN FACTORY.
THE CROWN AND FRAME ARE GILT

Miss Martin's Collection

PLATE 24

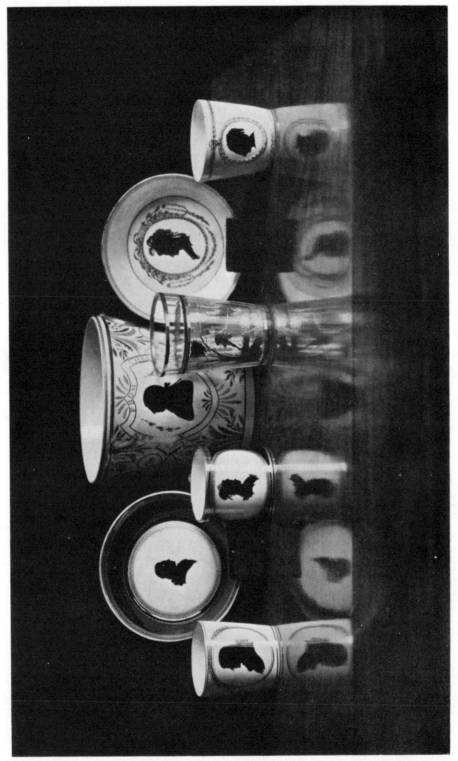

CENTRE : JARDINIÈRE, KING GEORGE III JUBILEE PORTRAIT, WITH COLOURED DECORATION, CHAMBERLAIN, *WORCESTER*. LEFT : CUP, WHITE AND GOLD, *FÜRSTENBURG* MARK ; CUP AND SAUCER, DARK BLUE, GOLD, *DRESDEN*, MARCOLINI PERIOD ; TUMBLER, GOLD BETWEEN GLASS, *ÉGLOMISÉ* SAUCER, MARCOLINI, *DRESDEN* ; CUP, WHITE GOLD, *FÜRSTENBURG* MARK

PLATE 25

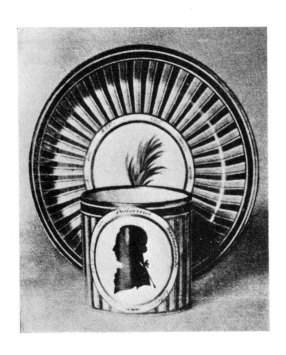

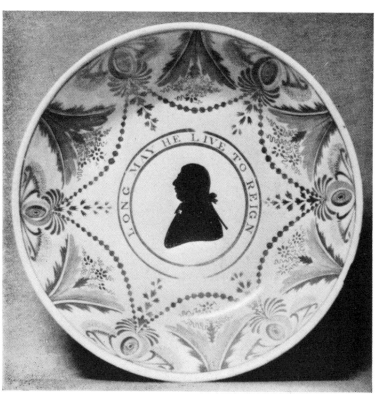

COFFEE CUP AND SAUCER, RAYED
DECORATION, 1801–1808

VIENNESE PORCELAIN, SILHOUETTE OF THE
ARCHDUKE CHARLES. SOLD IN 1928, IN THE
COLLECTION OF MRS. KARL MEYER, FOR £200

Courtesy of the ' Illustrated London News '

ROYAL WORCESTER DISH, MADE TO CELEBRATE THE JUBILEE OF
KING GEORGE III, PORTRAIT PROBABLY AFTER MIERS

CONVENTIONAL FLOWER FORMS. IN GREEN, GOLD AND MAUVE
DIAMETER, 8½ INS.

In the Royal Collection, Windsor Castle (By gracious permission of H.M. the King)

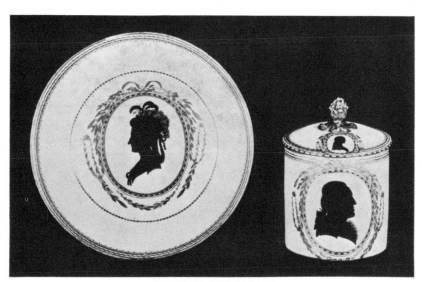

MEISSEN PORCELAIN

WHITE AND GOLD, WITH GRAND DUCAL PORTRAITS, FORMERLY IN THE
COLLECTION OF CAPTAIN DESMOND COKE

Nevill Jackson Collection

PLATE 26

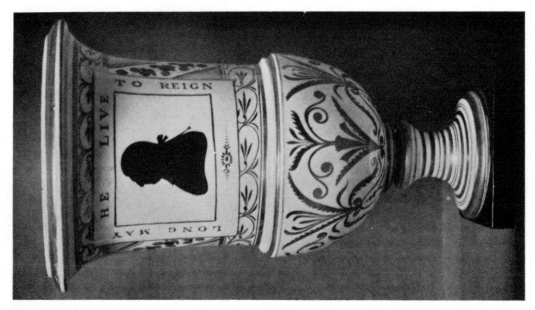

CHAMBERLAIN WORCESTER VASE

GOLD DECORATION, WITH SILHOUETTE OF KING GEORGE III

HEIGHT, 18 INS.

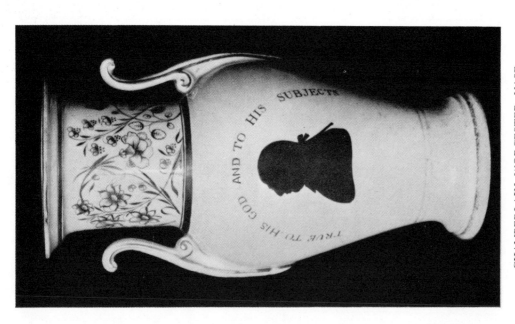

CHAMBERLAIN WORCESTER VASE

GOLD FLORAL DECORATION, WITH PORTRAIT OF KING
GEORGE III AND MOTTO 'TRUE TO HIS GOD AND
TO HIS SUBJECTS,' 1809

In the Royal Collection, Windsor Castle (By gracious permission of H.M. the King)

PLATE 27

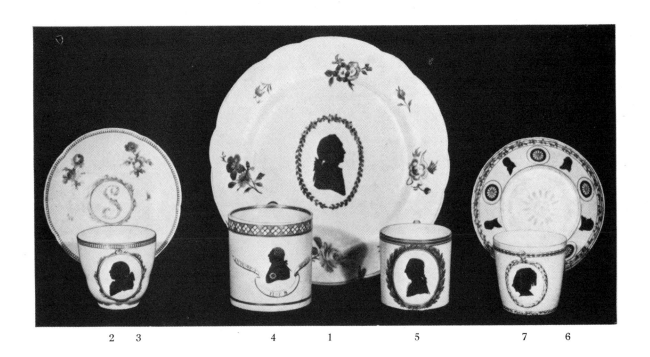

2 3 4 1 5 7 6

1. CENTRE PLATE, COLOURED FLOWERS, 1812. PORTRAIT STYLE, 60 YEARS EARLIER, 9½ INS. DIAMETER.
2. CUP, LEFT, GOLD RIM TWIST HANDLE.
3. SAUCER, COLOURED FLOWERS, MARK *BERLIN* SCEPTRE, BLUE, 1760–90.
4. JUBILEE MUG, KING GEORGE III, *WORCESTER*
5. MUG, GREEN LEAF FRAME TO SILHOUETTE, FREDERICK, KING OF PRUSSIA, 2¾ INS., MARK SCEPTRE *BERLIN*
6. SAUCER, GOLD LINES TURNED IVY, 5 PORTRAITS PROBABLY OF BROTHERS. THURINGIAN, MARK, *GOTHA* IN RED, CURSIVE LETTERS
7. CUP WITH GOLD HUSK RAISED DECORATION, 2½ INS.

PLATE 28

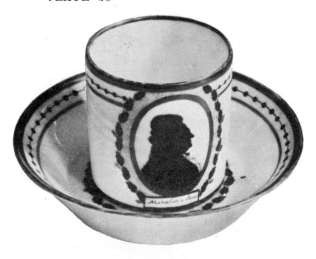

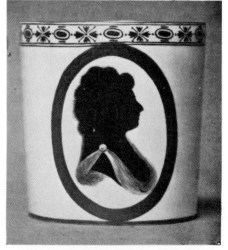

CUP OF SÈVRES PORCELAIN WITH PORTRAIT
OF MIRABEAU
In the Musée Carnavalet, Paris

PRINCESS LOUISA OF DENMARK,
RELATIVE OF KING GEORGE III
ON WHITE AND GILT MUG, 4½ INS.
In the Royal Collection at Windsor
(By gracious permission of H.M. the King)

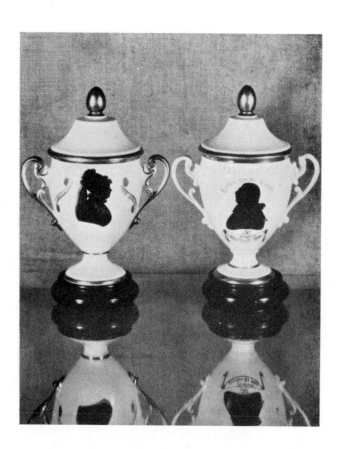

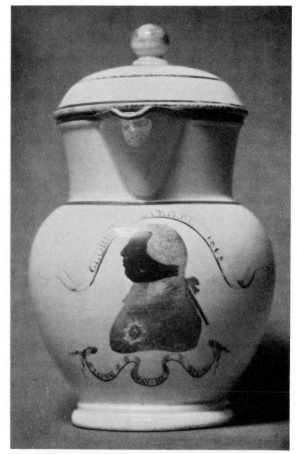

PAIR OF VASES DECORATED WITH GOLD AND
MOTTOES, PORTRAITS OF KING GEORGE III
AND QUEEN CHARLOTTE
WORCESTER PORCELAIN OF THE FLIGHT AND BARR PERIOD
Nevill Jackson Collection

HOT-WATER JUG MADE AT THE ROYAL
PORCELAIN FACTORY, WORCESTER
PORTRAIT OF KING GEORGE III
COMMEMORATING HIS JUBILEE, 1809
Nevill Jackson Collection

PLATE 29

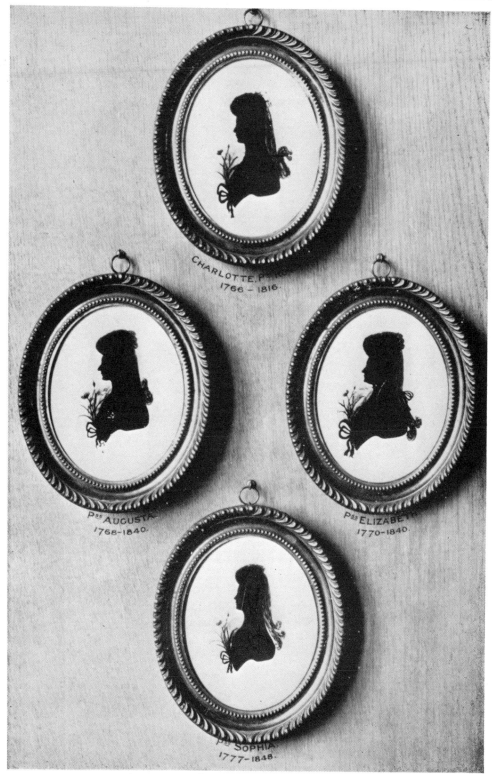

FOUR PRINCESSES, DAUGHTERS OF KING GEORGE III,
BY CHARLES ROSENBERG, COURT SILHOUETTIST
GLASS PAINTING
In the Royal Collection, Windsor Castle (By gracious permission of H.M. the King)

PLATE 30

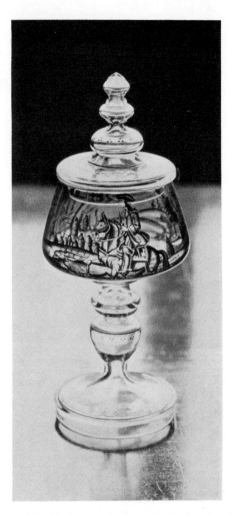

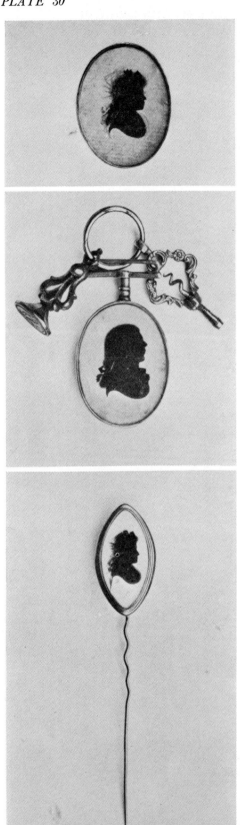

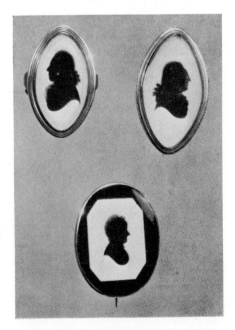

GLASS WITH COVER, MADE AT
NUREMBERG, PAINTED BLACK
A HUNTING SCENE. 10½ INS. HIGH
Nevill Jackson Collection

TWO LOCKETS AND PIN BY MIERS
SUCH A PIN MIGHT HAVE BEEN MADE FOR ROBERT
BURNS, SO OFTEN MENTIONED IN HIS LETTERS
TO MRS. MACLEHOSE

TWO RINGS MOUNTED IN GOLD
BROOCH WITH PORTRAIT
ALL SIGNED MIERS

PLATE 31

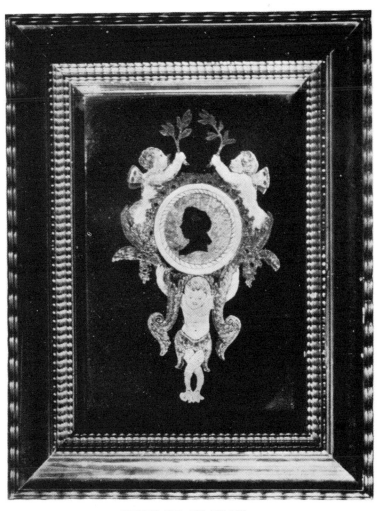

PORTRAIT ON GLASS
ÉGLOMISÉ, GOLD AND SILVER, ONE OF A PAIR

IVORY AND TORTOISE-
SHELL BOX, MOUNTED
GOLD, PORTRAIT BY
DEMPSEY
COLOURED

TORTOISESHELL BOX, GOLD MOUNT,
WITH LADY'S PORTRAIT
ÉGLOMISÉ, 3 INS. DIAM.

IVORY AND TORTOISE-
SHELL BOX, MOUNTED
GOLD, WITH PORTRAIT
OF A LADY
COLOURED

All objects on this page in Nevill Jackson Collection

PLATE 32

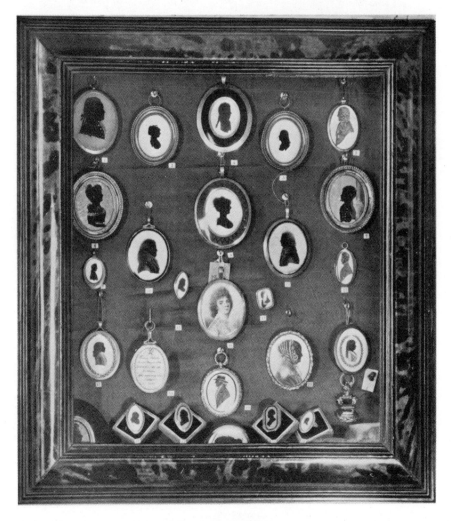

CABINET WITH LOCKETS, RINGS, BROOCHES, FRILL PINS, AND
COLOURED MINIATURE BY MRS. BEETHAM, PUPIL OF SMART

Nevill Jackson Collection

1. RUSSIAN LOCKET, SIGNED *ROSEN*
2 and 3. RUSSIAN PAIR
4. GENTLEMAN, SIGNED MIERS, GOLD AND BLUE ENAMEL
5. JUDGE IN RED ROBE, SIGNED DEMPSEY
6 and 7. GIRL AND BOY, GOLD ÉGLOMISÉ
8. LADY, SIGNED MIERS
9. RARE PORTRAIT, ENAMEL
10. PORTRAIT BY MRS. BEETHAM
11. PORTRAIT BY MRS. BEETHAM
12. OFFICER IN RED UNIFORM
13. BOY IN LEAF FRAME
14. GIRL IN LEAF FRAME
15. LADY, BY MIERS, SIGNED
16. THE ONLY KNOWN COLOURED MINIATURE BY MRS. BEETHAM
17. FRILL BROOCH
18. MEMORIAL LOCKET, EMBROIDERED AND SILHOUETTE AT BACK
19. OLD GENTLEMAN IN HAT AND WIG, DEMPSEY
20. LADY IN LACE CAP
21, 22, 23. RARE MEMORIAL RINGS, ÉGLOMISÉ
24. RING, BY MIERS
SECRET SEAL WITH PORTRAIT. BREAST PIN, ALL BLACK

PLATE 33

1

2

3

4

5

6

7

8 9

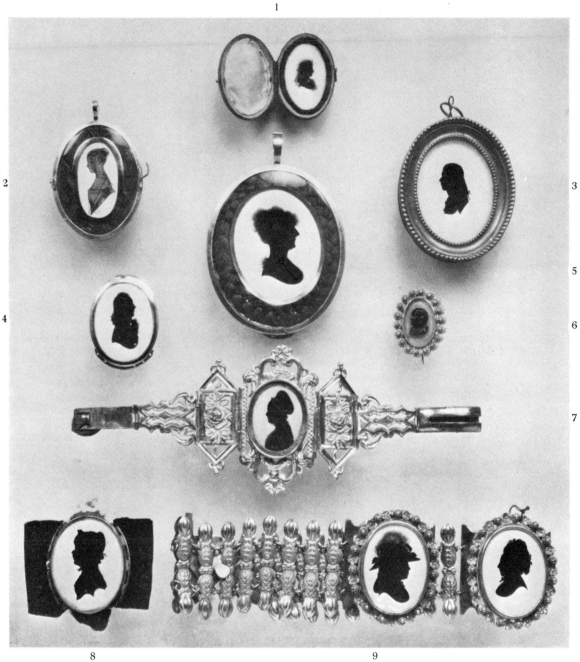

SILHOUETTE JEWELLERY

1. PORTRAIT BY MIERS IN CASE
2. LOCKET, LADY, BY DEMPSEY, SIGNED
3. BY RUSSIAN ARTIST
4. MAN'S PORTRAIT AS BRACELET CLASP, BY MIERS
5. LADY BY MIERS, PAINTED AND SIGNED
6. BROOCH SILHOUETTE OF NELSON IN GLASS
7. LADY IN BRACELET OF FINE DESIGN IN PINCHBECK
8. CHILD ON VELVET ARM-PIECE, CUT PAPER, MOUNTED ON SATIN
9. PAIR OF BRACELETS WITH PORTRAIT CLASPS

PLATE 34

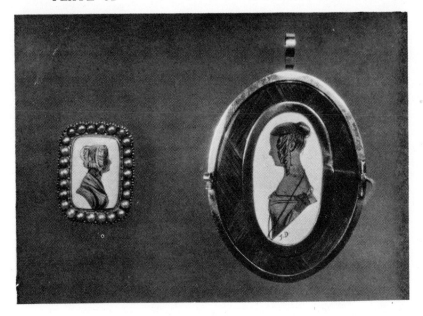

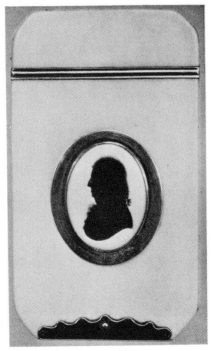

BROOCH SET IN PEARL
FRAME, LADY IN A CAP
PAINTED BY DEMPSEY

LADY WITH RINGLETS IN LOCKET SET
WITH HAIR
PAINTED BY DEMPSEY
Nevill Jackson Collection

IVORY AND GOLD MOUNTED
SNUFF-BOX WITH PORTRAIT
SIGNED MIERS
Nevill Jackson Collection

OVAL TOBACCO BOX OF HORN, WITH
SILHOUETTE PORTRAIT
PAINTED BY DEMPSEY IN COLOUR

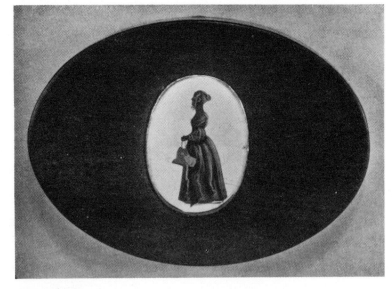

*The 3 portraits illustrated below are in the Royal
Collection, Windsor Castle (By gracious permission of
H.M. the King)*

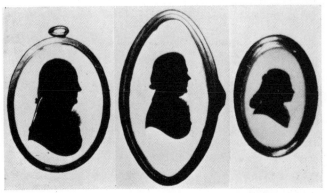

1 2 3

1

SIR WILLIAM FAWCETT, K.B., 1728–1804,
GENERAL, PRIVY COUNCILLOR, 1799

2

GEORGE BRUDENELL, DUKE OF MON-
TAGU, K.G., 1712–1790, GOVERNOR TO
PRINCE OF WALES, 1776, MASTER OF THE
HORSE, GOVERNOR OF WINDSOR CASTLE
RING REPRESENTED ¼ LARGER THAN ORIGINAL

3

LOCKET, PROBABLY PORTRAIT OF A
BROTHER OF KING GEORGE III

PLATE 35

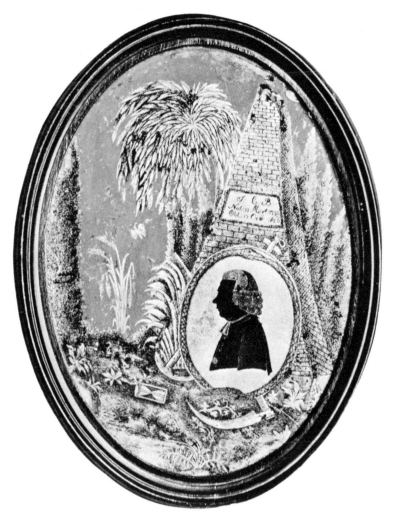

MEMORIAL PLAQUE, PAINTED ON GLASS
BACKED WITH GOLD AND SILVER FOIL AND COLOURED BLUE WAX. INSCRIPTION
'I.C.B. BORN 1739, DIED 1806.' SIGNED FORBERGER. 8 INS. × 6 INS.
Nevill Jackson Collection

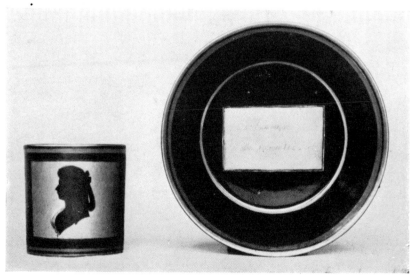

CUP AND SAUCER, MARK GOTHA
THE CUP HAS PORTRAIT OF A LADY, THE SAUCER THE LABEL 'HOMMAGE
DE L'AMITIÉ'
In the British Museum Collection

PLATE 36

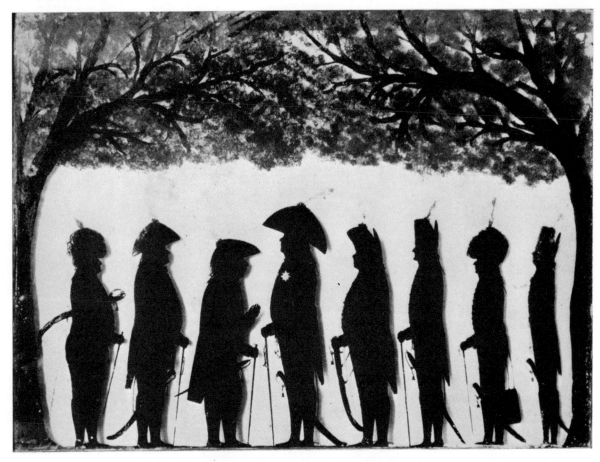

A WEYMOUTH GROUP: GEORGE IV, CENTRE, FACING THE DUKE OF MECKLENBERG-STRELITZ,
WITH OTHER ROYALTIES AND ATTENDANTS
PAINTED ON GLASS BY ROSENBERG, COURT SILHOUETTIST, 26 INS. × 19 INS.
In the Royal Collection, Windsor Castle (By gracious permission of H.M. the King)

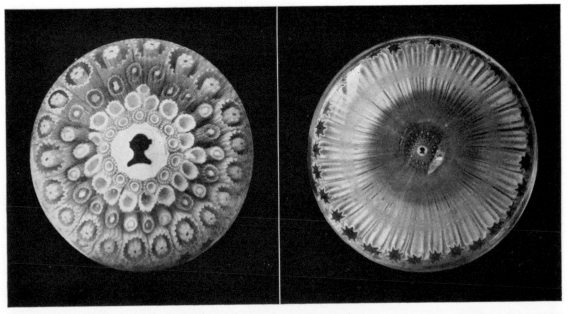

OBVERSE AND REVERSE OF A MILLEFLEURS GLASS PAPERWEIGHT MADE AT BRISTOL OR STOUR-
BRIDGE FOR THE ACCESSION OF QUEEN VICTORIA
THE QUEEN'S PORTRAIT IS SHOWN OVER 30 TIMES

CHAPTER III

CONVERSATIONS, ALBUMS, SCRAP-BOOKS

THOSE who have studied the work of artists in silhouette, have always been familiar with the Conversations, or Family Pieces, the older name, which the workers in shadow so often mentioned on their trade labels. From the first half of the eighteenth century these characteristic groups have delicately indicated family life at its most intimate.

In comparatively recent years however the precision in its formula seems to be misunderstood. Deriving from the Dutch school its size, whether large or small (generally the latter, about 12 by 9 inches), its chief interest was always portraiture and character, with accessories and background, if any, suggestive of home life and the gracious occupations of the family.

The medium is of no consequence : we can have stately interiors in oil painting by Hogarth or Zoffany as setting for the Conversation ; or the Adam room of a mansion, a garden, riverside, or a parklike glade, in water colour or plain black and white. But there must be no sign of pseudo sixteenth- or seventeenth-century classicism; goblets offered to gods or goddesses place the picture at once out of the definite Conversation convention, and fashion magazine pictures are entirely ruled out, as well as shop advertisements and trade cards.

The latter are prominently displayed in a work on the subject, though in the text it is correctly stated ' the necessity is for a picture (Conversation Piece) to portray definite personalities in their intimate surroundings ' [1].

Francis Torond, the French Refugee working in England in the last quarter of the eighteenth century, is one of the finest exponents of the Conversation piece in Silhouette. I am able to give three fine examples of his work in this genre, one specimen shows no fewer than six figures; each of these pictures adheres correctly to the formula : *intimate family life*. The small oval label on the front of the picture can be seen on both groups (Plate 39) ; this small label is also on Mrs. Alec Tweedie's group, which she has given to the Victoria and Albert Museum.

These Conversations afford great opportunity for the display of simple domestic equipment : the shape of the silver tea-urn, teapot, sugar-bowl, which the artist's delicate draughtsmanship makes as true to its type of that date, as if it were set forth in subdued glitter of colour. We note the tea-service, the

[1] *Conversation Pieces*, p. 4, by Mr. Sacheverell Sitwell.

Chippendale tea-table with Chinese fret gallery, the stately dress of the ladies, their elaborate heads, besides the charming figure of the father of the family (Plate 39) instructing his son or grandson in the art of fishing : a homely occupation we saw so often depicted in the painted Conversation Pictures lent to Sir Philip Sassoon's Exhibition in March 1931.

Johann Friedrich Anthing, described as Friedrich Anthing Suwerows A.D.C. after his long sojourn in Russia, made few family pieces ; the only other at present known is that reproduced in the History of Silhouettes, where Gustav Adolph is in a garden with his son. It is signed Anthing, fec., and is owned by Madame Nossof of Moscow.

The Anthing Family Piece shown here measures 24 by 16 inches. It was lent by Madame Alexandra Rosenberg (to whom I am indebted for permission to reproduce) to the Russian Exhibition held in London in 1935. The figures represented are the Emperor Paul I of Russia ; the Empress by his side and their two sons. The work is mostly cut, fine lines in Indian ink being added as in the boys' hair and the lace ruffles; the foliage is beautifully executed, the whole example very restrained and lovely (Plate 41).

In the advertisement in a newspaper of the end of the eighteenth century, Mr. Wellings, 1785, Miniature painter (Plate 40), makes special mention of Conversations and we are fortunate in being able to reproduce a charming example of his work[1]; the original can be studied at the Victoria and Albert Museum. The ladies are seated in intimate friendliness, one with her needlework, the basket and scissors on the table, the younger with a book in her hand ; both wear large hooped skirts (for this picture was painted in 1782), elaborate head-dresses, and are seated in ladder-back chairs.

Delicate needlework and other handicrafts played so important a part in the education and occupations of the day that there were probably many groups suggesting family conversation, or it might be gossip, while nimble fingers embroidered, rolled paper perhaps, or snipped it.

Let us listen. We hear that, ' It is reported the lovely Perdita has not been seen in the Broad Walk at Kensington Gardens for days,' or that ' Margaret Nicholson who attempted to take the life of the dear King has been found to be mad—Do you approve, Madam, of the shading of this vine-leaf, or the curve of that tendril in my embroidery ? I hear Mrs. Delany has lately finished another of her fashionable filigree works, it is a marvel that she rolls her scrolls of coloured papers so neatly as to get the gilded edge uppermost when she puts them on her tea caddies.' Conversation pieces bring such topical gossip to our ears.

In England the tea- or dessert-table, in Germany a coffee equipage, as in the Goethe cutting from the Wellesley collection. Writing-table equipment or a lamp-table all serve to draw together and suggest the home life of the family

[1] Presented to the Victoria and Albert Museum by the late Captain Desmond Coke.

with no fashion plate falsity : and later—snuff-taking, harp or piano playing, children's dancing or games, serve as settings for Edouart, Dempsey or Hubard.

The two-, three- or four-figure Conversation is perhaps the most successful. Skilful grouping suffices one or two figures such as King Charles X, the Dauphin, Dauphine and Duchess de Berri as in the Holyrood group, but for large groups the Conversation formula becomes less successful, and apt to resemble the abhorrent ' all in a row ' method such as King George III with his sons and sons-in-law, or the quaint procession of Queen and Princesses at Windsor.

In Germany between 1780 and 1790 there was a great vogue for Conversation pieces and often only the face was drawn in shadow fashion. Other members of the family and friends are depicted ; friendship and family intimacy is still the keynote.

In one of this date, the subject is ' Grief at the Tomb of Prince Frederick Ludwig Carl '. Female figures stand beside the tomb, another places flowers on the steps, the chief mourner raises her hands in grief to heaven, children bear wreaths. This picture painted on glass is backed with gold and is dedicated to the widow. My own Jane, Countess of Harrington, with her son Viscount Petersham and the Hon. Lincoln Stanhope, 1795, is another example of the rare pieces in *églomisé* process of the family group.

There is a quaint picture of Frederick William II, 1741–97, and his family ; in the centre is a tree to which two children cling, it has the effect of dividing the family to right and left, a useful convention. On the extreme right is the King, on the left the Queen,[2] married in 1769, a few months after the first wife's divorce. The eldest daughter is there who married our Duke of York, and the second daughter Wilhelmina.

Edouart's Family pieces are very numerous. King Charles X, seated with his family, is shown at Holyrood Palace during the second Exile. This picture was destroyed by fire, but another (Plate 88) shows us the King standing, the Dauphin, the Dauphine, and Mme. de Berri. Other members of this exiled court entourage, from my collection, are now at the Bibliothèque Nationale, Paris. Again, Sir Walter Scott sits chatting to his son-in-law J. Gibson Lockhart, while ' Spice ' the rough-haired terrier ' begs ' between ; Lord Cockburn with two of his eight children is seen as Henry Cockburn before he became Solicitor-General of Scotland ; Mr. and Mrs. Thomas McKenzie of 10 Herriot Row have a harp and daintily held snuff-box indicating pleasant occupations.

Then my own Fisk family of Oxford make a happy group (Plate 88). Mama in her beribboned cap ; papa suggesting improving discourse or the discussion of a book with his son Marshall ; Fred, whose portrait taken in oils later in life I own, and the elder sister Elizabeth Prudence, in three years to wed the Rev. Thomas Jackson, the handsome and popular preacher at Oxford, my late husband's father. In another example Mrs. Newnham and Miss Wilkinson enjoy

[1] *One Hundred Silhouettes.* [2] *née* Hesse-Darmstadt.

their game of cribbage or piquet at a table so typically early Victorian, with chairs and lamp so definitely 1830, that the intimacy is sheer delight in such friendly surroundings.

In his treatise Edouart (always on the defensive) writes : ' Can my groups of Families with the simplicity and the playful attitudes of the children, the expression portrayed . . . in the countenances and figures of the father and mother . . . in a room adapted to the grouping of the figures . . . Can these, I repeat, be compared in execution and value to those " all in a row processions ? " '

Of some of the eighteenth-century artists in Shadow who mention Conversations or Family Pieces on their labels or advertisement, we can mention alphabetically, and not according to merit, Charles of Bath, Rosenberg of Bath from 7s. 6d. to £1 1s. Family Pieces in whole lengths, various attitudes. F. C. Sideau ; 1782, during and after his visit to St. Petersburg. Thouard, who calls his groups ' Family Pieces '. Francis Torond 1743–1812, of whose work we give examples : ' groups in the taste '. William Welling, fl. 1785, ' Busts Conversations, &c., in the most elegant manner '.

Our modern exponents seem shy of cutting subject pictures or Conversation groups. One by Mr. Leslie of the West Pier Brighton is rendered effective by shadowed lines. Captain Oakley cut several during the time of the Great War, representing scenes at the front ; these were reproduced by the *Bystander Magazine*.

ALBUMS

' And there's my Album,' says Thackeray in the FitzBoodle Papers, ' a little book after the fashion of German albums in which, good simple little ledger, every friend or acquaintance of the owner inscribes a poem, a stanza from some favourite poet or philosopher, with the transcribed name . . . with a flourish and the picture mayhap of a rose.'

Such a book, which confounded Fitzboodle with its facts, was the sentimental descendant of the serious *album amicorum* of an earlier generation, and the ancestor of the autograph album of the present day : a comparatively poor thing.

There are no more complete and circumstantial examples of these old books than the silhouette records of Anthing.

By means of his named and dated Portrait pages, we follow the young student from Brunswick to Berlin, see him painting his shadow portraits of the handsome swaggering officers of a cavalry regiment in 1783, find each profile named ; then come the 158 ' illustrious persons ' in St. Petersburg, 44 of them from Russia are in the ' 100 Collection ' which is now before me, reprinted in 1913 at Weimar. In two others of these priceless albums are our 200 shades of men of science, of artists, or aristocrats, with their verses, a sentiment, the signature of the sitter, and there for all time is a great little record. Less than 100 years ago these were on the market, now, they are in Moscow in private ownership.

PLATE 37

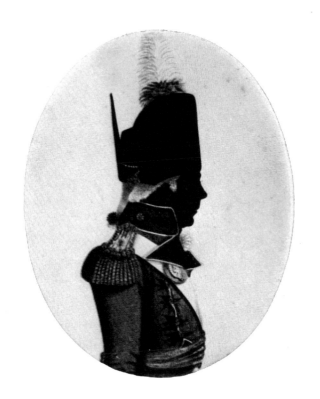

PAINTED MILITARY PORTRAIT OF THE
18TH CENTURY, BY J. BUNCOMBE, OF
NEWPORT, ISLE OF WIGHT

More Anthing Albums tell us in shadow and in script of travels in Russia in 1786, Novgorod, Kazan, Astrakhan, back again to the capital, each page filled with pictorial records.

In Berlin and Potsdam in 1787, after taking many portraits, he went in June to Copenhagen ; in August to Stockholm. In September he returned to Copenhagen and thence to Hamburg and Gotha, his home. In January 1788 his albums show that he was working in Vienna. In May, while in Prague, appears, amongst a large number of portraits of the Austrian aristocracy, the name of the English ambassador, Sir Robert Keith. And so Anthing goes back to Berlin, Potsdam, Copenhagen and a shadow pageant of the notabilities at the coronation of Leopold II in 1790.

The London Album would be intriguing. 1789, did Florizel inscribe a sentiment beside his handsome features ? or is Frederick Duke of York within those pages ? At any rate Rosenberg has given us evidence of their profiles in Silhouette elsewhere. Goethe was ever ready with a verse at Weimar. And Anthing himself began more prolific written records and a biography which eventually led this gifted album-filler into sad trouble in St. Petersburg, for though he was given an appointment as Cadet and eventually Major in the Russian army in a dragoon regiment, he fell into disgrace when Czar Paul ascended the throne and was degraded in 1797. Eventually Anthing was dismissed the service with his Field-Marshal Suwarow, and died in great poverty in 1805.

Not less important than the Albums of Anthing are those of his contemporary F. G. Sideau, a Frenchman. He was chiefly a cutter and worked in St. Petersburg, where he took the shades—including that of Catherine II, and many important personages of the Court. Two volumes, containing 189 Silhouette portraits, were discovered in 1895 in arranging the library of the Grand Duke Michael Pavlovitch, of which the Duke George Alexander of Mecklenburg-Strelitz is the owner.

The original collection was in 2 volumes bound in yellow leather in the style of the mid-nineteenth century. On the first was stamped ' Silhouetten tom 1 ', inside was the ex-libris of Comte Pierre Ragoumowsky, son of the Marshal, 1751 ; he was grand chamberlain at the Court of St. Petersburg and died there in 1813.

Most of Sideau's portraits are cut out of black paper and pasted on engraved mounts ; there are inscriptions on the back of each one in the same handwriting, the name of the sitter and his or her social position.

Other work by Sideau includes one album of Silhouettes cut in black paper and pasted on the leaves ; there are 62 portraits now in the collection of D. Rovinsky. Another album is in the Museum of the University of Göttingen. 24 of these portraits are in duplicate in a collection in the Library of the Musée Historique of Moscow, under the Number A.4/33. The total number in this volume is 255 portraits ; they have each name written in Russian, followed by

the social position in French and occasionally genealogical descriptions in a third handwriting.

Four volumes of the Silhouettes of Sideau were in the Library of the Hermitage Museum at St. Petersburg, each has 50 pages : a rectangular engraved frame holds two ovals in which are 2 silhouettes facing each other ; at the bottom are the names of the subjects in French. There is one portrait drawn in Indian ink.

The shadow portrait of Empress Catherine II who sat to Sideau, is reproduced in the History of the Empress by A. Brihuer.

Sideau also silhouetted the Empress, the Grand Duke Paul, the Grand Duchess Marie, and their sons, Alexander and Constantine, surrounded by eight dignitaries of the Court of Her Majesty.

This picture is reproduced in the Archives of Russia, 1881, and in L'Empereur Alexandra I by Schiller.

Another portrait by Sideau of the Empress faces right, she is more simply dressed ; it is in the collection of M. P. Daschkow.

It is interesting to note the nationalities of the three most important silhouettists and album record makers, whose work has come down to us, named and dated with meticulous care. Anthing was German, Sideau and August. Edouart were Frenchmen, who travelled from town to town making the portraits and adding biographical details which are of such priceless value to posterity. In the albums of Edouart were 188 portraits of 'Bath Characters' alone. Bath was the first important town visited professionally outside London in 1826–7.

I name other specially noteworthy centres : Birmingham, Bristol, Cambridge, Cheltenham, Clifton, Coventry, Gloucester, in this latter town no fewer than 1588 portraits were cut. From Edinburgh visits were paid to Holyrood Palace, which resulted in the fine series Charles X of France and all his Court and entourage, most of which I sold to the trustees of the Bibliothèque Nationale in Paris, where this record of the second Exile of the Bourbons naturally belongs. In the National Portrait Gallery in Edinburgh Edouart's portraits of the great men of that day, 1830–2, hang in rows, bought from my albums by the trustees. Glasgow was visited the same year. Ireland in 1835, where his Treatise was published at Bandon. Next came Kinsale, Killarney, Youghall, Fermoy, Limerick, Cork, and Dublin. I have four hundred portraits in an album from Ireland alone, many of them of the officers of regiments stationed there, in full uniform. A very interesting military collection. Then Leamington, Liverpool, London, Peebles, Perth, Worcester—all were scenes of the artist's labours.

Those are the towns named in the precious addresses of the sitters which make absolute their identity.

The names of the towns in America where Edouart filled his albums from 1839, when he landed in New York, working there up to 1849, are given in the chapter on America. There over 3,800 portraits were taken.

Possibly other albums have been filled by other profile artists, but it is the names and dates which give the great value to the albums of Anthing, Sideau and Edouart. The only present-day cutter I know who preserves duplicates and names of his sitters is Mr. Leslie at Brighton West Pier.

There is a fine German Album of the last quarter of the eighteenth century with sentiments and shadow portraits by P. Bauer, which has wandered far. I saw it at Newark, New Jersey, U.S.A. It contains over 70 portraits slightly varying in size and probably most of them are of personalities in the neighbour-hood of Poland, where the artist was at work at that time. I know of only one other example of this Album man's work.

My good friends at Newark have had this old Album example photographed for me (see Plate 50). It is a typical specimen of the old travelling notebook. What a poor thing in comparison is the modern scanty Diary with no vivid personality, no shadow acquaintance flitting across our page; leaving a name, a date, a fleeting memory of pleasant meeting and passing friendship, but poise and features unrecorded.

In Lavater's own albums, heads were collected for physiognomical purposes, later transferred to illustrate his work and his lectures on this subject.

In lighter mood he recommends that a silhouette should be cut out in doubled paper, or the paper preserved from which it has been cut, so that by placing black paper beneath the hole 2 portraits are obtained with 1 cutting. 'The first can be stuck into the family album, the second used to decorate the wall.'

There was Goethe's own album in the late Mr. Wellesley's priceless collection, now dispersed.

The late Mrs. Andrews of Bournemouth owned Beaumont's Album, more in the nature of a pattern-book for prospective sitters to choose their style or pose, as also is my own Dempsey Album, where silhouettes are shown in samples cut or painted, plain or bronzed, coloured sanguine, brown or stipple painted ; and I have Edouart's Album of subject pictures in little, besides ten volumes of his named and dated portraits containing 12,000 portraits.

The late Captain Desmond Coke described the Laura MacKenzie Album of 90 years ago where various charming domestic pictures are cut out in white paper ; the family is shown at work and play, and there is a beauty in the simplicity and sentiment of it all with its mixture of cupid and domestic duty. There are the delightful old volumes where perfumed valentines, hearts and darts, coloured scraps, and miniature landscapes were gummed by our great-aunts and grand-mothers ; these are scrap-books, less interesting than the mighty portrait records with names and dates, nevertheless many a treasure may be found hidden between the leaves of the scrap-album. A silhouette portrait or two, possibly taken out of frames wanted for something else, a snipped out landscape, a miniature shade of great-grandpapa. Everyone is hastening to buy old silhouettes, the museums want them, before prices rise higher. They will

rise because the finer ones appeal to the artistic appreciation of modern times; yet the shade is so distinctive that it gives the spirit of its period.

I have an interesting album full of cut portraits, varying in size, but up till now have found no clue which will give me the name of the artist. Some of the portraits are full length.

There are class albums and college albums. Sometimes in little thin old volumes are the silhouette portraits of the boys and young men who worked and talked and played and strove together long ago, and in shadow are still together.

Albums were much in vogue at the colleges in America. 'At Bowdoin,' Mrs. Bolton says, ' the class albums were as much a part of a senior's life then as they are at present.' In the College Library the classes of 1824, and 1825, are preserved and are leather bound. It is a moot point whether the silhouette portraits there assembled were the work of the lads themselves or one of them gifted with the knack of painting or cutting. As the shades are cut hollow I should be inclined to believe that they were machine cut by some machine operator in the neighbourhood and collected in the volume. The leaves of the 1824 class are alternately black and white, so as to show up the cut hollow variety: amongst them is Franklin Pierce, afterwards President, whose portrait the visiting French cutter, Edouart, took in 1844.

Longfellow as a senior appears in a loose-sheet album of 1825. Edouart cut his portrait when the poet was a professor at Harvard and in 1841 had just had published his ' Hyperion' (Plate 61).

Mrs. M. A. De Wolfe Howe in Boston possesses a class album and here the portraits are undoubtedly professional work, for they have on them the mark of Peale or Bache, both of whom were machine cutting men; as was Samuel Chapman of an earlier date, whose machine is still extant in the possession of Rev. M. A. Morse, who also has several interesting silhouette class albums.

Another type of album is probably a family record or visitors' book, where beautiful portraits are cut hollow and mounted on brown; they measure $5\frac{1}{2}$ by $2\frac{1}{2}$ inches, and the heraldic arms or ex-libris of the Clutterbuck family are on the cover.

The portraits are charmingly dressed and coiffed in the style of the early nineteenth-century mode. The girls with pendant curls and laughing lips, older sisters with hair dressed high, mother and aunts with caps and capes. Fathers and brothers with collars and stocks that only just escape the Regency cravat. Some wear wigs, others their own hair. This book is another phase in the tragedy of anonymity.

Mrs. Delany's albums, of which there are eight in the British Museum, give us not only a marvellous collection of botanically correct flowers and herbs in mosaic paper cutting, but an example of talent and industry by the gifted woman who dauntlessly began the work after she had reached three-score years and ten, and finished 1,000 examples just before her death in 1788, at the age of 88 years (Plate 50).

PLATE 38

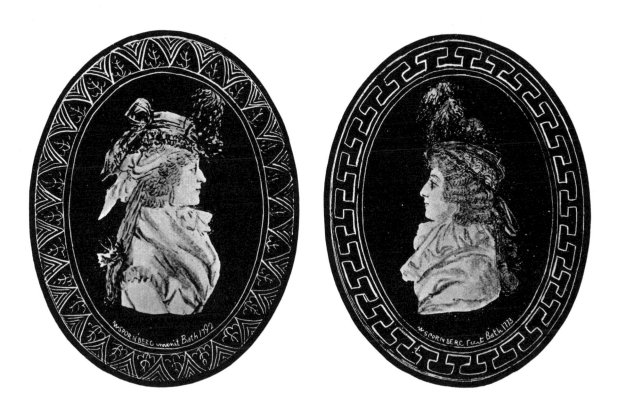

PORTRAITS OF LADIES OF THE ANSTEY FAMILY
PAINTED ON CONVEX GLASS, BACKED WITH SCARLET PIGMENT, BY W. SPORNBERG, BATH, 1792
From the Collection at Knole

Of a different nature is the very interesting leather bound volume once owned by my friend the late Lady Dorothy Nevill. Silhouette paper cutting was at the zenith of its popularity during the reign of George III in England, and all the Court amused themselves by snipping the features of the Royalties and their entourage. The bust portraits of King George and Queen Charlotte in this album are drawn in Indian ink and are excellent likenesses; they were taken in 1792 by their third daughter, Princess Elizabeth, 1770–1840, who was a skilful cutter (Plate 47). Many of her cuttings were put into this little album, 7 by 5½ inches, bound in blue Morocco leather with silver clasp. This the Princess gave to Lady Bankes, one of the Ladies-in-Waiting at Court, and later it was in the possession of Lady Dorothy Nevill, who gave me some examples of cutting from it. This little album is now in the Royal collection at Windsor. From the example of lino cutting reproduced by special permission (see Plate 73), it seems that Princess Elizabeth of the present day has inherited the talent. Her delineation of the Circus given to her Royal Father last Christmas is a notable example. Possibly she studies the silhouette album, now at Windsor, of her great-grandmother [Queen] Victoria, 1834, where within the leaves, now yellow with age, are the black paper portraits cut by Pearce (Plate 48).

Lastly, one must mention the tragedy of the album by the amateur silhouettist, Assistant Surgeon F. Paterson (q.v.) of the 45th Regiment, full of portraits taken when quartered in Ceylon 1818–26. At the Royal United Service Institution, Whitehall, is the little book containing portraits of the officers with members of their families: some are coloured, others black with white relief, but alas none is named. A note on each would have made this little volume a valuable record of the personnel of the regiment.

Puzzle prints come sometimes in silhouette paper cutting. Find the head of Napoleon, or find the goat climbing a tree, being subjects chosen.

When the period of parchment cutting of religious subjects for book and church music markers had passed in Germany, there were many cutters who devoted their talents to landscape and genre work, and in early specimens heraldic emblems are much to the fore. In the seventeenth century R. W. Hus, 1653, makes spirited pictures of fighters in woods, hunters, horsemen, lake and mountain scenery, all in minute size. The method of cutting in doubled paper or parchment so that, on opening, both sides of a device are alike was freely used: also the ingenious use of the cut out pieces of a picture for building up its companion copy, so that there was a positive and a negative.

Anniversary and mourning cards or sheets up to the beginning of the nineteenth century show influence of Missal border ornamentation by their close medallion arrangement; strange misadventures in perspective and proportion are perpetrated. Later Luise Duttenhofer makes her figures stand on carpets beyond all belief realistic, and sees much humour in life, so that we detect her tongue in her cheek, even when drawing the revered Goethe.

In album-silhouette cuttings one constantly finds amateur work, farmyard groups, woodland scenes, figures more or less successful (under the dictionary names Karl Fröhlech 1821–98, and Müller, such cuttings are described). Both these artists worked with extraordinary skill and in a series of figures on the tray of a plaster of Paris bust-seller, the portraits are easily recognizable, though of minutest size. Konewka, 1840–71, was another cutter of great skill whose work has been freely used for book illustration for children and a German version of Shakespeare's plays. Runge the flower-cutter and many other German artists have cut beautiful landscape and genre pictures, which it is not within the scope of this chapter to describe at length. The names of many will be found in the Dictionary.

In albums also occasionally an old visiting card may be found which shows us another use to which the art of the Profile was put—a medallion with a silhouette of a fashionably dressed lady or a distinguished man in a wig will be in one corner.

Such a visiting card belongs to the period when cone-like profiles were freely used with garlanding and architectural details for decorating visiting cards; but the filling up of the profile as a shadow portrait is rare. That such cards were made ready for anyone to buy and use is proved by several in the Bankes collection in the British Museum, where the space left for the name is filled in writing. The date is about 1786–93.

(Brit. Museum. Vol. IV, packet 18. C.1. 2788.)

Mourning cards were also occasionally decorated with the silhouette of the deceased, as well as mourning rings, lockets, as described in Chapter II.

Valentines sometimes had small portraits or domestic scenes pasted on them, while the lace-paper foundation of the early 1830 period has close connection with the subject of hand-cutting before machinery was used.

With the advent of the photograph during the second quarter of the nineteenth century the album lost its *raison d'être*. Mounted portraits gummed on card were slipped into slotted openings of a family album made for photographs only; occasionally one saw floral borders on a page adorned with these frames, but the hand-made profile no longer appeared, and albums filled with miscellaneous subjects are only to be found with newspaper cuttings and pictures, a valentine or old Christmas card here and there. These records are rightly called scrap-books, since they no longer give us the sentiment and personality of work by a vanished hand.

The Cronies.
Cut by Edouart.

PLATE 39

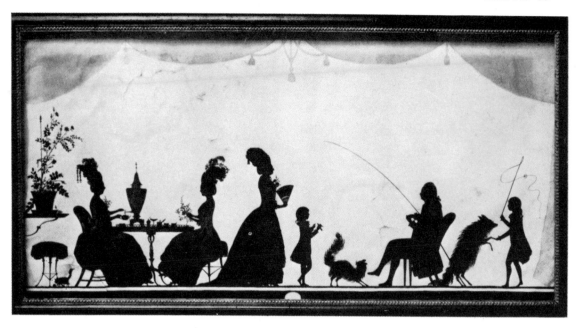

FAMILY GROUP BY FRANCIS TOROND, 1766
The Rev. Glenn Tilley Morse's Collection

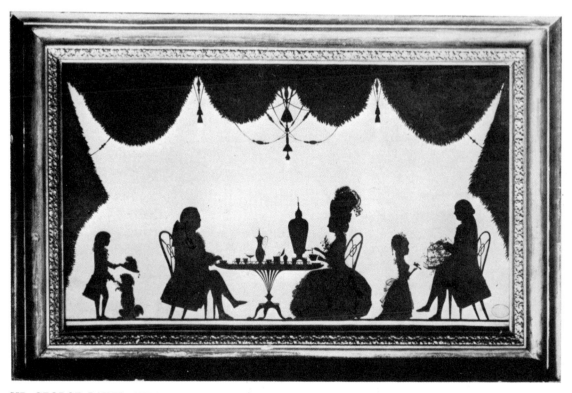

SIR GEORGE BAKER, FIRST BARONET OF LOVENTOR, COUNTY DEVON, PHYSICIAN TO KING
GEORGE III, WITH HIS WIFE, SON, DAUGHTER, AND PROBABLY THE FAMILY PARSON, BY TOROND
The Hon. Humphrey Pakington's Collection

PLATE 40

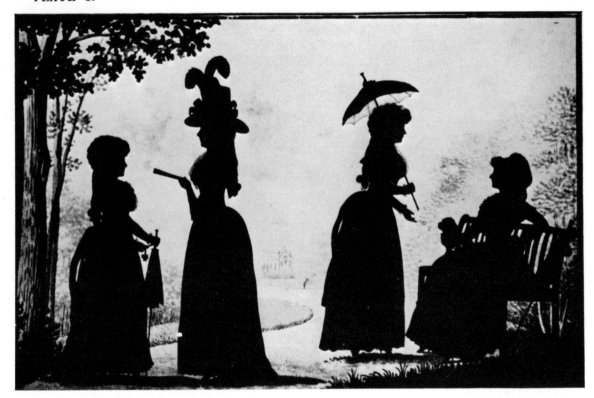

THE GRAND DUCHESS AMALIA, 1739–1807, AND ATTENDANTS IN THE PARK AT WEIMAR
In the Goethe National Museum, Weimar

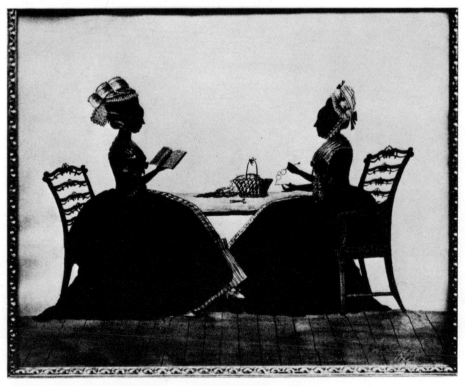

CONVERSATION PICTURE SIGNED 'WELLING 1782'
PAINTED ON CARD
In the Victoria and Albert Museum, presented by Captain Desmond Coke

PLATE 41

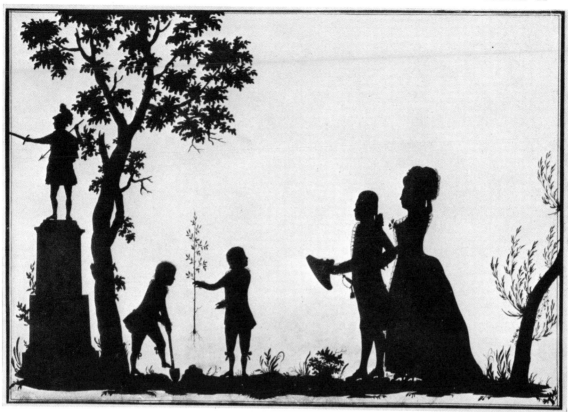

THE EMPEROR PAUL I OF RUSSIA WITH THE EMPRESS AND TWO SONS
CUT PAPER WITH ADDED LINE WORK BY J. F. ANTHING, 1758–1805. 24 INS. × 16 INS.
In Collection of Madame Alexandra Rosenberg

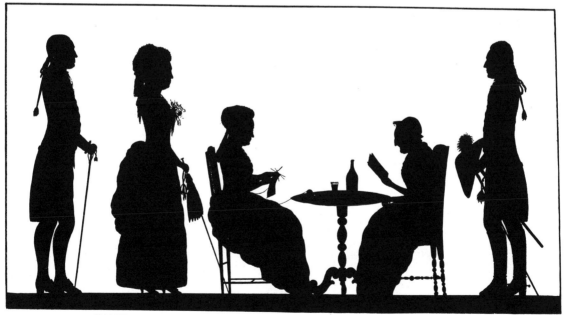

FAMILY GROUP BY TOROND, 18 WELLS STREET, LONDON, 1788

PLATE 42

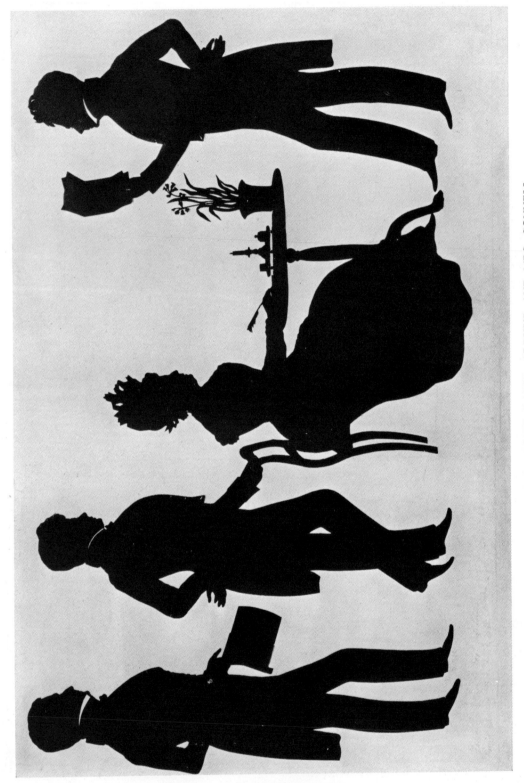

CONVERSATION PIECE, JOHN, DAVID, ARTHUR AND MRS. CONNELL.
CUT BY AUGUST EDOUART IN GLASGOW, JUNE 10, 1832
Presented to Victoria and Albert Museum by the Author

PLATE 43

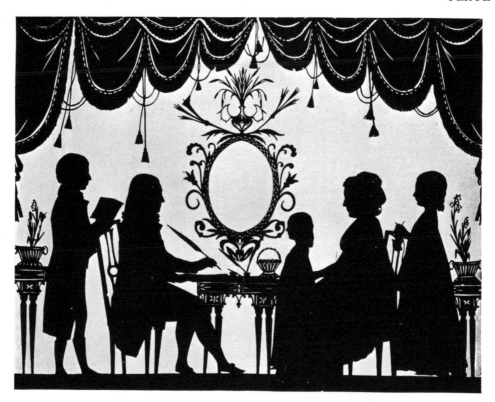

THE BURNEY FAMILY, CONVERSATION PIECE
From the Wellesley Collection

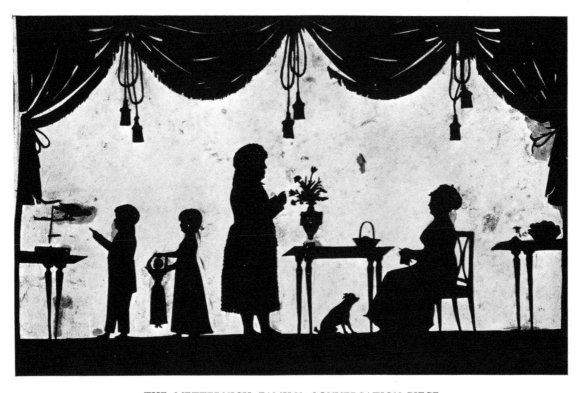

THE METTERNICH FAMILY, CONVERSATION PIECE
From the Wellesley Collection

PLATE 44

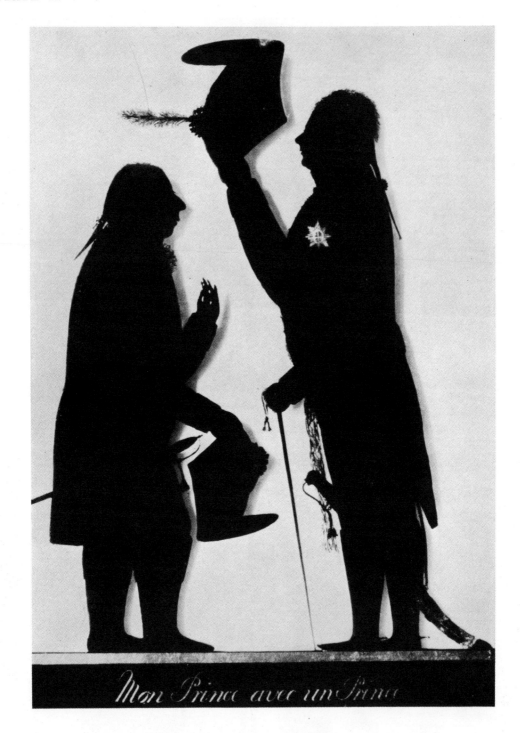

GEORGE IV, PRINCE OF WALES, WITH HIS UNCLE, DUKE OF
MECKLENBURG-STRELITZ

PAINTED ON GLASS BY ROSENBERG, COURT SILHOUETTIST

In the Royal Collection, Windsor Castle (By gracious permission of H.M. the King)

PLATE 45

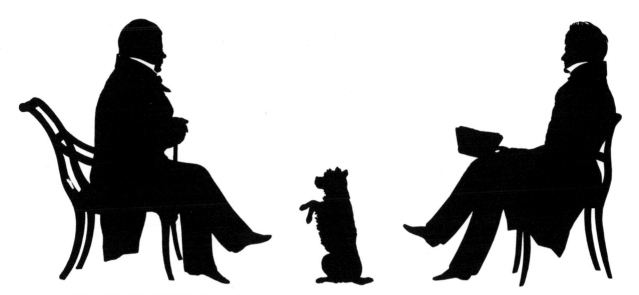

SIR WALTER SCOTT, 1771–1832, WITH HIS SON-IN-LAW, GIBSON LOCKHART, 1794–1854,
AND SPICE, HIS ROUGH-HAIRED TERRIER
TAKEN BY EDOUART
Now in the National Portrait Gallery, Edinburgh

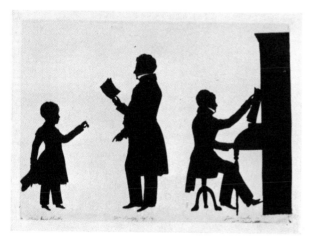

THE BENTLEY FAMILY AT GLASGOW, NOVEMBER,
1831
Nevill Jackson Collection

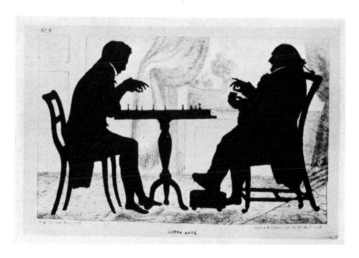

' CHECK MATE '
From Edouart's ' Treatise ', 1835, on lithograph mount

CUT BY EDOUART

PLATE 46

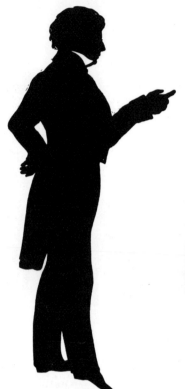
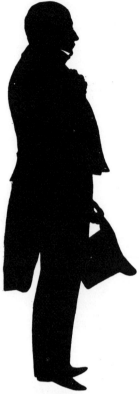
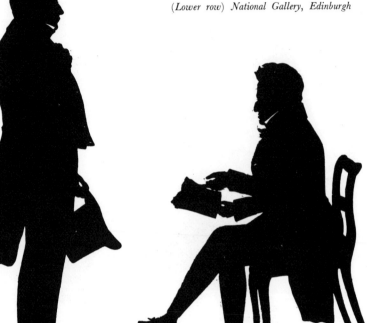

DR. ADOLPHUS ROSS, M.D.

'Abercrombie and Ross had me bled with a cupping glass : reduced me confoundedly '—SIR W. SCOTT.

EBENEZER CLARKSON, M.D., SURGEON OF SELKIRK, WHO THROUGHOUT SCOTT'S LIFE ATTENDED HIM FOR HIS LAME-NESS

A keen antiquarian, prototype of Mr. Gideon Gray of Middlemas in ' Tale of the Surgeon's Daughter '.

DR. ABERCROMBIE, M.D., SCOTT'S MEDICAL ADVISER

' Dr. Abercrombie threatens me with death if I write so much '—SIR W. SCOTT *to Robert Chambers, 7 March 1831.*

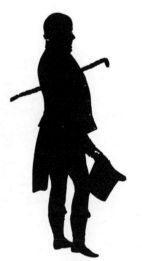

THE COCKBURN FAMILY.—HENRY THOMAS, LORD COCKBURN (1779–1854)
LAURENCE COCKBURN *Taken 15 February 1830* MASTER HENRY COCKBURN

Scottish Judge, educated in Edinburgh. One of Scott's Whig Friends. Wrote on many legal and political subjects, besides ' Life of Lord Jeffrey ', ' Autobiography ' and ' Letters '. Was Solicitor-General for Scotland ; Lord Rector of Glasgow University ; a Lord of Session and of Justiciary

Lady Cockburn and six other members of the family were taken by Edouart. Now in the National Gallery, Edinburgh

PORTRAITS BY EDOUART TAKEN 1839–32, IN EDINBURGH

PLATE 47

INSCRIPTION ON THE ALBUM OF PRIN-
CESS ELIZABETH, THIRD DAUGHTER
OF KING GEORGE III, GIVEN BY HER
TO LADY BANKS
In the Royal Collection, Windsor Castle
(By gracious permission of H.M. the King)

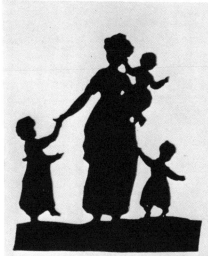
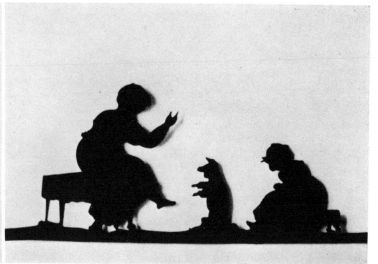

GENRE CUTTINGS BY PRINCESS ELIZABETH
From the Album given to Lady Banks

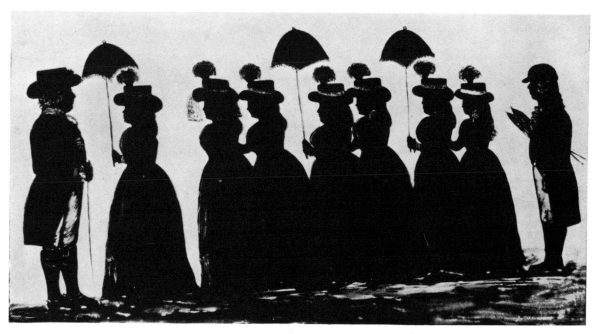

KING GEORGE III, QUEEN CHARLOTTE AND THEIR SIX DAUGHTERS
PAINTED ON GLASS BY ROUGHT OF OXFORD
This picture, now in the Royal Collection, Windsor Castle, was given by Queen Charlotte to Mrs. Gwyn, her bedchamber woman
(By gracious permission of H.M. the King)

PLATE 48

INSCRIPTION ON QUEEN VICTORIA'S ALBUM
In the Royal Collection, Windsor Castle

IN COLOURED PAPERS
CUT AND PRICKED WORK, BY THE INVALID AMELIA

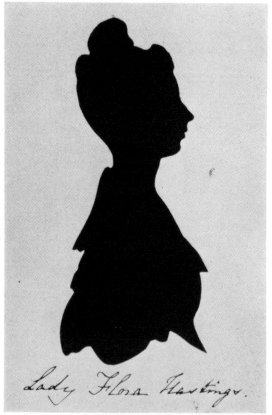

LADY FLORA HASTINGS, LADY OF THE BED-
CHAMBER TO QUEEN VICTORIA
CUT BY PEARCE
*In the Collection of Shades at Windor Castle (By gracious permission
of H.M. the King)*

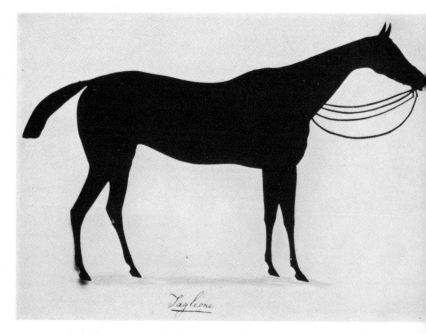

TAGLIONI
*In Queen Victoria's Collection of Shades. In the Royal Collection, Windsor Castle (By gracious permiss
of H.M. the King)*

PLATE 49

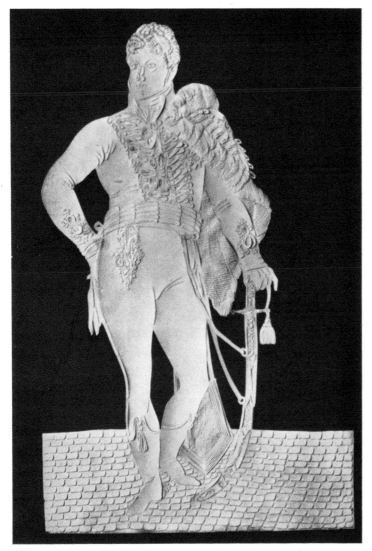

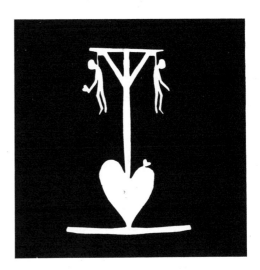

THE PRINCE REGENT
KING GEORGE IV, CUT, PRICKED AND EMBOSSED, A SINGLE SHEET OF
WHITE PAPER, 15 INS. × 10½ INS.
In the Royal Collection, Windsor Castle (By gracious permission of H.M. the King)

TWO SPECIMENS OF HANS ANDERSEN
PAPER FIGURES
From 'Hans Andersen the Man' by Edith Reumert
(Methuen)

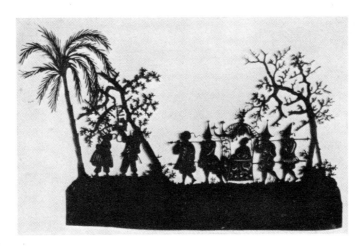

SCRAP-BOOK CUTTING, 1798

PLATE 50

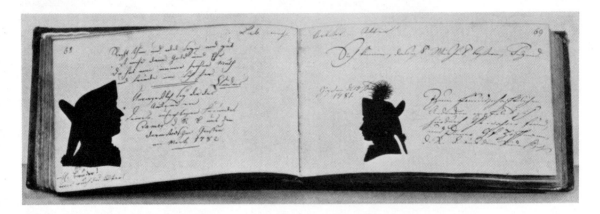

ALBUM, WITH SOUVENIRS OF FRIENDSHIP AND SHADOW PORTRAITS BY P. BAUER, 1782
Owned by the Trustees of the Free Library, Newark, New Jersey, U.S.A.

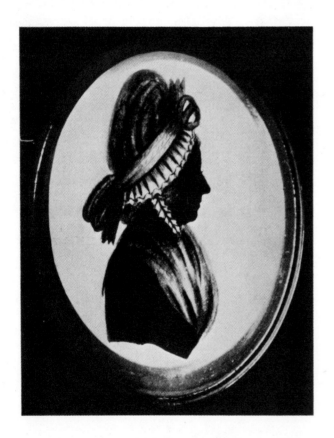

MRS. DELANY, INVENTOR OF CUT FLOWER
MOSAIC, 1700–1788

*In the Royal Collection, Windsor Castle (By gracious permission of
H.M. the King)*

SPECIMEN OF MRS. DELANY'S CUT
FLOWER MOSAIC

By Courtesy of the British Museum

CHAPTER IV

AMERICA

AMERICAN silhouette portraits are of great importance, however elementary the process ; for pictorial records of the late eighteenth and early nineteenth century are so comparatively rare in the States, that even machine cut profiles, the humblest in technique, may open a page in social life of the past ; provide a new name in the scanty list of native artists, or furnish a link in hitherto unrecorded family history.

It is for this reason that the 3,800 full-length profile portraits, cut by Edouart, a visitor to the States, are of such paramount interest, as they are each named and dated, and the address of the sitter is added with meticulous care. Photographs of these original portraits, the complete series, should be in every reference library in America, so that the citizens of to-day may identify their forebears.

The original series is now broken up and scattered broadcast ; the series of negatives is complete, each full-length figure with name, date and address.

Mr. van Wyck Brook [1] writes in his study of America early in the nineteenth century, ' The wealth and population of the country were growing at a prodigious rate, most of all perhaps in Massachusetts.' It is to New England that we chiefly look for the silhouette cutter by hand and machine.

Later Emerson asserts, ' Boston commands attention as the town which was appointed in the destiny of nations to lead the civilization of North America.'

We must remember that the ways and thoughts of the eighteenth century lingered long in America, but a spirit of personality was germinating as in the countries of Europe, and there was soon to be an active longing for individuality.

Surely the mind of Emerson sensed this, for it has been said that every shadow ministered to his pleasure, and Nathaniel Hawthorne would ' sit at the top of a cliff and watch his shadow gesturing on the sand far below '. Our shade projects from us an intimate yet intriguingly separate entity.

As the villages grew into towns in America, as factories brought men and women into new neighbourhoods, new emphasis was needed and the urge for personality made the business of the silhouettist a lucrative one.

The ' cut outs ', often crude and rigid, but always intimate and familiar,

[1] *The Flowering of New England*, p. 23.

gave definite shape to personality and pleased the multitude who were unable to afford more elaborate portraiture

Then again [1] :

there was an age of family pride nowhere more marked than in Boston, an age of moderate wealth, which the recent war had checked, but not extinguished. For three generations . . . Boston had supported its portrait painters . . . It was true that the town had little feeling for art, Stuart was to die as obscure and poor as any tippling poet in the gutter. The Boston people did not cherish him—much as they enjoyed his company . . . If they cherished him it was because he added to their pride in themselves, for they buried him in the Common . . . and did not even mark his grave. Boston was torpid in æsthetic matters . . .

The *North American Review*, however, founded in 1815, marked an era in cultural growth and the *Monthly Anthology* printed essays on Italian painters, Luca Giordano and Carracci.

Though Boston was only a regional capital, it has been said that ' this town was much more of a capital than either New York or Philadelphia for the people were more homogeneous '. They had a passion of admiration for their parochial institutions and their neighbours.

In their cut portraits of early date, simple in execution, we see the successful merchant and his lady, the Puritan type, men who valued the virtues of silence and secrecy. In some of these old profiles one seems to look at those who were enjoined to ' keep the countenance open but one's thoughts closed '.[2]

We see men in shadow portraits, lean, shrewd, lantern-jawed, if by Todd working in the first decade of the nineteenth century, scrupulously named, as shown by examples at the Boston Athenæum. Occasionally hollow cut and named, there are examples by Williams as at the Worcester Museum and elsewhere. His advertisements mention painting on glass and ivory ; and Doolittle, on plaster. Very many other silhouette portraits were produced by cutting machines, mostly by amateurs, relatively primitive in execution.

It was of advantage both to the home worker and the itinerant, that silhouette, being the most simple and restrained of all the arts, needs the fewest materials for its fulfilment. Shadow outline, avoiding all detail, assists remembrance and fits comfortably between need and luxury, satisfying the primary demand. We may count up to sixty names of American silhouettists and about twenty more strangers who worked while visiting the country.

Their work occasionally brings an historic scene to the mind, thus Louterberg's Indian ink portrait of George Washington as he stood taking his last leave of Congress at Christchurch, Philadelphia, which was presented to the wife of Major de la Roche, aide-de-camp to Lafayette.

I have in my possession an original copy of *The Times* printed in London,

[1] *The Flowering of New England*, p. 3. [2] *Ibid.*, p. 6.

in which the 'Address of President Washington on his resignation' is printed in two columns of this valuable little early edition of the mighty 'Thunderer'.

The earliest native silhouettist of note is Miss Nellie Custis, a gifted amateur, the step-granddaughter of George Washington. She was born at Abingdon, Virginia in 1779; her father, John Parke Custis, being the son of Martha Washington by her first husband. The girl was adopted by the President on his marriage, and we can imagine the scene at Mount Vernon in 1798, when, a candle nicely adjusted, her step-grandfather posed, while Nellie Custis traced upon a paper fixed to a wall or screen, the outline of the shadow, thrown on the background.

The good placid Martha, we feel sure, looked on with approval, and afterwards she herself was made to submit to the homely ordeal. Then the outlines were filled in (Plate 53).

These precious records, rather larger than life size, were presented to the Everett School, Boston, Mass., by Edward Shippen of Philadelphia. Alas, they no longer exist, as I hear from the master of the school, that they were destroyed by fire several years ago. Happily outlines, taken from the originals have been preserved, and I am able to reproduce them through the courtesy of Rev. G. T. Morse.

Of the same period is another amateur silhouettist, a visitor to the States, the handsome gifted *Major André*, Adjutant-General of the English army, quartered in Philadelphia, where he moved in the old world society, exercising his artistic talents, in drawing, water colour painting and designing, and cutting out of black paper the portraits of his friends; just as the Beaux of London, Paris, Berlin, St. Petersburg, Gotha and Berlin, were doing, at the same time.

The fact that the personality of the cutter is of supreme interest, being the most tragic figure in the whole war of Independence, and further, that his sitters were men of note, such as George Washington, Benjamin Franklin, Generals Horatio Gates and Burgoyne, etc., make his work of very great value. His lines are strong and bold, the sitter placed often at an unusual angle, by no means half face but almost three-quarters. The black paper is thin, the mounting card browned with age, the signature A. alone and sometimes the full name.

These valuable portraits were at one time in the possession of the late Henry Hart, a notable American antiquarian, a silhouette collector, whose correspondence concerning Edouart's rare Treatise is of great interest.

André's silhouettes at present known are:
1. Washington—signed A (Plate 54).
2. Benjamin Franklin—signed *André* (Plate 82).
3. Phineas Bond—*Major André*, 1778.
4. Bourgoyne : *André*.
5. Gen. Horatio Gates : *André*.
6. Captain Noel : *André*.
7. Sir John Woollaston—1773 : *André*.

8. Captain Cathcart—1778 : *André*.

9. Captain Batsford : *André*.

In the reading-room of the Philadelphia Library are three more of his cut portraits, Major Stanley of the 17th Light Dragoons, afterwards Earl of Derby, and two others unnamed, and of smaller size.

In the catalogue of the Loan Exhibition of miniatures held under the auspices of the Maryland Society of the Colonial Dames of America, January 1911, at Baltimore, occur these words : ' Ring, Miniature of Wilhelmina Smith, painted by Major André, Loaned by Mrs. Thomas Cradock of Pittsville '. It is highly probable that André painted as well as cut. I have had no opportunity of examining such a relic. His landscape painting is well known.[1]

Amongst the early native professional makers of shadow portraits in America *Moses Chapman*[2] is noted ; he was one of the itinerant workers by machine, travelling mostly in Massachusetts, judging by the dress of his sitters, and the silhouette profiles which adorn his handbills, several of which survive, having been used as packing in an old trunk (see Plates 58, 67).[3]

He worked at the end of the eighteenth and beginning of the nineteenth century ; he occasionally cut free-hand, but mostly by means of a machine, and it is of this type that I have recently found many in America ; in fact, the hollow cut (I now discover) seems to predominate on account alas ! of so much machine cutting.

Chapman's handbill shows spaces left for the filling in of his address, and the name of the town in which he worked. His machine is still in existence.[4] He is one of those who supplied frames which must have been of superior quality, as their price was up to two dollars.

Massachusetts seems to have been a favourite hunting ground amongst portrait painters and cutters. In a record of the last quarter of the eighteenth century we read [5] of Exhibitions of Silhouette Likenesses held in 1791–1799–1801. '*Mr. Bowen's* likenesses of General Washington and his lady and others from the Boston Museum to be shown at the Assembly Rooms, admission for each adult 20 cents.'

Daniel Bowen, whose date 1791 occurs on the likenesses of ' General Washington and his Lady ', worked in partnership with *W. M. S. Doyle*, with varying success, which was a good deal discounted by disastrous fires at their museums.

Mr. Tuckerman [6] found such ' fraternities, more convival than artistic . . . though such pursuits were followed in a spirit of meritorious patience, with precarious reward, spasmodic success, and incomplete results.'

This gloomy outlook does not seem to be shared by *William Bache*, 1771– 1845, who, in an advertisement which has recently been found [7] ' feels confident

[1] *Connoisseur*, Dec. 1926, Mrs. Nevill Jackson. [2] Dictionary, p. 89.
[3] *Boston*, p. 122. [4] *Connoisseur*. The machine belongs to Rev. G. T. Morse.
[5] Dictionary, p. 84. [6] *Art in America*, Tuckerman.
[7] Mr. H. E. Erving, Hartford, Conn.

PLATE 51

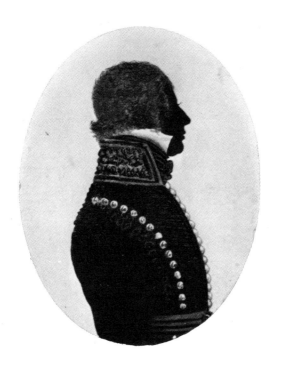

OFFICER OF THE 60TH RIFLES (ROYAL AMERICANS)
BY J. BUNCOMBE, OF NEWPORT, ISLE OF WIGHT
Formerly in the Nevill Jackson Collection

of rendering general satisfaction on account of great success in business'. His signature is Bache or 'Bache's Patent' below the bust-line; he added bronze or white lines to his cutting. Nearly 2,000 examples of his work are preserved in an album by one of his descendants; they vary considerably in size, and are often found with scraps of philosophy or sentiment as in old albums (Plate 55).

Such an album is treasured at the Free Library at Newark, New Jersey, but is not of native origin. *P. Bauer* [1] painted the fine silhouettes, the script is in German dated 1781 (see Plate 50).

Another treasure of German origin now in America is the fine snuff- or patch-box in the Lazarus Bequest in the Metropolitan Museum, New York. It measures about 3½ by 2 inches, and has on it two beautifully painted heads signed by *Schmid*. I discovered it quite by chance after I had been firmly told by the authorities that the Museum possessed no silhouette portraits of any kind.

Schmid worked in Vienna at the end of the eighteenth century and has been called 'the busiest silhouettist in Austria".[2] The fact that his work is always signed 'Fecit Schmid, Vienna' makes it reasonable that he should have earned this title, as so many authenticated specimens are to be found.

Samuel Folwell, 1763–1813, was an American veritable 'Jack of All Trades'; he engraved book-plates in New Hampshire, painted miniatures and silhouettes in Philadelphia, also worked in hair and kept a school! His portrait of Washington was taken when the great man visited Philadelphia in 1795 and is signed 'S. Folwell Pinxt' and dated; it is now in the possession of the Pennsylvania Historical Society. It is strongly reminiscent of the silhouette portrait of the first president in the gallery of the New York Historical Society, which, however, is not very easy to examine, as it is badly lighted.[3]

The treatment of the hair with grey pigment by Folwell, perhaps suggested this method to *William H. Brown* of the mid-nineteenth century; certainly it is alike, and very distinctive. Another example of Folwell's work is the quaint Absolom Jones in the possession of Miss M. Martin (Plate 58). How we should like to see specimens of book-plates, miniatures, hair designs, and highly educated infants, all the result of busy Folwell's industry; his address in 1795 was at No. 2 Laetitia Court, Philadelphia, and he exhibited portraits the same year at Columbeanum, a kind of museum in Philadelphia; his George Washington portrait has been reproduced in *Watson's Annals and Occurrences of New York City and State in the Olden Time*, 1846. In the Dyckman House in New York, built by William, grandson of Jan Dyckman, who came to New Amsterdam from Bentheim, Westphalia, towards the close of the Dutch occupation of New York 1660, there are several silhouette portraits in the parlour and in the small room behind, known as Isaac Dyckman's room, which is opposite the doorway, under the staircase close to the entry to the 'winter kitchen'.

[1] Described Chap. IV. [2] J. Leisching.
[3] *Watson's Annals and Occurrences of New York City*, 1846.

Unfortunately the wise precautions to prevent entrance, made it impossible for me to examine these treasures closely, but it is interesting to know that amongst the family belongings of old time in New York there is represented this little side issue in family portraiture, the silhouette. Did 'black Hannah', a servant of the house who had been born in the place, daughter of a slave and partly of Indian blood, look at these black faces of master and mistress and wonder what folks were about? Tradition describes her with a bright coloured kerchief on her head, a face black as ebony (or a silhouette), a weakness for a corncob pipe and a temper 'irregular'. Her kitchen had a white stone floor and in her days was strewn with sand in patterns; the summer kitchen opened on to a porch.

In the van Courtland house in Courtland Park, New York, also beautifully kept in its old family state, there were some silhouettes. I was delighted to hear the custodian call them 'thumb pictures', clearly going back to the old glass painted portraits, with black pigment manipulated by the thumb so that in the patterns of lace, hair or drapery one can often distinguish the whorls of the skin.

William M. S. Doyle (see Plate 59), whose signature is generally in cursive lettering, and who occasionally painted on plaster, was son of an English army officer, and born in Boston, 1796, when his father was stationed there. I have not been able to find out which was his regiment, possibly he was one of the 60th rifles, the Royal Americans, officered by Englishmen, though the rank and file were mostly recruited in Pennsylvania. In the 29th year of the reign of George II, 1755, the sum of £81,000 was voted in the English Parliament for the purpose of raising a Regiment of four battalions for service in North America; the Earl of Loudoun, who had shortly before been nominated Commander-in-Chief of the Forces in New America, was appointed Colonel-in-Chief of the Regiment. Mrs. Van Lee Carrick considers that Doyle was influenced in his work by the success of Charles Wilson Peale [1] (Plate 60).

In tracing the history of the shadow portrait in America and the life stories of the artists, one is haunted by mechanical contrivances; even if the silhouettist works free-hand now and again, he seems to fall back on his machine cutting.

Charles Wilson Peale apprenticed to a saddler, preferred to study art. He probably received some help from J. S. Copley, then came to London for two years and painted many portraits; especially of military men when he took part in the war of Independence. He was interested in natural history, and finding the remains of a prehistoric animal, the museum complex seized him, and a silhouette cutting machine was added to the attractions. Thus his art became mechanized, and though he helped to establish the Pennsylvania Academy of Fine Arts and contributed to seventeen of its annual shows, he continued his machine cutting, assisted by his many sons with ambitious names. Experts have expressed an opinion that 'had Wilson Peale devoted himself to his art alone, he would have attained high honour' the museum and machine cutting intervened.

[1] *Shades of our Ancestors*, p. 33.

In the catalogue of the Miniature Exhibition under the auspices of the Maryland Society of Colonial Dames of America, 18 January 1911, held at Baltimore, there are many silhouettes done at West Point from 1814 to 1818.

Lieutenant Joseph Nicholson Chambers, 1818.

Cadet James Alexander Chambers, 1814.

Cadet Thomas Noel, 1814.

Cadet Edward Lloyd Nicholson, 1814, etc.

Doubtless some silhouettist found a good market for his work near the Military College, just as Buncombe worked at the Isle of Wight near the Military Depot in 1810, and a profilist opened her studio at St. Leonards-on-Sea where the cadets of the British Flying Corps were receiving their training for service in the Great War, 1914 (see Plate 81).

Possibly the owner of a West Point profile may find a signature and tell me whose name may be associated with these portraits of cadets of West Point, America, of the early nineteenth century.

It is interesting to see in this catalogue that English examples by H. Gibbs, by Field, Miers and Gapp of the Chain Pier, Brighton, have been imported ; while a silhouette (print doubtless) by Anthing is of Czar Paul of Russia, from Gotha, together with a full-length of Goethe 1782 (print), and a coach and four cut in Düsseldorf.

Before describing the work of visiting silhouettists who worked in America, which in chronological order should be mentioned here, it is best to continue the list of native born.

What type of machine was used by *Martin Griffin*, 1784–1859, a man crippled by a fall from the steeple of a chapel, it is difficult to guess ; we are told ' he invented it himself '. Did he with difficulty mount his horse carrying his machine with him, and plod from town to village along the roads in New England ?

As he could draw fairly well, his work is not all machine made. He itinerated in Berkshire, in Vermont and New York State,[1] and made a speciality of family groups, eventually settling down as a shoemaker.

Charles Peale Polk, 1767–1822, nephew of Charles Wilson Peale, made portraits in black on a gold background. The American Antiquarian Society in Worcester, Mass., are in possession of three of these rarest of types by American artists. Two of them are of Madison and Gallatin ; the signature on one is *C. P. Polk* fecit, the other is signed *A. R. Doolittle* fecit ; possibly this was Amos Doolittle, the engraver, 1754–1882.

William Henry Brown, 1808–83, amongst the American silhouettists is an outstanding figure, on account of his full-length method, and also because he has left an authenticated record of twenty-seven of his most important portraits,[2] so that we are able to study definite examples of his work. Original copies of

[1] *Wax Portraits and Silhouettes*, Mrs. Bolton.
[2] *Portrait Gallery of Distinguished American Citizens with Biographical Sketches*, 1845.

this book are now rare ; a disastrous fire having destroyed most of the first edition, the book has been reprinted. Like other itinerants, he called his studio after his own name in whatever town he visited; and to the 'Brown Gallery' his sitters flocked. His first important portrait was that of Lafayette taken in Philadelphia, when the artist was sixteen years of age. He cut with surprising speed, and some of his work is in black alone, but he usually painted in white and grey, the hair, shirt-frills, outline of clothes, etc. His work is unequal, but his memory was so remarkable that it is said he could duplicate a portrait without a second reference to his sitter.

Brown also cut elaborate compositions for exhibition purposes, building up groups of figures such as did Dempsey in his Cotton Exchange, Liverpool (see Plate 86), on a suitable background. In one example Brown shows every member of the local volunteer fire brigade on a background twenty feet long.[1]

Like Edouart this artist often used lithographed backgrounds and occasionally, specially drawn interiors in line or wash. His charge was one dollar for each full-length figure. One seldom sees a profile by him of a woman or child, but they are to be seen in his family groups, which he arranges in the all-in-a-row method deprecated by Edouart.

In 1832 Brown advertised in *The Gazette*, published in Salem. His address was 'Over Mr. Horton's, Apothecary, opposite the Lafayette Coffee House'. William Henry Brown died in his native town ; twenty years before his death he ceased to exercise his art, possibly on account of the discoveries of Daguerre having a modifying effect on his clientele. His remaining years were spent in the railroad service.

There were other American silhouettists, less important on account of machine work, such as *William King*, the cabinet maker, on whose hand-bill two silhouettes appear. He charged 25 cents, and provided frames, and sometimes embossed mounts. In 1805 he was working in Portsmouth and advertises : 'A new delineating pencil'. He took many portraits in Salem and Newbury-port, and in 1806 he was in Boston.[2] He travelled as far as Halifax and Nova Scotia. There are probably many hundreds of these machine cuts in the possession of New England families in their 'Elegant Frames'.[3] His signature was King or W. K. He eventually disappeared, leaving a note to say he was about to commit suicide (see Plate 59).

There are several other American profilists such as *Pleasants* of Boston, *Powell* of Philadelphia (Plate 59), *Charles B. Wheeler*, but they generally worked by machine or, like *Miss de Hart*, friend of Washington, are known chiefly for one or two examples only ; so that in viewing the ever moving flow of profilists on the roads and in the towns and villages we find them at work not always under favourable conditions.

[1] Rep. in *Wax Portraits and Silhouettes*, Mrs. Bolton. [2] Library of Congress, Washington.
[3] *Antiques*, Sept. 1927, by Mr. Homer Eaton Keyes.

According to Harriet Martineau in 1836 even 'Chicago was a raw bare town with insignificant houses run up with no regard to architectural effect, and inhabited by land-mad people'.

Did our silhouettists dare to use the 34 miles of railway from Adrian to Monroe which were in use in 1840, or did they prefer their own walking powers, to the adventures of the four miles of the Lake Erie and Raisin River Railroad, which had been so strangely built that no locomotive would go over the rails and the cars were drawn by horses?

Such records make us think of these early silhouette artists as bold adventurers as well as pictorial recorders, and we marvel at their temerity as well as their modest efforts in art, which are so important as records.

Now let us complete the picture by noting the Visitors to the States, who worked in taking the portraits of the citizens.

One of the earliest of these was *Jean François de la Vallée*,[1] 1795, a French *émigré* of whose work little is known. After correspondence with Washington and Jefferson on the subject of cotton growing he went to Alexandra, Virginia, intending to build cotton mills.[2] His project was not a success and he is known to have painted some miniatures and a silhouette in Indian ink, of Washington, when the President was 63 years of age.[3]

Samuel Metford was also an early visitor. Born in Glastonbury, Somerset, about 1834, he worked in New England, that Mecca of the silhouettists; he became a naturalized citizen of the United States, working there for ten years, eventually returning to England. His family groups are much sought after. He signed S. Metford or Sam'l Metford; he sometimes touched his full-length figures with white or grey relief (see Plate 57).

Master Hubard is generally called The Infant Prodigy for he had his own studio in England when he was only 12 years old. Five years later he landed in New York, then travelled to Boston and Philadelphia, always establishing 'The Hubard Gallery' wherever he worked professionally; his mounting cards have these words embossed in one corner.

He exhibited his silhouettes in the Pennsylvania Academy of Fine Arts in 1826, 1827 and 1828. On the silhouette portrait of John Grey Park, of Groton, Mass. 1824 is the label: 'cut with scissors without drawing or machine, at the Gallery of Cutting and Philharmonic Concert Room'. This gives us an earlier date. His address at Boston was the Exchange Coffee House; during January, February, and April. In 1807 he visited Portsmouth, New Hampshire, where he advertised his 'Cutting of correct profile likenesses'.

While at Boston, I was told [4] (at the Capitol Library, Washington), Hubard was advised by Thomas Sully to take up portrait painting of small full lengths

[1] See Dictionary.
[2] Mantle Fielding Dictionary of American Painters.
[3] *Ibid.*　　　　　　　　　[4] Mr. Roberts's Print Dept., Capitol Library, Washington.

of the approximate size of his shade portraits. It is said that he became inspired to do this type of work by cleaning the oil-paintings of Gilbert Stuart. Hubard studied under Sully at Philadelphia, and exhibited his first painted portrait at Boston in 1829. He then went to Baltimore, Maryland, where he painted the portrait of Charles Carroll, which is now in the Maryland Historical Society's Gallery. His painted portrait of Lafayette is well known, also that of Henry Clay, the orator.[1]

His method in silhouette work was free-hand cutting, without drawing or the use of any machine. Sometimes he used Indian ink and gold bronzing. His shades are generally full lengths, the same as his work in England (see Dictionary).

Subject pictures are also attributed to him :
Dr. Syntax and Grizzle, 1821.
Dr. Syntax, Sketching the Lake.
Dr. Syntax, Rural Sport.
Captain Philip Juggins.

Hubard eventually moved to Richmond, Virginia, where he died in the Confederate Service, 25 February 1862.

Master Hanks or *Hankes*, free-hand cutter, was also a visitor from England. He went to America in 1828 and his work is alluded to in the Records of Salem. The author of that book considers him ' successor of the celebrated Master Hubard.' A full-length portrait by him is owned by the Maine Society. He is advertised as ' capable of delineating every object in nature and art with extraordinary correctness '. This he did by means of paper and scissors, merely looking at the object to be represented. It took him but a few minutes to give an exact bust of any person he saw (see Plate 56).

At Concert Hall, where his talent was fully and successfully tested, was exhibited the Papyrotomia, a curious collection of paper cuttings, admission 25 cents. ' In this department of art, several young women of Salem have greatly excelled,' according to the local press.

Charles B. J. Fevret de Saint Memin, the French *émigré*, was also a visiting artist. Five of his black shades were made in America conjointly with Valdenuit, whose signature also appears on them. These are now in the folios of the Corcoran Gallery. Saint Memin's chief work, however, is in delicate line on coloured ground and without black filling. He eventually returned to his native land.

Of the visiting silhouéttists, working in America, *August. Edouart*, 1789–1861 is by far the most important, not only on account of the quality of his work, but also because he named and dated every portrait-cutting in duplicate ; there exists to-day a complete photographic record of profiles of three thousand eight hundred of the citizens of the States of 1839–1849, their wives and families, sometimes of their servants and slaves. This remarkable series in my possession

[1] Historical Society's Gallery, Baltimore.

is invaluable in family research work and should be available for the benefit of descendants.

This French *émigré*, after fighting and being decorated in the Napoleonic wars, landed in New York in 1839. He lodged at the house of Roe Lockwood, 114 Broadway, whose portrait was in the folios of duplicates, for as I have said, Edouart cut in doubled paper and named, dated and put the address of each sitter on one of these originals, to keep in his reference folios. So that we can see to-day besides 3,800 named portraits of American citizens, 1839–49, some 5,000 of English, Scottish, and Irish.

My discovery of this enormous mass of authentic pictorial documents in England is related in the Dictionary, together with details of this able artist's work in the British Isles. It was Edouart's custom to open a studio whenever he arrived in a town and advertise in the local Press. I have not been able to find these advertisements as newspapers are not filed in the Public Libraries in America, but the town names on the portraits indicate how widely he travelled.

He took mostly full-length, 7½ inches—37 portraits in Albany, 884 in New York. Amongst these names and addresses are most of the well-known people of the day; occasionally quaint or valuable particulars are added as to relationship or descent, such as Irving van Wart, son of Henry van Wart of Birmingham, England, relative of Washington Irving; or again Thomas A. Tomlinson, Member of Congress.

From Cambridge, Mass. we have ' H. W. Longfellow of Cambridge, Poet ' (Plate 61), Josiah Quincy, President of Harvard, and all his family; Mrs. Edmund Quincy, daughter of Daniel C. Parker. In Boston 613 portraits were taken in Philadelphia, 354 in Saratoga Springs, which he visited several times. While all the folks were holidaymaking many portraits were taken, all named and dated and with home addresses added.

Several visits were also paid to Washington and six presidents and ex-presidents are in his folios. Harrison's autographed portrait is pathetic, dated 20 February 1841; two months after his strenuous fight for the presidency, he was struck down with that fatal attack of pneumonia which his wearied frame had little power to resist. Martin van Buren came to Edouart's studio in Washington, 1 January 1841; Millard Fillmore, 14 June 1841; Henry Clay; Daniel Webster, ' that magnificent specimen ' as Carlyle calls him; Franklin Pierce; cabinet ministers, congress men, democrats, men of letters, journalists, their wives and families in crinolines and ringlets, as they were in the year of the Great Log Cabin Election (Plate 55).

I have had a letter from an American correspondent who tells me that Edouart's work has enabled him to complete his collection of political portraits of that day, members of the Cabinet.

The fact that Edouart sometimes visited the houses of his sitters is curiously brought out in connection with the portrait of President John Tyler, 1798–1862.

It had been taken at the White House, and I was desirous of returning it, as a gift to the American nation, and applied to our Ambassador at Washington, the late Lord Bryce. He was interested at once, for he said he remembered his father's description of the visit of Edouart to the old Bryce family home in the north of Ireland. ' Edouart cut excellent portraits of my father and grandfather. The silhouettes still hang on the walls of my home in Ireland and are considered excellent likenesses.'

I spent a pleasant hour at the White House. The late Mr. Taft received the portrait which now hangs in the morning-room, returned by me after wanderings, in Edouart's folio, all over the United States—crossing the Atlantic, shipwreck, rescue, fifty years of obscurity in an English country house, when these priceless portraits were considered by experts to be lost, and then rediscovery by me in 1911, and the return to the little old White House, so picturesque, at Washington. Edouart left America in December 1849, taking with him about 10,000 named portraits in his folios ; his ship the *Oneida* laden with bales of cotton from Maryland and with twenty-five passengers, was wrecked in Vazon Bay ; all lives were saved and a few of Edouart's cases. He was hospitably received by the Lukis family resident on Guernsey, for he was ill and depressed with the peril of the wreck and loss of so much of his property. He gave the rest of his portraits to his kind host, Mr. Lukis. He worked little professionally after the shock of the shipwreck, and died at Guines in 1861. Contemporary newspapers and letters give accounts of the storm and make interesting reading. This was in 1849. I purchased the folios in 1911 from members of the Lukis family in whose care they had lain unnoticed for sixty years.

Alphabetical listing of all his portraits has led to the placing of many of them in the possession of descendants of the sitters of long ago who visited Edouart's studio in their home country and probably had no other portrait taken.

As well as the ordinary individual portraits in black paper Edouart cut in brownish cartridge paper the portraits of sixteen natives, North American Indians. They are painted on the buff cartridge paper and doubtless Edouart's imagination had been fired with stories of early conditions in America, the wild wilderness and the battling with the Redskin : his strange dress alluringly picturesque to an artist, especially so in its expressive ornament, symbolical of aboriginal customs and life. To a man such as Edouart, accustomed to take in and reproduce at a glance the slightest variation in our rigid fashions, any such unusual example would be fastened with lightning speed.

Every visitor to the American continent, except the most superficial, must feel that subtle influence of the forest and its early inhabitants, which with its vast stretches of unexplored territory, and its unexpected hiding-places, haunted with a subtle and deadly foe, bears influences which have sharpened the wits and moulded the standards of the American to-day.

Professor J. A. Harrison [1] and other experts have admitted that the Redskin has been a prime factor in American education. How characteristic of Edouart's thoroughness and acute observation that he should register the strange outward semblance of aboriginal tribes, with his inimitable skill, though all is silence as to where he met the fine types he draws and cuts. In a black paper bust portrait of Tsernycaathaw, or 'The man who keeps you awake', Chief Speaker of the Five Nations, this was probably done from a picture or bust. There are also no fewer than sixteen cuttings in brownish cartridge paper carefully painted in sepia and touched with white ; some are unnamed.

The effect of the sepia-drawn profiles is the same as a head in sepia taken from the antique, in one of Edouart's folios, possibly a study for one of his Royal Academy pictures. Two very fine groups show three Indians seated on the ground playing musical instruments, a drum, three bells mounted on a piece of wood pierced with holes, and a hand-bell. They wear moccasins and cloaks.

In another fine group the same three men are dancing, with the same instruments. The drum is laid aside and a spear and axe take its place. They wear long-fringed leggings. A mounted Indian bears an axe and wears a strange head-dress.

A 'Creek' from the borders of Morocco smokes a 'Peace Pipe' which is ornamented with feathers. A squaw of the Saes and Foxes bears a baby on her back.

Chief of the Yankton Saes has a feathered head-dress.

A Winnebagoi wears a fur cap with feathers. Chief of the Winnebagois has a feathered cap.

No. 8 is a fine old man (Plate 60).

Roroly McIntock, Chief of the Creeks (Plate 60).

No. 1 Black Hawk, the old Chief of the Saes and Foxes (Plate 60).

A splendid bust portrait of an Indian with a live bird on his head, unnamed.

Black Hawk.

Aupaumut, Chief of the Mocogomuck.

The full-length portraits measure 10 inches ; the head and shoulders from 3 to $5\frac{1}{2}$ inches. Several of the men wear ear-rings.

When one reads circumstantial history of the lives of some of the most famous Chiefs, their Councillors, the exploits of their warriors and speeches of their orators, one looks with special interest on the fine features of these men, shuddering at the wars, massacres, deprivations, wrongs and sufferings which were involved on them, and the Europeans, before they were ousted from their country. These portraits from life by a skilled artist are indeed precious records.

Where Edouart had opportunities for cutting these portraits, we shall probably never know, as his diaries were lost in the shipwreck. He may have reached their reservations, for his itinerary was very wide-spread, or groups of them may

[1] University of Virginia.

have been in the towns he visited. For in reading the history of these aborigines, one is struck with the frequency of their wanderings and visits, even from the time of Queen Anne, when some of them were received at Court in England. In Edouart's pictorial album in my possession, there is a fine picture with many miniature figures of Indians.

Since 1849, when Edouart left America in the *Oneida*, the tale of the silhouettists in the States has gone on, but in less volume, as the daguerreotype and the photograph became known.

Of the modern silhouette artists who still carry on the old traditions, there are many whose names can be read of in the alphabetical dictionary. As in England, I believe, no machines are now used ; at any rate, I have not seen them during my visits to the States ; the full-size shades are seldom attempted. *Perry*, a free-hand cutter, was at work at Coney Island in 1911. Miss Burdick is also a cutter and practises in Massachusetts, the favourite district of the itinerants long ago. Baroness Meydell also cuts, after laborious drawing, and varies her methods ; she is a visiting artist from Russia. Mr. Sackett is a free-hand cutter, and also Mr. Scotford, who is a great traveller, and visits England at regular intervals.

That such fragile souvenirs may have double value for future generations, let me beg of the artists that they sign their work, and name and date each portrait before it leaves their hands.

I hope from time to time the Dictionary, culled from all available sources of information from 1773 to 1938, may be added to, through the study of old diaries, biographies or from the discovery of signed portraits, so that additional information concerning early workers may be obtained.

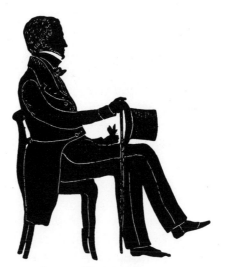

Prescott, Blind Author of *The Conquest of Mexico*, &c.

PLATE 52

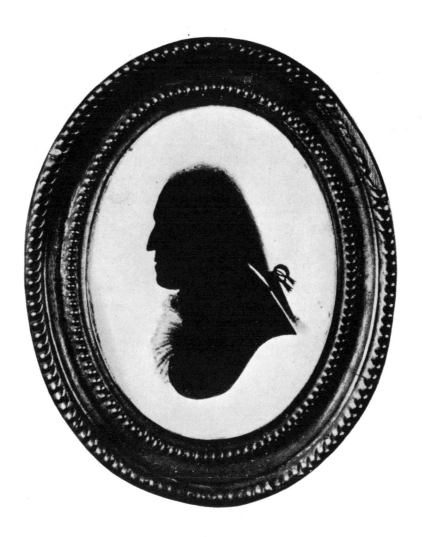

GEORGE WASHINGTON
PAINTED ON PLASTER BY I. THOMASON, *circa* 1790
This portrait is now at Sulgrave Manor, Oxford, home of the Washington family

PLATE 53

GEORGE WASHINGTON
LIFE-SIZE PROFILE CUT BY HIS STEP-DAUGHTER,
NELLIE CUSTIS, FORMERLY AT EVERETT SCHOOL,
BOSTON, MASS., U.S.A.

MARTHA WASHINGTON
LIFE-SIZE PROFILE CUT BY NELLIE CUSTIS. BOTH
THESE PORTRAITS DESTROYED BY FIRE AT THE
EVERETT SCHOOL, BOSTON, U.S.A.

By courtesy of Rev. Glenn Tilley Morse

GEORGE WASHINGTON, BY JOHANN FRIEDRICH
ANTHING, FROM HIS *100 SILHOUETTES*
By courtesy of Dr. Conrad Höfer

PLATE 54

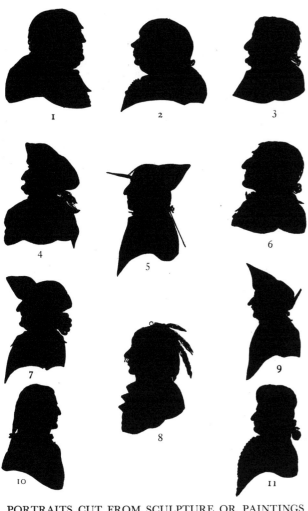

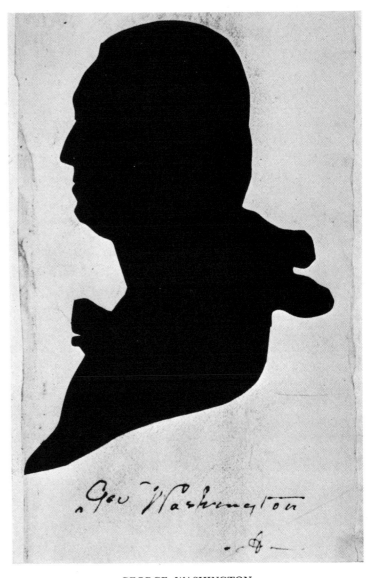

PORTRAITS CUT FROM SCULPTURE OR PAINTINGS
BY EDOUART WHEN VISITING AMERICA

1. BENJAMIN FRANKLIN, AGED 84
2. ROBERT MORRIS, FINANCE CHIEF, REVOLUTION, SIGNED
 DECLARATION OF INDEPENDENCE
3. J. HULTON, NEW YORK AND PHILADELPHIA, AGED 107,
 SILVERSMITH
4. DR. ABRAHAM CHOVET, PHYSICIAN, AGED 85
5. BENJAMIN CHEW, CHIEF JUSTICE OF PENNSYLVANIA, AGED 70
6. TIMOTHY PICKERING
7. JOHN REDMAN, M.D., FRIEND OF WASHINGTON
8. TSERNYCAATHAW, CHIEF SPEAKER OF THE FIVE NATIONS
9. PHILLIP BENEZET
10. WILLIAM BARTON, DESIGNER OF U.S. ARMS, SOMETIMES SAID
 TO BE FOUNDED ON WASHINGTON HERALDRY
11. A. JAMES DALLAS, COUNCILLOR UNDER PRESIDENT JEFFERSON

GEORGE WASHINGTON
CUT BY MAJOR ANDRÉ AT PHILADELPHIA
By courtesy of Mr. Fredenburg

PLATE 55

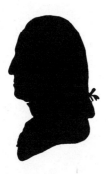

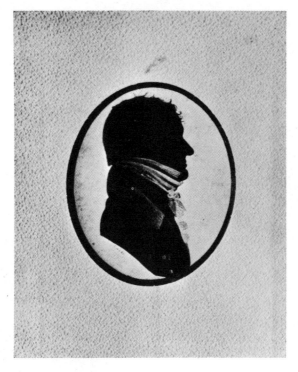

GEORGE
WASHINGTON
CUT AT PEALE'S
MUSEUM 1794

DAVID WADSWORTH BY WM. BACHE
Belonging to Wadsworth Atheneum, Hartford,
Connecticut

GEORGE
WASHINGTON
DRAWN BY J. F.
DE LA VALLÉE, 1795

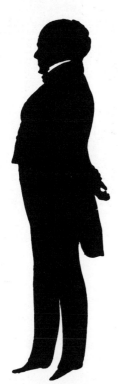

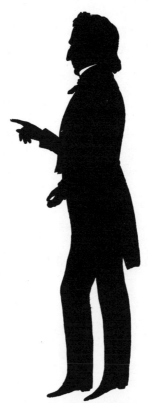

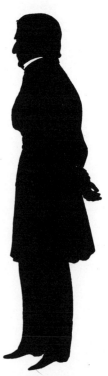

MARTIN VAN BUREN, 1782–1862,
EIGHTH PRESIDENT OF U.S.A.
TAKEN BY EDOUART WITH TWO
SONS, 1 JANUARY 1841
From the Folios owned by the Author

JOHN TYLER, VICE-PRESI-
DENT, SUCCEEDING W. H.
HARRISON WITHOUT ELEC-
TION
CUT BY EDOUART
At White House, Washington, D.C., where
it now hangs, having been presented to the
American nation by the author two months
after its discovery in England, 1911

WM. HENRY HARRISON, 1773–
1841, NINTH PRESIDENT OF
U.S.A. AND THE FIRST TO DIE
IN OFFICE
TAKEN BY EDOUART, 4 APRIL 1841

PLATE 56

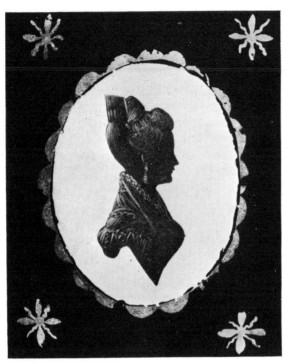

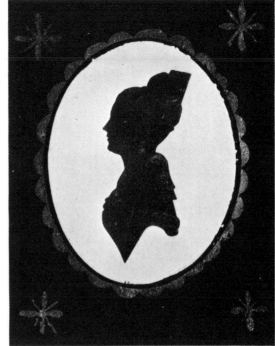

UNKNOWN LADY OF BALTIMORE A LADY OF BALTIMORE, BY MASTER HANKES

Bronzed with gold lines. *Owned by H. N. Erving*

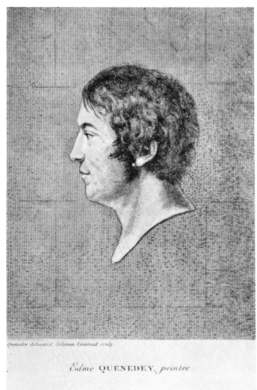

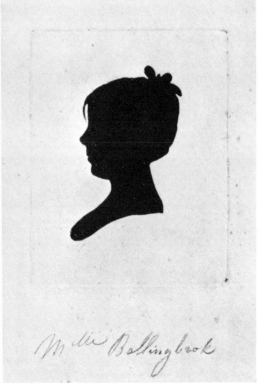

SELF PORTRAIT OF EDME QUENEDEY MADEMOISELLE BOLLINGBROK

BOTH THESE PORTRAITS WERE TAKEN BY THE PHYSIONOTRACE, WHICH WAS ALSO USED BY SAINT-MEMIN

From the Folios in the Bibliothèque Nationale, Paris (Courtesy of Miss Martin)

PLATE 57

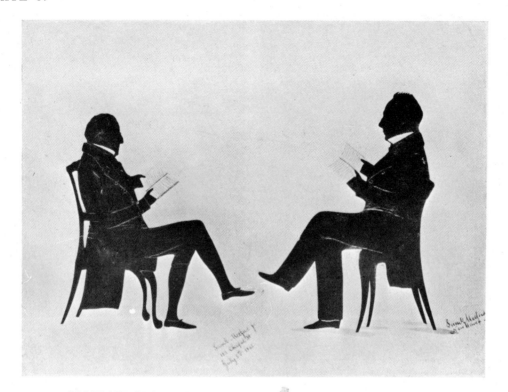

PORTRAIT GROUP BY SAMUEL METFORD, 1810–90, ENGLISHMAN
TRAVELLED FREQUENTLY IN U.S.A.
CUT AND PAINTED ON CARD

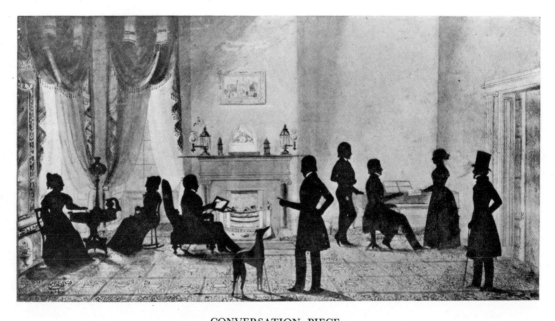

CONVERSATION PIECE
CUT BY EDOUART, DATED 1840, 411 BROADWAY, NEW YORK, 38 INS. × 21 INS., WASH BACKGROUND,
SIGNATURE LEFT, FIGURES 8 INS. TO SCALE

PLATE 58

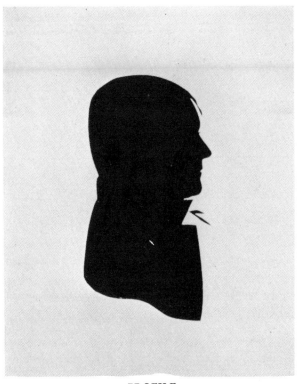

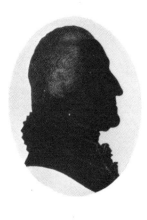

PROFILE
CUT BY MACHINE, BY MOSES CHAPMAN, SILHOUETTIST,
NEW ENGLAND
Given to the Author by Rev. G. T. Morse

PORTRAIT OF GEORGE WASHINGTON
USED IN FRONTISPIECE IN BOOK BY WM. H.
BROWN, LITHOGRAPH, 1844
By courtesy of Rev. Glenn Tilley Morse

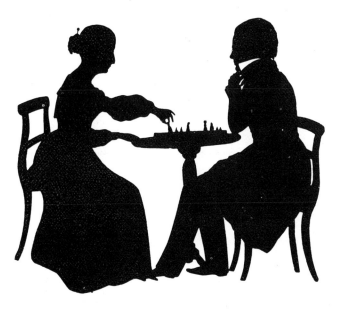

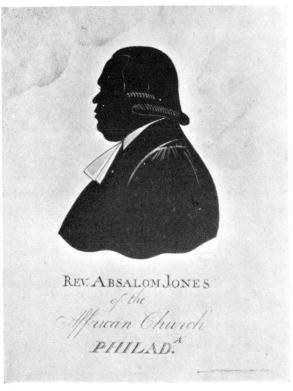

J. L. O'SULLIVAN, EDITOR OF THE *DEMO-
CRATIC REVIEW*, PLAYING CHESS WITH
MRS. G. W. WARD
*These portraits were taken in New York, 5 October 1840,
by August Edouart*

PORTRAIT BY SAMUEL FOLWELL,
1765–1813
Miss Martin's Collection

PLATE 59

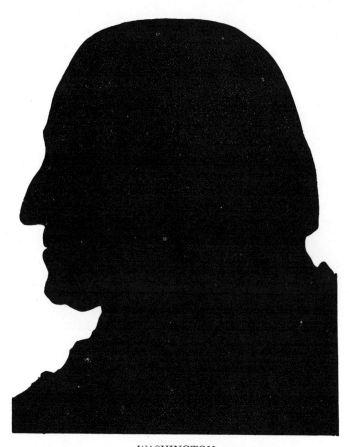

WASHINGTON
TAKEN BY LAMPLIGHT BY HIS FRIEND S. POWELL,
MAYOR OF PHILADELPHIA
*Deposited in the rooms of the Historical Society of Philadelphia, J. Jay
Smith's American and Literary Curiosities*

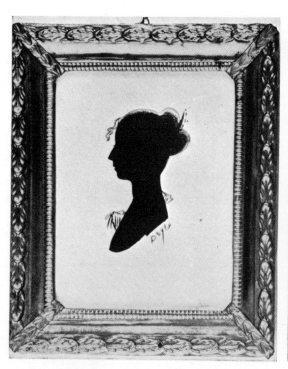 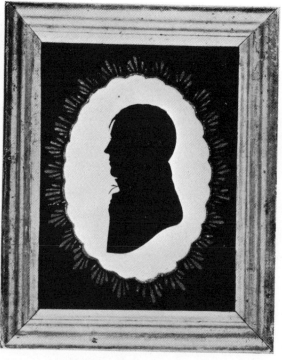

**MACHINE-CUT PORTRAIT BY WM. DOYLE,
SIGNED, WITH LINES ADDED**

PORTRAIT OF A GENTLEMAN
CUT BY MACHINE BY WM. KING
Collection of Henry W. Erving, Hartford, Connecticut

PLATE 60

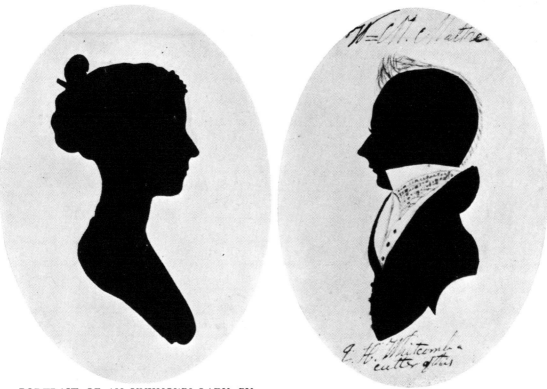

PORTRAIT OF AN UNKNOWN LADY BY
CHAS. WILSON PEALE

MR. W. M. MATTHEWS, BY J. H. WHITCOMB

By courtesy of Miss Martin

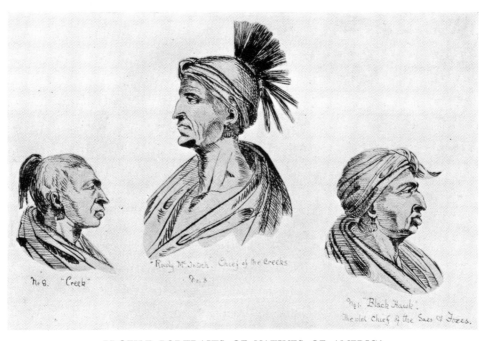

PROFILE PORTRAITS OF NATIVES OF AMERICA
CUT AND DRAWN BY AUGUST EDOUART DURING HIS VISIT TO U.S.A., 1839–49
In the Collection of Rev. Glenn Tilley Morse

PLATE 61

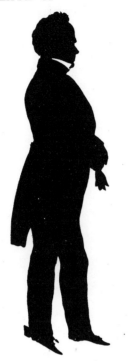 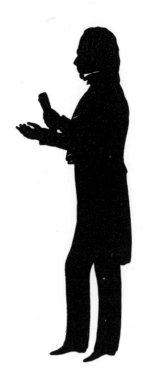 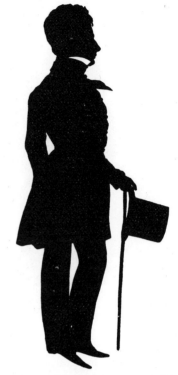

DANIEL WEBSTER, SECRETARY OF STATE IN THE CABINET OF PRESIDENT HARRISON, AMERICA'S GREATEST ORATOR

From the Folios of Edouart, once in possession of the Author. Silhouette 8 ins. in height

HENRY CLAY, SAT TO EDOUART IN 1841, SHORTLY BEFORE HE RESIGNED HIS SEAT IN THE SENATE

HENRY WADSWORTH LONG-FELLOW, 1807–82, POET, PRO-FESSOR OF MODERN LAN-GUAGES AT HARVARD, WHERE THIS PORTRAIT WAS TAKEN BY EDOUART IN 1841

PORTRAIT OF A MAN
CUT BY MACHINE AT THE PEALE MUSEUM, STAMPED MUSEUM, BENEATH SHOULDER-LINE
Nevill Jackson Collection

CHAPTER V

MECHANICAL CONTRIVANCES : THE SHADOW THEATRE

SINCE the earliest days of silhouette taking, mechanical contrivances have been used.

1. For easing the sitter and steadying the outline, such as those of Shrott's and Höfner's, friends of Goethe.
2. To frame the paper in such a way that the artist's hand may not obliterate the outline, as in illustration.
3. To reduce the life-size shadow to a $2\frac{1}{2}$-inch size or smaller.
4. To modify the flickering of a candle.
5. To focus the light.
6. For the cutting of silhouettes, by passing a guiding rod over the features as in Schmalcalder's machine (see Plate 65).
7. The Camera Obscura reflector.
8. The stencil method of duplicating portraits.
9. The Reflecting Mirrors of Jones, Coventry St.

The contrivances were at first simple, such as a bar to steady the subject, a pad for the back or head to make the position less irksome and also to keep the head in a strictly vertical position. This paralysing instrument was used till a few decades ago by photographers, who, however, have now wisely dispensed with all such aids, and take their pictures when the subject assumes an easy and natural attitude, improved speed in the process making this possible.

Lavater describes a board which gripped the shoulders ; pegs were provided to tighten up the tension. In the souvenir of Goethe by Kissler we are told that Shrott used it in taking the silhouette of the poet in 1770. The method entailed the grasping of a board with both hands, pressing it against the chest, the head at the same time being held against a padded wall.

Later, an improvement was suggested, that the contrivance should be fastened down instead of being held, ' so that the strain and tension on the features should not be observed '.

A skit on this instrument of torture was printed, in which the unfortunate subject is seen in the grip of an instrument called the Limomachia invented by one ' Pinion ' which is described as ' The new-invented Machine for taking Likenesses

by which the usual objections to Art, viz. Time, Trouble, and Expense are entirely removed by the Portrait-Grinder at his Manufactory, in Leicester Square, opposite the Equestrian Statue of the King ' (see Plate 64).

There is a long and turgid description of the advantages of this machine, ending with the assurance that ' any Lady or Gentleman may have their Portrait taken in one minute . . . and, as the machine admits of more than one sitter, the Lady and her Spouse, the Lover and his Mistress, may be drawn at the same time '.

The price diminishes as the list goes on. Families treated historically 1s. 2d., half-lengths 7d., Kitkats 4d., three-quarters 2½d.

This comic advertisement ends by offering ' for sale a Trap for catching the Aurora Borealis to be ground in water for the use of Miniature Painters '.

The method of drawing the outline without the hand of the artist interfering with the shadow was simple. A kind of vertical easel was used : a sheet of oiled paper stretched on a pane of glass at the side of the chair on which the subject was posed, her shoulder touching the glass to keep her profile steady. The artist stood on the other side and drew the shadow on the same transparent paper (see Plate 63).

The contrivance is shown in Lavater's Physiognome,[1] and a similar machine for taking full lengths is described in a book published in 1780.[2]

Höfner, the friend of Goethe, a man of many hobbies and a clever handicraftsman, constructed such a chair, which was exhibited at Leipzig in 1914. If a chair of this kind was not available, there are directions for straining paper between an open doorway, the sitter on one side, the artist on the other.

Argument raged round the subject of lighting ; many used candles as in our illustration, others declared for sunshine and were in favour of midday sun at its brightest, while others preferred a sunset light.

Lavater, who seems to enjoy complicating matters, recommends the use of a magnifying glass and the conducting of the light through the crack of a window or shutter, so that the light should be focussed.

Leonard Heinrich Hessell of St. Petersburg, 1757, who is best known in England as a stipple engraver, was the inventor of a machine for the taking of correct profiles by sunlight.

In 1807 John Oldham, a miniature painter and inventor of a process for engraving bank-notes, which was adopted by the Bank of Ireland, invented a machine which he called the *Ediograph* for taking miniature profiles. I have not been able to find out on what he relied for his success.

There are several early books on engraving and duplicating profile portraits : one by P. H. Perrenon, now a rare and valuable volume, was published in 1780 at Münster ; a second by the same publisher soon after, and a third appeared

[1] *Lavater's Physiognomy*, 1794.
[2] *A Detailed Treatise on Silhouettes*, anonymous, 1780.

giving 'a description of *Boumagie*'[1] or the art of reduplicating easily and surely.

In this last, improvements are suggested in the printing of silhouettes.

Lavater plunges into intricacies and propounds rules on the most trivial and self-evident matters, seeming to try and justify the poverty of his matter by laboured reiteration. The engraving of profiles is described at length and allusions to prisms, cylinders, pyramids, cones, horizontal and perpendicular lines abound with reference to the sun and moon, with which we need not concern ourselves, as this sketch is a description of old methods and not instruction.

How to get space sufficient for the women's enormous head-dresses is a subject which agitates him ; the advantages of wax over tallow, or suet, the avoidance of coughing, sneezing or laughing while the portrait is being taken are gravely discussed. He considers white, green, red or blue portraits are in bad taste, and contrary to nature.

The importance of the eyelash, whether or not it should be registered, provoked a storm of controversy in Germany. Protagonists declared that unless the eyelashes of the sitters were very long they would be invisible in a shadow. Others said the eyelash must always be represented. Such words as exaggeration, caricature, distortion, disfigurement, are freely used—a veritable storm in a tea-cup. Höfner's portraits sometimes have eyelashes and are sometimes without.

About 1775 to the last quarter of the eighteenth century belongs the very beautiful machine work[2] by Mrs. Harrington (see Dictionary), of 131 New Bond Street, London, though she also 'cut with scissors'.[3]

She applied for a patent for the protection of her inventions, instruments and materials for the new and curious method of taking and reducing shadows, for the taking of likenesses, etc., in miniature, so as to procure his or her shadow to the best advantage either by the rays of the sun or received through an aperture into a darkened room or by illuminating the room, &c., &c. (see Plate 64). So we see Mrs. Harrington of Bond Street is working on the same lines as the silhouettists of Germany.

In America Moses Chapman[4], 1783–1821, cut, painted and also used a machine on his professional travels through Massachusetts. At the end of his leaflet advertisement (see Plate 67), he says : ' He makes use of a machine universally allowed by the best judges to be more correct than ever before invented.'

I have seen the relics of his simple contrivance kept as one of the chief treasures at the Rectory in the collection of Rev. Glenn Tilley Morse, which is indeed a fine and comprehensive one representing the labour and study of many years.

Noether, a travelling handicraftsman in 1809, used a ' *Pasigraph* ' in his profile making ; whether this was a cutter or a special type of *pantograph* I have not been able to discover.

[1] A Description of Boumagie.
[2] Rep. Chap. I.
[3] Rep. *One Hundred Silhouettes*, J. P. Wellesley.
[4] Information Rev. G. T. Morse.

With regard to the *Pantograph*, which is perhaps the most important of the mechanical aids in shadow portraiture, we find it first mentioned in a book written in 1631 by a German Jesuit, Christopher Schreiner, who described it as a diminishing instrument, in use for mathematical drawings.[1] Apparently it was of iron or steel, cumbersome to use and heavy.

In the eighteenth century it was used in frame for reducing the size of profiles ; letters are extant which accompanied such a machine as a gift. Goethe would admit no silhouette as original, after it had been diminished. Some of the poet's silhouette work is preserved in the Goethe National Museum ; a few full lengths, some to the shoulders only, all are a little larger than life (see Plate 7).

One sometimes sees such examples in a portfolio in an old country house. I have seen one life-size by Miers signed and with his address in the Strand, Number 111. This must have been taken about 1788.

It was in 1806 that Charles Schmalcalder of Little Newport Street in the parish of Saint Ann, Soho, applied for and obtained a patent for his apparatus for taking, tracing and cutting profiles. His specification, which I had copied from our Patent Office, together with his drawing lodged there at the same time, is so explicit that it is the only one of such machines which is understandable by the lay mind, briefly : [2]

He humbly Petitions His Majesty King George III to grant His Royal Letters patent for the Delineator, Copier, Proportionometer, for the use of taking, tracing and cutting out Profiles, upon Copper, Brass, hardwood, card, Paper, Asses skin, Ivory and glass, etc., for the term of 14 years in His Majesty's United Kingdom for the sole making and vending of his Invention.

* * * * * * *

The King was graciously pleased to grant his request on the 22nd day of December in the 47th year of his reign.

Schmalcalder's description occupies three pages. In it is set forth the fact that the said Charles Schmalcalder shall lawfully have and enjoy the whole profit, benefit, commodity and advantage from time to time, coming, growing, accruing and arising by means of the said invention.

It is described at great length as consisting of a hollow rod, screwed together and from 2 to 12 feet, or longer, chiefly made of copper or brass, sometimes wood, or any metal applicable. One end carries a steel tracer, the other end of the rod either a steel point or a black lead pencil. There is a tube in a ball 10 inches long, two half-sockets, a frame of wood, swing-boards, clamp-screws, holes and divisions galore ; there is a fixed weight, a hook, a pulley, a screw-clamp.

Many pages of closely written matter which would fill this volume describe the whole affair, including minute measurements as to the pose of the sitter. Let me suggest for the help of anyone who wishes for the technical description

[1] Herr Kippenberg, *Sammlung*, p. 147. [2] Patent Office, London.

that the document is dated 1806, No. 3,000, and a copy can be obtained if wanted at the Patent Office, London.

Considering the rather strange method of having a rod passing over the face it is interesting to read a contemporary account of the sensations of a sitter. I cannot help thinking that a simpler instrument must have been used here.

[1] We were all three taken in High Street, Sheffield, at a shop situated upon the right-hand side going down that thoroughfare, a few doors above George Street. The operator used an instrument of brass and wood, elbowed much like the pointing machines in vogue in sculptors' studios. The end of this passed lightly over the sitter, touching, in turn, back, shoulder, neck, head, face and bust. By some mechanical contrivance—one that I really do not now remember—a point or pencil was made to work in unison at the other extreme, and it traced accurately in miniature, upon a card laid upon the table upon which the machine stood, the outline of the subject. That formed the basis of this likeness, which a young man afterwards filled in. I recollect I was wearing a purple frock at the time, but, of course, the actual colour does not show in this black affair.

At Huddersfield and Newcastle the *Prosopographus* was used. An automaton was supposed to trace the profile of any person placed before it in the space of one minute. The profiles cost one shilling; if coloured, from 7s. 6d. upwards.

The machine *Physionotrace* was used by Chrétien, Quenedey, Bouchardy, Gonord and Saint Memin (see Dictionary),[2] all Frenchmen, and though these artists did not always fill in black and thus produce silhouettes in the true sense, they traced profiles and sometimes painted black; there is such a fine line between a profile coloured and the outline filled in as shadow, that mention must be made of their work with this machine; especially as the output by this process was enormous and here and there amongst it is a true silhouette. G. L. Chrétien (see Dictionary), 1754–1811, is described sometimes as the inventor of the machine, sometimes as having improved on a machine of earlier date, which is the more likely. He was born at Versailles in 1754 and studied engraving; after perfecting his profile machine he used it exclusively to the neglect of any other process; some of his profiles are to be found engraved and coloured by hand.

Edmé Quenedey, 1750–1830 (see Dictionary), was one of his assistants, Fouquet and Forunier two others; the business must have required this numerous staff, for it was very large. In 1796 Chrétien had twelve frames exhibited in the *Malon*, each containing fifty portraits.[3] Many of these are still to be seen in the Bibliothèque Nationale, Paris.

The original drawing of Chrétien's machine is now in the Bibliothèque Nationale. Gonord and the inventor both sold copies of it, for the machine, though cumbersome, was not difficult to manipulate; the resultant portraits were engraved, some of these plates still exist, and though much worn, are

[1] *Notes and Queries*, 9th Series, Vol. 5. [2] Martin.
[3] Martin, *Connoisseur*, Vol. 74, p. 145.

occasionally used for reprinting, old paper being procured to give an appearance of age.

Quenedey, 1750–1830, not only assisted Chrétien but also worked on his own account in Brussels and Hamburg. He was a busy man ; in Paris, in the Bibliothèque Nationale, there are twenty-eight albums of named and seven albums of unnamed portraits containing in all 12,000 examples. Miss Mary Martin in her excellent article on his life, illustrates Mlle Bollingbrok of England, filled in by Quenedey in black. Bouchardy (see Dictionary) also used the *physionotrace* and called himself its inventor on his advertisements ; Godefroy and Roy also used it, and lastly Saint Memin who popularized it in America.

One of Saint Memin's assistants was Valdenuit, and examples of the black profile portraits exist with this signature, in conjunction with Saint Memin's.

Le Met calls himself ' the late partner of Saint Memin '. I have not had an opportunity of examining an example of his work.

Isaac Hawkins (see Dictionary), an Englishman, also used Chrétien's *Physionotrace*, and writes from London to Charles Wilson Peale of its success, Peale being in Philadelphia at the time ; he also describes his stencil method for duplicating the shades.

So these processes gradually became known in the United States ; it is to be regretted that they may have stopped some good original hand-work. Chrétien's method was later simplified. Hawkins went to America and became assistant to his friend Peale at the Museum at Philadelphia. Subsequently he took out papers of naturalization, thus becoming an American citizen.[1]

Hawkins's claim that his machine produced with a steady hand a correct indented outline *to be cut out with fine scissors* and then placed over black paper or silk, seems to bring a slight confusion into the matter. American machines certainly seem to have cut the outline through the paper outright without further scissor work being necessary. Pen and ink lines were often added to indicate detail, but no further cutting.

Peale's son Rembrandt, in his Reminiscences[2], says : ' I introduced him (Hawkins) on his arrival in London, in 1802, to Mr. West (Benjamin, P.R.A.), and assisted him in putting up his Physionotrace in the artist's gallery, and the profile of West was the first which was drawn (cut) by that instrument in London.'

Mr. Jones, dating from 7 Coventry St. Leicester Fields, and 165 near the New Church, Strand, advertises in 1752.

Likenesses of certainty taken with Royal Patent Instruments, Reflecting Mirrors at one guinea each. *Jones's new invented Mirrors*, with which any Lady or Gentleman may take the most perfect Likenesses of any person whatever, in proper colours, either in profile, three quarters or full face ; they are made on so curious a plan, that a child of ten years old cannot fail to take a perfect likeness with them. Also his new invented mathematical

[1] Martin.
[2] Published in *The Crayon*, 1855. Quoted by Miss Mary Martin, *Connoisseur*, July, 1926.

instruments, at Half a Guinea each, for reducing Profile shades to any size whatever. These instruments have been long wished for by several artists and the public at large, as they also reduce maps, prints, etc. Mr. Jones by study, labor and practice has brought them on so easy a principle that every Lady or Gentleman has the opportunity to take the Likenesses of his own little family or friends at the trifling expense of Half a Guinea. Mr. Jones not doubting but that several imitations will be made to impose on the public, he hopes they will note No. 7 Coventry St. and No. 168 Strand as no person whatever will be appointed to the sale of them on his account in London, and they are all stamped with his name.

In an English newsheet of 1785 is an advertisement for the sale of a profile machine.

Likenesses. To the ingenious World. There is now to be had a mathematic Instrument by which any Person for the expense of half a guinea may reduce Miniature Profiles of themselves or a thousand different persons in a most correct manner—all orders to be sent to Brookes's Portfolio Manufactory, 2 Coventry St. (The Golden Head, next House to the corner of Oxendon St.).

From other advertisements of the time we see that there was great demand for profile taking machines. Another runs thus : In January, 1785 :

Likenesses To the ingenious world there is now to be had a mathematical Instrument, by which any Person for the expense of half a guinea may reduce miniature profiles for themselves . . . all orders to be sent to Brookes Portfolio Manufactory, 2 Coventry St. The Golden Head next House to the Golden Head (Hogarth's House) in Leicester Square.
Specimens may be seen every day as above and from 12 to 5, No. 7 Coventry Street.
Profiles taken and shaded with all drapery at 2*s.* 6*d.* each. Ladies taught the art of painting on silk to imitate needlework, tambour, etc., in three lessons at one guinea each. Nothing required till the pupil be fully instructed. All orders from any part of the Kingdom post paid, punctually attended with proper directions how to use either instruments.

He advertises in the same strain from 331 Strand in 1788, Reading 1790, 293 Oxford St. London, 1798, 4 Wells St. London, 1800.
Edward Ward Foster, 1761–1865, remarkable as a centenarian, a clever free-hand worker, also used a machine occasionally by which copies could be made. He describes the process in an advertisement.
Huardel Bly, the Frenchman, worked on the West Pier, Brighton, for many years. He wrote : *A Practical Guide for Amateurs*, 1913, and alludes to his instruments, the *Profilograph*, the *Reflectograph* with which he can produce most accurate yet scientific likenesses. With another instrument which he calls the *Camera Lucida*, probably founded on Benoist's general Camera Lucida, he affirms he has taken 50,000 profiles. No wonder his method was popular, for he slyly points out that though a portrait must be faithful to life it may require softening ' *La vérité nue n'est pas toujours belle* ' (Plates 68, 71).
The *Prosopographus* was the name given to a sham and paltry machine dressed up in some human resemblance and advertised as the automaton who takes

a Likeness in Black for one shilling. With such foolish trickery we can leave the subject of machines, as unworthy of further description.

Of prints, lithographs and such machine-made silhouette portraits there are not a few. I give examples : King George III, by Rosenberg, a 50 Years Jubilee souvenir with Windsor Castle as a background. ' A Likeness of his most Excellent and Honourable Majesty.' This print is sometimes to be found with brilliant colour added by hand. Crimson saddle cloth, gold sword, etc. In the Royal Library at Windsor, it is preserved in all its five 'states' ; proof before letters, &c.

A print of William IV wearing the Garter Star, seated, wineglass in hand, about to drink the toast—Peace and affection to all. The round table with equipage, glasses, decanters in their Sheffield plate coasters, is typical of the period.

The print is by L. Bruce, 85 Faringdon St., London, and is one of a series of the famous men of the day (Plate 18).

There have been many contrivances used for multiplying the silhouette : from the simple home-made stencil of card or metal, to modern lino-cuts ; from paper ' blocks ' of Dr. James Lind (see Plate 62) ; from the days of the lithograph, such as is shown in our wrapper design, where the portrait is traced on stone, and transferred to paper by printing (an art invented by Senefelder of Münich in 1793), up to lithophotography and engraving and ordinary photography. With these processes there is no need to deal here, as our theme is the making permanent the original shadow, and not the copying and multiplication of Portraits.

THE SHADOW THEATRE

This type of shadow profile, sometimes worked with simple mechanism, requires special description, for these silhouettes are used as puppets of the shadow theatre.

How far must we reach back to find the beginnings of the shadow theatre? And forward too, now that pioneers in stagecraft for the day after to-morrow, are using magic lantern slides (to use the old name) to throw on backcloths, vistas of great columns, graceful cloisters and pillared corridors, so that at trifling cost the shadow masonry may lead the eye to glorious interiors before which actors play their parts upon the stage.

When Dr. Paul Kahle discovered, in the Nile valley, that great cache of figures, ships, castles, and forts, cut out of leather specially prepared in India, he laid hand on the earliest known puppets of the shadow theatre.

By the stylistic devices cut in silhouette the eleventh to the thirteenth century is indicated ; by that same token these conventionalized shadow puppets are known to be heroes of the Mamelukes (Plate 5).

In a battleship carrying bowmen, a pilot at the bows gazes upwards ; a small instrument in his hand seems to serve the purpose of a primitive quadrant.

PLATE 62

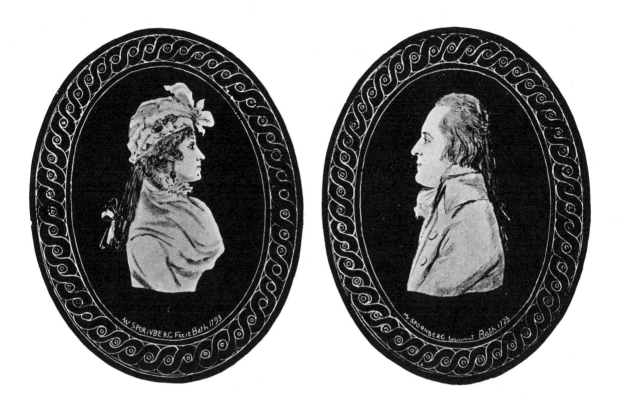

PORTRAITS OF MEMBERS OF THE ANSTEY FAMILY
PAINTED ON CONVEX GLASS, BACKED WITH SCARLET PIGMENT,
BY W. SPORNBERG, BATH, 1792
From the Collection at Knole

Hundreds of these figures must have been in use and none might have still survived except for the useful legend that it was unlucky to touch one of the cut figures unless you were a custodian of the show, this rumour having been invented probably to keep away marauders. On some of the dresses are ornaments used for similar figures in the shadow theatres of Persia, China, Siam and on the national heroes of Java where children are taught history by means of the itinerant shadow show's marionettes ; undoubtedly the shadow theatre came from the East.

The shadow puppet shows flourished before Christ and were popular in Greece and Rome where special laws regulated the performances ; the name of a manager has strangely survived.

One may see articulated figures of ivory, wood or baked clay showing holes for the strings to be manipulated by the showman.

In Greece to-day there is the shadow theatre on the northern slope of Lyca-bettas which was transplanted from Constantinople in 1860. Every summer evening, for it is an open-air theatre, Antonios Mollas shows on a 20-foot wide linen cloth, shadows of his screen figures. These are mostly made of parchment, with no detail, and are seen in silhouette, the legs are jointed at the knee ; and the arms ; three joints are used, with considerable effect, a rod held by Mollas or one of his assistants, guiding the gesticulations. There are at least fifty of these shows which are called Karangiosi, and their masters belong to their trade union ; they travel about, one having ventured as far as America, it is stated in *The Times.*

The Persian shadow theatre hero is bald, his name indicating that unheroic defect. A palace may be elaborately cut, a peasant's hut is a plain dark all-over silhouette ; if a scene is supposed to take place indoors, all the sound, talking, &c., takes place off. There was that earlier and more primitive shadow show in old Teheran of which Omar Khayyám sang in the eleventh century, looking at the moving silhouette figures in a lighted box or lantern, and thinking of life's shadow show. FitzGerald describes it in his fine Quatrain XLVI :

> 'Tis nothing but a magic shadow-show,
> Played in a box whose candle is the sun,
> Round which we phantom figures come and go.

I have seen at Palermo figures using the conventional gestures of shadow theatreland. Should a Paladin place his hand against his forehead he is thinking, if the back of his hand is against his eyes, he is weeping, and I have seen this same gesture on a Greek vase made 400 years B.C. Nearly all Sicily's puppets are Paladins, who have marvellous adventures in love and battle, generally with heathens, for the memory of Saracen invasion still survives on the stage of the shadow theatre as it does in Sicilian architecture and in the features of the people.

Even if a Nativity Play is given, or Old Testament story, Paladins and

their ladies are introduced as accessories to accompany the shepherds or go with Noah into the Ark.

A Paladin by the way was an officer connected with the palace at the court of Charlemagne. The name is now given to any hero or knight-errant.

In the reign of Louis XV in France a showman was named Seraphim who in 1771 owned a little theatre at Versailles ; the charming verse on his handbill begins thus : [1]

> Venez garcons, venez fillettes
> Voir momus à la silhouette.

So those dancing shadows amused the boys and girls before the shadows of Paris became grim in the Terror and Gonord in the Palais Royale started to cut the paper portraits of the condemned when they arrived in the tumbrils and walked up the steps of the guillotine.

Rolf von Hoerschelmann cut fantastic figures for the shadow theatre,[2] and C. Brentano published a play to be acted on this mimic stage. Its theme was largely political, its title ' The Unhappy Frenchman, or the Ascensions of German Freedom '. It is profusely illustrated with silhouette pictures.

Madame Lotte Reiniget has brought, in the present day, silhouettes on to the screen. Her exhibition at the Victoria and Albert Museum, where she revealed her work and methods, placed her at once in the forefront of present-day cutters.[3] Of her ' trick films ' as she chooses to call them, ' Papageno ' and the ' Little Chimney Sweep ' are among the best known ; the articulated limbs of her puppets, where the art paper is reinforced with metal, are very clever. Her ballet-pieces are of delicate and graceful workmanship, direct descendants from the stylistic cutting of the primitives of the shadow theatre in old Egypt.

So we reach the shadows on celluloid reels that millions now witness every day at the cinemas. The shadow theatre has always had its idols ; these were necessarily of local fame, but the printing of shadows on celluloid has widened the popularity of the nebulous hero and heroine. Now charm and beauty are ' canned ' in shadow for universal delight.

[1] Rep. M. Knapp. [2] History of Silhouettes. [3] See Moderns.

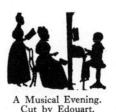

A Musical Evening.
Cut by Edouart.

PLATE 63

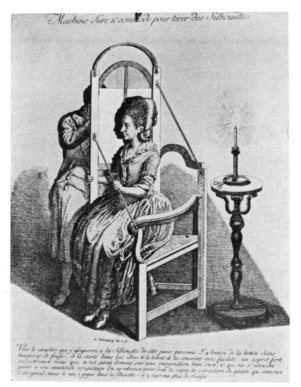

DEVICE FOR STEADYING THE POSE OF A SITTER

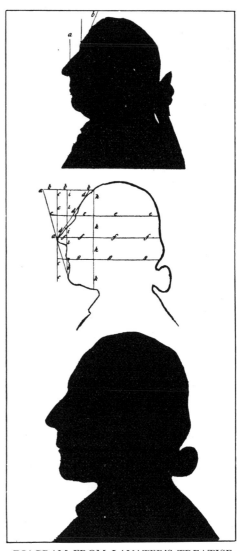

DIAGRAM FROM LAVATER'S TREATISE

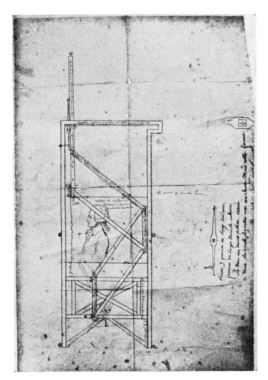

APPARATUS FOR MAKING THE PHYSIONOTRACE,
AS USED BY CHRÉTIEN

From a drawing in the Bibliothèque Nationale, Paris

PLATE 64

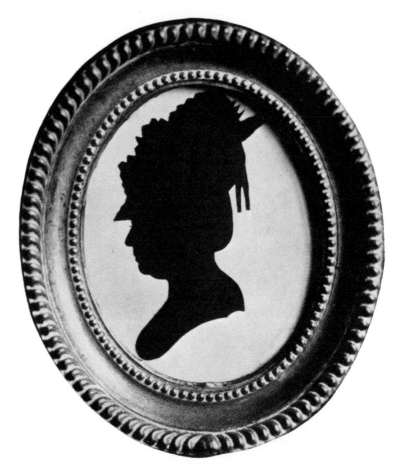

MACHINE-CUT
BY MRS. HARRINGTON, 1760
Nevill Jackson Collection

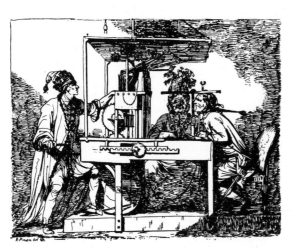

L I M O M A C H I A.

By His MAJESTY's ROYAL LETTERS PATENT,

The new-invented MACHINE for taking LIKENESSES,

By which the usual Objections to the Art, *viz.* TIME, TROUBLE, and EXPENCE, are
entirely removed,

By R A P H A E L P I N I O N,

PORTRAIT - GRINDER,

At his Manufactory, in LIECESTER SQUARE, Opposite the Æquestrian Statue of the King.

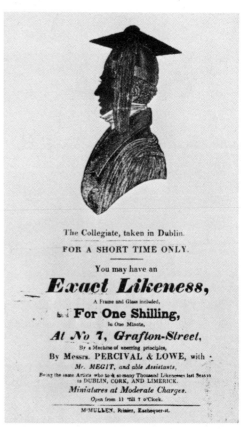

The Collegiate, taken in Dublin.

FOR A SHORT TIME ONLY.

You may have an

Exact Likeness,

A Frame and Glass included,

For One Shilling,

In One Minute,

At No 7, Grafton-Street,

By a Machine of unerring principles,

By Messrs. PERCIVAL & LOWE, with
Mr. MEGIT, and able Assistants,

Being the same Artists who took so many Thousand Likenesses last Season
in DUBLIN, CORK, AND LIMERICK.

Miniatures at Moderate Charges.

Open from 11 Till 7 o'Clock.

M°MULLEN, Printer, Exchequer-st.

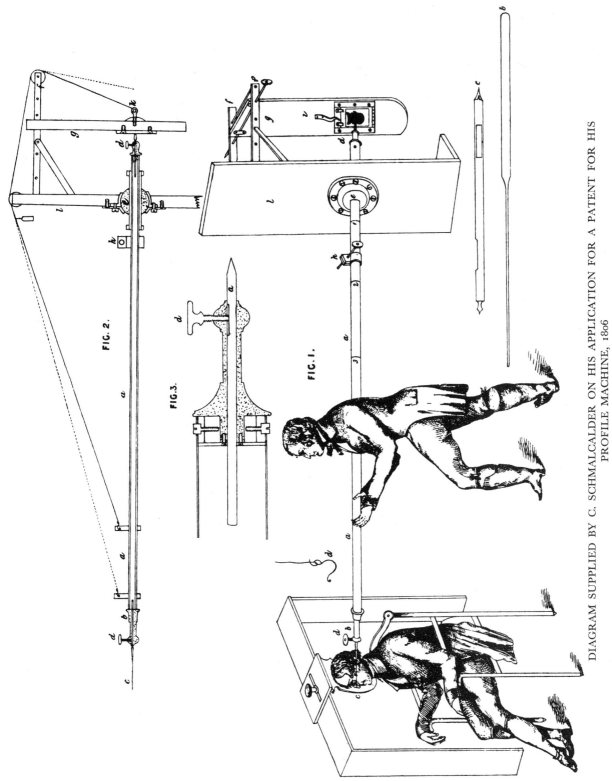

PLATE 65

DIAGRAM SUPPLIED BY C. SCHMALCALDER ON HIS APPLICATION FOR A PATENT FOR HIS
PROFILE MACHINE, 1806

His specification, now at the Patent Office, London, describes the machine as for cutting out profiles on copper, brass, hardwood, card, paper, skin, ivory and glass

FIG. 2.

FIG. 3.

FIG. 1.

PLATE 66

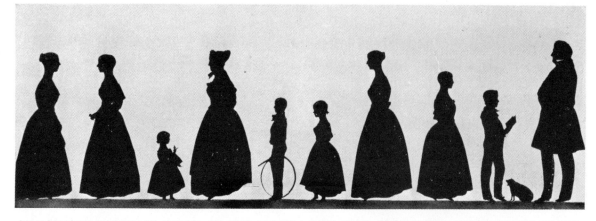

SILHOUETTE PORTRAIT GROUP OF THE ALL-IN-A-ROW TYPE DEPRECATED BY EDOUART IN HIS
TREATISE
MACHINE-MADE

UNPARALLELED
Mechanical
PHENOMENON!
NOW EXHIBITING
At No. 161, STRAND,
Opposite the NEW CHURCH.

PROSOPOGRAPHUS,
The Automaton Artist!

The Public will probably be startled, when it is stated that a lifeless Image is endowed by mechanical powers to draw likenesses of the Human Countenance, through all its endless variety, yet it is no exaggeration to say, that this beautiful little Figure not only traces an outline in less than one minute, but actually produces more perfect resemblances than any living artist can possibly execute ; and as the Automan neither touches the face, nor has the slightest communication with the persons whilst sitting, they are scarcely conscious of the operation, which renders these likenesses more natural and pleasing than any that have been produced by previous methods. The novelty of sitting to an Automaton, united with the advantage of obtaining a correct resemblance, will, it is hoped, induce every one to sit, however often their likenesses may have been attempted before. The public are not usually backward in patronizing works of art and ingenuity, and this, as a unique and original invention, deserves, it is fully trusted, a considerable share of encouragement.

Visitors, for *One Shilling* each, not only see the Figure perform, but are entitled to their own likeness, or if not inclined to sit, may receive a copy of any one of the various specimens in the room, among which are His Majesty, Mr. Canning, Sir W. Scott, &c. As most persons will probably require their likenesses to be finished in a superior manner, Artists are retained to complete the outlines taken by the Automaton, in various styles, at different charges.

Hours of Attendance from Ten till Dusk.

Printed by J. Davy, Queen-street, Seven-dials.

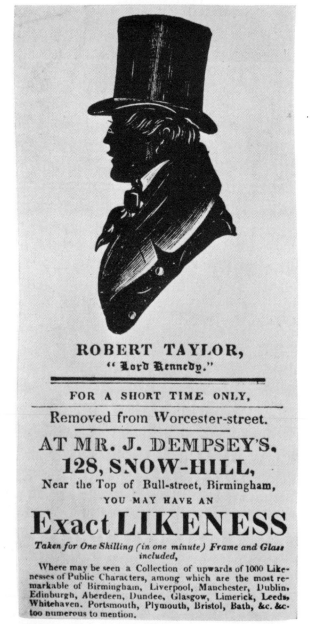

ROBERT TAYLOR,
" Lord Kennedy."

FOR A SHORT TIME ONLY,

Removed from Worcester-street.

AT MR. J. DEMPSEY'S,
128, SNOW-HILL,
Near the Top of Bull-street, Birmingham,

YOU MAY HAVE AN

Exact LIKENESS

Taken for One Shilling (in one minute) Frame and Glass included,

Where may be seen a Collection of upwards of 1000 Likenesses of Public Characters, among which are the most remarkable of Birmingham, Liverpool, Manchester, Dublin, Edinburgh, Aberdeen, Dundee, Glasgow, Limerick, Leeds, Whitehaven. Portsmouth, Plymouth, Bristol, Bath, &c. &c. too numerous to mention.

J. DEMPSEY'S ADVERTISEMENT IN A BIRMINGHAM
NEWSPAPER

PLATE 67

CORRECT

Profile Likenesses,

Taken at Mr. *from*

8 o'clock in ... e morning until 9 in the evening.

M. CHAPMAN refpectfully informs the Ladies and Gentlemen of that he takes correct Profiles, reduced to any fize, two of one perfon for 25 cents, neatly cut on a beautiful paper. He alfo paints and fhades them, if requefted, for 75 cents; fpecimens of which may be feen at his room. Of thofe perfons who are not fatisfied with their Profiles, previous to leaving his room, no pay fhall be required. He makes ufe of a machine univerfally allowed by the beft judges to be more correct than any ever before invented.

☞ Thofe who wifh to embrace this opportunity of having their Profiles taken, will pleafe to make early application, as he will pofitively leave town on

N. B. *Frames* of different kinds, for the Profiles, may be had at the above place, from 50 cents to 2 dollars each.

ADVERTISEMENT SLIP OF MOSES CHAPMAN, WHO CUT PORTRAITS BY MACHINE;
ITINERATED IN MASS., U.S.A.

His machine is now in the possession of Rev. Glenn Tilley Morse, to whom I am indebted for the above example

PLATE 68

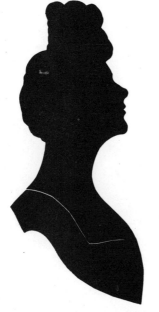

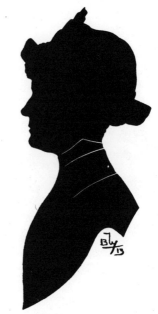

MISS CAMILLE CLIFFORD

SIGNED AND DATED PORTRAIT OF E.N.J., 1913

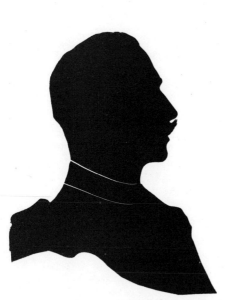

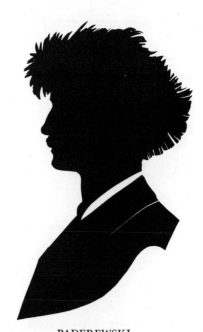

KAISER WILHELM II

PADEREWSKI

SHADES TAKEN WITH THE CAMERA LUCIDA BY HUARDEL BLY, WEST PIER, BRIGHTON

PLATE 69

let the person whose profile you want, stand before it, nearer or farther, according to the intended size of the profile, and against the light of a window. The books with the two pieces must not stand in one straight line with the person, but the one with the direction for the eye, must be a little on one side, and the plane of the other must be a little inclined towards the former. Things being thus disposed the operator, (and I think my friend Lacy can make a very good operator) looking with one eye through the hole at A, upon the glass B, will see the reflection of C projected upon the paper D, and by extending the hand with a pencil, may draw it very accurately. As for fixing C steadily &c. I leave it to your experience —

TIBERIUS CAVALLO'S PRIMITIVE CONTRIVANCE FOR THE TAKING OF SHADOW PORTRAITS
AS SHOWN IN A LETTER FROM HIM TO DR. JAMES LIND, 1807, NOW IN THE BRITISH MUSEUM
By courtesy of Mr. Gordon Roe

PLATE 70

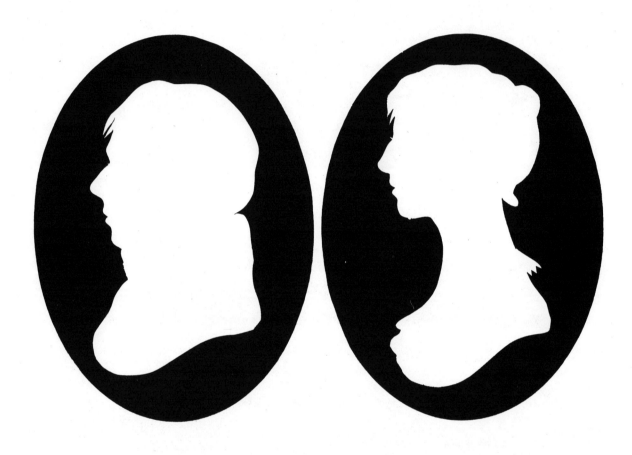

PORTRAITS OF TWO MEMBERS OF THE BOOTH FAMILY OF BOSTON, MASS.
MACHINE-CUT, SHOWING THE LOCK OF HAIR ON THE FOREHEAD, CHARACTERISTIC OF THIS METHOD
Nevill Jackson Collection

PLATE 71

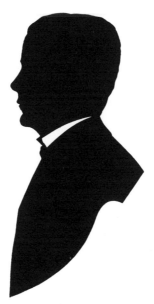

PORTRAIT OF A MAN

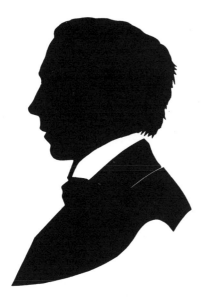

SIR HARRY LAUDER

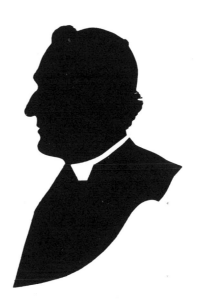

CARDINAL VAUGHAN

THESE PORTRAITS WERE CUT WITH THE REFLECTOGRAPH BY HUARDEL BLY, WEST PIER, BRIGHTON

CHAPTER VI

FAKES AND FORGERIES

THERE are craftsmen who, having considerable talents and much in-
genuity, use these gifts in order to pretend they are doing the work
of somebody else : a vain and foolish thing to do, resulting in such obvious
fakes that one looks at the pitiful things, and wonders why ?

If a man has sufficient skill to paint or cut silhouettes let us welcome him
and encourage him to do better, rather than keep him in the ranks of fraudulent
workers by buying the copyist trash, with or without forged signature.

Besides those who deliberately work to defraud the public there are some who
live on the border-line, copying on glass engravings of ships, shoes or sealing
wax, cabbages and kings, framing them in old bird's-eye maple and placing
them on the market to achieve their own assurance of age in the minds of the
purchaser; leaving it to the shopman to assert or deny antiquity. I have also
found clumsy fakes mounted on white paper, the whole varnished over to give a
brownish-grey effect.

On the other hand, some copyists are completely honest. Why should not
other members of a family have a replica of great-grandfather's silhouette ? By
all means, but write the word copy on the back with the other data ; it may save
a mistake at a future date.

There are clumsy fakers who work on modern paper ; those who are cleverer
obtain old paper torn out of odd volumes or what not. Their work is generally
placed in a messy old frame and the back pasted over with a page from an old
book. Unfortunately, such is the ignorance and gullibility of the public that
their fraud succeeds, when exposed for sale at such places as the Caledonian
Market, the Paris Quais, and shady shops.

The phase has passed when little jewels were made, poor scratched daubs
on the glass of really old rings and genuine frill brooches. Many years ago I
enquired for a specimen of silhouette jewellery at a shop in Bath, and instead of
being met by the usual tantalizing news that last month they had one, or last year
one had been seen at a sale, I received the astonishing reply that they had ' plenty '.
They thought perhaps that I was a fraudulent trader. I was shown into a little
room where two men were painting at the backs of the tiny old glass ' boxes '
the most obviously incorrect specimens.

69

I used now and then to come across the result of this activity, but it has evidently ceased.

Amongst the most usual subjects for faking are the small cut pictures of Müller and Frölich, who, with extraordinarily delicate precision, cut minute representations of country groups and often used the plaster-cast seller and Sideau's King of Prussia, so that it became an acknowledged formula of the day. There is astonishing skill in the cutting of the figures of well-known men such as Frederick the Great and Napoleon. Though incredibly tiny, these are so meticulous as to detail that the features are recognizable.

The fakers, however, paint on flat glass; this method neither Müller nor Frölich ever used. Silhouette collectors should eschew glass painted 'plaster-cast sellers', especially where an old peasant has a cage full of birds on his back. Such groups, to be genuine, must be of cut black or white paper.

I know now an industrious and painstaking workman who fakes the cut hollow variety of silhouettes. His skill, if turned to better purpose, should earn him a good livelihood, but he continues to cut hollow, backing with modern cotton velveteen (a material never used with an 'old specimen') and choosing old frames or faking these as well.

All through these nefarious processes one feels 'how clever, but just not clever enough!' So that only fools are taken in and careful collectors need have no fear, if they remember a few obvious precautions, and examine carefully. The forgers give themselves away at so many points, and merely enhance the value of our original examples by their foolishness.

The wisest precaution is to purchase only from reliable dealers and experts who will know that the shape of the lower bust-line of a head and shoulders of the nineteenth century cannot have the unmistakable curves of the eighteenth century, and a dozen other perfectly simple tests.

I know a present-day cutter who was approached by a firm of fake frame-makers. Would he cut 'antiques' for these frames? I am glad to say the cutter had the honesty to say 'NO Birmingham', and so avoided damning his eternal soul for a shadow. He continues to cut quite good modern portraits for his many sitters.

Printed specimens from books or magazines are often put into old frames and sent to me as originals. I shall probably have a large consignment when this book is published and my waste-paper basket will become very full. The fact that my discernment is rated so low, annoys me more than anything.

Labels are being faked, those of Miers especially, but don't depend on labels, familiarize yourself with the technique of an artist; they all vary so delightfully. It means study, but what does not, if it is worth while?

Above all compare with any authenticated example in a public or private collection. On the walls of one of our great art centres are the words ' To compare

is to know ', never was a truer aphorism in confounding the knavish tricks of the silhouette fake and forger.

Bronzed figures may be offered—as the work of Edouart. This most brilliant of all portrait cutters *never* put a gold line on a portrait. In Paris imitations of Buncombe's coloured military portraits are painted on ivory, which Buncombe never used.

Worn engraved plates are painted with black faces—easily detected with careful examination ; genuine old brooches or lockets as above. In an American paper there appeared a light-hearted advertisement ' Old silhouettes copied with signature '—whatever that may mean !

Provenance may also be faked, modern imitations slipped into an old family or farm-house sale.

My dragoman at Luxor in 1931 stumbled almost convincingly at the foot of one of the great pillars at the Temple of Karnak, and declared himself surprised to find he had kicked up a little clay figure of the god Bes.

Would I buy this treasure so surprising ? I felt that it would be still more surprising if the little god Bes had come straight from a Birmingham factory to be taken home by me as a find.

Bes is the god of laughter ; it was the dragoman's turn to be surprised.

Inscriptions on silhouettes require very careful scrutiny. The handwriting may have been carefully done in the old pointed way by the hopeful forger ; but look at the ink, perhaps it is a faint black, but not the right sort of faintness or blackness. Watered blue-black ink is quite unlike the brownish yellowish black of faded old ink.

It is curious how unsatisfactory genuine inscriptions often are ; when we long to have ' Sir Robert James Smith, Bart. : 1798 ', we shall probably find ' dear Uncle Bob ' which leads us nowhere, and without date.

I have even been stymied with ' identification notes for the housemaid '. Top, right-side chimney-piece morning-room, alas left me guessing as to the identity of a lovely Mrs. Beetham lady—though in this case she had her trade label and date. Occasionally a collector's private mark such as Captain Desmond Coke's Cupid (from a cut by Princess Elizabeth, George III's daughter), or his later connoisseur's figure by Lovat Fraser, may be reproduced to put on to a doubtful specimen, thus stealing connection with a genuine collector. I have even been asked if I have ' one of the Coke labels to spare ' ! Probably such reproductions will appear on the publication of this book where there is the original illustrated.

According to the Oxford Dictionary a fake is one of the windings of a cable or hawser, as it lies in a coil—very suggestive !

An amusing addition to a genuine family group was recently found at the Caledonian Market, that playground spread for the gullible. The picture of the Burney family had been copied from my History, but the graceful framed

mirror in the centre was too tempting for the clumsy faker, and he had put into it a badly drawn head of the wrong period. So do rascals live and flourish on ignorance, where there is more money than knowledge—and the deluded purchaser prided himself on a ' find ', and showed it to me with zest.

The study of fashions, of the dating of costume and hair arrangement, is all-important for the collector ; the shape of bag wigs, tie wigs and the rest, changed more rapidly than we are apt to think, while birth dates, and approximate age of the alleged subject, help to verify the truth of an attribution. Small changes in cravats, shirt-frills, high stock collars, the shape of coat lapels for men ; the high dressed heads, caps, lappets, fichus of women ; and lastly the side ringlets of early Victorian days, give clues in proving a date or disproving the possibility of an invented name.

It is safe to mistrust high-sounding names with the exception of King George III and Queen Charlotte, the Duke of Clarence, Sussex and such royalties of that time, when silhouette work was the delight of amateurs and the sport of kings. There is always a possibility of finding an example of this fruitful period ; but when dealers offer Nelson, Shakespeare, and Charles I or II, beware. If they are obviously like the great men, they are modern fakes ; if they are unlike, you may know that attribution according to wish, rather than fact, is quite a hobby with some collectors and dealers as well.

It is only really hard work, which helps one to guard against false attribution. We must accustom ourselves to the shape of the heads and features of the great. Unfortunately it is only the Duke of Wellington and Pitt who were formed by nature for easy guessing.

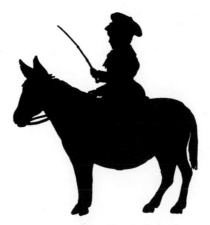

Master Foley, Kinsale, Ireland.
Cut portrait by Edouart, 1834.

PLATE 72

SOME MODERNS

WOODCUT BY ERIC GILL, 1916

By kind permission

PLATE 73

31 August 1937.

From The Librarian, Windsor Castle, Berkshire.

Dear Mrs.Jackson,

 In reply to your letter of August 23 I am happy
to be able to convey the permission of Their Majesties
for the inclusion in your forthcoming book of a repro-
-duction of the lino-cut by Princess Elizabeth

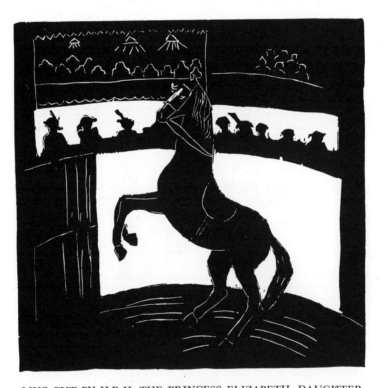

LINO-CUT BY H.R.H. THE PRINCESS ELIZABETH, DAUGHTER
OF H.M. KING GEORGE VI

PLATE 74

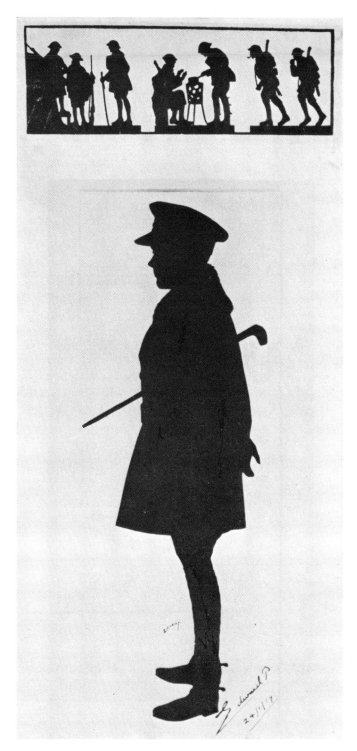

'I REMEMBER', SAID GENERAL McARTHUR, 'A CHIT BEING HANDED TO ME IN MY DUGOUT IN FRANCE BY A YOUNG GUARDS OFFICER. HIS FACE SEEMED FAMILIAR. "ARN'T YOU THE PRINCE OF WALES?" I ASKED. "I AM," WAS HIS REPLY, "BUT I'M ONLY A SUBALTERN ON DUTY JUST NOW"'

PORTRAIT CUT BY MAJOR H. L. OAKLEY, M.B.E., 1917

PLATE 75

'DRAWN BY LOVAT FRASER FOR ME AS A GIFT 1913'
WRITTEN BY CAPTAIN DESMOND COKE AT THE BACK OF ABOVE, AND USED BY
HIM AS A COLLECTOR'S LABEL, AFTER THE CUPID OF PRINCESS ELIZABETH (*D.* OF
GEORGE III), FOUND ON HIS EARLY ACQUISITIONS, HAD BEEN ABANDONED

PLATE 76

ORIGINAL SCISSOR-CUTTING BY
HUBERT LESLIE, 1922

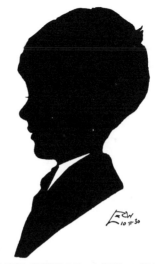

ROBIN HOWARD, AGED 6 YEARS
CUT BY LEON, 1930

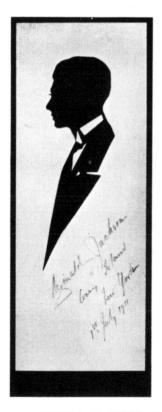

REGINALD NEVILL JACKSON, D.S.O.
CHEVALIER LEGION OF HONOUR,
CROIX DE GUERRE
CUT BY PERRY

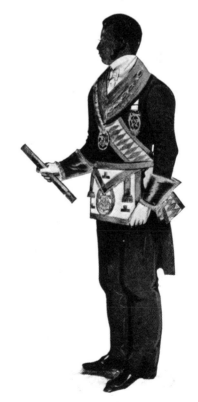

MR. J. P. DIXON
PAINTED ON CARD, ONE OF THE TWO KNOWN
EXAMPLES OF PORTRAITS IN MASONIC DRESS
Wellesley Collection

PLATE 77

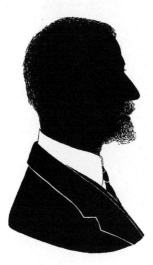

GRANDFATHER
PAINTED BY JAMES MILNER

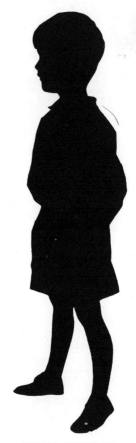

PETER HOWARD
CUT BY LESLIE OF BRIGHTON, 1926

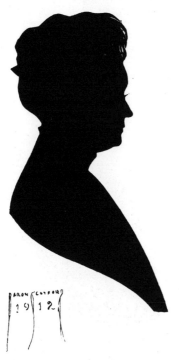

PORTRAIT OF THE AUTHOR
CUT BY BARON SCOTFORD, 1912

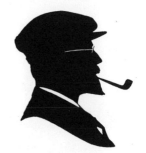

CUT AND SLASH WORK

PLATE 78

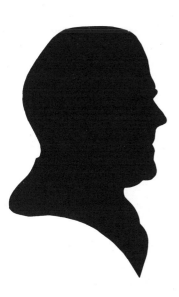

Pres: H Hoover -

PRESIDENT H. HOOVER
The original cut hollow is in the possession of Mrs.
Hesketh Hoover

Theodore Roosevelt,
President of the United States

CUT BY REV. GLENN TILLEY MORSE

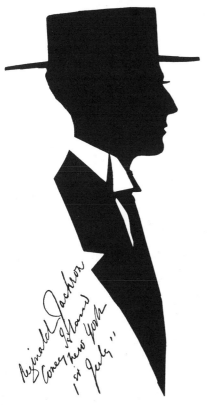

CUT BY PERRY

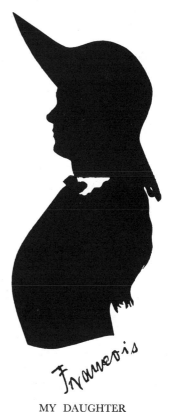

François

MY DAUGHTER
CUT BY FRANÇOIS, 1911

PLATE 79

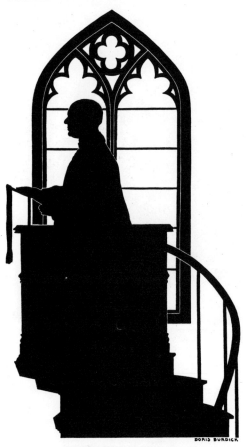

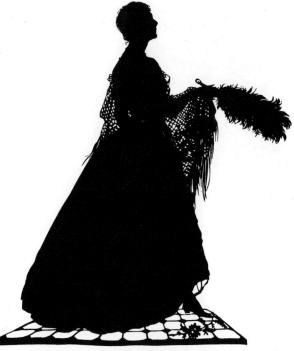

THE REV. GLENN TILLEY MORSE, ALL
SAINTS, NEWBURY, MASS.
CUT BY MISS DOROTHY BURDICK

PORTRAIT OF MRS. FANEHAM GREEN
CUT AND DRAWN BY BARONESS MEYDELL AT
BOSTON
By special permission

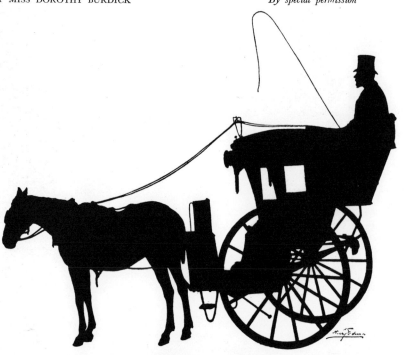

HANSOM CAB, LONDON
CUT BY HARRY EDWIN
From his Brochure in the Library of the National Portrait Gallery, London

PLATE 80

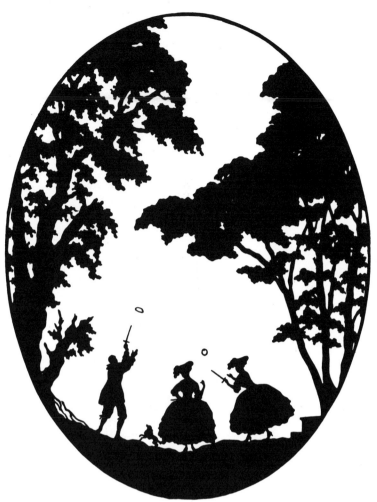

THE GAME OF LES GRACIS
CUT BY GUDRUN JASTRAU, EXHIBITED IN LONDON IN 1920
By special permission

SELF-PORTRAIT
BY AUBREY BEARDSLEY

BASIL S. LONG, 1881–1937, BY DAER,
MONTPELIER, 1927
OWNED BY MR. GORDON ROE

JOHN NEVILL
CUT BY LEON, 1926

PLATE 81

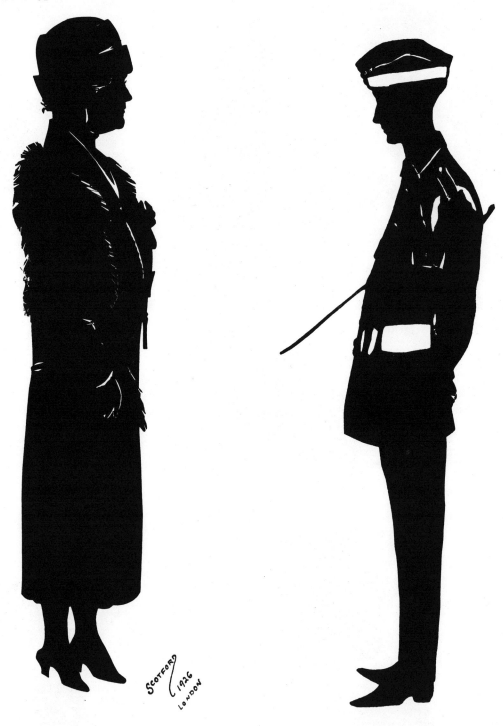

EXAMPLES OF SLASH CUTTING BY
BARON SCOTFORD, 1926

CADET BERNARD N. JACKSON, 177930,
AIR FORCE TRAINING CAMP, JULY 1917
SLASH CUTTING DETAIL BY MAIDIE ROBERTS,
FROM SAN FRANCISCO

A DICTIONARY OF ARTISTS IN SILHOUETTE
WITH NOTICE OF THEIR LIVES AND WORK
TOGETHER WITH THEIR POINTS OF CONTACT
WITH PUBLISHERS, ENGRAVERS AND COLLECTORS

BY E. NEVILL JACKSON, F.R.Hist.S., F.R.G.S.

A

ACKERMAN, Rudolph. 1764–1834. Art publisher and bookseller. He was educated at Schnieberg and apprenticed as coach-builder; settled in London as coach designer and opened a print shop in the Strand. He patented a method of making articles waterproof and in 1801 was interested in lithography. In 1817 he worked extensively for the relief of sufferers in the War 1814. He published a sheet of printed silhouettes, chiefly groups of children at play.

In 1830 his address was Beaufort Buildings; soon after he moved to 101 Strand. Some of his early advertisements are in the Bankes Collection.[1]

ACKERMAN, Wilhelm. 1786. Viennese painter and silhouette cutter by machine. In his youth while working at his profession, as barber, he attended Gonord each day when the French Silhouettist was in Vienna; he stole the secret of Gonord's process and set up for himself. Gonord discovered his deception and caused him to advertise as follows:

'Wilhelm Ackerman, painter of shadow portraits, native of the Netherlands, encouraged by the approval and patronage of the nobility and gentry, desires to admit having learnt the art and deliberately imitated the methods of the illustrious designer and artist M. Gonord, during the time he had the honour of attending him at his house; therefore with grateful heart to M. Gonord, he wishes to make known that he works with different instruments and at much lower prices.'[2]

ADAM, J. 1748–1811, of Vienna. He engraved mounts for shadow portraits and with J. E. Mansfeld produced a series of portraits of distinguished personages in Austria. 'To be found in Vienna at Artharias' is sometimes added to his signature on examples of his work.[3]

ADAMS, Dorothy. Cutter, 1734. A fine example in cut vellum is to be seen at Victoria and Albert Museum; it shows incredibly fine cutting in conventional floral forms, in a two-handled vase $4\frac{1}{2}'' \times 4\frac{1}{2}''$ mounted on green satin. At the back is written: 'Cut in vellum with scissors by Miss Dorothy Adams, now Mrs. Comberback of Chester, when we lived there in the year 1734, to Liz Grant who lives at Taunton 1785.'

(Molesworth's property, brought from England 1742.)

This example silences those critics who declare that such fine work can only be done with a sharp pointed knife.

ADOLPHE. 1840. Frenchman. 113 St. James St., Brighton. He frequently painted in a greenish tint, not otherwise relieved with colour, sometimes he used convex glass, much rounded, and protected his brush work with wax; on a signed portrait of Lady John Townshend 1840 in the London National Portrait Gallery, London, 'The Origin of Profiles, sketched by Mons. Adolphe, Portrait, Animal, Miniature and Profile Painter, 113 St. James St. Brighton.' Then follow many verses beginning:

> 'Twas love, 'twas all inspiring love, 'tis said,
> Directed first a female hand to trace, &c.

They can be studied in full in the Library of the National Portrait Gallery, London.[1]

An address at Brighton is 4 East Street.[2] He is described as Mons. Adolph under the heading 'Drawing and Miniature Painting'. An example of his work in the Museum at Hove and one in my own cabinet show his signature 'Adolph' written in the shadow beneath the waist-line. This I have found is his most usual signature. Dixon also signed in shadow thus at Bath and also Wellings and Frith. Adolph describes his method as 'manographing'; the 4 East Street label is printed on grey paper, a fine group of a family nine in number has been reproduced.[3] (Plate 82.)

AGALHANGELUS, F. Bouneuses Capuchin; the signature of a Capuchin monk, on fine cutting of a bishop's arms with inscription Joanni[4] Ernesto S.R.I. Princepe Metropoletannæ Eccl. Salisbury. Shown at the Brunn Exhibition by Dr. M. Strauss in Vienna. The subject of the cutting was The Baptism of Christ in the Jordan.

AGASSE, Jacques Laurent. 1767–1849. Cutter of animal forms and country scenes.[5]

ALDERSON, Amelia. 1769–1853. Novelist, poet and amateur cutter, married John Opie, 1761–1807, portrait and historical painter. She moved in the court literary and artistic society of the end of the eighteenth century and, being an enthusiastic silhouettist, cut many portraits in England and France. She was intimate with Dr. Johnson, Sydney Smith, Sheridan, Mme. de Staël, and was a friend of Mrs. Beetham, the fine Profilist of 27 Fleet Street.

Mrs. Opie, *née* Alderson, wrote a Memoir of her husband. In 1809 she became a Quaker under the influence of the Gurney family. A portrait by her of her friend Mrs. Beetham is executed in the method 'cut hollow'; this is now in the possession of Dr. Beetham, great-grandson of the Fleet Street Silhouettist.[6]

ALDOUS. On a silhouette portrait of 'His Late

[1] Brit. Mus. [2] *Vienna Zeitung*, 13 May 1786.
[3] J. Leisching.

[1] No. 68, p. 36.
[2] *Brighton Directory*, 1845–6, Leppard & Co.
[3] *The Art of the Silhouette*, Plate xxiv.
[4] Rep. Deutsche Schatten und Scherenbilder, Dr. Martin Knapp.
[5] Rep. M. Knapp, pp. 6–7.
[6] *Dic. Nat. Bio.*

Royal Highness, Frederick, Duke of York' (brother of George IV) is written. 'Drawn on Stone by Mr. Aldous, 15 Great Russell Street.'

In 1824 it is recorded in the Catalogue of the Royal Academy that Aldous painted the portrait of a nephew of the late General Riego.

ALLPORT. Practising in 1830. He cut portraits in olive green paper, painting in grey and bronzing.

AMELIA. 1830. Cutter of birds, fishes and flowers in white and coloured paper. (Plate 48.)

Each detail of feather or petal is cut separately, sometimes as fine as a hair, and gummed in place so that the picture is gradually built up. Sometimes needle-pricks of varying size are used to achieve the desired effect in rounding a bird or the body of a butterfly. Amelia was said to be 'an invalid and used her scissor work as a pastime, she had several imitators but this type of work is always quaintly called Amelia'. For similar work on more naturalistic lines, see Mrs. Delany.

AMES, Mrs. 6 Ball Street, Birmingham. An advertisement [1] announces that Mrs. Ames takes Profile Likenesses of any size from 2s. to 5s. each. Likenesses painted on glass. Her trade label runs thus : 'Profile Likenesses in miniature taken in the most elegant taste at 2s. each by Mrs. Ames, patented.' Another address is 'At Mrs. Sands opposite the Pump Room, Bath'.[2]

AMES, Mrs. Painter on glass, 1785. An advertisement in *Aris's Birmingham Gazette*, 19 September 1785, announces that Mrs. Ames takes profile likenesses of any size approved 2s. to 5s. each. Likenesses painted on glass. Her trade label measures about 3½ inches × 4½ inches.[3] 'Profile Likenesses in miniature, taken in the most elegant taste at 2s. each. | Mrs. Ames. |' In ink at the top of the only known example [4] are the words : 'At Mrs. Innes, opposite the Pump Room,' probably identical with above.

ANDERSEN, Hans. 1805–75. Author, Danish, writer of fairy tales, &c., skilled cutter from childhood, generally used white paper.[5] A grim example shows a gallows growing out of a heart, a man and a woman are suspended with broken necks.[6] A mystical phase is depicted by angels beneath a palm-tree. Humour is shown in an intricate example with grinning heads, cupid dancing, birds, winged fairies, &c.[7] These specimens are cut in the folded method, so that the two sides are alike ; another which contains the name Marie is of the open flat variety. (Plate 49.)

[1] In *Aris's Birmingham Gazette*, 19 Sept. 1785, F. & G. B. Buckley.
[2] Banks Collection, Brit. Mus. [3] Buckley.
[4] In the Banks Collection, Brit. Mus.
[5] *Hans Andersen the Man*, by Edith Reumert.
[6] See *Illustrated London News*, 31 Dec. 1927.
[7] *Kunst und Künstler*, 1904.

His silhouettes are shown in his museum house at Odense in Denmark [1] (*see* Chap. III).

ANDRÉ, John. 1751–80. Major. Born and educated at Geneva ; came to England ; was befriended by Miss Seward at Lichfield ; entered the army, served in America and was captured at St. John's 1775. On release was aide-de-camp successively to General Grey and Sir Henry Clinton ; adjutant-general ; entrusted with secret negotiations with Benedict Arnold, who was plotting the betrayal of West Point to the British. André was captured by Americans and hanged as a spy. A monument was erected to his memory in Westminster Abbey. As a talented amateur Major André will be remembered by the fine series of cut portraits in black paper which, with notes and accounts of the Pennington family, were inherited by them, from the daughter of Washington's friend Dr. Redmond. (Plates 54, 82.) As will be seen by the examples in this volume the portraits are by no means the slight efforts of an amateur, but show great artistic discernment. In George Washington we see the fine brow and firm mouth and chin, while the stiff angle of the ribbon-tied wig gives force to the portrait. André's cutting of Phineas Bond is the only known portrait of this personal friend of the first president. The artist cutter has seized on the bold line of the hat as a note of value.

In his Benjamin Franklin the slightly waved natural hair must have given a vivid touch of personality to the philosopher's picture, in those days of wigs, worn by old and young. The upstanding shirt-frill is a valuable asset in line.

Burgoyne's profile is almost that of a lovely woman, and, if it were not for detail in dress, one might imagine this victor at Germantown and loser at Saratoga to be a belle of old Philadelphia.

His portrait of Gates is curiously like the portraits by Stuart and Hudson, the latter done in England, when Gates was on two years' leave ; the long nose, with an extra point at the end, is unmistakable.

The self portrait was engraved by J. K. Sherwin. He was 27 years old when André cut it and also that of his friend Captain Lord Cathcart. Both these young men were White Knights at the famous Festival called Mischianza, which was a medley of modern parade and medieval tournament, in May 1778, which is the year noted by André on three of his silhouettes. Two years later came patriotic devotion misapplied, and the death penalty. When he saw the gibbet on that morning of 2 October, André was startled, for he had petitioned Washington that he might die a soldier's death ; no reply was received. 'I dread not death but the manner of it', said this young and gifted victim in his last hour.

[1] E. V. Lucas, 22 Nov. 1936. *Sunday Times. Dic. Nat. Bio.*

ANDREWS, Mrs. M. Died 1831. Amateur silhouette cutter. She has illustrated her reminiscences of Washington, U.S.A., with cut portraits of the friends she describes in *My Studio Window*.

ANDREWS, S., of Calcutta worked in imitation of a cameo in an example in the Desmond Coke Collection, sold at Sotheby's, July 1931, originally in the Croft Lyons Collection. Another example is of two heads, and has a ticket 'Andrews' on the back. He worked in India, being in Calcutta in the nineteenth century. One example owned by Commander Melvile A. Jameson is signed 'S. Andrews, Calcutta, July 1803', and at the British Museum there is an engraved portrait, after S. Andrews, of the Marquess Wellesley, Governor-General of India, published in 1804.[1]

ANTHING, Johann Friedrich. Registered in 1753 at Gotha, died 1823 at St. Petersburg. He was the eldest son of J. P. Anthing, a military chaplain, who died in 1772, leaving his wife and sons in great poverty. After attending a school in his native town, J. F. Anthing went to Jena to take up his father's profession. He matriculated, and his name is mentioned in biographies of the day. He gave up theology, but it is not known where he received his artistic training, nor how he earned a living from 1772 to 1782, and it is chiefly through the information given in his remarkable diaries or pictorial albums that various episodes in his career can be traced. (Plates 41, 53, 82.)

The first entry in his album is by the sculptor Doll, a friend of his youth at Bodenverder, on the Weser. He silhouetted some Brunswick noblemen and officers of a cavalry regiment. The same year he was in Berlin, where several important people made entries in his diary beneath their portraits.

He went by sea to Russia. His collection contains 158 portraits, mostly of illustrious persons; 44 of these are in the collection of *One Hundred Silhouettes*, reprinted in 1913, published in one volume; of these, 10, according to Anthing's own words, were taken from painted portraits without seeing his subject. Amongst such are Henry IV of France, Pope Clement XVI, Frederick II of Prussia, Peter I of Russia, George Washington. The originals are now privately owned in Munich and Leningrad.

His second collection consists of two albums where there are 214 autographs by men of science, artists and members of important families ; with these are 144 silhouettes all in Indian ink. These volumes are mentioned in the catalogue of an Amsterdam dealer, and were acquired in 1897 by Count S. D. Scherennetzev and until recently were in his library near Moscow.

It is evident that, like Miers, Rosenberg, Hamlet,

[1] *British Miniaturists*, 1935, Basil Long.

and others of our English silhouettists of the same period, Anthing executed miniature portraits for rings, brooches and snuff- and patch-boxes.

In September 1784 there is a note in the Minutes of the Sessions of the Imperial Academy of Science in St. Petersburg, that thanks must be given to M. Anthing for the picture of 12 silhouette portraits of members of the Academy.

This picture of 12 heads in one frame was published in 1903 by the Archivist of the Academy as an appendix to the Index of Members 1725-1907. From St. Petersburg, Anthing travelled through Russia exercising his profession as he went on his way to Moscow.

In 1786 he was in Nijni Novgorod.

May and June 1786, Kasan.

August, Astrakhan.

November, back again in St. Petersburg.

After a short stay, he worked his way home to Germany via Riga and Warsaw.

In March 1789 Anthing came to London for two months, and while here silhouetted the Prince of Wales, Frederick, Duke of York, Georgina, Duchess of Devonshire, and many others.

Anthing attended the Election and coronation of Leopold II, and his first literary effort is an account of this event, published anonymously 1790.

He appears in the Court Directory as a Councillor of the Duke Karl August (of Saxe-Weimer) ; the following year he announced the forthcoming publication of an account of his journeys, this is illustrated with engraved portraits. Leaving Moscow he visited Constantinople, then we find by his dated album work that he went to Warsaw 20 November 1795. He met Field-Marshal Suwarow, and wrote his biography, dedicating it to the Czarina Catherine.

For this he was given an appointment in the Russian Army, as cadet, and soon advanced to major in a cavalry dragoon regiment.

Anthing fell into disgrace, on the ascension to the throne of the Czar Paul, and was degraded in 1797, and retired to a small estate in Grodno, which had been given to him by the Czarina Catherine. Later it is known that both he and his patron the Field-Marshal Suwarow were dismissed from the service ; the rest of Anthing's story consists of vain application for restitution of rank, and complaints of the loss of his estate, his slaves, and other property. He gave all he could to Suwarow and died in 1805, poor and friendless. His death is registered at the Lutheran Church, Leningrad. Anthing did very fine work, and his travels and authenticated portraits make all his achievement of supreme interest. Herr von Schüddekopf, to whom I am indebted for many particulars, says in his sketch of Anthing's life that only three examples of full-length figures by Anthing are known ; one appeared in my *History of Silhouettes*, 1911 ; the second is in *Goethezeit in Sil-*

houetten, by H. T. Kroeber. It was Madame Nossof of Moscow who sent me this photograph, besides many others of her priceless early Russian collection, but unfortunately I have lost touch with her, should she read these words I assure her of my indebtedness.[1]

The third example, a Conversation piece by Anthing which was exhibited at the Russian exhibition held in London in June 1935. It represents the Emperor Paul I (Plate 41) and the Empress and their two sons aged about 10 and 12. [2] This example numbered 813 in the catalogue, measures 24″ × 16″ and is described as by ' Frederic Anthing Suverovs A.D.C. 1758, 1805 ', lent by Madame Alexandra Rosenbergh, Paris. [3]

ARNIM, BETTINA VON. 1785–1859. Wife of the German poet, friend of the Goethe family. She cut in black and coloured papers and mounted her designs on colour. [4]

ARTISTS. This name with the address 431 Oxford Street is on a portrait painted on card, of Mrs. Fonnah—done September 1833. The work is good, ribbons painted buff, on an example bequeathed to Victoria and Albert Museum.

Another address is ' The Artists ', Saloon 84, Farrington Street, on a specimen owned by Mr. Kelner.

ASMUS, HILDEGARD. Cut genre subjects in black paper.

ATKINSON. Painter. Label on an example of a man looking right.

ATKINSON, F. Cut portraits and bronzed profusely, occasionally an all-black portrait is to be found. He lived at Windsor and styled himself ' Silhouettist to the Royal family '. His figures are usually full length. A large group of George III, his seven sons, and two sons-in-law standing in a pillared room with ornamental glass skylight, hung for many years at Carlton House and has been reproduced. It was exhibited at the Royal Amateur Art Society's Exhibition in 1911 and is reproduced in *One Hundred Silhouettes*, belonging to Mr. Wellesley.

Atkinson's work is rather wooden, but his proportions are good. In his portrait of Queen Victoria with Lord Melborne one realizes the small stature of the Queen.

ATKINSON, G. Cutter. Son of F. Atkinson above. Like his father, he styled himself ' Profilist to His Majesty and the Royal family '. One of his portraits of George III was engraved by Scriven ; beneath are the words, ' From a drawing by George Atkinson, Profilist to His Majesty and the Royal family, published 20th April 1825.'

[1] *Johann Friedrich Anthing*, by Carl von Schüddekopf, 1913.
[2] Rep. in *History of Silhouettes*, by E. Nevill Jackson, 1911.
[3] His Series *One Hundred Silhouettes* was reprinted at Weimar, 1913.
[4] Rep. M. Knapp, p. 56.

AUDUBON, JOHN JAMES. 1785–1851. Ornithologist, portraitist and profile painter, born in West Indies, travelled in France, North America and Canada, where examples of his work are occasionally to be found. Mrs. van Leer Carrick mentions life-size heads done in coloured crayons by Audubon.

AUTOMATON. A machine dressed as an artist which was supposed to draw likenesses in profile, possibly the pencil was guided by a man concealed. This trickery, which seems to have amused the public, marks the debased taste in this once lovely art of silhouette. The description of an eye-witness of the machine is interesting, as there cannot be anyone alive now who saw this abortion of a hundred years ago.[1]

I remember very well the automaton that professed to draw silhouettes. Somewhere about 1826 the Automaton was brought to Newcastle ; it was a figure seated in flowing robes, with a style in the right hand, which by machinery scratched an outline of a profile on a card, which the exhibitor professed to fill up in black. The person whose likeness was to be taken sat at one side of the figure near a wall. One of our party detected an opening in the wall through which a man's eye was visible. This man, no doubt, drew the profile, and not the automaton. Ladies' heads were relieved by pencillings of gold. Another performer, I remember, went to work in a more scientific manner ; a long rod worked in a movable fulcrum, with a pencil at one end and a small iron rod at the other, was his apparatus. He passed the rod over the face and head, and the pencil at the other end reproduced the outline on a card, afterwards filled in with lamp-black.

AYRER, GEORGE FREDERICK. 1764. Worked at Lausanne.[2] Of him was written by Madame Weston (*née* Bry) 1778 : ' Tous les talents marchent qu'on les prise. Le votre est joli interessant, en le perfectionnant vous rendez, inutile qu'on bas de vos portraits ou écrive son nom.' Ayrer is said to have made over 1,370 portraits, some of which have been published. He worked in England 1768. Many of his silhouettes are to be seen at Leipzig,[3] where he studied jurisprudence from 1762 till 1767, pupil of Gellert ; 1771, tutor to Count O. K. E. von Schoenburg ; 1776, on his journey through Northern Germany, visited Weimar, Gotha, Dessau, Brunswick, and Hannover ; 1777–9 he went to South Germany, Switzerland, France, and England. See E. Krocker, *Die Ayrerische Silhouettensammlung*, Leipzig, 1899.

AYRTON, MAXWELL. 1914. Draws genre scenes and English landscape in silhouette.

[1] *Notes and Queries*.
[2] *Swiss Artists*, Brum.
[3] Stadtgeschichtliches Museum in Alten Rathaus, Leipzig.

B

BACHE, WILLIAM. 1771–1845. Born in England, worked in America, profile painter and cutter. Son of the postmaster of Wellsboro, Worcestershire. He used two processes, either hollow cutting by machine, adding details in Indian ink on the margins, or cut free-hand and shaded white, grey and bronze. (Plate 55.)

His advertisements refer to profiles shaded and painted. His backgrounds are indicated in brushwork.

His signature is used freely on the portraits cut by machine ' Bache Patent ', sometimes rosettes, stamped or drawn, are added on either side.

In an album belonging to his descendants there are over 2,000 examples of his work.

Mrs. Bolton[1] mentions two albums in which silhouettes by Peale and Bache are to be found. Other specimens belong to the Rhode Island Historical Society.

The following advertisement has been recently found.[2] ' Cutting, shading and painting of profile likenesses in a new and elegant style from long experience and great success in business and aided by an improved Physionotrace, feels confident of rendering general satisfaction.'

The portrait by Bache illustrated is of Daniel Wadsworth, now in the Wadsworth Atheneum, Hartford, Connecticut. It is elaborated with bronzing and brush work (Plate 55).

Other advertisements appeared in the *Salem Gazette* and the *Essex Register* on 10 July 1810.

An advertisement, when Bache was working in Newhaven shortly after, mentions the use of the Physionotrace, which the French artist Saint-Memin was using in America. This paragraph is signed W. Bache and T. Nixon.

Nixon, partner or assistant, painted profiles, chiefly in flesh tints and colour, and joined Bache in 1809. His work has little merit.

J.B. Signature of a sheet on which are mounted two full-length figures well-cut, date 1784. The portraits are of Louis Coutat and Joseph Dazincourt in the *Mariage de Figaro*.

A contemporary note runs ' Ressemblance parfaite '.

BAEYER, H. VON, of Munich. 1911. Cut flowers and botanical specimens exhibited in Berlin.[3]

BALBAMA, C. Cutter, mid-nineteenth century ; Italian. Two fine sporting subjects 20″ × 16″ show country scenes with sportsmen in the dress of 1860. They are cut out in very thin black tissue paper mounted on card. The signature is also in cut lettering.

BALEUHAM, G. G. Painter on glass about 1820. Address : Mrs. Haydiners, St. Asaph.

BALLUTI. Signature on fine group of students in gold on black background.

BANNISTER. Cutter, 1850. Label, round in shape, with palette and brushes, also a small printed label with cursive lettering.

BANTON, T. S. Silhouettist cutter. Early nineteenth century. Worked in New England U.S.A. Generally all black. Little is known of him.

BARBER. Master, aged 10 years, free-hand cutter. Exhibited at the 1851 Exhibition, London. He is described in the official Catalogue as ' executing figures and landscapes out of paper with scissors, no design having been first traced '.

BARBER, C. L. 1821. Free-hand cutter. ' Striking peculiarity of genius. The Nobility, Gentry and Inhabitants of Norfolk are respectfully informed that Mr. C. L. Barber Schiero Chiratomist to His Majesty, celebrated for his extraordinary talent in the delineation of the human face and figure, animals and every variety of natural and artificial object on paper, without drawing or machine in a manner peculiar to himself. Will shortly visit Yarmouth.'

This advertisement appeared in the local press in 1823.

BARBER, M. S. 1824. Signature on a black paper cut man's head looking right. It is inscribed on the back : ' Cut in half a minute '.

BARRETS. 122 and 148 Holborn Bars. Artist, signature on an early Victorian portrait, cut and bronzed. Label 2″ × 1¼″ square. (Plate 85.)

BARRETT. 122 Holborn Hill, London. ' Daguerreotype portraits. Miniatures on ivory, life-size portraits in oil. Profiles, &c. taken in a superior manner, and at astonishingly low charges. Likenesses copied, repaired, &c. Frames provided.'

This label is on an 8-inch full-length figure poorly proportioned, bronzed with landscape background in sepia. In possession of the author.

BARRETT. Miniaturist and silhouettist, working at Exeter, 1799. Produced profiles of Lord Duncan.[1]

BARRETT, MRS. Painted on glass. ' William Pitt, a gift to the Villiers family.' Inscription on a portrait in the Wellesley Collection, reproductions in *One Hundred Silhouettes*, Plates XVIII and XXIII.

In Mrs. Barrett's work, the figure is well proportioned, but the execution is rather confused and messy.

BASTIDON, CATHERINE. 1760–94. Cutter. Married the Russian poet G. Derjavene.[2]

BATEMAN, MRS. 1810. Painted full lengths about 7½ inches in size. An example in the collection of the late Mrs. Andrews, Bournemouth, also an example bust-size in the collection of Rev. Glenn Tilley Morse, signed Bateman.

[1] *Wax Portraits and Silhouettes*, Ethel Staewood Bolton.
[2] By Mr. H. E. Erving Hartford, Conn., U.S.A.
[3] Rep. M. Knapp, p. 114.

[1] *Exeter Flying Post*, 2.5.1799.
[2] *Œuvres de Derjavena*, Vol. 1, pp. 58, 107.

BATEMAN, H. M. 1930. Black and white artist, 1913. Draws silhouette figures often comic or grotesque, but is not primarily a silhouettist.

BAUER, P. 1781. In a small album of German origin now in the possession of the Newark, New Jersey, U.S.A., Free Library, there are over seventy all-black painted shadow portraits by P. Bauer. The head and shoulders only, these shadow portraits vary in size from 3 inches to an inch and a half. They are mostly of men of the last quarter of the eighteenth century. On each page are sentiments and verses in faded German script and a signature with the portrait of the friend who transcribed ; all the portraits are by the same hand. See Albums, Chap. III. (Plate 50.)

Bauer fecit 1807 is a signature on a portrait in the collection of M. E. Teviaschew, which is drawn with the needle-point on pierre doré, or gold leaf, fixed on glass, the scratched line being filled with black paint.[1]

BAUSER, M. 1779. Portrait of a man in a book of operettas published in Germany.[2]

BAZING. 408 Strand. See Rider and Bazing.

BEACH. Cutter. Strong outline, uses short neck line, worked on Margate Pier, 1927.

BEAUMONT, of Cheltenham. First half of nineteenth century, Cheltenham. Cut and painted on card, often dark brown with coloured ribbons, scarves and shawls. Generally full lengths with painted carpets and backgrounds. A book of these portraits was in the possession of the late Mrs. Andrews, Bournemouth. Has a signature on the portrait of Ed. Copleston, D.D., Cheltenham, 1845. More harmonious and beautiful work than that of most of the Victorians.

Other well-known authenticated specimens.

C. Fowler, Esq., Surgeon, Cheltenham, signed Beaumont fecit. Cut out of dark brown paper. Florence, wife of Admiral Deron, signed Beaumont fecit, cut portraits, bronzed, painted carpet.[3]

BEAUVAIS, Mr. Circa 1773. ' Well known in Tunbridge Wells, to several of the nobility and gentry, for taking a striking likeness, either in water colour or Indian ink. Miniature pictures copied from large pictures to any size, and pictures repaired if damaged. He also teaches by a peculiar method. Persons of the least capacity to take a likeness, in India ink or with a black lead pencil in a short time. To be spoke with at Mr. Bryans, the Blue Ball, St. Martins St. Leicester Fields, from eleven to one o'clock.' Advertisement in newspaper of contemporary date.

BECKMANN, Johanna. 1868. Cut silhouettes of flowers and herbs, later was employed in a porcelain

factory ; some of her silhouette work has been published with verses, and prose description.[1]

BEECH, Wm. Cutter, first quarter twentieth century. Worked at the Earl's Court Exhibition in London.

BEETHAM, Isabella, *née* Robinson. 1750. Granddaughter of John Robinson of Forton, whose name was included in a list of Roman Catholics and Non-jurors after 1715.

Running away from home when aged 20, she married Edward Beetham, son of a landed proprieter of Westmorland. He was painter and machinist. The young couple had a hard struggle, and it was at this time when funds were badly needed that Mrs. Edward Beetham began to use her gift for catching a likeness by cutting out profiles in black paper. Various addresses of lodgings in Clerkenwell, Little Queen Street, Holborn, are known, though on her first professional label none is printed, and not until the use of this first flowery description had ceased, do we get the second rare label when ' 4 Cornhill near the Mansion House ' is given.

It was Foote the actor who encouraged her to use her talent professionally, and doubtless with his kindly encouragement, she was soon able to set up as a professional silhouettist.

Meanwhile her husband's *New Lecture on Hearts* and *Moral Lectures on Heads*, printed by J. Robson, had a frontispiece, a mezzotint portrait of the author, engraved by Mrs. Beetham ; a copy of this pamphlet is in the Library of the British Museum.

In 1782 Edward Beetham bought the lease of 27 Fleet Street, having invented a patent mangle which was most successful. Here Mrs. Beetham had a fine studio on the fourth floor, looking out on to St. Dunstan's Church. She assisted her husband in painting with gold on glass and continued her profile cutting and painting.

These beautiful glasses she advertises as ' Crystals ornamented with gold and silver '.

In an advertisement of 1790 she declares that she finishes her portraits on ivory composition and paper, for Rings, Lockets, Bracelets, &c. Specimens to be seen at her house, No. 27 Fleet Street. Another Fleet Street label was printed in 1785.

The cutting process seems to have been abandoned soon after, and she took lessons from Smart, the miniature painter, whose profile she painted, and whose technique has great points of similarity with her own, especially in extreme fineness of touch, and method of painting the hair. This is specially demonstrated in the only known example of coloured miniature painting, signed by Mrs. Beetham (Plate 32). I purchased it at the sale of Miss Chambers's effects 12 September 1929, at Houghton, Sussex. The portrait is of Miss Chambers, daughter of Dr. Cham-

[1] *La Cour de l'Impératrice Catherine II*, Vol. II, p. 24.
[2] J. Leisching.
[3] Rep. by Major Desmond Coke, in *Art of the Silhouette*, p. 84.

[1] Rep. M. Knapp.

bers, Surgeon at the London Hospital, and had never changed ownership. The technique shows the influence of Smart on the touch of Mrs. Beetham.

There are three known labels in the profiles of Isabella Beetham. One we may assign to her earliest days of cutting, the only known specimen at present on the back of a man, cut in black paper, wearing the wig and shirt-frill, was in the possession of the late Captain Desmond Coke. The label is of large size, and most of it has been lost on account of its having been fitted into the small pearwood frame. It runs thus (the letters in parenthesis are missing) :

' (By ap)plication, leagued within good nat(ural gifts) (Mrs.) Beetha(m) (Has ena(bled herself to remedy a difficulty much | lamen(ted and) universally experienced by | *Parents, Lovers* and *Friends*. | The former, assisted by her art may see their off-spring in any part of the terrageous globe ; nor can death obliterate the features from their fond remembrance. | *Lovers*, the *Poets* have advanced " can waft or sigh from Indus to the Pole ". She will gratify them with more substantial, though ideal (inter) course by placing the beloved object to their view. | *Friendship* is truly valuable, was ever held a Max(im). | They who deny it never tasted its Delicious *Fruit* or shed a sympathizing tear. | . . . that was so *Endearing* nay *Ravishing* . . . | . . . separations existed . . . *Mrs. Beetham* will call into (B)eing.'

The sentimentalism typical of the period and shown in the label, doubtless caught many sitters, dazzled by the grandeur of the words, the loftiness of ideas, ' the co-mingling of Delicious Fruit of Friendship, and the sympathizing Tear, that was so *Endearing* nay *Ravishing*.'

After this, comes the shorter, more business-like, but alas equally rare label, which I have seen only reproduced in Mr. Rohan's book.[1] It is at the back of a man's portrait dated Oct. 8, 1784, in hand-writing, and runs thus :

' Profiles | in Miniature by | Mrs. Beetham | 2/6d. for each and a duplicate gratis, and if not, the most taking likeness, no gratuity expended, at 4 Cornhill W. the Mansion House. Children taken equally perfect. Time of sitting one minute. N.B. Shades of absent or deceased friends accurately reduced to any size and dressed in perfect taste.'

An ornamented engraved line in oval shape surrounds the words.

An interesting, and to my experience unique, example is on a portrait in the Victoria and Albert Museum, number P. 54, 1931. The label is oval and fits exactly the original oval brass frame. An engraved portrait of a lady with long curling headdress, and the distinctive bust and shoulder-line of the artist is surrounded by ornamental bead and rope lines forming an engraved frame. In small cursive

[1] *Old Beautiful.*

lettering are the words : ' Profiles by Mrs. Beetham, No. 27 Fleet Street.'

Lastly, the label generally to be found is so short that we realize the superiority of Mrs. Beetham's work must have been by then too well known and acknowledged to need explanation or appeals to the Heart or ' wafting of sighs from Indus to Pole ' or even ' the Hope of seeing offspring in any part of this terrageous globe '. There were probably two variants of this label, one with small profile heads at the four corners, one without (the former is mentioned by the late Captain Desmond Coke), in each case the wording is identical.

' Profiles | in | Miniature | by | Mrs. Beetham, No. 27 Fleet Street | 1785.'

Her portraits throw considerable light on the characteristics of eighteenth-century modes in features, pose and dress, sober homeliness and good nature is shown, which is quite different from the gaiety and insouciance of Charles and the artificial and more dramatic pageantry of Spornberg, Rosenberg, or the Jorden brothers. Her finest portraits are painted on the back of convex glass and are sometimes filled with wax, but not always. Great taste and dexterity is shown in the delineation of ribbon, gauze and elaborate hair dressing. I have heard her called the Holbein of Silhouettists, for though she paints ornaments, such as beads and jewels with meticulous care, she never weakens, with such detail, the supreme interest in the face ; though there is little hard massed black in her shades, yet they are as convincing as those of Jorden, the boldest of all glass painters. (Plates 15, 17.)

Mrs. Beetham's jewel-work is very rare. A family ring and three beautiful lockets in my own possession are examples, others are owned by Dr. Beetham and Sir Henry Sutcliffe Smith. One other example was destroyed by fire in 1815. In 1808 her husband became a Director of the Eagle Assurance office, which he and his friend Sir William Rawlins founded and the following year he died, after a short illness.

The Director presented the profilist with a hundred guineas and a piece of plate. She ceased to rent her studio and continued to live in Somers Town ; nothing further is known of her life, when she died, nor where buried.

In consequence of her not being on good terms with her husband's family or her eldest son, all her letters and personal belongings probably became the property of her eldest daughter Jane Read. In 1871 Jane Read's personality passed (at the death of her only daughter, the eccentric Cornelia Read) to the Brompton Hospital for Consumption in Fulham Road, together with £100,000, with which a large wing was built. In course of time, all personal documents have been destroyed or lost, as no one seems to have had any interest in preserving them.

About 1784 Gainsborough painted a small portrait

of Mrs. Beetham. The original was destroyed by fire, but a charcoal sketch of it remains in the possession of the family. Besides this, there is one old ring with minute monochrome portrait, surrounded by paste. It was given by Mrs. Beetham to Elizabeth Beetham, and is now in the possession of Dr. Beetham, her descendant.

Another Beetham label has recently been found. ' Profile Likenesses by Mrs. and Miss Beetham, No. 27 Fleet Street, London, finished in a most beautiful and slight manner on Crystal Ivory and Paper. Time of sitting 1 minute. Price 2s. 6d. to 2 guineas. Old shades reduced and dressed in the Present fashion.'

This label was discovered by Rev. G. T. Morse at the back of a Beetham portrait on glass; the label had been covered.

BEETHAM, EDWARD, 1744–1809, invented an improved method of gilding glass mounts; in this he was assisted by his wife, Isabella, the distinguished silhouette portrait painter. (Plate 17.)

He was born at Appleby, Westmorland, and left home, joining a company of strolling players, thereby distressing his family, landed proprietors, whose family estate had been occupied by Beethams for 600 years : it must be remembered that it was not till nearly a century later that an actor was safe from apprehension as a rogue and a vagabond.

At the age of 29 Edward Beetham married Isabella Robinson ; after a precarious existence with travelling companies, he obtained permanent employment at Sadler's Wells Theatre, and occasionally at ' The Little Theatre ' in the Haymarket, which had been rebuilt in 1767.

At this time he invented the rolling up theatre curtain, weighted at the bottom to obviate the danger of fire if flapping over the footlight candles ; this was universally adopted, but the inventor gained little profit. His lecture, which he delivered in many parts of the country, was printed at Newcastle-upon-Tyne by T. Robson, in 1780. On the title page is—

' Moral Lecture on Heads '
By Edward Beetham
' Curious and Serious Things are mingled here
And more is meant than seems to meet the Ear.'

On the frontispiece is a portrait of the author in mezzotint ; in ovals at 3 of the corners are small heads, Misery, Laughter, Gravity, signed ' Mrs. Beetham delt '. A copy of this interesting pamphlet is in the British Museum Library.

In 1782 Beetham invented the type of mangle which exists to the present day, with wooden rollers worked by cog-wheels, instead of the clumsy stone rollers, an example of which is still preserved at Warwick in the Leicester Hospital. Prosperity dawned through this invention, and the lease of No. 27 Fleet Street was obtained for a dwelling-house, factory and saleroom ; later No. 26 was taken for a warehouse.

Edward Beetham was assisted by his wife in painting the gold ornamental glasses, and in 1784–5 visited Venice with an improved method of glass gilding and also an invention to facilitate the painting of portraits on glass. Later he became one of the Founders of an early Fire and Life Assurance Company, ' The Eagle ' : he died after a short illness in 1809.

BELLERS, WM. 1761–74. Landscape painter, contributor to exhibitions of Free Society of Artists 1761–73. Silhouette portrait by him in the possession of Mr. A. R. Bagley, Malvern.

BELLUTE. Signature on a series of portraits of students of astronomy, painting on glass. Black ground, profile bronzed with gold.[1]

BERMINGHAM, NATHANIEL. Circa 1774. Paper cutter. Born in Dublin, moved to London where he was described as heraldic painter and artist in the curious art of cutting out Portraits and Coats of Arms in Vellum with the point of a penknife. His address in 1763 is ' the corner of Great Queen St. opposite Long Acre '. In 1774 he is still in London but at another address. He exhibited at the Society of Artists ' a portrait of the Duke of Gloucester cut in an entirely new manner '.

There is a fine example of his work at the Museum and Fine Art Gallery Bristol representing Shakespeare as he is on his monument at Westminster Abbey. There is every detail shown by the Sculptor ; it is in white paper. The inscription at the base in cut lettering on Nat. Bermingham's work, runs as follows : ' Mr. Fleetwood and Mr. Rich : Masters of ye two Theatres, having generously given a Benefit Play each, towards erecting a Monument to the Memory of that Inestimable Shakespear, which is now set up in Westminster Abbey by the Direction of the Rt. Hon. the Earl of Burlington, Mr. Pope, Dr. Mead and Mr. Martin.'

The cutting measures 16″ × 10″ and is signed Nat Bermingham Sc 1746.

There is also a fine example at the Victoria and Albert Museum[2] set up in a small mahogany table screen (19½″ × 11¼″). The subject is a portrait in oval frame of Frederick Prince of Wales. A female symbolic figure stoops over the portrait and drapery is above. An interesting and unusual background of blue, *semé* with small stars, shows beyond the curtains and a finely cut achievement of arms is in the lower left corner. This piece was the gift of Mrs. Vanden Howard. A marvellous cutting of Judge Jeffreys, probably from a print, is shown in Plate 84.

I have also seen a beautiful equestrian portrait

[1] Captain Desmond Coke.
[2] *Mortimer's Universal Directory,* 1763. M.37–1932. Buckley.

(29½″ × 23″), by Bermingham, of the Duke of Cumberland (Butcher Cumberland), uncle of George III. It also is in white paper, it is mounted on looking-glass and finely framed in tortoiseshell, as was the beautiful achievement once at Strawberry Hill, later in possession of Lady Dorothy Nevill, giving the heraldry of the Walpole family.

A fine example of his work was recently sold at Sotheby's—a cut portrait of the Duke of Cumberland mounted, holding his baton and wearing armour, with the order and ribbon of the garter. The figure was mounted on looking-glass and framed in ebony and tortoise-shell 27 ins. × 23.

BERNSTORF. Free-hand Cutter, Hanover. Worked at the time that the silhouette played so important a part in the record of friendship, sentiment and study of the emotions, eighteenth century, when Lavater was preparing his work on *The Recognition of the Inner Self Through the Outer Man.* Bernstorf also adapted life-size shadows to more reasonable dimensions by means of a pantograph.

BETTS. Cutter, 1847. Made a 'newly invented machine for reducing a life-size shadow'. He used bronzing on his portraits.

BETTS, MRS. Painter, 1840. She used greyish black with heavy shiny black lines. Her label is 'Mrs. Betts, artist, Shopton'.

BINGHAM, G. Near the Infirmary, Manchester. Painted on plaster. Label: 'Likenesses in Miniature, profile, taken by | G. Bingham, | reduced in a manner entirely new, paints on Composition, perfectly white and finished in the first taste. | He also reduces them upon ivory for lockets, rings, etc., from 6s. to 10s. | N.B. He keeps the original shade. Near the Infirmary, Manchester.'

A portrait by G. Bingham in the Wellesley collection [1] is of Jane Brooks.

BITTERLICH, C. 1834–72. Cut animated groups such as post-chaise and troops and figures of children playing games. Her diabolo players reproduced by Professor M. Knapp, p. 52, is in the collection of Dr. Albert Sibor, Vienna. This silhouettist was the mother of Edward Bitterlich the painter.

BLACK, G. B. 'A great man and his shadow' is a picture of the Duke of Wellington. There is a well-defined full-length silhouette portrait on the wall by which he is standing, beneath is written, 'Drawn and Lithographed by G. B. Black'. A similar shadow portrait is shown in a print of Nelson.

BLACKBURN, J. 1850. King St. Manchester.

BLACKBURN, W. Junior. 303 Oxford St. Label on portrait of a man, cut black paper, bronzed finish, about 1850, possibly son of above.

BLESSINGTON, MARGUERITE, Countess of. 1789–1849. Authoress. Cuttings, formerly in the possession of the late Captain Desmond Coke, contained in a small morocco bound album. Domestic

[1] *One Hundred Silhouettes.*

scenes, duels and out-door games. Cut in different coloured papers, outlined in Indian ink and partly painted.

This book was destroyed by fire in 1916.

BLOCK or **BLOK,** JOANNA KOERTON. Wife of Adrian Block, a Dutchman, born 1650, died 1715.[1] B. Amsterdam. Though a talented artist in music, embroidery and modelling of fruits and flowers and diamond engraving on crystal, this lady is chiefly known as an expert paper cutter of figures, landscapes, marine views and animals. Her work on a very minute scale was highly valued. Peter the Great offered 1,000 florins for three pieces. This price was refused. The Emperor of Germany ordered a cutting of the arms of the Emperor Leopold I. The price paid was 4,000 florins.

The example in the Victoria and Albert Museum is a cutting between crystals, dated 1763, signed Joanna Koerton.[2] In the centre is the Virgin with St. John in the foreground, a cat, stag, turkey, trees are at the back. The whole enclosed in a beautiful floral border, on a ribbon are the words 'Nihil Est Cando ris nihel et splan dorio quod in Virgine, glori oza 1703'. (There is no beauty or brightness which is not found in Our Lady the Virgin.) The whole of this remarkable work measures 2¾″ × 2½″ and was bequeathed to the Victoria and Albert Museum by Mrs. Louisa Plunky in 1931.

BLUM, fec. Signature on the silhouette of Oberthue in 1795, in the *Annals of Modern Theology and Church History.*[3]

BLUMEL, OTTO. Cutter, b. 1881, Augsburg. His Indian figures have some humour; in his landscape work he illustrates well the tangled effect of jungle growth.[4]

BLY, HUARDEL. 1913. Frenchman. Pavillon Condé Vancresson, Seine et Oise, France. Cutter and experimentalist in other processes. He has written *A Practical Guide for Amateurs* and describes himself as a silhouettist, caricaturist, and painter-etcher. This brochure, 1913, contains three original cut portraits, and is otherwise illustrated. Some of his headings run thus: What is a silhouette? Cut-out silhouettes, materials, tools, free-hand, scissors work. The sketch on the wall glass frame, profilograph, reflectograph, coloured silhouettes, frames, collecting, &c., &c. Mr. Bly began work as an amateur, his art training was under Professor Guillemin, Grand Prix de Rome, for ten years; and for three years at the Colorochi Academy, Paris. He occasionally introduces colour, and also used gold or pencil strokes, and describes the use of the reflectograph, and other mechanical aids, and 'a method entirely of my own invention by which the

[1] Vic. & Alb. Mus.
[2] See *Women Artists in All Ages and Countries,* 1859, p. 105.
[3] T. Leischer. [4] Rep. M. Knapp, pp. 97, 105.

most accurate and scientific (yet artistic) likeness, may be obtained'. His instrument he calls the Camera Lucida, founded on Benoist's Universal Camera Lucida. Mr. Bly affirms that he has taken 50,000 portraits with this instrument. He slyly adds : ' The amateur should not forget that although the sketch should be faithful to life in most points, some may require softening.' ' *La verite nue n'est pas toujours belle*. You are making a picture, make a pleasing one.' He worked on the West Pier, Brighton, for many years. (Plate 68.)

BOBROW, ANDRÉ. 1836. Russian. Cut many spirited and original silhouette portraits of the cadets of the First Corps at St. Petersburg. Some of them have been reproduced in lithograph in Istoril-chesky Westmik. He was himself a cadet of this Corps in Russia.[1]

A profile of André Bobrow done by one of his friends is now in the collection of Mr. M. P. Ephremow.

BOCKNIAK, CHARLES. 1780. Doctor at the court of Brunswick ; four examples of his work are reproduced in *Russkaia Starina*, 1874, Vol. IX, p. 4,[1] namely the portraits of the two daughters of the Regent, Anne Leopoldovna and two silhouettes of his sons.[2]

BOCKTON. On the silhouette portrait of Sir Wm. Wynne Knight, LL.D., Dean of the Arches and Judge of the Prerogative Court of Canterbury. ' Mr. Bockton his Proctor took his resemblance as he sat giving Judgement.' [3]

BÖHLER, DR. OTTO. Vienna. 1847–1913. Cut 21 silhouettes of musicians and others which have been reproduced. He is considered the best modern silhouettist in Austria.

BÖHM, E. Painted silhouette portraits of small size.

BONVALLET, L. Engraver of Profiles made by the Physionotrace, Paris.[4]

BOUCHARDY. Frenchman, end of the eighteenth century. He used a machine invented by Chrétien called a physiognotrace which traced and cut profile portraits. In his advertisement Bouchardy calls himself Chrétien's successor, and at another time ' the inventor of the Physiognotrace or profile cutting machine '.

One of his advertisements quoted by Miss Martin in the *Connoisseur* reads : ' Palais-Royal café de Chartres, No. 82 BOUCHARDY, Painter in minia-ture and life size in oil, successor to M. Chrétien, Inventor of the Physionotrace, Notifies the lovers of this clever invention that he makes Profile Por-traits by the same means as his predecessor, and will strive to merit the patronage of the public, of which sieur Chrétien has made himself so worthy at Paris.' [1]

BOUNER. Profilist, signature on portrait of Simon Fenton, in the uniform of the West Suffolk Yeomanry, also one cut and bronzed silhouette in the possession of Mrs. Warner, Chicago.

BOUTTATS. Signature on a fine family group in *églomisé*. A lady elaborately dressed in the style of 1760 is seated in a handsomely furnished room. By her side is a child who waves adieu to another child, with basket of flowers in her hand, who is leaving the room.

A handsome mirror is against the wall, an up-holstered settee beneath, wall panelling, draped curtains, with cords and tassels, half conceal the bust of a man on decorated pedestal.

Beneath the picture is written : ' Jeane, Countess of Harrington, Lord Viscount Petersham, and the Honble. Lincoln Stanhope.'

The work is very good, the perspective faulty. Sight measures 8″ × 10″, a very rare specimen of large size English picture in *églomisé*. In possession of the author.

BOUVIER, J. Signature on the portrait of the Rt. Hon. Sir R. Peel, Bart., M.P., showing the New Exchange, Glasgow, in the background. Published by Wm. Spooner, 377 Strand. Lithograph in National Portrait Gallery, London.

BOWEN, DANIEL. 1791. Name and date on the ' Likeness of General Washington and Lady ', shown at the Annals of Salem Exhibition of Silhouettes.

He was in partnership with Wm. S. Doyle at a Museum established in 1791, opposite the ' Bunch of Grapes ' Tavern, in State St. Possibly in order to obtain space, a hall was taken above the schoolhouse in the same street.[2] In 1795 Daniel Bowen and William Doyle moved their business to the corner of Bromfield and Tremont Street ; here they were burnt out in 1803, and reopening north of King's Chapel. They were again burnt out. Mrs. Bolton informs us : ' Bowen seems to have tired of this fiery partnership after the second conflagration, and left Boston.' His son Abel remained, and became a maker of woodcuts. Doyle (Plate 59) reopened and at his death was proprietor of the Columbian Museum, Boston.

BRANDENBURG, DORA. 1884. Cutter. Gen-erally produced figures in intricate design, used for shadow plays and for fairy-tale illustration. Her ' Battle, and game attached ' are animated and dis-tinctive in design.[3]

BRANDES, MINNA. 1765 in Berlin. Signature

[1] *Revue Historique*, 1885, t. XIX, p. 83.
[2] *Cour de l'Impératrice Catherine II.*
[3] This example is in the Library Collection of the London National Portrait Gallery, No. 94, p. 43.
[4] Martin.

[1] Martin.
[2] According to a list of silhouettes courteously supplied to me by Mr. Roberts of the Library of Congress, Washing-ton. Daniel Bowen with Edward Savage established a Museum in New York City.
[3] Rep. M. Knapp, p. 96.

on a girl's head in the operettas published in Germany 1799.[1]

BRANDT, H. C. Published in 1785 a book on the silhouette portraits of German professors and artists, and also the profiles of women. This book is now very rare. There is a copy in the Goethe house, Frankfort.

BRASCH, H. Twentieth century. A Japanese lady. Exhibited silhouette drawings at the Rochdale (Yorks) Exhibition, 1921.

BREILSCHWERT, LOUISE VON. 1833–1917. Cut book illustrations and added pen lines, occasionally. Her work is raised from the back by pricking. She used the carefully drawn floor perspective and the birdcage of fine wire found in so many German cut pictures. This formula is now exploited by the silhouette fakers, who paint it on glass, as it was never done.[2]

BRENTANO, CLEMENS. 1816. Author of a play for the shadow theatre. Its subject was mostly poetical, its title 'The Unhappy Frenchman' or 'The Ascension of German Freedom'. It was freely illustrated in silhouette.

BRETTANER, BARBARA. 1721. Parchment cutter, mother of Johann Esaias Nilson, q.v. 1721–88.[3]

BRIERLY, S. L. 1835. Rochdale, Yorks. Printer's pattern designer, cutter of subject pictures, landscapes and annuals. Many examples of his work are to be seen at the Free Library and Museum in his native town. He never used his gift professionally.

BRISTOW, MRS. Haller Church St. Hackney. Circa 1840. | On a portrait cut and painted | NOTICE | Thursday will be the last Day | LIKENESSES Will be taken by the Patent Delineator | at | One Shilling each. | With a frame and glass included | At Mrs. Bristow's | Hatter Church Street, Hackney | coloured equal to miniatures. | Poor work.

BROC, VERFERT KECK L. Signature on a cut paper, crucifixion with border of emblems of the Passion. At one time in the possession of the late Captain Desmond Coke.

BROCAS, JAMES. B. 1754–80. Portrait painter, miniaturist and silhouettist. He was the fourth son of Robert Brocas, an Irish artist, and obtained prizes in 1772 and 1773 at the Dublin Society's School.

In 1778 he advertises : 'Mr. Brocas takes leave to inform the nobility and gentry and the public that he has returned to the city, and that he intends to continue his profession of painting likenesses in the most natural and striking manner in oils, crayons and miniatures. He will also take off likenesses in profile at an English half-crown each, and whole lengths (which mode was never attempted before) at a crown each.'

He was buried in St. Andrew's Churchyard, Dublin.[1]

BROCKMER, J. 1771. 'At the Golden Head, Bridges Street, Covent Garden'. 'Painting in miniature, crayons and Indian ink, performed in the most elegant manner and striking likenesses on more reasonable terms than could be expected, the merits of the performance considered.' Advertisement in newspaper of contemporary date.

Advertisement in *Gazetteer*, 25 February 1767. 'At the " Golden Head ", Bridges Street, Covent Garden.| Portraits painted for Cabinet pieces, bracelets, rings, etc.,' also in the *Public Advertiser*, 28 February 1769.

D.n. *Daily Advertiser*, 8 September 1772. *Bath Journal*, 25 September 1758.[2]

BROOKS. 1785. '*Likenesses.* To the ingenious World. There is now to be had a Mathematical Instrument, by which any Person for the expence of Half a guinea, may reduce Miniature profiles of themselves or a thousand different persons, in the most correct manner. In short it answers every intent of not having any of its complicated difficulties and not one-eighth of the expence and are so portable as to lay in the compass of a foot rule. The Public are assured that the above are the original ones, but their great utility and demand for them has induced persons to make very imperfect copies, for if they are not put together with mathematical exactness they can never work true.

'All orders sent to Portfolio Manufactory No. 3 Coventry St. (the Golden Head, next house to the corner of Oxendon St.) will be executed, with engraved directions so as to render the operation perfectly safe. N.B. The above house is the only manufactory for portfolios in London, where may be had all sorts of prints, drawings, writing, &c., &c., to any size. Likewise a Collection of modern drawings.'

The grammar of Mr. Brooks is so full of ' complicated difficulties ' which he tells us are avoided in his instruments, that it is not easy to decide if portraits were taken at the Golden Head. On the whole we fancy they were not ; perhaps another contemporary advertisement will be found one day, which will throw light on this point.

BROOKS, SAMUEL. 1790. Boston. Medallist, miniature and profile painter. This advertisement appeared in the Boston *Independent Chronicle*, 30 September 1790 : ' The public are respectfully informed, that the Artists (Samuel Brooks and Joseph Wright) who took the most correct likeness of the President of the United States and executed a medal of him, are at the House of John Coburn in State Street, and will continue for one month only, to take the most correct likenesses in two minutes' sitting ; and

[1] J. Leisching. [2] Rep. M. Knapp, p. 58.
[3] J. Leisching.

[1] Strickland, *Freeman's Journal*, 28 Feb., 3 March 1778.
[2] Buckley.

finish them for one Dollar to three or a miniature from seven to fourteen Dollars.

'The Artists cannot stay longer than the time proposed having engaged to go to Carolina in the next month.'

This can scarcely be the same as the Brooks of the reducing Machine of Coventry St. London.[1]

BROWN, J. Profilist. Circa 1820. Worked at Salem, Mass. Two addresses are known.[2] The Essex Coffee House, 1802, and two years later the Lafayette Coffee House. His price was six cents for each profile; his signature J. Brown in print and sic-cavit in cursive writing. His work is of inferior quality. An example is to be seen at the Essex Institute, U.S.A.

BROWN, MRS. 1785. Cutter. This silhouettist is identical with Miss Brown listed in my *History of Silhouettes* as having ' cut Gibbon's profile without a sitting ', for Gibbon's portrait, illustrated in my book,[3] together with two others, are to be found in an album of Mrs. Brown's cuttings owned by Mr. John J. Cullen [4] of New Jersey, U.S.A.

On the cover of this book are the words ' Silhouettes by Mrs. Brown of Portman St. Portman Square ', and Holden's *London Directory* of approximate date yields the confirmatory fact that at 15 Portman Street lived Mr. Brown.

There are two self-portraits of the silhouettist in this interesting album, one seated illustrated in the *Antiquarian*, October 1931. A beautiful full length of the Duchess of Devonshire, Mrs. Jordan,[5] which I first saw in Lady Dorothy Nevill's Collection, also Roscius at the time of his great popularity when he was aged about 13, in a theatrical attitude. Mr. and Mrs. Danby in a very beautiful Conversation piece, the lady seated at the piano, Danby tuning his cello; every accessory, candle-stands, music, crystal-drop chandelier, is cut with exquisite skill.[6] Mrs. Brown was a very clever cutter, and omits no detail which may indicate texture or movement or suggest atmosphere in surroundings or a characteristic mode of the sitter.

Amongst the 300 specimens are portraits of Lord Cholmondeley, Lady Buckingham, Mrs. Mundy, wife of the friend of Collingwood, Lord Harrington, Mrs. Fox, and many others; not all are named. Many are of bust size; her range extends occasionally to genre compositions and her skill is rather unequal.

Occasionally white paper is used, there is a cutting of Voltaire in this variety, but as a rule black is chosen.

BROWN, WM. Henry. 1808–1883, b. in Charleston, S. Carolina. Cut free-hand. Itinerated in U.S.A., calling his Studio ' The Brown Gallery '. His first important silhouette [1] was produced when he was sixteen. He worked with surprising speed, sometimes leaving the black paper untouched, as in the equestrian figure John Parker, Junior, but more frequently painting in white or grey, the hair, outlines of the clothes, &c. His original work may be studied at the Essex Institute, Salem, Mass. His work is rather unequal; it is said that he could duplicate his portraits from memory, a remarkable feat. I have not been able to ascertain if he cut in duplicate in the first instance, as did the contemporary free-hand cutter Edouart. Brown mounted his portraits on lithograph backgrounds, and in his book, which contains 27 portraits, all but that of Washington (*see* Plate 58) being by his own hand,[2] he gives details of the lives of his sitters and holograph letters. A greater part of the original edition of this book was destroyed by fire. I have examined a copy owned by Mr. Henry Sleeper. It was published by E. B. and C. C. Kellogg in 1845, and has since been republished. Brown also produced compositions of large size, one belonging to the Historical Society of Connecticut [3] measures 6' 9", of the same type, built up with many figures, as Edouart's 90th Regiment on the parade-ground, Glasgow, and Dempsey's Cotton Exchange, Liverpool, or the large-size subjects cut in Germany for commemoration and wall decorating purposes by Runge.

I have not seen a woman's portrait by Brown, nor any work other than the full-length figure about 7½ inches, but doubtless they exist. His memory was so remarkable that he could cut portraits some hours after casually seeing men in the street. His charge was one dollar. His advertisement in the *Salem Gazette* runs thus : ' The Citizens of Salem are respectively invited to call at Mr. Brown's Room over Mr. Horton's Apothecary store nearly opposite the Lafayette Coffee House and examine the Likenesses of several of the most respectable citizens, taken in the short space of 10 minutes each.

' The above individuals were pointed out on Saturday last in the street, and from recollection alone, without a sitting these Likenesses were taken several hours after seeing the persons in the street.'

This advertisement indicates a new phase of the portrait-taking gift and postulates a very remarkable memory. Twenty-four years before his death Brown gave up his profession and entered the employ of the Huntington and Broadtop Railroad. He died in his native city, Charleston.

BRUCE, GEORGE. Painter, jeweller, South Bridge St., Edinburgh. During the last quarter of the eighteenth century he painted all black on plaster,

[1] T. Bolton.
[2] Carrick.
[3] *History*, Nevill Jackson.
[4] Mr. John J. Cullen.
[5] *History*, Nevill Jackson, p. 34.
[6] I am indebted to Mr. Joseph Jackson for information.

[1] Lafayette.
[2] Taken by a machine in Alexandra.
[3] Rep. in *Conn.*, Feb. 1926.

very much in Miers' early style, and doubtless many unsigned portraits attributed to Miers are by Bruce. I found a fine contemporary portrait of Robert Burns by Bruce. It is one of the three known contemporary silhouette portraits of the poet. It is now in the Burns Cottage Museum. The two others are in the National Portrait Gallery of Edinburgh.

Bruce was also a jeweller and frame-maker. His advertisements are in contemporary news-sheets and on the backs of his portraits and labels in Scotland. 'Striking profile shades in miniature executed on a peculiar plan by George Bruce pupil of the late Celebrated Mr. Houghton. Who respectfully informs the Public that he purposes to stage with Mr. Moffat, where he will take the shades of such as are pleased to come to him at his Room.

'He humbly solicits all who wish to procure accurate Likenesses and attends from 10 in the morning to 3 in the afternoon, until 7 in the evening. Time of sitting 5 minutes.

'The Profiles may be framed in a new Style of Elegance or reduced on ivory so small as to set in rings, pins, bracelets, lockets, etc. He expects no money if the resemblance is not judged to be perfectly exact.'

Such labels are on the backs of two portraits all black on plaster, owned by Mr. Malcolm Laing.

BRUCE, L. 1820. 85, Farringdon St. and 3, Somerset Place, Brighton. Signature on a series of engraved portraits in the National Portrait Gallery, London. They include the silhouettes of William IV (*see* Plate 18) and Lord John Russell, and have been reproduced in aquatint.

BRUFF, W. Baltimore, U.S.A. Machine, cut-hollow, the signature stamped, is on a portrait of a son of Judge Breckenridge now in the Library of Congress, Washington.[1]

BUDDHA. Silhouette portrait of. Cut out in paper H. 29 c.m. Lines added in sepia. Lent by Bibliothèque Nationale, Paris, at the International Exhibition of Chinese Art at Royal Academy of Arts, London, 1935-6.[2]

BULL, Mrs. Opposite the India House. Address given on a painted bust portrait in the possession of the late Captain Desmond Coke. Her work is rare and seldom signed. It resembles that of Charles in many particulars, but the hair is painted with more detail. Possibly Mrs. Bull was the wife of R. Bull,[3] 1777-1809, miniature painter and hair worker. He was an exhibitor in the Royal Academy from 1794 to 1889.[4]

BULLOCK, W. Worker with Physiognotrace, label on portrait of a man painted on card, white relief, fine work. | 'Drawn | In One Minute | By

the Patent | Physiognotrace | At the House of W. Bullock. | Jeweller and Silversmith and Chinaman to His R.H. the Duke of Gloucester at the Liverpool Museum and Bronze Figure Manufactory opposite the Post Office, Church Street. | N.B. Miniature Frames.'

The Museum consists of upwards of six thousand articles of Natural History, Antiquities and Productions of the Fine Arts arranged in 5 apartments upwards of 150 feet long, fitted up for the purpose and is open for public inspection from 10 till dark at 1s. each. Descriptive catalogues at 2s. 6d. each. Label on a fine portrait painted on card of J. H. Galton, the hanger, has the word museum stamped on the brass.

BUNCOMBE, J. A painter of silhouette portraits of the last quarter of the eighteenth century, and first quarter of the nineteenth, worked at Newport, Isle of Wight. He has left to the world a fine shadow pageant of military portraits, in which every detail is correct, numerals and badges on buttons, badges on shakos, and facings and lace; in none is to be found a single inaccuracy, in form or colour. The method of this silhouettist was to paint the face dense black, in which the eyelash is indicated, all details of dress in his military portraits are in colour. His work is of extraordinary merit, the stance as well showing fine quality. I have only seen two portraits of women, both were in black only, the faces dense, the details of dress in black line, one is in my possession. (Plate 84.)

No trade label has ever been found though 'Mr. Buncombe, High Street, Newport' has twice been found written on the back of the wooden packing of the frame, and until corroborative evidence was acquired such writing might have been found to be the name and address of the sitter. (Plate 83.)

After twenty years of search I got into touch with Mrs. Snell, formerly of Newport, in 1931 after much correspondence, and after very full inquiry I am able to make public the following facts.

J. Buncombe, silhouettist, was the name of the painter of these fine military figures. He lodged with Mr. George Smith, whose ironmonger's shop in High Street, Newport, is shown in the book of engravings of Newport by Brannon published in 1821. The shop is distinguished by the trade sign, a kettle, over the door and was done at the time the silhouettist lived there, a group of officers such as he had as sitters, are outside the shop. Mrs. Snell is the granddaughter of Mr. George Smith, owner of the shop in Buncombe's day, and her father was born there in 1824. From her I have received photographs of a Buncombe portrait of her aunt as a girl, and her great aunt with whom the silhouettist lodged, also a photograph of the artist's marble palette and his block paint-box on the lid of which are three stamps each with an oval frame line, within which are the words

[1] Information supplied by Mr. Roberts, Washington Library, D.C.
[2] No. 3013 A in Catalogue. [3] Strickland.
[4] Graves, Algernon, R.A.

J. Buncombe. No sign of label or stencil. The words are stamped, no indication of price. There is still much to learn, perhaps some day a portrait will be found which will give further details.

These portraits, being of a very attractive kind, are being freely faked. Sometimes the legitimate colour reproductions, published for me in *History of Silhouettes* and in the *Connoisseur*, are cut out and put into old lacquer frames and sold as originals, sometimes the portraits are copied, chiefly on ivory (which Buncombe never used) by fakers in France and Austria; probably on the publication of this volume many more will appear.

Most of the genuine specimens I have examined bear on the backs of the cards, on which they are painted, indications of their having come from old scrap-books, which accounts for their fine preservation; they are very rare and of the first importance to collectors. Their value also in recording in colour the accurate details of uniform at that date is considerable; in several instances no other example is extant showing some important detail in the uniform or accoutrements. The Infantry Depot in the Isle of Wight was of great importance at that date, and the number of units shown in Buncombe's portraits show how many regiments were passing through at that period.

A major-general and a large staff of officers were in command in 1810.

Examples in colour are reproduced. (Plates 2, 37, 51.)

Coloured Silhouettes by J. Buncombe, in possession of Mrs. E. N. Jackson.

1. Officer 97th Queen's Own.
2. Officer Lt. Infantry. Bugle horn badge, buff facings, Ox. L.I.
3. De Meuron, raised 1795.
4. 64th.
5. 89th. Sphinx, blue facings.
6. Cocked hat and plume, gold lace, epaulettes, Harp.
7. 65th York and Lancs.
8. 53rd Shrop. L.I.
9. Grenadier Guards up to 1822.
10. Shako and plume all black.
11. Shako like top hat, plume, green facings, gold lace, epaulettes.
12. 2nd Queen's. Silver lace.
13. R.A.
14. 74th. Shako, white facings, gold lace, epaulettes. Fourteen years earlier than any recorded at S.N.M. Museum, The Castle, Edinburgh.
15. 30th Cambridgeshire, now East Lancs.
16. A Royal Regt. 1800, blue facings, gold lace, epaulettes.
17. An Irish Regt., red coat, blue facings, silver epaulettes.
18. 35th Sussex, silver lace, white facings, epaulettes, red collar.
19. 56th (Volunteer) Regt. Essex. Gibraltar.

BURDICK, DOROTHY. 1925. Cutter of portraits and illustrations. Address 16, Park Avenue, Malden, Mass., U.S.A. Draws her subject, whether full length or bust portraits or genre groups, and then cuts them out. (Plate 79.)

BURMESTER, G. H. 1797. This signature is on an important family picture in the Hohenzollern Museum, Berlin. The figures are painted in black on flat glass which is backed with red. Weeping women and children are crowning the bust of Prince Frederick Karl. There is an inscription 'Grief at the Tomb Dedicated to his widow, died 28 December 1797'.

Burmester [1] was Court Silhouettist in Berlin during the last quarter of the eighteenth century. A portrait of a man on an engraved mount was shown in the Century Exhibition at Berlin, bearing his signature. Many examples of his work are now to be seen at the Ermeler Haus Museum, Berlin; good work.

BURT, ALBIN R. Engraver and itinerant portrait painter or profile miniature painter in colour; that he also painted silhouettes is proved by the fact that two of his signed shades were sold at Christie's, 1 December 1932.

He painted many eminent persons and produced a portrait of Lady Hamilton as Britannia unveiling a bust of Nelson; d. at Reading 18 March 1842, aged 58.

BURT. Painter, signature on portrait in Silhouette painted on paper, sold at Sotheby's, 1 December 1932.

BUTTERWORTH, J. Last half eighteenth century. Opposite the Vicarage, Kirkgate, Leeds. On the portrait of Wm. Marshall of Hatton 1769–1808, reproduced in Crisp's *Visitation of England*, Vol. V, p. 50. Three other examples of this silhouettist's work are in my own possession. Each is signed 'Taken by John Butterworth, Kirkgate, Leeds'. They are portraits of James, William and Samuel Gatliff, sons of James Gatliff, whose silhouette, dated 19 May 1790, is of special interest to Americans, as in our family records he is noted as having 'gone to America, married E. Griffin', and it is his portrait 'Samuel Gatliff, merchant of London' which was painted by one of the early American portrait painters, Gilbert Stuart, and now hangs in the Fine Art Gallery in Philadelphia. My great-aunt, Mrs. Samuel Gatliff, *née* Griffin, is also there; a lovely portrait with her eldest daughter Elizabeth Gatliff and Mrs. Gatliff's father Samuel Griffin, all by Gilbert Stuart.

This latter gentleman married Betsy Braxted, whose great-grandfather, Carter Braxted, signed the Declaration of Independence. E. N. Jackson, *née* Gatliff. (Plate 85.)

[1] J. Leisching.

C

CAHAN advertised silhouettes of Captain Lindberg and his plane, the 'Spirit of St. Louis', cut in cardboard, 5 dollars. 'Lindy only, 1 dollar 50 cents.' Address : 240 Fifth Avenue, New York City ; July 1927.

CAIRNRYAN. Signature on two painted silhouettes, black with white relief, 1839, owned by Mrs. Delomone, Kensington.

CALDECOTT. Cutter, 1838. A portrait looking left of Emma Livius is marked 'Taken by Mr. Caldecott of Torquay'.

CAMPBELL. Painter. Signature on man looking left beneath bust painted sanguine brown, bronzed. Fine. Circa 1820. Owned by Mr. R. Kilner.

CANDY, MARGARET. Modern English cutter of portraits. Amateur.

CATCHPOLE. Painter and cutter. Large label. Owned by Mrs. Cameron, worked 1820.

CATERMEYER. Painted on flat glass, using gold background, on the signed portrait of a woman in the Arts and Crafts Museum. His signature is conspicuous. His work has been found as panels framed in small caskets.

CATLIN, MRS. 1870. 'Artist cutter at the Pavilion of Arts, base of the Rotherhithe Shaft Thames Tunnel.' Stencil label on the cut portrait of a woman looking left. (Plate 85.)

CAVALLO, TIBERIUS, F.R.S. 1749-1809. Natural philosopher, interested in experiments in aerostatics, and inventor of a machine for reducing profiles ; his own description of it is in a letter dated 24 June 1807 to Dr. James Lind : [1]

'Herewith you will receive . . . an instrument for taking profiles, which I have made for you having another for myself, which seems to answer very well. It consists of 2 pieces, viz. one containing a lens of long focus, and another containing a hole for directing the eye. . . . Pin a piece of paper upon the wall of the room, set a table close to it, and place 2 thick books straight up upon the table by way of stands, to hold the above-mentioned pieces. Let the person whose profile you want stand before it nearer or farther, according to the intended size of the profile, and against the light of a window, &c.'

There is a drawing of this machine by its inventor in the volume of Cavallo's letters [2] preserved in the British Museum. (Plate 69.)

CHAMBERLAIN, WILLIAM. Circa 1824. Itinerated in New England, cut hollow by means of a machine, cutting his profiles in duplicate, 'and these

are the ones he preserved ', writes his granddaughter, Mrs. F. McClure of Worcester, now living in Massachusetts. Eighty-nine examples of his work are to be seen at the American Antiquarian Society. He used neither signature nor stamp.

CHAPMAN, C. W. Cutter, 59 Oxford Street. Fine portrait heavily gilt painted, 1830, in possession of Mr. Kilner. Lady looking left.

CHAPMAN, MOSES. 1783-1821. Cut, painted and used a machine to produce hollow cuts. Itinerating, his work is chiefly found in the eastern districts of Massachusetts, especially near Salem. On his handbill, which I own,[1] are the silhouette portraits of a man and a woman, space is left for his address and the name of the town to be filled in wherever he worked : 'Correct Profile Likenesses Taken at Mr. . . . from 8 o'clock in the morning until 9 in the evening. Mr. Chapman respectfully informs the Ladies and Gentlemen of . . . that he takes correct Profiles, reduced to any size, two of one person for 25 cents, neatly cut on a beautiful paper. He also paints and shades them, if requested, for 75 cents ; specimens of which may be seen at his room. Of those persons who are not satisfied with their Profiles, previous to leaving his room, no pay shall be required. He makes use of a machine universally allowed by the best judges to be more correct than ever before invented. Those who wish to embrace this opportunity of having their Profiles taken, will please to make early application, as he will positively leave town on . . .' (Plate 67.)

In another advertisement he adds : 'Those who have taken them (Profiles) away without payment are requested to call and adjust the same immediately.

'N.B. Frames of different kinds, for the Profiles, may be had at the above place from 50 cents to 2 dollars each.'

His work either in cutting or painting is without distinction, correct.

Chapman painted in black and white and grey ; his numerous machine-cut profiles are cut hollow ; his silhouettes are sometimes to be found cut free-hand in black paper. His machine is now in the possession of Rev. G. T. Morse, who owns several of his trade labels found in the lining of a box cover. It is to this collection that I am indebted for information and for the gift of one of the labels and an example of Chapman's work.

In January 1808 Chapman's address was : 'Next to Mr. Morgan's shop in North Street, Salem.' In April 1808 he is at Mrs. Little's shop in Main Street.

CHARLES, A. 1785. A poor miniaturist and fine silhouettist. Address : 130 Strand, opposite the Lyceum. He painted on plaster, ivory or card, and is one of the few who mention enamel as a medium

[1] 'A forgotten group of Profilists,' by F. Gordon Roe, *Apollo Magazine*, Vol. XXII, No. 131.
[2] Brit. Mus. Letters, 2 vols. Print Dept. 1791-1809.

[1] See Chap. IV.

on his labels. He also painted 'Conversations', for which he charges 2s. 6d. to four guineas. He worked 'without the help of any glasses or any instrument whatever' and according to the Diary of Fanny Burney, 'Mr. Charles of the Strand, to the astonishment and satisfaction of several thousands of people, has, and continues to draw the Line of the Human Face in 3 minutes and that to resemble Nature in a curious correct and unimaginable manner . . . finishing in one hour by the watch.'

The advertisements and labels of Charles are most bombastic and he is guilty of a trick, calling himself 'Royal Academean' or signing R.A., obviously to mislead his patrons.

After being appointed Likeness Painter to H.R.H. the Prince of Wales, 6 November 1793, and taken 13,000 profile shades and miniatures, he raised his prices from 3 to 25 guineas for coloured miniatures, for shades 10s. 6d., framed 13s. Hours of attendance, 11 till 2. There is no necessity for persons to come with their hair dressed.

A fine label with lady silhouetted on the card runs thus : ' Profiles taken in a new method by A. Charles, No. 130 Strand, opposite the Lyceum. The original inventor on glass and the only one who can take them in whole length, they are also enamelled, and on Paper and Ivory, miniatures in bust, whole length or conversations from 2s. 6d. to £4 4s. They have long met the approbation of the first people and are deemed above comparison. Miniatures painted in a masterly manner for £1 1s. and finished in one day. N.B. Drawing taught.' (Plates 83, 84.)

Altogether he is amongst the first six silhouettists who of English exponents of the art have made the eighteenth century famous in silhouette history. A very beautiful portrait of Madame de Genlis is in the royal collection at Windsor. It is finely painted on card heavily framed in black and with a convex glass decorated with gold. This example was at one time in the Wellesley collection and wrongly marked as a portrait of Queen Charlotte. His signature is beneath the bust line—' by Charles or by Charles, R.A.' He did not always sign and his labels are rare, so that much work of inferior artists has been wrongly attributed to him.[1]

CHEARKLY, ANTHON. Cutter, 1744. The finest known example of the early English eighteenth-century thin paper cutting, shows a bust statue on pedestal of Marcus Tullius Cicero, in white paper. The whole statue is made up of arabesques and floral forms in which are mingled human heads, birds, cornucopia with minute features painted in *grisaille*, full length figures with microscopic embossing, occasionally names are placed in *grisaille*. The whole work measures 6½″ × 3½″ and is signed on the pedestal of the bust, Anton Chearkly, 1744.

[1] Banks Collection, Brit. Mus., Vol. v. Packet 2.0.2.3195.

CHENEY of Banbury. Signature on the portrait of a lady, early seventeenth century, wearing a strange helmet-shaped cap, illustrated Plate XXVIII in the book of *One Hundred Silhouettes* from the collection of the late Mr. F. Wellesley. This example was formerly in the collection of Lord Polworth.

Cheney sometimes cut in darkish brown paper which he afterwards painted and bronzed.

The label is 1½ inches square : ' Profiles—in miniature—J. Cheney—Banbury.'

CHESTERTON. Artist Cutter, nineteenth century. An example cut in black paper and bronzed is in possession of the author.

CHICKFIELD, MRS. Cutter. 1833. Address, Market Place, Norwich.

CHINE, S. Painter, eighteenth century, of Banbury.

CHOLLE, H. C. Cutter, 1920. Bold open designs, genre and subject cutting well executed. Some examples are to be seen in Victoria and Albert print room. Don Quixote and other examples, E. 2277, 1920. Occasionally coloured papers are used beneath the black, showing at the open lines.

CHRÉTIEN, G. L. Frenchman, born at Versailles 1754–1811. Musician and inventor of the physionotrace. He was first violin at the opera, a musician of the Chapel Royal, and conductor of the Queen's private concerts.[1]

The revolution depriving him of his profession, he began to use, as a means of livelihood, the portrait-cutting machine which he had invented for his own amusement. Its invention has sometimes falsely been attributed to Quenedey ; it is more likely that it was improved by Quenedey. Chrétien frequently engraved the portraits he had thus cut, sometimes in colour, sometimes with simple black filling. He completed an enormous number of these profiles. The original drawing of his machine is preserved in the Bibliothèque Nationale, Paris, together with many volumes of his profiles.

This new art of the physionotrace in Paris killed for a time the taste for silhouettes produced in older processes. Twenty years later the taste for them revived and persists until the present day.

Chrétien wrote ' La Musique etudue comme science naturelle, certaine, et court art ou Grammaire et Dictionnaire musical, Paris, 1811 8 '.

CLARK, WILLIAM. 1828–9. Profile Delineator, Ashet Place, Pickering. (Pigot's *Commercial Directory*.)

CLARKE, EDWARD DANIEL. Fellow of Jesus College, Cambridge, drew a silhouette portrait of Napoleon Bonaparte in Indian ink at the Military Levée held in the Palace at the Tuileries, Thursday, 2 September 1802.

This has been engraved by Tomkins, enclosed in a frame of sunrays and with Bonaparte's signature.

CLARKE, W. 1781, of Newcastle. Painted on

[1] See Machine, Chap. V., Plate 63.

plaster. Label on an example in the Wellesley collection :

' W. Clarke takes the liberty of acquainting Ladies and Gentlemen of Newcastle and Places adjacent that during his stay in Town he takes the most stricking Likenesses in Profile.

' So low as One Shilling each. Time of sitting only Two Minutes. He begs Leave to acquaint the Ladies that they need not be at the Trouble of getting their Hair dress'd as he finishes the Head in an elegant Manner entirely from his own Fancy : Old Shades reduced with Care and Expedition. He also executes Designs in Hair for Lockets, Rings, Pins, Bracelets, &c.

' Ladies and Gentlemen taught the art of Platting Hair so expeditiously, as to execute it in the most complete manner in only six teachings.'

This label was used in various towns. I have seen one in Harrogate instead of Newcastle, the work is painted on thin plaster layer over card, detail is opaque, never thinned. Fine work.

In Chester he advertises in *Adam's Weekly Couroux*, 19 September 1780. Likenesses in Hair.

CLUTTERBUCK. The name with Heraldry on a book-plate in a scrap-book containing fine large size silhouettes cut hollow. Unnamed, but indicated as the guest book of the Clutterbuck family. Date first quarter of the nineteenth century.

COKE, FRANCIS DESMOND TALBOT. D. 1931. Captain-Adjutant of the 10th Loyal North Lancashire Regt. from December 1914 to February 1916, when he was invalided home with ' Trench Fever ' which left his heart in a weakened condition. For the rest of the War he had to be content with doing school-mastering ; a position few men could have done so admirably. Always keen on Educational matters. Writer of novels and books on school life of which the best known are *The Bending of a Twig*, *The Worm*, and his last, *Stanton*. Novels written by him are : *Pamela*, *Herself*, *The Monkey Tree*, *The Pedestal*, amongst many others.

Perhaps as a collector he was best known. His collection was both large, varied, and invariably good.

He had a great flair as connoisseur and collecter and wrote on well-defined lines. *The Art of the Silhouette* (Martin Secker), *Confession of an Incurable Collector* (Chapman & Hall), largely concern the subject of this book.

He presented to the Victoria and Albert Museum a collection of eighteenth-century silhouettes in 1923. On his death in 1931 the collection of drawings and water-colours by Thomas Rowlandson was the most extensive to come into the market for many years, twenty of the best being left to the Victoria and Albert. His pictures by modern artists in which examples by Paul Nash and S. H. Sime appear, were also sold.

His collector's mark up till 1914 was a small black print of a cupid with bowed head, originally cut by Princess Elizabeth, daughter of George III. His later label was a small print of a man in eighteenth-century dress, holding a carved figure in his hand, by Lovat Fraser ; beneath are the words ' Collection of Desmond Coke.' (*See* Plate 75.) The original is now in my possession.[1] These two marks will be found on all silhouettes once in Captain Coke's collection and give assurance of undoubted authenticity of any object to which they are attached.

COLLES, J. In the *New York Gazette* and the *Weekly Mercury*, 9 November 1778, this silhouettist advertises Miniature Profiles, No. 20 Golden Hill, opposite the sign of the Unicorn. ' J. Colles having had the honour of taking off the profiles of many of the Nobility of England and Ireland, begs leave to inform the Ladies' and Gentlemen of New York that he takes the most Striking Likenesses in Miniature and Profile of any size at so low a price as 2 Dollars each framed and glazed. A specimen only, which may be seen at Hugh Gaine's, can furnish an idea of the Exhibition. Hours of attendance from 10 o'clock in the morning till 4 in the afternoon. It requires only a moment's sitting.'

The same advertisement appears in the *Royal Gazette*, 10 May 1780, with additional N.B. ' He has a few machines made on an entirely new plan for reducing Likenesses, &c., which he will sell at 2 guineas each with which he will instruct the purchaser the use of them and the whole art of reducing figures to any size.'

COLLINS, MRS. 1777. Late pupil and assistant to Mrs. Harrington and now her partner, takes ' Likenesses in Miniature ', from the *Leicester and Nottingham Journal*, 24 May 1777. In Bonner and Middleton's *Bristol Journal*, 14 February 1778 : ' Mrs. Collins joint Patentee with Mrs. Harrington commences on this 17th February to take Likenesses which any outline of nature can possibly afford.

' Miniature likenesses from shadow in profile. Time of sitting no more than 1 minute and but 1 sitting required. Price half a crown.'

COLLINS, MRS. By H.M. Letters Patent. Late pupil and assistant to Mrs. Harrington ' who has the honour of taking Profiles of the Royal Family, &c., is now making a tour of the whole Kingdom, having purchased a moiety of that Lady's Patent. Price 2s. 6d. Time of sitting 3 minutes. Coventry, Warwick, Wolverhampton, Litchfield and Derby, will be visited. Adverts. *Birmingham Gazette*, 6 January 1777.'[2]

COMBES. Cutter, Derby. Cut the portrait of the Duchess of Bedford.

COOK, JANE, E. Cutter, 1890. Subject-pieces cut out of white paper and embossed from the back by varying sized needles and stilettos were chiefly done by this skilful worker. Sometimes the em-

[1] See *Some Moderns*. [2] Buckley.

bossing was done in such high relief, with additional ornament superimposed, that the effect was that of shell cameo. Classical subjects after Wedgwood were done, and extracts from the *Ingoldsby Legends* illustrated, the latter were reproduced for private circulation.

Another subject was 'The Sculptor caught napping', 1899.

COOMBE. 1833. Painted full-length silhouettes.

COOPER. 1833. Signature on portrait of a man painted on card in red-brown, bronzed, in the Knole Collection.

COOS. 1782–1812. Signature on woman's profile on glass backed with gold, oval mounted on silver shield, surmounted by silver vase and garlands;[1] on the vase are the words 'Pensez a moi'. This example was in the possession of Lady Sackville Knole, now owned by Mr. Perkins.

COTTU. 1811. Frenchman, emigrated to America early in the nineteenth century, and worked there in the methods most popular in France, namely in water-colours, sometimes in black, sometimes in colour; with gold or silver backing, of which I have seen an example in the collection of Rev. Glenn Tilley Morse. In a Providence newssheet found by Mrs. Carrick his prices are given under date 28 January 1812.

'Mr. Cottu Respectfully informs the Ladies and Gentlemen of the town of Providence that he continues to take Likenesses at his Room, next door to the Post Office at the following prices :

'Profile cuts	25 cents.
Ditto shaded black	75 ,,
Ditto gilt on glass or painted in natural colours	$3.00
Full faces	$8.00
Miniature on Ivory . . .	$15.00

' Frames of all kinds for sale. |
' No Likenesses No Pay.

' Those who wish to see specimens of his work will please call at his Room where he gives constant attendance. Mr. Cottu also takes this opportunity to inform the Ladies and Gentlemen that he teaches the French language and Drawing and that his schools for that purpose are open for 2 days alternately for each of these branches every week. He will also attend on Private Schools.'

CROWHURST, GEORGE. 1832–4. 40 Old Steine, Brighton. Address on woman looking right, painted on card, hair with light dress shaded white. Gold necklace and ear-rings, and sometimes gold beneath a grey white drapery. Profiles taken and finished in Black Bronze, Blue-tint cameo and coloured by Crowhurst, 40 Old Steine, Brighton. Profiles accurately copied and every description of frames for mounting. Profiles and miniatures.

[1] *History*, Nevill Jackson, p. xxi.

On portrait of ensign, afterwards Colonel H. J. Daniel, Coldstream Guards, the number 11 Old Steine, Brighton.[1]

Crowhurst uses formula occasionally with regard to such drapery resembling the work of his neighbour in Brighton, T. Neville in 4 Pool Lane, namely body colour crossing the neck-line in ruffle outline with a charming effect.

CRUIKSHANK, ISAAC ROBERT. 1789–1856. A fine painted picture of a Mameluke in silhouette on an elaborately accoutred horse is signed I. Cruikshank. The background in wash is appropriate with pyramids in the distance. Isaac Cruikshank was at first a midshipman in the East India Company and later devoted himself to painting miniatures, book illustrations and caricatures.

In the British Museum there are drawings by him which may be studied.

CUMMINGS, R. K. Painter and cutter, address 60½ Court St., Boston, Mass. Room No. 8, upstairs. This is written at the back of a card on which is a black cut profile of Mr. E. Fletcher, 31 January 1843. The portrait is finely bronzed. Another specimen is in the possession of Rev. G. T. Morse; it is painted black with bronzing. At the back is 'R. K. Cummings, Profilist'. I have seen several other examples in the Morse collection.

CUSTIS, ELEANOR PARKE. 1779–1852. Daughter of John Parke Custis, son of Martha Washington by her first husband. Born at Abingdon, Virginia, she was adopted by President George Washington and living at Mount Vernon in 1798 she traced the shadow profiles of her grandmother and her stepfather, rather larger than life-size, filling them in with black she achieved the silhouette portraits of which we are able to show a reproduction owing to the kindness of Rev. G. T. Morse. (Plate 53.)

These portraits came into the possession of Miss Eleanor P. Lewis at Woodlawn, July 1832, and were presented by her to Edward Shippen of Philadelphia.

They were destroyed by a fire about 1920 which took place at the Everett School, Boston, where they had been placed by Mr. Shippen.[2]

There are no other records of silhouettes by Eleanor Parke Custis. She died at Audley, Virginia.

D

" D'ACHE, CARAN." 1859–1909. French. Black and White artist and caricaturist. He was not primarily a silhouettist, but executed a few black profile portraits, &c., of great interest. [EMMANUEL POIRÉ.]

DAER. Cutter, Montpelier, working 1927. Cut the portrait of Basil S. Long (1881–1937). Keeper

[1] *Miniaturists*, B. Long.
[2] Information by the Headmaster of the Everett School, Boston.

of Prints and Miniatures and Silhouettes at Victoria and Albert. (Plate 80.)

DANILOW, K. 1850. Russian cutter. When he left the college of St. Petersburg he had cut 22 portraits of the professors on the staff; these have been reproduced by M. Moltchanow in his *First Years of the State School of St. Petersburg*, published in 1892.

DARBYSHIRE, A. Mentioned in the *One Hundred Silhouettes*, portraits belonging to Mr. F. Wellesley's Collection, now dispersed.

DASHWOOD, LADY. 1795. Cut subject pictures for illustration in *The Birth and Triumphs of Cupid*, published 1795.

DAVIES, J. H. Did good work in New Hampshire, U.S.A. Examples owned by Rev. G. T. Morse are full length and are set in coloured backgrounds. The names and ages of his sitters are noted.[1]

DAY, AUGUSTUS. Circa 1833. Painter and cutter, probably worked only in and near Philadelphia. Worked sometimes in black, occasionally cut green paper and bronzed. Signature ' Day fecit ' and on his machine work ' Day's Patent '. I have seen some of his profiles at the Library of Congress, Washington, U.S.A.

DAY, T. F. 26 Frances Street, Newington Butts, 1844. Example of his work is in the Canning Museum, Walworth Road. Good work.

DE COCQ, C. 1842. Dutchman. Painter. Signature on painted silhouette of Madame Capadose, *née* Mendes da Costa, the Portuguese wife of Isaac Hain Capadose. Details are marked with white and grey paint, the lace cap is very elaborate, and carefully done. This silhouette was taken in Holland,[2] and is in the possession of Mr. Capadose, who owns several other Dutch silhouettes which unfortunately are unsigned. One of them, a shadow portrait of Wm. Jacob van Hogtenia, is painted on card, another of Johann Gerard van Angebeck, 1816, 1834, son of the Governor, when Ceylon was a Dutch colony.

There are some minutely cut flowers in a small family album of mid-nineteenth century date. These were done by a member of the Capadose family at the home of Huislen Noat van der Houven.

DE HART, SARAH. 1783, of Elizabethtown, New Jersey. Cut the portrait of George Washington in Philadelphia. This was presented by Mrs. Washington to ' Lady ' Kitty Duer, daughter of the claimant Lord Stirling, and shows an all-black cutting of the President with the wig and shirt frill—the lower line is above that usually shown which gives it a shortened appearance.[3]

DEIWEL, F. Signature on silhouettes cut out of black paper and details, hair, lace, &c., drawn afterwards so that the veil on the lady's high dressed hair,

her lace and the gentleman's cravat and hair ribbon on his wig are well represented. Two of his portraits are of Councillor von Scharff and his wife Therese.[1]

DELANY, MARY. *née* Granville, 1700–88. Worker in cut paper. Her remarkable collection of nearly 1,000 different varieties of cut paper flowers begun in 1774. After gaining experience in the quaint rolled paper-frames, caskets, tea caddies, &c., which had delighted and intrigued members of the Court of George III.

There are eight volumes of the *Paper mosaick flowers* [2] which are mounted on black paper, a page is often signed M. D., and occasionally a specimen is dated. Her inscriptions also delight the eyes of research on account of their lucidity.

' Plants copied after Nature in paper Mosaick begun in the year 1774.

> Hail to the happy hour ! When Fancy led
> My pensive mind this Flow'ry path to tread.'

The work is also a tribute to her second husband, recently dead, for she continues :

' This paper mosaick work was first begun in the 74th year of my age, which I at first only meant as an imitation of an *Hortus Siccus* as an employment and amusement, to supply the loss of those that had formerly been delightful to me ; but had lost their power of pleasing ; being deprived of that Friend, whose partial approbation was my Pride and had stamp't a value on them.'

These words allude to Mrs. Delany's second husband whom she sincerely mourned. Born a Granville she married firstly, against her will, Alexander Pendarves of Loscrow, Cornwall, a man twenty years her senior whom she met at the house of her uncle, Lord Lansdown. Her second marriage to Patrick Delany (1685–1768), friend of Sheridan and Swift, an eminent preacher, was a very happy one ; she was left a widow in 1773. She remained a *persona grata* at Court. Both King George III and Queen Charlotte visited her in her small house at Windsor given to her by the King, together with a pension of £300 a year in 1785. Doubtless Princess Elizabeth, herself an expert cutter (*see* Chap. III, Plate 50), would be specially interested in Mrs. Delany's work.

The preface in the first Folio is signed ' Mary Delany, Bulstrode, 5th July, 1779 '.

The specimens are mounted on black paper and are of natural size, each is signed ' M. D.' in the right corner in a different colour, according to the varying years of execution, some are painted red, others of the red initials are cut out of red paper, others are yellow or blue.

The Latin name of the flower is clearly written and pasted on the page, other details are noted on

[1] Information, Rev. G. T. Morse.
[2] Information, Mr. Capadose.
[3] Information, Carrick.

[1] J. Leisching. [2] Folios at Brit. Mus.

the back. The date is given when finished, the name of the plant repeated, where it was grown and occasionally the name of the friend who gave it.

Madame d'Arblay describing the mode of work in her diary : ' Then she (Mrs. Delany) showed us the new art which she has invented. It is staining paper of all possible colours and then cutting it out so finely and delicately, that when it is pasted on paper or vellum, it has all the appearance of being pencilled, except that, by being raised, it has a still richer and more natural look.'

Another contemporary author tells us that in the progress of her work Mrs. Delany pulled the flower in pieces and having cut her papers to the shape of the several parts she put them together, sometimes overlaying one transparent piece over another colour to soften it. (This was the method of the Persian and Egyptian cutters of the eleventh century.)

This indefatigable lady wished to complete 1,000 specimens, but her sight failed and this number is short of twenty.

In 1782, St. James's Place, there is an entry which foreshadows the end :

' The time is come I can no more
The Vegetable world explore.'

Mrs. Delany also painted miniatures and worked in hair.[1]

DE LA VEGA, P. L. A Spanish cutter, 1775. He exhibited a portrait of Her Royal Highness Princess Royal in 1775, the inscription and dedication cut with scissors.

DELOIST. Signature on cut portrait of Napoleon I, sold at Knight, Frank & Rutley, London, December 1911.

DEMPSEY, J. Cutter and painter, 1830. Both these processes were sometimes used on the same portrait. He cut the outline, then covered the surface with paint, not flecking with gold or colour here and there, as was the custom with many of his contemporary works, but laying on flat colour and shading it. In his miniature work for lockets, rings, pins and boxes he used the brush alone.

According to an advertisement in the Birmingham local press his address in that town in 1840 was : 128, Snow Hill.

His portraits were taken for ' one shilling in one minute, Frame and glass included '.

He was the lowest priced silhouettist, obviously intending to work at a cost below his rivals. ' Likenesses in shade 3d., Bronzed 6d., Coloured 1s. 6d. ! ! and upwards.' He suggests ingenious reasons why people should come to him for their portraits. Thus in Liverpool where great ships start on their voyages, he reminds ' Emigrants, Travellers as well as the Public that the penny postage offers a safe and cheap method of sending mementoes '.

[1] Dic. Nat. Bio.

Dempsey worked in England, Scotland and Ireland. His itinerary can be traced by advertisements. In Birmingham, Liverpool, Manchester, Dublin, Limerick, Edinburgh, Aberdeen, Dundee, Glasgow, Leeds, Whitehaven, Bristol, Bath, &c., he advertises : ' Upwards of 1,000 Silhouettes of Public characters.'

Rivalry with other cutters is constantly indicated. ' Observe it is Dempsey's.' It is probable that Edouart's bitter remarks in his treatise published in 1835 against the folly of using colour in black shade work, were directed against Dempsey's methods— the two men were constantly working the same country in the same towns, so that his holding up to ridicule Dempsey's gold ear-rings, coral necklaces, &c., would militate against his rival. We know that though in America Edouart, in a very few portraits, added pencil lines to indicate contour, he was consistent in never adding colour.

Nevertheless Dempsey's coloured silhouette work reveals great charm, so that perhaps the fault is condoned. In women's portraits he excels, and his Quaker girl in cool greys, high mob cap and a hint of bronzing, shows us beauty and restraint, the signature is ' J. D.' In The Whip Seller, owned by the late Mr. Henry Sleeper, Gloucester, Mass., we saw a fine study in brown, heavily bronzed. In the painting of hair Dempsey reminds us of the white and grey treatment of Wm. Henry Brown, the American silhouettist who was working in the United States at the same time.

Alone amongst English silhouette workers Dempsey painted miniature full-length figures which one occasionally finds on boxes or rings—in the track of his visited towns. That these tiny affairs were portraits is proved by my full-length Sir Robert and Lady Peel. Miss Martin of New York has a portrait of Queen Victoria : the size of a pea, it is set in a quaint round locket of the period. These minute jewel portraits are never cut.

He worked at Liverpool for some time on the figures used in building up his remarkable ' Cotton Exchange, Liverpool ', where on the Flags the cotton merchants met to do business. In a pattern or scrap-book of Dempsey's I have several of these coloured figures named. There are in it many types of work, some in the style afterwards imitated by the Dightons. The figures are generally full length, measuring about 10 inches, the face and hair and dress in natural colours ; they are mostly set in elaborately painted landscape background.

On a group picture of this type two musicians in their cut-away coats and brocade waistcoats of the Dickens period, is the signature : ' Jho. Dempsey. Pinxt. Sept. 1842.' Two children holding flowers and bird are elaborately stippled. Surely his price must sometimes have been increased.

Indian-ink portraits in bust size are given ;

'Stippled Miniatures' on card 8″ × 6½″, and some very fine heraldic work in correct tinctures, the Achievement of Arms of the Duke of Sutherland and that of Lord Ferrers Townsend being excellent. My book was evidently used to show his work to intending sitters, for he strictly remarks on the first page : 'Whoever uses this book will please keep it *flat*.' (Plates 31, 32, 33, 34, 66, 85, 86.)

DENON. Frenchman. 1745–1825. Engraver of decorated mounts for silhouettes. He was at one time General Director of French Museums and specialized in engraving after Rembrandt's pictures.[1]

[2] **DENON,** DOMINIQUE. Medallist, engraver, silhouettist. Born Châlon-sur-Saône ; died in Paris. He accompanied Napoleon to Egypt. His silhouettes are mounted, with elaborate borders.

DERJAVINE (*see* Bastidon).

DESTINU, MRS. End eighteenth century. 'Profiles taken here at 2s. 6d. each,' on the advertisement sheet showing three ladies and one man from the Knole Collection, late in the possession of Miss M. Martin, New York, reproduced in Histor's *Silhouettes*.

DESPREAUX, T. E. An example in the collection of the late Mr. Francis Wellesley.

DE VITRE, HENRY. Painter On the portrait of a student dated 1849 is the name Carl Woller by Henry De Vitre. The portrait is all black on a shiny card.

DEWEY. Fl. 1800. Name on silhouette of Ambrose Clarke, in the possession of Mrs. Wm. A. Fisher, U.S.A. In the catalogue of the Miniature Exhibition held under the auspices of the Maryland Society of the Colonial Dames of America January,[3] 1911, at Baltimore, occurs this entry : 'Silhouette of Mrs. William Graham by Dewy, Loaned by L. M. Gunby of Salisbury, Ind.'

In 1810 an advertisement appeared in a Baltimore newspaper. 'S. Dewey paints profiles and miniatures in various styles.'

Mr. T. Bolton considers that the silhouettist may be identical with Silas Dewey, a portait painter, Vulcan Alley, Baltimore, in 1814–15.

DEYVERDUNS. Eighteenth-century silhouettist.

DIEFENBACH, K. W. 1852–1914.[4] Painted friezes for house decoration. 'Divine Youth' and other subjects in silhouette show graceful figures with much action ; his work was usually filled in by his pupils.

DIETERS, HANS. Cutter, nineteenth century. A portrait of Bismarck, with two of his great hounds, used as an illustration in *The Revival of the Silhouette*.

DIXON, JOHN. In *Bath Directory*, 1826, he is described as miniature and profile painter of Northumberland Place which was also his address in

1819–22, quoted in *British Miniaturists* on the authority of Mr. F. Gordon Roe, and probably husband or brother of M. Dixon below.

DIXON, M., of Bath. Painted in black and grey on a portrait in Victoria and Albert Museum. Label : 'M. Dixon | Miniatures and Profiles, | 7 Northumberland Place, Bath. | Miniature from 7 guineas. | Miniature on card £1 1s., | Coloured on Ivory, £1 11s. 6d., | Cameo Profile on Ivory £1 11s. 6d., | Bronze Profiles 5s., | Black shaded Profile 2s. 6d., | Black shade 1s. | Exclusive of Frames and glass.'

This label is also on a black profile in the possession of Mr. H. Draper, Leamington.

The bronzing is usually slight, a shadow beneath the bust-line is characteristic and here the signature is placed, as Adolphe of Brighton wrote his name.

Another address is that of Dixon, Long Room, White Hart Inn, Old Flesh Market. Label : 'Striking Likenesses cut with common scissors in a few seconds, without drawing or machine or another aid than a mere glance of the eye.'

Until further evidence is found it is impossible to say if these two labels refer to the work of the same man as silhouettists often both cut and painted.

DOHREN, JACOB VON, of Hamburg. Circa 1790.[1] Made shadow portraits from life or reproduced from sketches supplied, portraits of any size. His process of reproduction is mentioned in the book on 'Bon Magic'. Examples of his work are in the possession of Dr. Lutteroth at Hamburg. His payment was about equal to 8s. for two dozen. This fact is in the Year Book of the Kippenberg Collection.

DOOLITTLE, A. B. American. Circa 1807. Painter on glass, gilt background. 'A. B. Doolittle fecit' on a portrait at the American Antiquarian Society in Worcester, Massachusetts, possibly the portrait of his father, Amos Doolittle, 1754–1832, of New Haven, an American engraver. In Mr. Fieldings' *Dictionary* there are no fewer than five artist engravers and etchers of this name. A. B. Doolittle's advertisement reads thus : 'Miniatures painted and set in handsome style. Profiles accurately taken and all kinds of devices painted and set.'

DOOLITTLE, S. C. Profile machine cutter of South Carolina, signature 'S. C. Doolittle'. His work is unimportant. Two portraits by him were shown at the Charlestown Museum. His date is probably the first decade of the nineteenth century as his sitters wear wigs and have ruffled shirt-fronts. A hollow cutting by him is in the Library of Congress, Washington, D.C., the portrait of a son of Judge Breckenridge.

DOYLE, WILLIAM M. S. D. 1828. Portrait painter, son of a British officer born in Boston, Massachusetts. With Daniel Bown the silhouettist he became associated with a museum opposite the

[1] *Conn.*, Nov. 1928. [2] *Miniaturists*, B. Long.
[3] Cat. of Min. Ex. of M.S.C.D.A.
[4] Rep. M. Knapp, p. 75.

[1] Vic. & Alb. Mus., p. 69, 1924.

'Bunch of Grapes' Tavern in State Street. This was afterwards removed to a hall over the schoolhouse in the same street, later to Tremont Street, where a fire occurred in 1803. Yet another fire disaster necessitated new premises, the partnership was dissolved, and on Doyle's death in 1828 he was proprietor of Columbian Museum, Boston. Amongst his portraits are those of Governor C. Strong and John Adams. He painted miniatures on ivory. In silhouetting he apparently used one of the cutting machines in vogue at the time in Massachusetts, touching the surrounding card with Indian ink outline. He also painted miniatures on ivory in colours and occasionally 'on plaster in the manner of the celebrated Miers of London'. I have not seen one of this genre. His signature 'Doyle' is sometimes incursive, sometimes in block lettering. His price from 25 cents to 1 to 5 dollars. On one occasion he advertises his profiles as cheap New Year Gifts, a handsome shade or 4 plain cut for 25 cents, framed 1 to 3 dollars.

A portrait of a lady by William M. S. Doyle cut hollow by machine and elaborated with Indian-Ink, line work. (Plate 59.)

DRISCOLL. 1830. Label: ' Portraits and fancy subjects. Black shaded Profile 2s. 6d., Black shades 1s., Exclusive of Frames and glass.' Worked in Ireland.

DUBOURG, M. Engraver. Translated all the 25 full-page designs, 18″ × 13″ in the large folio volume published by Edward Orme about 1810.[1]

The title-page runs thus : ' Introduction to the Art of Cutting Groups of figures, flowers, birds, &c. In black paper, by Miss Barbara Anne Townshend, London.'

The introduction giving instructions as to paper, scissors, cutting, &c., occupies one page, and M. Dubourg's plates are of the following subjects, black with white lines indicating form and detail ; Greek influence is marked.

1. Two ladies with children in a garden. |
2. Six Dancing figures round a maypole. |
3. A spray of passion flower with butterflies. |
4. Six cooks and scullions at work in a kitchen. |
5. Six figures male and female in fancy dress. |
6. Four studies of birds, parrots, pheasant, &c. |
7. Three vases pseudo-Greek design. |
8. Six witches in consultation, broomsticks, cats, &c. |
9. Six female figures in pseudo-Greek dress. |
10. Dancing figures in Greek dress with cupids. |
11. Ivy spray vetch and butterflies. |
12. Ladies in Greek dress with children and dogs. |
13. Four men in eighteenth-century dress, two women dancing. |
14. Three vases pseudo-Greek design. |
15. Vintage, five figures, goat, &c. |

16. Scotchman in tartan, boy with harp approaching a ruin. |
17. Six women and children. |
18. Birds and nest, ruined arches. |
19. Ivy spray, butterflies. |
20. A peep show, three adult, three children's figures.

This book is now exceedingly rare, single pages are occasionally to be found, but the complete book should contain above list, which is specially given in order to verify.

DUDLEY, D. Cutter. 1881. Label : ' D. Dudley, Station A, Boston. The great Lightning Artist, 1881.' Amongst a number of specimens owned by Rev. G. T. Morse, 1887, is the latest date. This silhouettist itinerated, attending fairs and exhibitions.

DULFIELD, JAMES. Painter on glass. Paragraph in the *London Chronicle* 21 April 1759. ' James Dulfield lately died at Brentford.'[1] Esteemed the greatest artist in Europe for painting on glass.

DUMPLE, A. Advertisement and label on an example in the Wellesley collection.

DUTTENHOFER, CHRISTINA LUISE. 1776–1829. A German cutter, accompanied her husband, the engraver, to Rome. She was well known in artistic circles, where her sharp tongue and busy fingers led to the description of her as the ' Cutter and Pricker '. In the January number 1909 of *Westermann's Monthly Magazine* many of her silhouettes are reproduced. Some of the originals are now in the Schiller Museum, Marbach. A slight tendency towards caricature marks her work, and a very elaborately cut carpet pattern in correct perspective is also characteristic. The inevitable Goethe portrait shows both these distinguishing marks of her skill.[2]

E

ECKERT, J. A. 1807–68. Silesia. Cut genre pictures and portraits, sometimes pricking at the back. He worked in a sealing-wax factory and later itinerated, selling his silhouette work. A series of sheets have been reproduced.

ECKSTEIN, W. 1863. Free-hand cutter in black and coloured papers. His ' Crucifixion ' is an interesting piece of silhouette work.[3]

EDOUART, AUGUSTIN AMANT CONSTANT FIDÈLE. B. 1789, d. 1861. French *émigré*, free-hand cutter of portraits. Born at Dunkerque, he was the sixteenth child. His mother died when he was seven years of age ; four of his brothers sacrificed their lives for their country, Edouart fought in the Napoleonic wars and was decorated.

At nineteen years of age he was ' managing a

[1] *Conn.*, Vol. 74, 1926.

[1] Buckley. [2] Rep. M. Knapp, pp. 40–3.
[3] Rep. M. Knapp.

china factory, where 120 men were employed ', thus he writes in a letter to Miss Hutton.

He came to England in 1814 having married Mademoiselle Vital, by whom he had five children. The teaching of the French language being unsuccessful in providing sufficient income, Edouart practised the art of Hair work, not only in the fine plaiting and floral ornament of the day, but in modelling portraits in wax and embedding the natural hair so that the animals had a lifelike appearance.[1]

At this time he began that careful naming and dating of his portraits which has made his work world famous.

Though most of these strange canine models have probably long since decayed, one reads of them in his catalogue below, when he exhibited all his work during his professional travels.

In 1815 he had a 'Portrait of a horse' number 680 in the Royal Academy : his address was given, Rathbone Place.

In 1816, portrait of an old man, address, 17 Wardour Street. Also No. 734 in catalogue, portrait of dogs ; 735, portrait of a dog.

In 1817, portrait of an old man besides other portraits of dogs. All exhibited in the Royal Academy.

I have an interesting sketch by Edouart in sepia, this is of the type of work he used in his sepia sketches of North American Indians taken later in America.

Edouart also made pictures with human hair, of which he gives a long account in his treatise ; he says : ' They resemble the finest engravings ', and declares that one of these took him three years to complete, ' it was made of hair in natural colour and when not fine enough the hair was split '.

Thus was his eye and hand trained for the portraiture whose line was perfect to the breadth of a split hair. No wonder that he became the most sympathetic and accurate silhouette cutter the world has ever seen.

The death of his wife made it essential that a fresh interest should occupy Edouart's mind, which was always prone to pessimism, and in 1826 he accidentally discovered his facility for catching a likeness.

The story of this is fully set forth in the *History of Silhouettes* [2] and *Ancestors in Silhouette*,[3] and from this date he continued to exercise his talent to the exclusion of all other work, 1826.

Doubling his black paper, partly for the sake of stability, he cut the portrait in two minutes after a glance at his sitter's features, pose of shoulders and limbs. He maintained there was much individuality in hands, and disliked working at anything short of the full figure. The client having departed with his silhouette, Edouart wrote the name, date, and address at the back of the second portrait of his double, then gumming it on to a folio page, wrote the details

again beneath, thus he acquired a huge number of correctly catalogued portraits, which he kept for exhibition purposes and for future reference, as a photographer keeps his negatives.

Working thus, Edouart itinerated throughout England, Scotland and Ireland, advertising in the local press in each town ; so that we can trace his journeys from old newspaper files.[1]

Early in 1826 he was at Bath, lodging with Mr. Price the auctioneer and appraiser at 14 Old Bond Street. He illustrates with his usual vigour the Bath of Pickwick, Tupman, Snodgrass and Winkle, of old Lady Snuphanuph, Lord Mutanhed and Bantam, M.C., but it was without Dickens's spirit of fun that Edouart worked. He cut his portraits with exactitude but with no levity or caricature.

The late Captain Desmond Coke in the *Art of the Silhouette* writes, ' where Edouart was quite supreme, is in his sense of character. This accounts for his success in studies of child-life. He had the first gift of a portraitist, he could portray and explain in a single illuminating moment. We know an Edouart subject as we know a Sargent : the soul is there no less than the mere shell. Edouart had a fine control of the scissors, but he had more than that, he had an eye for important feature. None of his portraits it may be fall definitely beneath the head of caricature, yet in many of them he good-humouredly betrays the human weakness, under an expression.'

In 1826 Edouart's silhouettes were a good deal larger than later on, a full length often measured 12 or 13 inches ; it was not till late in 1827 that he adopted what he calls ' the military standard '—from that time, till the end of his life, his portraits measured 7½ to 8 inches or less, varying only with the height of the individual, except with his miniature work.

He visited Oxford and Cheltenham. In his library, depicted in the frontispiece of his treatise, a folio is marked Oxford, but no such volume was saved from the wreck of which I write below.

Here is an early Bath label :

' Likenesses in Profile. | Executed by Mons. Edouart. | We beg to observe that his likenesses are produced by Scissors alone, and are preferable to any taken by Machines, inasmuch as by the above method, the expression of the passions, and peculiarities of Character, are brought into action, in a style which has not hitherto been attempted by any other artist. Proof specimen may be had as above. | Full length 5s. | Ditto children under 8 years of age 3s. 6d. | Profile Bust 1s. 0d. | Duplicate cuttings to any quantity are for each full length 3s. 0d. | Ditto children 2s. 6d. |

' At Mrs. Price's, 14 Old Bond Street, Bath. Attendance abroad, Double.'

[1] *Conn.*, 1925. [2] *Conn.*, 1911.
[3] Bodley Head, 1926. *Ancestors.*

[1] Bodley Head, 1926. *Ancestors.*

Further stages in his itinerary may be traced by Newspaper advertisements.

Cheltenham Journal, June 1829. Address : 3 The Colonade.

Scotsman, Edinburgh, February 1830. Address : 72 Princes Street.

Evening Courant, Edinburgh, May 1830. Address : 72 Princes Street.

Scotsman, Edinburgh, February 1831. Address : 72 Princes Street.

Glasgow Herald, December 1831. Address : Queen Street.

Glasgow Free Press, December 1831. Address : Queen Street.

Glasgow Free Press, October 1832. Address : Queen Street.

Being in Edinburgh in 1832 he was invited to Holyrood Palace to amuse the Royal circle in the evenings, Charles X of France being there at that time during the second Exile. Every member in the suite and entourage was taken, including the Dauphin, the Dauphine, Madame Gontaut, the Duc de Polignac, and other ministers ; even the King's *valets de chambres*, and his confessor were taken.

This fine series, 78 in number, many portraits having the height, the date, autographs of the sitters and other details, were purchased by the Bibliothèque Nationale, Paris, from me, and it was interesting to see that the 10 years' old Dauphin Henri, in a volume at the Bibliothèque, had tried to copy in pencil and black chalk some of his own and his playfellows' portraits by Edouart. This pathetic little sketch is in a portfolio of childish drawings. I have retained one group of the King and his immediate relatives which were in duplicate. (Plate 88.)

When in Dublin, where Edouart's address was 27 Westmorland Street, he held an exhibition of his works, as he had already done in other stopping places. In the catalogue there are 15 models of animals with natural hair on wax foundation, other hair works were 45 in number.

It is, however, with his silhouette work we are chiefly concerned here. The following is the complete list in brief, omitting Edouart's long explanations of each subject.

DESCRIPTIVE CATALOGUE OF MY EXHIBITION.

No. 1. *Royal Exchange, London* . . . where Rothschild . . . and others are engaged in business. (The Rothschild portrait shows the great man standing with his back to the pillar as he stood when he financed the Peninsular Wars. Arliss has made us familiar with this pose in his cinema picture (Plate 91).)

No. 2. *Stock Exchange, London*, with its members. (Duplicates of these portraits are now in the library of the Stock Exchange and show many of the members in riding-kit, as they rode to their offices from the outskirts of London.)

No. 3. *Monsieur Edouart's Rooms in London* thronged with public characters.

No. 4. *The Rev. Charles Simeon of Cambridge* preaching, in 9 different attitudes (Plate 89). His centenary having been recently celebrated, one of this series of portraits was acquired by the authorities for presentation at Cambridge.

No. 5. *The late Rev. Edward Irving.*

No. 6. *Monsieur Edouart's Family in a garden.*

No. 7. *The French Royal Family, Charles X* at Holyrood Palace. These are the four figures, the remainder with 78 members of the Suite were bought from me by the directors of the Bibliothèque Nationale Paris. *See* Conversations, Plate 88.

No. 8. *The Temptation of St. Anthony*, with monsters, imps, goblins and fairies. (This must have resembled Edouart's satire on his adverse critics of Cheltenham which is in my possession.)

No. 9. *Four Scottish Chieftains.*

No. 10. *The officers of the 90th Regiment Light Infantry.* (This picture 4′ 8″ long was exhibited at the Rochdale Free Library Exhibition in 1913.)

No. 11. *Royal Exchange, Glasgow*, with eminent public characters.

No. 12. *The Presentation of the Sword of the Dey of Algiers to the Duke of Bourdeaux as Henry V*, taken at Holyrood Palace.

No. 13. *Eminent Actors, Musicians, &c.*

No. 14. *A View of Jesus College, Cambridge* : a moonlight effect.

No. 15. *Royal Crescent, Bath*, with beggars, boys, sedan chairs, &c.

No. 16. *High Street, Cheltenham*, with well-known characters.

No. 17. *The Top of Park Street, Bristol.* Horsemen, a bull and crowd.

No. 18. *Mrs. Hannah More at Barleywood Cottage*, Bristol, 12 June 1827.

No. 19. *Sir Walter Scott in his Study at Abbotsford*, 1831.

No. 20. *Skirmish.* A Troop of Hussars attacking a French outpost. (I have a miniature of this subject in my album of Edouart's genre pictures.)

No. 21. *The Murderer.* In Edouart's genre album in my possession.

No. 22. *John's Funny Story.* In Edouart's genre album. Plate No. 10 in the treatise.

No. 23. *The Good Match.* In Edouart's genre album. Plate No. 4 in treatise.

No. 24. *Jealousy.* In genre album.

No. 25. *The Night Mare.* In genre album.

No. 26. *Drunkenness and Derision.* In the genre album in my possession.

No. 27. *The Juvenile Plunderers.*

No. 28. *The Drunken Irishman.* In the genre album in my possession.

No. 29. *Past 12 o'clock.* In the genre album in my possession.

No. 30. *The Connoisseur.* In the genre album in my possession.

No. 31. *Devotion.* In the genre album in my possession.

No. 32. *Grandpapa's Surprise.* In the genre album in my possession.

No. 33. *The Hard Bargain.* In the genre album in my possession.

No. 34. *Magic Lantern.* In the genre album in my possession.

No. 35. *A Male and Female Slave.* In the genre album in my possession.

No. 36. *The Haunted Chamber.* In the genre album in my possession.

No. 37. *The Mischievous Boy.* In the genre album in my possession.

No. 38. *How do you do.* In the genre album in my possession.

No. 39. *The Long Story.* In the genre album in my possession.

No. 40. *The Chess Players.*

No. 41. *A Camp.* In the genre album.

No. 42. *A Rencontre.* In the genre album.

No. 43. *An Engagement.* In the genre album.

No. 44. *A Transparent Moonlight View.*

No. 45. *Monsieur Edouart and his two Sons in a balcony.*

According to the local Press notices crowds viewed the exhibition. Edouart remained nearly twelve months in Dublin, and while there took 6,000 portraits, including those of the Marquess of Anglesey, the Archbishop of Dublin and Tuam, the Duke of Leinster, &c. He then went to Cork and took rooms at 77 Patrick Street, afterwards moving on to Killarney and later to Kinsale. In December 1834, the *Cork Evening Herald* reports his doing ' wonders in the spirited town of Kinsale, the number of likenesses he has already taken being surprising for so small a place '.

This the writer can personally vouch for, the Irish album in my possession overflowing with over 400 Irish portraits, all named and dated ; many of officers in the army stationed in Ireland.

At Fermoy, Edouart took 151 portraits, at Bandon 197, Youghal 112, Mallow, Limerick, and many other places were also visited.

Edouart published at this time the rare demy octavo volume mentioned above, which he had been writing, as he had moved from town to town. It was published by Longman & Co., Paternoster Row, and J. Bolster, Patrick Street, Cork, 1835. The full title is : *A Treatise on Silhouette Likenesses, by Monsieur Edouart, Silhouettist to the French Royal Family and patronized by His Royal Highness the late Duke of Gloucester, and the principal nobility of England, Scotland, and Ireland.* This book is very scarce, it contains eighteen full-page illustrations of portraits and also of fancy subjects mentioned in the catalogue. It is interesting to see the originals of these and many others in my genre album referred to.

In the treatise these subjects are reproduced by lithographs by Uncles & Klason of 26 South Mall, Cork.

A self portrait of Edouart is depicted in the frontispiece, he is seated in his library, where in a bookcase are stored the duplicate portraits in the albums (Plate 89), which I now possess. Each one has the name of the town on the back where the hundreds of portraits were taken and when named and dated were put into the book to keep for reference.[1]

One may gauge the termination of Edouart's stay in Ireland by the fact that in 1839 he cut the portraits of David Scott, a blind boy, and Sarah Armstrong, a dumb girl, pupils in the Ulster Institution, for the benefit of the funds ; these were lithographed and sold. I have one of them on quaintly embossed card.

After working for a short time in Liverpool previous to his departure, Edouart started for ' the Americas '. I have old letters from friends wishing him prosperity on his travels.

The artist took his albums and exhibition pictures with him and on arrival in New York he seems to have met with immediate success.

He lodged with Lockwood Roe at 112 Broadway. The portrait of his landlord with name and date is in one of the American folios, just as that of Mr. Price had been when he lodged at Cheltenham at the beginning of his professional career as a silhouettist.

In the list of American portraits one may see that he visited Saratoga Springs, Boston, Philadelphia, Washington, and many other places in the States.

Everybody of note flocked to his studio, including six Presidents and ex-Presidents, Senators, Orators, Webster Clay, &c. August Belmont, founder of the New York Jockey Club, is entered as ' Agent of the House of Rothschild '. Henry Wadsworth Longfellow, handsome and well dressed, Catherine Sedgwick the writer, both rare portraits of this period : lovely ladies in ringlets and crinoline skirts accompanying their politician husbands in Washington, bonnie children in trouserettes to their ankles play with their toys. The Appleton family by the halfdozen, Quincy Adams, and the Quincys with their families. Army and Navy officers in their uniforms. Wingate, Commander-in-Chief ; Presidents of Colleges, Banks and Institutions, all named and with Edouart's inimitable method and meticulous care.

Though the original cuttings and these portraits

[1] A complete list of all the names and addresses will be found in *Ancestors in Silhouette*, published Bodley Head, and originals or photographs can be supplied by the author, if required.

are now dispersed and no longer available I have a photographic plate of each one, 3,800 in all, and one day I hope every reference library and museum in America will apply for the complete set, so that the ancestors of the American nation may be studied by their descendants in folio volumes. These shadow pictures of assured authenticity will be treasured for all to see in such number as no other nation possesses.

Space does not permit here for the full catalogue, but that can be obtained, and the chapter on American Citizens in *Ancestors in Silhouette* gives a full account.

In 1849 Edouart started home, like every Frenchman longing to spend his well-earned rest in his own land. He sailed in November in the ship *Oneida* with his immense collection of precious duplicate portraits in albums, packed in great cases. Storms were encountered from the first, and on the cruel jagged rocks of Vazon Bay off the coast of Guernsey the ship was wrecked ; the lives of the crew and twenty-five passengers were saved, and some of the albums, the rest, with most of the cargo, bales of wool from Maryland, were lost. I have examined the local newspapers of the time at Peter Port, Guernsey, and in the private letters amongst Edouart's documents there are spritely stories of the excitement of the wreck and the misfortune of the old French artist.

Edouart was ill with shock and exposure and distress at the loss of much of his collection, he was hospitably treated by the Lukis family living on the Island, who helped him in restoring to order what was left of his treasure, and he gave to the Lukis family about 12,000 portraits saved out of the 200,000 he had probably taken, the rest being lost at the bottom of the sea.

Some of the folio pages show marks of sea water, but no portrait is disfigured as the good old handmade paper is quite undamaged.

I do not know how long it took the old silhouettist to recover from the shock of the wreck and the loss of so much of his property, but the fact that he did a little work after leaving Guernsey is proved by one of his albums containing a few portraits dated after 1849.

Curiously they are in the volume which he was filling when on his way up to Liverpool to join the ship in which he travelled to America in 1839.

Possibly the Lukis family gradually forgot the incident of the wreck, other members grew up who knew nothing of it, at any rate the whereabouts of this great mass of authentic contemporary portraiture, English, Scottish, Irish and American, was not known, and Mr. Andrew Tuer in *Notes and Queries* and elsewhere bewailed its disappearance. Sir Sidney Colvin, head of the Print Department of the British Museum, longed to find it as did Sir Alfred Scott Gatty, Garter King at Arms at the Heralds'

College, where many work to find portraits and pedigrees.

When in 1911 I had my *History of Silhouettes* in the press I put a few lines advertisement into the *Connoisseur* asking that I might examine any specimens of silhouettes, as nothing had been written on the subject and research is difficult when few specimens only can be examined. Answers came and amongst them from one who had ' numbers of old books full of cut portraits '. These were sent for examination with many old letters and other documents, and I found on inquiry that the wife of the writer had been Miss Lukis of Guernsey who had brought them to England on her marriage. I purchased the complete set of volumes, had one more offered to me by another member of the same family, so that now I have ten folios of English, Scottish and Irish portraits, and six volumes containing 3,800 portraits of American men, women, and children, taken during his 10 years' travels in the U.S.A., 1839–49, which are more fully described in Chapter IV. American lists of Statesmen, men of letters, presidents, journalists, actors, and private citizens, their wives and families, are there in the old fashion of the day each named and dated. I have recently found another folio containing most clever and valuable genre and fancy pictures, some with miniature cuttings all set in beautiful water-colour backgrounds, and many of them the subjects mentioned in his catalogue of exhibition specimens, others used for illustrations in his treatise.

I have made alphabetical catalogues of all the portraits in accordance with the wish of Garter King-of-Arms, so that students may have access to the names and dates, and now descendants may acquire portraits of their ancestors from me and obtain groups or single figures in the quaint dress of their forebears.

Some of these portraits may be studied in our national portrait galleries, and in nearly every museum and library in the world, for they have been purchased from me by the trustees, and could the old artist but see how his careful work and annotation is valued by this generation and will be increasingly so in the future, he would no longer write gloomily of ' the Slights my Profession has brought me ' as he did in his treatise.

One of Edouart's sons was the Vicar of Leominster (*see* Chap. I), and wrote a short history of his parish ; his widow died at Ealing about ten years ago. One of his grandsons, I hear from America occasionally.

Edouart all through his professional career used labels sparingly.

His earliest label is very rare : it is round, measuring (Plate 89) 2½ inches ; at the top are the Royal Arms, with far more mantling than ever the College of Arms approved, on each side.

' Taken with Scissors only. *Silhouette likenesses.*

Under special Patronage of H.R.H. The Duke of Gloucester. | *Monsieur Edouart.* |

' Full Length Standing 5*s.* o*d.* | Duplicate 3*s.* o*d.* |
 ,, ,, Sitting 7*s.* o*d.* | ,, 4*s.* o*d.* |
Children under 8 years of age 3*s.* 6*d.* | Duplicate 2*s.* 6*d.* |

Busts 2*s.* 6*d.* | Duplicate 1*s.* 6*d.* |

' Families attended at their Residence double price of not more than two Full Length Likenesses. |

' Full lengths taken from Busts or description of absent or deceased persons.' These words are surrounded with a chain of open scissors.

Here a royal crown and laurel wreath surrounds a bust portrait of King George III, and below the words : ' Celebrated Characters 3/– each.'

The following wording is disposed in frame circles in minute lettering so that it encloses the central notice :

' Likenesses taken in 5 minutes. Frames at manufacturers' prices. Orders sent with cash for the amount post paid to Mr. John McRae, 155 Cheapside, London Agent to Mons. Edouart, will be attended to immediately.'

Edouart also used a stamped A. E. occasionally and also a square printed label with fewer details and no ornament as above.

What was charged for background I have never discovered, certainly if a draughtsman were sent to sketch a room, where a family was to be grouped, as was so often done, an extra fee would be charged, even the lithographed background indoors, with the looped and bulging curtain of the period, or outdoor terrace with foliage, there would be extra payment if we know anything of our businesslike Frenchman.

He took a stock of bird's-eye maple frames with him on his travels, or if a long visit was paid to any town, he employed a local frame-maker to produce the frames he recommended.

Though Edouart did very beautiful miniature work I have never heard of it in lockets, rings, &c., nor did he advertise such work for that purpose.

In his album or scrap-book mentioned above, are fine genre pictures, the sepia backgrounds are by G. F. S. whom I cannot trace. The figures of men, women and children, animals, grouped soldiers, mounted and unmounted, are often subjects mentioned in his catalogue and in the list I have noted them.

In addition are domestic scenes, farmyard subjects, feats of arms and character studies, all cut with inimitable skill, the sizes varying from 7½ inches to half an inch.

It is in this album that I found the Indian figures which had been cut in America, a further description of these will be found in the chapter on America (p. 57).

A life-size portrait of Edouart in oils by William Roe, the landscape and portrait painter, was ex-

hibited at the Royal Hibernian Academy in Dublin in 1833, at the time when the silhouettist was working in Ireland.

Rep. in *Ancestors in Silhouette*, 1921, Bodley Head. | Original letter to Miss Hutton. | Other documents in the possession of the author. | *Treatise on Silhouettes*, by Edouart. | *History of Silhouettes*, by E. Nevill Jackson. | *Ancestors in Silhouette*, by E. Nevill Jackson. | Newspaper advertisements as above. | *Birmingham Post*, by Mr. V. W. Clarke. | ' Hair Portraiture, by Edouart ', *Connoisseur*, 1925. (Plates 4, 14, 19, 42, 45, 46, 54, 55, 57, 58, 60, 61, 88, 89, 90, 91.)

EDWARDS, E. C. 1824. Name on printed silhouette of Thomas Coke of Holkham, afterwards Earl of Leicester, ' From a drawing made at Holkham ' in the National Portrait Gallery, London. (Plate 99.)

EDWARDS, THOMAS. 1822–56. Boston U.S.A. His label dating from No. 73 Market Street, shows the variety of his work : ' Portraits from 30 dollars to 60. | Miniatures on Ivory Paper 5 dollars to 10. | Profiles from 50 cents to 5 dollars. | Landscape, flower and Figure Drawing taught. | Specimens of the above to be seen at John B. Jones' Market Street. | Ladies and Gentlemen are invited to see Mr. Edwards' specimens at his Rooms. | Drawings of all sorts made and lent. | An assortment of the best oil and water colours, &c., for sale.' [1]

Edwards exhibited at the Boston Athenæum.

EDWIN, HARRY. Nineteenth century. Cutter of portraits and genre subjects. He cut the portraits of Lords Iddesleigh, Tennyson and Salisbury, Mr. Gladstone, and many other famous men. He published a small paper book with a few of his genre pictures, groups, &c., entitled *Silhouette Sketches and Portraits*, by Harry Edwin, 1887, in which he states that : ' Each Silhouette is cut with a pair of scissors from one piece of paper.' His groups ' Round the London Stock Exchange ', ' Loungers in Piccadilly ', and ' Playing Children ' are noticeable. (Plate 79.)

He had a stand at the American Exhibition in London in 1887, and travelled for some time in America.

His label was done from an oval rubber stamp, and read thus : ' Harry Edwin. | American. Exhibition. Art Souvenir. | A revival of ye olden Portrait. Silhouette Artist.'

EGGEL, EMMA. 1843–90. Cutter in white and coloured papers. She was the daughter of a Swabian minister and was educated in the Stuttgart School of Art, where Konewka had a great following ; his work undoubtedly influenced her style.[2]

ÉGLOMISÉ (*VERRE*). *See* Glomi, Jean Baptiste.

EHERMAN, ' Miniature Painter from London is

[1] *Columbian Sentinel*, 5 Jan. 1824.
[2] Rep. M. Knapp, p. 60.

arrived at Bath. Portraits in Oils, Crayons and Glass, etc., to any size.'[1]

E. & I. Signature on the silhouette portrait of Isola (Emma), Charles Lamb's adopted daughter, who was adopted after the death of her father in 1823. The portrait, in Indian ink on card, measures $2\frac{1}{2}'' \times 1\frac{1}{4}''$, looking right.

Exhibited at the Charles Lamb Centenary Exhibition held at Sotheran's, 1934.

ELIZABETH, ALEXANDRA MARY, H.R.H. Born Bruton St., London, 2 April 1926. Elder dau. of King George VI and Queen Elizabeth. Skilful cutter—giving an example of inherited talent from her ancestress, Princess Elizabeth, 3rd daughter of King George III, 1778. (Plate 73.)

ELIZABETH, Princess of England and Landgravine of Hesse-Homburg, 1770–1840. Artist daughter of George III, she designed a series of pictures entitled 'The Birth and Triumph of Cupid', 1795. Established a society in Windsor for giving dowries to poor girls, 1808. Married 1818 Frederick Joseph Louis, hereditary prince of Hesse-Homburg, who died in 1829. Set apart £6,000 a year to reduce the deficits of Hesse-Homburg. Re-issued her sketches 'Power and Progress of Genius' to benefit the poor of Hanover, 1832. A volume of her cuttings, mostly allegorical figures, was given by her to Lady Banks. At one time it was owned by Lady Dorothy Nevill and is now in the Royal Collection at Windsor (see Chapter on Albums; Plate 47).

ELLIS. 1799. Painted and cut paper. West and Ellis on an example in the Wellesley Collection.

Field and Ellis of the same date on a collection of fine portraits of the Field family.

ELLSWORTH, JAMES SANFORD. Connecticut, U.S.A. Circa 1833. 'Painter of Profiles.'

ENGELMANN, of Leipzig. Painted in Indian ink small figures, mostly in caricature. These were published by Joseph Miers & Co., 144 Leadenhall Street, and were sold in sheets.

ENGERT, E. M., of Munich. 1892. Born in Yokohama. His cut portraits show the Japanese influence in his clever and distinctive work. There is generally a short and eccentric neck line. His work verges on caricature.

ERNST. Example in the collection of the late Mr. F. Wellesley, now dispersed.

ESKOLAN. Cutter, 1820. Artist. Name and date in stencil at the back of his work.

EUAN, JANE, of Cork. Signature on a silhouette portrait of an old lady, coloured cap ribbon, at Knole in the collection of the late Lady Sackville.

EVERITT, MISS. Fl. 1807. In the Museum of the Royal Botanic Gardens, London, there are eleven silhouettes amongst the portraits of botanists, pioneers in scientific exploration, founders of different

branches of botanical science, or those who have conspicuously advanced its progress. Amongst these in the Hooker Collection are : 1. Portrait of Sir James Edward Smith, M.D., F.R.S., P.L.S., 1769–1828, founder of the Linnean Society.

Silhouette cut out of brown paper, September 1807, by Miss Everitt. Head profile to left. 2. Lilly Wigg, A.L.S., 1749–1828, contributed to Smith's *English Botany*, writing on Algæ and history of esculent plants.

Silhouette cut out of brown paper, September 1807, by Miss Everitt. Head profile to right.

EZRA. Signature on a painted silhouette, about 1840.

F

FALCON. The name embossed 'Falcon fecet' on the silhouette of Agnes Howard Peacock, descendant of the Norfolk Howards, about 1760–75.

FARTHING. Painter on glass or paper, first quarter nineteenth century. Brownish black colour with buff backing. Fine work. Dense, except for hair and frill on portrait of a man looking left.

Label : 'Patent Machine. For taking Profiles. | *Farthing.* | No. 12 Cheapside, | London. | Continues to execute Likenesses in Profile Shade, in a style peculiarly striking, whereby the most forcible animation is reclaimed to the minute size for setting in Rings, Bracelets, etc. |

' The original Sketches being preserved, those who have once sat may be supplied with any number of copies, without the trouble of sitting again. | Profiles taken on Paper 2s. 6d. each. Miniatures two guineas upwards.'

The work of this artist is rare.

FECHELM. Fl. 1779. Artist who silhouetted a portrait of Gunther, composer of operettas, in a volume published by C. F. Bretzner.

FE'ODOROVNA, MARIE. 1759–1828. Distinguished amateur silhouettist, Princess of Würtemberg, married Paul Petrovitch, was crowned in 1797. She both cut silhouettes and painted on convex glass, when the fashion, from the English court, in Paris and Berlin reached St. Petersburg. Her portrait was cut by Sideau, and is shown in *La Cour de l'Impératrice Catherine II*, published in 1899 by Krongly.

FEPK. 1788. Painted on glass. An example of man looking right in the collection of the late Mr. Francis Wellesley shows an elaborate mount, drapery below a vandyke border, and naturalistic swag of grapes, vine-leaves and roses above.

FERPELL. 1837. Signature on a sheet of fine engraved silhouettes. The portraits are of the Duke and Duchess of Dorset and their three children. In the collection at Knole belonging to the late Lady Sackville.

[1] *Bath Chronicle*, 22 Oct. 1772—Buckley.

FIDUS, HUGO HOEPPNER. Born 1868. Pupil of K. W. Diefenbach. Silhouettist. Painting and wall decoration chiefly [1] and illustration.

FIELD, H. W. Was the son of John Field, profilist, possibly the brother, but his description on the second label of John Field, ' Miniature Frames and Cases of every Description manufactured by H. W. Field ', points to the conclusion that the youngster went into the firm and learnt the business from the bottom upwards as was the custom in those days ; he seems to have worked chiefly at seal and jewellery engraving.

That H. W. eventually painted black profiles, however, is proved by the fact that at the Victoria and Albert Museum, presented by Captain Desmond Coke, there is a small double locket [2] in which on one side is a signed profile on ivory by John Field, and on the other side an equally well-painted portrait ; the latter of Mr. Robert Lees, 1837, aged 39, signed H. W. Field : both are in dead black. Possibly a label on which H. W. Field's name appears as a profilist will some day be found. In 1822 he had two portraits, which he calls ' Medallist portraits ', hung at the Academy, and the same number each year and similarly described up to 1827, in which year the catalogue description is : ' Portrait of J. Field Esqre.' One is surely justified in thinking this must be the partner of the late John Miers, the profilist, who had died in 1821. John Field died in 1841. This discovery of a single example by H. W. Field is very interesting, probably others will be found in time.

FIELD, JOHN. Born at Molesey in 1771, was seventeen years of age when John Miers came to London in 1788, and it is probable that Field received his training from the great silhouettist, whose fame, chiefly acquired in the North of England, would certainly have preceded him, when he settled at 162 Strand, and put ' late of Leeds ' on his first London label.

In 1800 Field commenced exhibiting at the Royal Academy (No. 779, View from the Cottage side of the Serpentine River). His address was then given as 111 Strand. In 1807 he ' sent in ' from 7 Great Newport Street, though his address is otherwise found as 111 Strand, with the words ' from Mr. Miers '. And in 1808 the Academy catalogue locates him at Mr. Miers', 111 Strand, where he remained for many years. It is interesting to note that among his Academy exhibits are a number of landscapes ' painted on plaster of Paris ', a surface to which he would be well accustomed in Miers's studio. Among these were views in Buckinghamshire (1804, No. 671), Monmouthshire (1816, No. 672), and Thames Ditton, looking towards Hampton Court (1818, No. 626). For twenty years I sought a

specimen of Field's work in this genre, and in 1930 my quest was successful. An example of great rarity (Plate 17) has been added to my collection, making a representative unit in the pictorial history of John Field's painting.

From this example it will be seen that his landscape work is delicate and minute, each touch in the foliage being indicative of the particular growth, as will be noted in the distant elms, the poplars, firs and hedgerows. This one would expect from the brush of so keen an observer as Field, an expert in silhouette portraiture, whose best work in this latter genre is hardly distinguishable from that of Miers's second period. It is interesting to note that the shadows indicative of the hour of the day are made to play an important part—again as one would expect from a shadow portraitist. The old toll-gate in Roehampton Lane is being opened to let the horseman go through. The plaster is of a larger and thicker type than that used for the portraits and is framed in a correspondingly substantial frame of black lacquer, with the usual patterned brass rim. Tiny brass rosettes clamp on to the back of a piece of wood for extra security. I have since found a second example of even finer workmanship.

According to the Royal Academy catalogues, Field remained at 111 Strand up to and including 1830. In 1831, when he was described as ' Profilist to Her Majesty and H.R.H. the Princess Augusta ', his address was given as 11 Strand, after which there was a lapse until 1835, when Field (' Profilist to their Majesties ') was at 2 Strand. 1836 was the last year in which his work was seen at the Academy. Then, it is interesting to note, he (as ' Profile Painter to their Majesties and H.R.H. the Princess Augusta ') was represented by No. 664, Landscape a la Silhouette (*sic*), containing upwards of twenty-five profiles on the detail, &c., &c. It is obviously one of his rare silhouette group pictures, the figures being of full length, about 8 inches. That Field did such work is proved by one authentic example, a single full-length figure which was in the possession of the late Captain Desmond Coke, and which he bequeathed to the Victoria and Albert Museum. (Plate 92.)

We know of Edouart's family groups, and of Dempsey's crowd on the flags of the Cotton Exchange, Liverpool, but that Field did such work will come as a surprise to many connoisseurs. The Royal Academy catalogue of 1836 proves it beyond a doubt.

John Miers, who made his will in 1820, writes of Field as his *assistant*, so that the first label for the *Partnership* of Miers and Field must come shortly after that date. As Miers died in 1821, henceforth the Miers of the firm would be Miers's son. The label runs as follows :

' Miers & Field 111, Strand, London (opposite Exeter Change). Profile Painters, Jewellers, Seal

[1] Information, Dr. H. Bräuening-Oktavio, Ph.D.
[2] No. P 184, 1922. Vic. & Alb. Mus.

Engravers and Manufacturers of every description of Miniature Frames, Cases, &c.

'Continue to execute their long approved Profile Likenesses in a superior style of elegance and with that Unequalled degree of accuracy, as to retain the most animated resemblance and Character, even in the minute sizes of Rings, Brooches, Lockets, &c. (Time of Sitting not exceeding five Minutes.) Messrs. Miers & Field preserve all the Original Shades, by which they can, at any period, furnish Copies without the necessity of sitting again.'

A variant of this label gives the time of sitting as three minutes. That these labels continued in use long after John Miers's death is proved by the date on a portrait of Mrs. Marshall, a lovely girl of 17, on which is written 1824, as the date of sitting, though the style of hairdressing looks much earlier.

Thus Miers's son, William, would be indicated as the Miers in the firm at that date ; but whether still as frame-maker and seal and jewel-engraver only, or as profile-maker as well, it is impossible to say with certainty until some signed and dated example is discovered which proves son William to have inherited his father's gift.

An old newspaper cutting of 22 May 1831 supplies a nearer date than the catalogues for Field's appointment as profilist to Queen Adelaide :

'The Queen's Profilist. Her Majesty has been pleased, by the following warrant, to appoint Mr. John Field of No. 2 Strand her Profilist, which distinguishing mark of honour has also been conferred on him by H.R.H. the Princess Augusta ; as also his present Majesty's Royal permission (signified to her Royal Highness) permitting Mr. F. to be His Majesty's Profilist.

'Mr. Field's specimens illustrative of his lovely practice in this branch of art, are very extensively before the nobility and public. He was the sole Artist for the late Mr. J. Miers nearly 30 years ! ! ! and also, subsequently, in the late firm of Miers & Field. Mr. Field now continues his profession on his own account, at No. 2 Strand, where profiles are taken in a sitting of five minutes, only, even to the minute size of a ring. As Mr. Field preserves the original outline he can furnish copies without a second sitting.[1]

'Adelaide R. Whereas We have thought fit to appoint John Field to be our Profilist during our Pleasure ; our Will & Pleasure therefore is, that in making out the Establishment of our Household, you do enter him as such therein, and for so doing, this being Registered in your office, shall be to you a sufficient Warrant. Given at St. James's the 24th day of August in the first Year of the Reign of our dearest Lord and Husband.

'By Her Majesty's Command. John Barton. (Royal Seal.)

[1] *Conn.*, Nov. 1931.

'To John Barton Esqre. our Right Trusty and Right well-beloved Treasurer.

'No. 101 Entered in the office of John Barton Esq., Her Majesty's Treasurer 24 August 1830. Chas : Goodman.'

Henceforward 'By Appointment', the Royal Arms with Supporters, are emblazoned on Field's labels (see Plate 92), with the address No. 2, Strand, London (two doors east from Northumberland House), and 'upwards of Thirty years sole Profile Painter and late of the Firm of Miers & Field continues to execute his long approved Profile Likenesses, combining expression of Character, with accuracy of Finishing, so as to give the most pleasing resemblance, for Jewellery Cases, Frontispieces for Literary Works and even in the minute sizes for Bracelets, Brooches, Lockets, &c., &c. Time of sitting five Minutes.

'Mr. F. preserves all the Original Shades by which he can at any time furnish copies, if required, without the necessity of a second sitting. Copies correctly taken from Profiles, outlines, Busts, &c. Miniature Frames & Cases of every Description Manufactured by H. W. Field also. |

'Jewellery & Seal Engraving.' |

Another Press advertisement is dated 1840 :

'Field's Profile Likenesses. Formerly Miers & Field.

'These Profiles, so extensively Patronized for their superiority of likeness, Character and finishing in bronze and in relief, have been solely executed for the last 40 years, to the present period, for the late Mr. Miers & Son, by Mr. Field, No. 2 Strand, two doors from Northumberland House, and are continued by Mr. F. in all their variety of sizes. Taken in five minutes and duplicates supplied (if required) at any time for rings, bracelets (superseding Cameos), brooches, secret lockets, Cases, frames, &c., or copied from his former works and other profiles.

'Or—mounts, miniature frames, and cases made. Artists supplied.'

In Pigot's *London & Provincial Directory*, 1830, page 604, 47 Craven Street, Strand, is given as the house of John Field. Probably this was his private house or lodging, as I have never seen a label with this address ; nor Bridge Street, Covent Garden, which is on an example in the Victoria and Albert Museum.

An oblong jewel-case label, measuring only 1¼ inches, belongs to the early Miers & Field period (111 Strand, opposite Exeter Change) ; and, like the larger label for 2½-inch portraits, sight measurement, was probably used long after John Miers's death (No. xi).

With regard to Field's style and technique as a profilist, one can give it no higher praise than to say that it strongly resembles that of John Miers, though it never attains the delicacy and distinction of that master's early all-black period.

There are few Field portraits untouched with gold or 'bronzing', as the old description puts it; occasionally Field uses a yellow paint and touches with gold only in the high lights. The effect is achieved with great skill, but a purist in taste, with regard to shadow portraiture, cannot altogether approve.

Field worked in black and brown and in brown and gold: on ivory, plaster, and on card. His labels are freely used, and the signature and sometimes the address appear beneath the bust-line, more frequently than with any other worker in this type that I know of.

The self portraits, with those of his wife and two daughters, are characteristic of his work. They were in the possession of Mr. J. A. Field, great-grandson of the silhouettist (Plate 92); they show him to be a profile painter of surpassing skill, and are reproduced in my *History of Silhouettes*, 1911. Field's output must have been very large, though the use of the label, Miers & Field, and the similarity in the work of the two members of the firm, makes the proportion difficult to gauge.

Considering Field's landscape work, of which the Royal Academy records are but a small indication of a much larger output, and his full-length portraits mentioned above, I should hazard the opinion that Miers was the chief contributor to the ordinary 2½-inch size portraits, and those in miniature for jewels, produced by the firm.

William Miers (son of John Field's partner) separated from the firm in 1835, fourteen years after his father's death, and continued his frame-making business alone. One of his labels at this stage is on a picture by Sir William Charles Ross, R.A., at the Victoria and Albert Museum.

FIKENTSCHER, OTTO. 1831–80. Cut silhouettes, chiefly animals, he was also a painter of battle pictures and a book illustrator.

FINDLOW painted on glass according to his label. He had a stand at the Crystal Palace, a label with extravagant description of chemical glass for painting, he declares that he draws his silhouette portraits on the 'chemical side of the glass', charges 8d. for the portrait. The only example of his label that I have seen was attached to the portrait of a man in a wig and dress of 1790–1805: in frame and mount of about 1860, obviously the frame and label were Findlow's and the silhouette either a fake or an example of an earlier worker, as the Crystal Palace was not opened till after 1855.

FLINT, ANDREAS. An example of his work was in the collection of the late Mr. F. Wellesley.

FOLWELL, SAMUEL. 1765–1813. Cutter and painter. Coming from New England where he had engraved book plates in 1793 for inhabitants of New Hampshire, Folwell arrived in Philadelphia and announced himself as a miniature painter, cutter of profiles and a worker in hair, he also kept a school in the town. In 1795 his address was No. 2 Laetitia Court, Philadelphia, and he exhibited portraits the same year at the Columbranum. In 1791 George Washington visited Philadelphia and Folwell painted his silhouette in Indian ink with lighter paint touches. Washington was unaware that it had been taken; it was declared at the time to be a most spirited and correct likeness. It was in the collection of the late Francis Wellesley, now dispersed, and is now owned by the Pennsylvania Historical Society, the signature is 'S. Folwell Pinxt 1795'. It was reproduced and published in Watson's *Annals and Occurrences of New York City and State in the Olden Time*, 1846. His signature also appears on a portrait of Absalom Jones, painted on cream card, taken (Plate 58) at the age of 72 in 1818, in the possession of Miss M. Martin, New York. Folwell's portraits are very rare.

The Washington Portrait is inscribed 'Presented to James Henry Stevens Esqre. by his friend Col. William Washington, Sept. 9 1800. Said to be a correct likeness taken from life of his Excellence Genl: Geo: Washington first President of the United States of America.'

FORBERGER, A. Paris. Born 1762, d. 1865. Painted on glass, used gold backing (*églomisé*) signature on fine pair man and woman with Prince of Wales's feathers on frame above, in the possession of Miss Martin. Signatures on portraits done in the *églomisé*[1] process are extremely rare. (Plate 35.) He also signed a remarkable oval memorial plaque which is dated 1804. The silhouette rests on a pyramid with silver backing, gold-backed trees and flowers are also shown, and a fine blue wax filling makes this superb example probably unique; it measures 6½″ × 10″. (Plate 35.)

FORRESTER, ARTHUR. Cutter, using slits in the paper to indicate details. Bournemouth 1932. This is sometimes called slashing.

FOSTER, EDWARD WARD. 1761–1865. Son of wealthy parents. He held a commission in the army. 'Great talent, ability and good connexions placed him in the position of miniature painter to Queen Charlotte and the Princess Amelia with apartments at Windsor.'

After the death of his Royal patrons he returned to Derby, but itinerated a good deal and had a special advertisement which he used during his travels. In 1811 he was at Mr. Abbot's, Trimmer, Friar Gate. Another address is 125 Strand, and on his trade label he is described as 'from London'. The Royal Arms are elaborately engraved at the top.

'Modern style of Executing Profiles sanctioned by the principal Nobility of England. | Foster | from London.' |

On his sheet advertisements: 'Foster, profilist

[1] *See* Glomi, Jean Baptiste. *Conn.*, Nov. 1931.

from London, most respectfully informs his friends and the Public that he has taken apartments at . . .' The example before me has ' Mrs. Whites' Totnes' written in the dotted space, ' for a few days only where, by means of his newly invented machine he proposes taking Profiles '.

In another advertisement he describes the machine as making ' a complete etching on copper plate '.

Foster's work has several unmistakable characteristics which make it easily recognizable even without the signature beneath the bust. Foster cut occasionally but more often painted in reddish brown colour and bronzed rather heavily. On his women's portraits one frequently detects the triple dots, grouped like a trefoil pattern, in gold ; on dress, lace or other drapery it is so usual that one looks for it almost as a signature.

Sometimes he worked in blue grey and white replacing the gold, with graceful effect ; in fact, Foster's elaborate portraits are very beautiful and artistic. Another special indication of his handiwork is the black tie for a man or black ribbon for a woman, which when placed on a red brown and gold or grey blue and white portrait gives one rather an unpleasant shock ; however, it is a sure Foster convention, and in so clever and lifelike a limner one must forgive, or possibly welcome, eccentricity.

The late Desmond Coke wrote of him : ' Amongst all the silhouettists, I would name Foster as the most daring, in so highly conventionalized an art he flings down barriers, tramples on rules, places a black tie round a brown neck, paints golden cheeks and ears—and yet—with what charm he works, his flavour is Victorian and not to be mentioned with the early eighteenth-century masters of the art : Beetham, Rosenberg, Miers, Jorden. Yet some of Foster's work has a fragrant value which makes his outrages in colour forgivable, perhaps it is on the lines of his formula that the silhouette may one day be lifted out of the dull rut it has fallen into and become again a charming thing.' A personal friend of Foster's writes reminiscences in 1863 in *Notes and Queries* :

' Numbers of silhouettes were done in Derby and the neighbourhood, and also in other parts of England, by a Derby man of the name of Edward Foster, who died in 1864, or the following year. I knew him well, and in December 1863, had a long conversation with him in his own house in Derby, he being then in the 102nd year of his age. He was quite active and moreover a respectable and intelligent old man. He had been married several times (five times), and at the time I speak of he had a wife much younger than himself, and a daughter, of whom she was the mother, eleven years of age. He had had children by former marriages, but they were all dead, and he told me that if his eldest child, a daughter, were then alive she would have been seventy-nine, or sixty-eight years older than her youngest sister ! '

Even in his framing Foster shows strong individuality, a Foster frame is unmistakable even if it has not the name on the brass hanger. Of ample size these frames are of black papier mache, a very fine quality, an acorn, a crown with twisted ribbon, or Foster in stamped brass work may be found.

He composed educational charts used in schools, of which the MSS. are in the Derby Museum, and was presented with £60 as a gift from Queen Victoria on his 100th birthday.

In the *Connoisseur*, XIX, 1907, p. 120, is reproduced a coloured miniature by Foster, and others are to be found at Victoria and Albert.

FOUQUET. An assistant of Chrétien, inventor of the physionotrace or profile machine of the latter half of the eighteenth century in France.[1]

FOURINER. Also an assistant of Chrétien.

FOWLER, W. 1808. Signature on minute portrait of George III with ornamental lines framing it, which are in lettering praising the King, probably a Jubilee production.[2]

FOX, E. J. 1855. Cutter. Poor work.

FRAMPTON, MARY. English cutter and painter. Probably an amateur, her collection of the profiles of the various guests who visited her home is an interesting example of the visitors' book of the early nineteenth century. It is now in the possession of Mrs. S. Campbell.

FRANÇOIS. French cutter. Worked at Earl's Court Exhibition 1911. (Plate 78.)

FRANÇOIS. Theatrical producer. Opened his theatre ' Seraphim ' where shadow plays were given in Paris, 1771, in the Tuileries Gardens.

FRANKLIN. Early nineteenth century. Worked in a booth in the Thames Tunnel, doubtless a rival of Mrs. Catlin.

FRASER, CLAUD LOVAT. 1890–1921. Born at Buntingford, Essex. Artist and designer, his drawings of theatrical characters and scenes, his decoration for chapbooks and broadsides are considered his most important work.[3]

He gathered his inspiration chiefly from the past, especially the eighteenth century. His work is generally very gay and brightly coloured, tinged with romanticism, so that the example in all black, done for his friend the late Captain Desmond Coke and used by him in labelling his collection, is especially interesting as a rare example.

He can hardly be counted as a silhouettist though he did this fine specimen. Perhaps other examples may be found, for he was specially interested in the formula and visited me especially, to examine my collection. (Plate 75.)

FREMY executed a portrait in silhouette of the

[1] Rep. *Conn.*, Miss M. Martin.

[2] Rep. *History*, E. N. Jackson. [3] *Dic. Nat. Bio.*

Emperor Alexander I, which however has not been preserved. See *La Cour de l'Impératrice Catherine II*, by Alexander Krongly, 1899.

FRERE, J. Signature on painted silhouette of a man with white collar and high stock in the possession of the author.

FRIEDRICHSON, G. A. Born 1882 in Hamburg. Fl. at Dachau, n. Munich. Cut in coloured papers genre pictures, full of action. Cutter of eccentric fantasy, of which ' The Burglary ' and ' Above the Balloon ' are examples. He decorated in silhouette the theatre at Heilbronn.

FRIEND, ROBT. [?1760–1820] Tunbridge Wells. This silhouettist was probably a gifted amateur. Examples of his work are to be seen in Mr. Gordon Roe's *A Family in Silhouette*. The portraits are painted in Indian ink on paper.[1] The faces alone dense black, all details of dress, hair, &c., in grey with charming effect. (Plate 93.)

No other examples of the work of this artist have yet been found ; they are exceptionally fine either in the Rosenberg manner or those with more refinement in detail. The signature varies slightly, either Rob. Friend T. Wells, or Friend. Tunb. Wells. Very good work.

FRITH, FREDERICK, of Dover, 1841. Early nineteenth-century cutter, he cut the whole figure usually, and painted finely in gold, and used white sparingly as well. He was first advertised as a youthful prodigy. ' The nobility and gentry and inhabitants of Tunbridge Wells are respectfully informed that Master Frith will remain but one week longer in this town. Those ladies and gentlemen who have not yet completed their family sets, are requested to make early application. That extraordinary talented youth Master Frith who has been the astonishment of all lovers of the fine arts, will exercise his ingenious and interesting profession for one week longer in this town, next door to the Ladies Bazaar, Parade, etc. His prices : A plain bust 1s., duplicate of ditto 6d. | A Bust in gold bronze or shaded with drapery 2s. 6d. | Whole-length figure in plain black 2s. 6d. | Ditto duplicate of ditto 1s. 6d. | Ditto very highly finished 2s. 6d. | The much admired coloured profiles 10s. 6d. | Whole-length figure in bronze or shaded drapery developing very characteristic peculiarity of hair, dress, &c. 5s. 6d.'

Like Edouart's early cutting, Frith also made large size figures, sometimes measuring 15 inches ; these are rare and very fine, ' the last silhouettist who bronzed without vulgarity ' is Captain Coke's opinion. Certainly his beautiful specimens are very far from meriting that objectionable adjective. The portrait of Col. John Cameron of Fassiefern, 92nd Gordon Highlanders, killed at Quatre Bras 1815, is the finest example of Frith's mixed style, cutting, bronzing and painting, that I have ever seen ; this

[1] *Conn.*, Vol. 70, p. 216.

must have figured in his bill as ' Whole-length figure in bronze or shaded drapery developing every characteristic peculiarity of hair, dress, etc. 5s.'. The sword girdle accoutrements, and the cross hatching on the plaid and stockings are put in with white paint. (Plate 93.)

The well-known ' Girl with the Bonnet '[1] corresponds to his trade description. ' Whole-length figure in plain black, very highly finished 2s. 6d.' Like many of his contemporaries, Dempsey and others, Frith gains softness in hair and lace by continuing the outline in brush-work on the mounting card, the fineness the bronzing also assists. Frith's backgrounds are very satisfying in water-colour, flowers in restrained patches, in the middle distance are indications of foliage, a sundial, a seat, a house ; whatever is needed for a suggested environment, without sufficient solidity to detract from the charm of the figure. This is well shown in the portrait of Princess Victoria 1836, our wrapper design. Frith worked in Cork and Limerick about 1840 ; he was in Scotland ten years before that date. He exhibited mostly landscapes done in Wales at the Royal Academy from 1809 up to 1828 inclusive. He also worked in Canada.

The late Mrs. Strickland writes in her Dictionary of Irish artists that ' Frith also did caricatures. His portraits of ladies are beautiful, the delicate details of dress, scarves, flowers being delicately suggested in fine bronzine.' Frith signs freely, but the excellence of his work alone gives us his identity. The full-length portrait of Princess Victoria one year before she was called to the throne by the death of her uncle William IV is a notable example of his work.

FRÖHLICKS, H. KARL. 1821–98. Cutter of genre pictures. A compositor in a printing office, his early work was published with letterpress in patois. He used, as did Müller, the *motif*, a pedlar of plaster cast figures, which was much in vogue at the time, and is now freely used by silhouette forgers. The Crucifixion, Napoleon with folded arms, Shakespeare, a bust, Frederick the Great on horseback, are the most distinctive types in miniature cutting, which was done with remarkable dexterity.

FROSSARD. Signature on an example in the collection of the late Mr. Francis Wellesley.

FURT, S. Silhouettist in the *églomisé* process. Signature on miniature portraits of a man and a woman in two superb rings lent to the Victoria and Albert Museum, one an oval, the other octagonal bezel, mounted in gold, in possession of the author.

G

GABILLOU. 1876–7. Vienna. This artist illustrated ' Puss in Boots ' in silhouette.

[1] Nevill Jackson, *History*.

GABRIEL À COBLENTZ. 1800. Signature on Conversation piece 5″ × 9″. Two women seated at tea-table with complete tea equipage. Behind stands a man at one side, on the other, a girl knitting and a cat playing with her ball of wool. Gold and silver foil is used, similar to portrait on gold ground with vase ' pensez a moi 1812 ', in the possession of Lady Sackville, Knole.[1]

GAPP, J. 1829, of Brighton. Worked on the Chain Pier. Label on full-length cut portrait of a boy in collection of the author ' Daily at the Third Tower on the Chain Pier '. | ' Full length 2s. 6d. | Bronze 4s. | On horseback 7s. 6d. | Horses 5s. | Dogs 1s. 6d. | Small cuttings for scrap-books.

There is a heaviness in Gapp's cutting that differentiates (p. 89) it from that of Edouart or Hubard, and makes it somewhat ironic when he assures us that he has ' no connexion with any other person '. We know this fact at once when we see an example of his work. Sala, in his *Brighton as I have known it*, writes : ' Old Chain Pier cabins, where they took portraits known as silhouettes which were profiles cut out, apparently of black sticking plaster, stuck on pieces of cards.' I have a self-portrait. (Plate 94.)

At the Municipal Library, Brighton, there is a portrait by Gapp of Mr. Lewes Slight, Clerk to the Town Council in 1858, who was mainly instrumental in the act of passing the valuable property of the Royal Pavilion with all its exotic art treasures from the Crown to the Municipality of Brighton. On this portrait is written : ' Given to me by Mrs. Lewes Slight at Mrs. Lappard East Street.' Amongst the archives of the town there is a silhouette of Elizabeth Pitts, aged 88, b. 1740. The portrait is a pen-and-ink sketch.

GARDINER, WILLIAM. Painter. Assistant to Mrs. Beetham. In his Autobiography we are told : ' On leaving Dublin and coming to London, he first became a scene painter and actor at the Mile End Theatre, and later at the Haymarket,' but acting was to me its own reward, which not suiting the state of my finances or my stomach, induced me to serve a Mrs. Beetham in Fleet Street, who had, at that time, a prodigious run for black profile shades. My business was to give them the air of figures in shade, rather than the black masses which were customary.'

Later he was engaged by a Mr. Godfrey, an engraver, and produced many of Bartolozzi's works. He also illustrated several books on Shakespeare which appeared at that time.[2] His Autobiography was published in 1814.

GARNETT, CLAUDE. Cutter of flower subjects. Simplified shapes are cut out in papers of natural tint, finished in water-colour and mounted in decor-ative groupings on black paper. The edges of the flowers are left free so that they stand out in slight relief. The whole framed usually in bird's-eye maple. Exhibitions of his work, London, Bond Street, in 1929, 1932.

GARSIDE, J. C. Painter musician, 1830. On the equestrian portrait of William Everett, Lieut.-Col., is the signature ' J. C. Garside musician 18th Huzzars fecit '. The silhouette portrait, in full uniform with coloured coat lining, sabre-tache and sash, is mounted on a grey horse, with brass studded harness and bearskin saddle. In the distance are troops on a parade ground.

GAÜS, H. Painter on glass. Fl. 1786. Grand Duke of Hesse-Darmstadt. Is the owner of a fine example, signed and dated.[1]

GEAR, J. On a full-length printed portrait of George III resembling the cutting by Princess Elizabeth are the words ' Drawn by J. Gear junr. engraved by L. W. Gear junr.'. Beneath is inscribed ' His Most Gracious Majesty King George the 3rd. Born June 4th, 1738. Reigned 59 years 3 months and 9 days. Died January 29th, 1820. Published by J. Gear, 29 Wellesley Street, Euston Square.' [2]

GEIGER, F. Fl. 1840. Cutter. In *Schatten und Scherenbilder* is reproduced an elaborate sheet by him consisting of twelve scenes beginning with childhood from ten years, depicting a group of children : in the next ten years *youth* and *maidenhood* and so on until two old people with sticks and crutches sit beneath a crucifix. The lettering cut beneath each medallion is well done.[3]

GENLIS, MADAME DE. Novelist. Governess in the family of the Duke of Orleans. Amateur cutter. A fine portrait of her by Charles was in the Wellesley Collection, now at Windsor in the Royal Collection.[4]

G. F. S. One of Edouart's draughtsmen. An Album in which are genre cuttings by Edouart, some of minute size, have elaborately painted backgrounds in sepia. Many of them are signed G. F. S. and seem to have been painted by a Frenchman, as the buildings and interiors are those of northern France, rather than England. Some of these genre pictures are those used to illustrate Edouart's treatise, published in 1835.

GIBBS, H. Queen Street, Ranelagh, Chelsea, painter on glass, plaster, card. ' H. Gibbs, profile ' on the back of a portrait of a woman in 1st Empire dress, painted on glass with wax filling, in possession of the author. ' H. Gibbs, profile painter, Queen Street, Ranelagh, Chelsea ' on silhouette painted on card, blue coat, yellow buttons, at Knole. A fine example painted on ivory with label is in the Victoria

[1] Reported by Miss Martin, New York.
[2] *Gentleman's Magazine*, Vol. 84.

[1] Information Dr. H. Bräuning-Oktavio, Ph.D.
[2] Rep : in *History of Silhouettes*, p. xxxiv, by Mrs. Nevill Jackson.
[3] Rep. M. Knapp, p. 70.
[4] See *Conn.*, Nov. 1932.

and Albert, as well as a portrait of a man on convex glass, No. P.142, 1922, and one of a lady painted with technique, resembling Mrs. Beetham's, face, dense black; frills and drapery semi-transparent.[1] His coloured work is beautiful. From above descriptions it will be seen that when seeking Gibbs's portraits we must be prepared to find many processes, glass painted dense black, or with transparencies, with or without wax backing. Painting on card with colour, and on ivory all black.

Another address is 23 College Green, Bristol, on a fine portrait of Mrs. Grinsfield. There is a good portrait of Queen Charlotte by H. Gibbs in the Royal Library at Windsor, convex glass, dense shadow face, light lace dress cap. (Plate 97.)

GIBBS, M. Painted on glass, white relief, card back, early nineteenth century.

GILBERT, of Sheffield, mid-nineteenth century. Name on a portrait of a boy cut and bronzed, owned by Miss Barlow.

GILL, ERIC. Born at Brighton, 1882, son of Rev. A. T. and Cicely Ross Gill, received art instruction at Chichester Art School, and from Douglas Caroe, architect; began inscription carving in 1903. Figure sculpture 1909. Wood engraving 1916. Publications: *Songs without Clothes*, &c.

Though not primarily a silhouettist, he has done supremely fine work in black profile portrait, woodcuts. (Plate 72.)

GILLESPIE, J. H. 1793. 'Likenesses drawn in one minute by T. H. Gillespie profile painter', on three painted silhouettes in the possession of Mrs. Whitmore, Bromley. Greyish black with black lines, white relief. Gillespie worked in London, Edinburgh, and Liverpool, then journeyed to Halifax, Nova Scotia, in 1820. He worked in various ways, and sometimes painted in colour on cut profiles of black or dark brown paper, slightly bronzed.

GLOMY or **GLOMI,** JEAN BAPTISTE. Circa 1760. Artist, writer, and antique dealer, who practised the art of under-side glass painting, though he certainly did not invent it. This technique, much used by silhouette workers, has been named *Verre Églomisé*. In the Catalogue of the Musée Cluny 1852, Italian 'Agglomizzato'. It was known in early Christian times. Specimens are to be seen with gold leaf still adhering, with or without a protecting sheet of glass fused on after the gold, to preserve it. An authority has declared that Glomy did not use metal foil backing; painting the pattern or portrait in opaque (generally black) and then backing with colour (as Spornberg worked.)

Forberger used both gold and silver foil and on rare occasions blue wax backing with very rich effect. (Plate 35).

Besides the foil or colour backing of under-side

painted portraits which are our chief interest in this work, there was much decoration of arabesque or floral design, done for the ornamentation of small pieces of furniture, such as cabinets, mirror-frames, &c. At the Victoria and Albert Museum one may see panels on the Vyvyan Salt, in the department of metals. At the British Museum there is an Elizabethan casket profusely decorated with *Verre Églomisé* panels. In the Eumorfopoulos Collection there is an enthronement of the Virgin in under-glass painting in black with foiled back. At Palermo I saw Mrs. Whittaker's beautiful series of pictures, $7\frac{1}{2}'' \times 14''$, of the Stations of the Cross, with gold foil back.

In 1780 was published in Germany *A Detailed Treatise on Silhouettes, their Drawing and Reduction*, by P. H. Perrenon. In this, instructions are given for under-side glass painting, protected with gold or silver foil. For other writings on the subject, see below—[1] to [7].

Under-side glass painting, chiefly heraldic, may be studied also at the Victoria and Albert Museum in an achievement of Arms of the Shuckburgh family impaling Skevyngton; this belongs to the second half of the sixteenth century.

GNEISENAU, FRAU VON. Signature on an example in the collection of the late Mr. Francis Wellesley.

GODEFROY. One of a group of Frenchmen, who during the last half of the eighteenth century used the physionotrace or profile cutting and tracing machine, an original example of which may be seen at the Bibliothèque Nationale, Paris.[8]

GODFREY, W. F. Label on the portrait of a woman painted on convex glass in the possession of the author. The face is black, dress white, gold ear-rings and a tortoiseshell comb in her hair. Label: 'W. F. Godfrey | announces to the Nobility and Gentry of this town and its vicinity that he executes likenesses in profile shadow in a style particularly striking and elegant, whereby the most forcible animation is reduced to the miniature size for setting in rings, lockets, bracelets, etc. | W. F. G. having a successful practice for the last seven years and the honour of taking the principal families in Somerset, Cornwall and North Devon to their fullest and entire satisfaction; and one trial only is required to ensure confidence and recommendation. | Like-

[1] Vic. & Alb. Mus., P. 148, 1928.

[1] Larousse, *Dictionnaire*.
[2] 'Verre Eglomisé', by F. Sydney Eden, *Conn.*, June 1932.
[3] P. H. Perrenon.
[4] *Il Libro dell'arte*. Cennino Cennini MS., fourteenth century, translated by Mr. W. B. Honey.
[5] 'Verre Eglomisé', by F. Sydney Eden, *Conn.*, June 1932, Sept. 1933.
[6] *Gold-engraving under Glass*, Mr. W. B. Honey, Dec. 1933.
[7] *L'Arte*, 1908, Professor Pietro Toesca.
[8] Martin.

nesses beautified and enamelled on flat and convex glass, in bronze on paper or glass. | Likenesses taken in colour. | Ladies and Gentlemen waited on in their own houses in town or country.' Good work.

GOETHE. 1749–1832. This German poet is so well known as a supreme creator of lyric poetry, that for the purposes of this volume we need only touch on facts concerning his interest in silhouette cutting.

He lived at the time when the silhouette began to have more importance as the foundation of a physiognomic study, and ceased to be merely the amusement of the amateur, the name of the Zurich Pastor Lavater being connected with it, especially in the illustration of his book. There was much correspondence between Goethe and Lavater on the subject, and all the Goethe family were silhouetted by Schmoll, one of Lavater's official draughtsmen. In the following year, 1775, the poet writes : ' I beg you will destroy the family picture of us, it is frightful, you do credit neither to yourself nor to us. Get my father cut out, and use him as a vignette, for he is good. You can do what you like with my head too, but my mother must not stand there like that ! ' There is a humorous climax to this, for when the third volume of the *Physiognomy* appeared, containing her husband's portrait, Frau Goethe was furious because her own was not there.

Goethe himself cut many silhouettes, which are now in the Goethe Museum at Weimar, but I have not examined them. Director Julius Leisching writes that Goethe was enthusiastic when he first saw the silhouette of Frau von Stein, and from it judged that ' it would be glorious to see the world reflected in this soul. Gentleness is the first impression.'

The poet certainly did not cut the portrait himself; it was shown him by the Hanover physician Zimmerman ; he had not yet met the lady.

There are many silhouette portraits of Goethe himself, one in Court dress in the castle grounds at Tiefurt (*see* Chap. I), another taken with Schiller ; both poets wear swords.

Besides their life portraits most German silhouettists have cut or painted the profile of their popular poet, so that silhouettes of Goethe are not uncommon, cut even by moderns.

In 1791 Goethe wrote : ' Everyone is accustomed to silhouette cutting in the evenings and no visitor enters the house whose portrait is not drawn on the wall, the Pantograph is never at rest.'

In his study at Grosse Hirschgraben 23, Frankfurt-on-the-Main, there is a life-size portrait, over his writing-table, amongst many other interesting relics of the poet. (Plates 7, 10, 40.)

GONORD, FRANÇOIS. 1756. Frenchman. Born at St. Germain, and brought up as a copper engraver at Rouen. He seems to have been one of the first to use a pantograph, which he applied not only for the reduction of portraits but also to make engravings smaller. This is described by Joubert in his *Manuel de l'Amateur*, who relates that he has seen a plan of St. Petersburg greatly reduced.

Gonord's advertisement in the *Journal de Paris*, 28 June 1788, runs thus : ' The Sieur Gonord dessenateur physionomiste announces that he is in a position to satisfy customers quicker than other artists. He continues to manufacture silhouette likenesses like the above, for 24 sols a piece, but he will not make less than two for each person. The price of miniature size for boxes, circulars for rings is three pounds, he adds to these silhouettes the head dress and the dress of the moment. The price is six francs each, either made of paper to be framed, or on ivory for an ornament. A sitting of one minute only is required and the following day the picture is finished. He makes Cameos and miniature likenesses in the style of the silhouette which he calls " silhouette colorie ", for these he charges twelve pounds, and the sitting lasts 3 minutes, they are finished the next day but one.' At this time his address was the Palais Royale under the arch No. 167 at the side of the Rue des Bons Enfants. A special lantern decorated with silhouettes which was lit up at night facilitated the drawing up of coaches and chairs. Gonord's mounts are sometimes elaborately engraved.

In 1799 he published profile portraits cut with the aid of the physionotrace of the members of the Consulate on engraved mounts and the name on the plates below which gives them great historical interest ; these were only occasionally filled in black. He also cut free-hand, and the victims of the Revolution were silhouetted by him as they alighted from the tumbrils and ascended the guillotine.[1][2][3][4]

GORDON, A. Painter, Taunton. ' Mr. Ware Ext[d] by A. Gordon, Taunton, Feb. 14th, 1814 ', on back of a shadow portrait painted on card.

GOSSET, DOROTHEA, MRS. Wife of W. T. Gosset, rector of Datchet and Windsor, and domestic chaplain in succession to George III, George IV, William IV, and Queen Victoria.

Her collection of silhouettes cut by Mrs. Wray, wife of Daniel Wray the antiquary, includes such names as :

The poet Gray, seated, cut in 1762. | Sir Joseph Banks, P.R.S., 1743–1820. | Solander, 1736–82, Bo. | Mrs. Delang, Mary, 1700–88. | Hume, David, 1711–76. | Paoli, Paskal, 1725–1807. | Bruce the African explorer, 1730–94. | Benjamin West, P.R.A.,

[1] See also François Gonord's *Silhouetten aus dem Jahre*, 1781, by Victor Klanwill, V. Wein, 1922.
[2] Joubert, *Manuel de l'Amateur d'estampes.*
[3] *Journal de Paris*, 28 June 1788.
[4] Rep. Nevill Jackson, *History.*

1738–1820. | Thomas Sandley, R.A., 1768. | Douglas John, Bishop of Salisbury, 1721–1807. | General James Murray of Louisberg and Quebec fame, 1719–94. | Garrick David, actor, 1717–79. | Heberden Wm., 1710–1801. | Herschel Sir Wm., 1738–1822. | James Watt, 1736–1819, &c. |

Upwards of 150 in all. The collection is still in the possession of the Gosset family. The portrait of Gray is reproduced in Mr. Gosset's *Correspondence of Gray*.

GOULD, ALEC CARRUTHERS. Nineteenth century, collaborated with his brother Francis Carruthers Gould, in illustrating *Michael Craig*, by Grant Allen, in 1893.

In his silhouette work, black with white outline is used, figures, rock scenery, birds, beasts and fishes are illustrated with consummate skill.

GOULD, F. C. Nineteenth century. The well-known political cartoonist, whose work was the mainstay of the *Westminster Gazette* for many years. He collaborated with his less known brother Alec C. Gould, in illustrating in silhouette *Michael Craig*, by Grant Allen, 1893.

By no means primarily a silhouettist Gould occasionally used this technique in his drawings. A group of 22 members of the Stock Exchange is preserved in the Library of the members of the committee of the London Exchange, and shows Gould's subtle wit in seizing characteristic personality and bending it to his purpose. The group has been published and a few of the names can be given by old members to those figures not too ruthlessly caricatured.

GOUYN, MRS. ANNE. Cut in card and vellum, exhibited flower pieces, 1763.

GRAFF, A. 1736–1813. German Portrait Profilist.

GRAPE, CHRISTOPH GEBHARD, b. 1761. 1795. Göttingen. Signature on silhouette portraits in the fifth volume of *Annalen der neueren theologis chen Literatur in Kirchengeschichte*. There are four silhouette portraits signed Grape fec. Göttingen.

GRASMEYER, THOMAS. Engraver of ornamental mounts for silhouette portraits, an example in the possession of Major Howell has on it the portrait of a man cut in black paper.

GRAVES, R. A.

GRAY, F. A. 1816. Clever figures in inch and a quarter size, verging on caricature are found on hand-screens, and on printed sheets usually unsigned, but name and date as above are on one example reproduced in *Antiques*, July 1932, published in America.[1]

A pair of such screens are in the Victoria and Albert Museum. A printed sheet by the same hand with two groups of thirty-six figures representing an evening party with dancing, music and refreshments, being handed, is enclosed in red curtains with gold tinsel decoration ;[1] below is written *Receipt for a Rout*, measures 16″ × 11″.

'Take all the ladies and gentlemen you can get, place them in a room with a slow fire. Stir them well, have ready a pianoforte, a harp, a handful of books, or prints, add them from time to time ; when the mixture begins to settle, sweeten with a little politeness and wit (if you have it) if not flattery will do and is very cheap. When all have stewed together 2 or 3 hours put in 2 or 3 Turkeys, some tongues, sliced beef or ham, tarts, cakes, sweetmeats, and some bottles of wine. N.B. Fill your room quite full and let the scum run off of itself.'[2]

Such skits on the fashions and foibles of the day were also done by Rowlandson, Gilray and Bunbury, but the silhouette illustrations are unique.

GREENBURG, OTTO. Free-hand cutter, 1923. His portraits of well-known people were made the subject of a guessing competition by the Newburyport *Daily News*, U.S.A., and the issue of 24 March 1923, gives thirty-five examples.

GREGORY. 1813. 'Miniature Painter, 32 Burlington Arcade, 1821' on a silhouette of a boy, Mereton Nelson, March 1813, in the possession of Rev. G. T. Morse, U.S.A.

GRIEN. Painter in Indian Ink on paper. A fine Conversation piece, portraits of the Sitwell family about 1760 reproduced in Randall Davies' *English Scenes in the Eighteenth Century*, the original owned by Captain Osbert Sitwell was shown at the 'Four Georges Loan Exhibition' at 25 Park Lane, 1930. Catalogued 'Thought to be by Grien'. (It is undoubtedly by Torond, E. J.)

GRIFFING, MARTIN. 1784–1859. A cripple by a fall from a steeple, worked in Vermont and New York State,[3] painted silhouettes in black or colour and also invented and used a machine. He eventually gave up this work and became a shoemaker.

GROSS, LEOPOLD. Of Vienna 1790, painted on under-side glass in the *églomisé* process and also etched on metal. (Plate 22.) Signature on a picture etched on metal depicting the balloon ascent of Jean Pierre Blanchard, 1753, 1809.[4] The faces of the crowd below are in silhouette, a profile portrait of the balloonist is shown in a circle above. This example is in the Victoria and Albert Museum ; it was presented by the late Captain Desmond Coke. The dress of the crowd indicates its date as twenty years after Blanchard's ascent.

It is signed Delmeavit Gross, No. P.122, 1922.

[1] *Antiques* cover illustration, July 1932. *Antiques*, Jan. 1934.
[2] Records of the Beetham family, *A House of Letters*, see Chap. XV. There are thirty-two of these silhouettes of members of society in Bath.
[3] Mrs. E. S. Bolton. [4] Rep. M. Knapp, p. 88.

[1] Rep. Nevill Jackson, *History*, p. xxix.

GROSS, Wilhelm. Sculptor, Grunewald. Born 1883. Cutter with good sense of design, he illustrated fairy tales, notably ' Snow White ', in silhouette.

GUEST, T. jun. pinsct. Signature beneath the bust-line on a finely painted silhouette portrait on card, of a man in the dress of 1790 to 1800, in my possession.

This artist was of London, and exhibited at the Royal Academy in 1801. The late Mr. Basil Long in his *British Miniaturists* quotes no example of his silhouette work, so that one may conclude specimens are extremely rare. He obtains his light effects without body colour, with thinned black.

GUMPPENBERG, Bertha von. Born 1897, Munich. Cutter of genre pictures of eccentric type and ornamental lettering.[1]

H

HAF. Fl. 1799. Painter and cutter, Berlin, Breitestr. 8. Fine examples of bust-size in possession of the Ermeler Haus Museum, Berlin.

HAINES, E. 1850. Worked on the Chain Pier, Brighton. Label on a man's full-length portrait, from the Montagu guest collection,[2] 'Profilist and Scissorgraphist, patronized by the Royal Family, most respectfully informs the nobility and gentry and visitors of Brighton, that he continues to execute the peculiar art of cutting profile likenesses in 1 minute, with the aid of scissors only, so as to equal any yet produced by the most accurate machine. | Terms : Full length portrait 2s. 6d., | ditto bronzed or two of one person 4s., | bust 1s. or two of one person, 1s. 6d. | Portraits of many interesting living characters may be seen at the first left-hand Tower on the Chain Pier. | Families attended at their own residences without additional charge. | Proprietor of original weighing machine.'

Bishop, writing of the Brighton Chain Pier in 1897, writes of ' the old tower keeper, Mr. Haynes, a skilful silhouette cutter, was very deaf and his invariable reply to any question was 1s. 6d. head and shoulders, 2s. 6d. full length. Haynes seems to have combined other sources of profit.

On another example of his silhouette work is a later label : ' E. Haines begs most respectfully to return his grateful acknowledgments to the Ladies, Gentlemen and visitors of Brighton for the very liberal support he has received as a Profilist, and begs to inform them, he has just started two very superior new Pleasure Boats at the Eastern Entrance to the Chain Pier, with steady and experienced men. E. H. respectfully solicits a continuation of those favours, which it shall be his constant study to deserve.

' N.B. These boats are admirably calculated for family parties, fishing parties, or excursions, being well provided with everything requisite and may be engaged at any time by applying to E. H. on the Chain Pier.'

In the Memoriam Pamphlet of the Brighton Chain Pier, published 1896 the name of the ' skilled silhouette cutter at the second Tower ' is also spelt Haynes.

HALLAM, T. 1820. Early nineteenth-century cutter. Signature on portrait presented to Victoria and Albert Museum by W. Barratt, Esqre. Written signature beneath the bust. Good work. Sometimes, heavily bronzed ; at other times, light bronzing, as in Victoria and Albert example.[1]

Occasionally his name is to be found on the brass hanger as on an example in author's possession.

HAMLET. 1779–1815. Painter on glass, silhouettes ; also coloured miniatures. His addresses are 12 Union Street, Bath, and 17 Union Passage, Bath ; 2 Bond Street, Bath. He also worked at Weymouth at 2 Conyer Street. His method is to paint black on flat glass, and he occasionally uses gold foil for ornament or military accoutrements. He painted full-length figures. A fine one in military uniform is at the Holburne Museum, Bath, No. 84, Captain Francis Holburne, 1788–1814, eldest son of Sir Francis, fourth Baronet. He served in the Peninsular War as a Lieutenant-Adjutant, 3rd Regiment of Guards, and died of wounds, received in a sortie from Bayonne. This portrait freely touched with gold measures $9\frac{3}{16}'' \times 6\frac{5}{8}''$, a similar type is in my own collection and also a full-length figure of an old man in civilian dress.

Bust-size portraits are rare. He sometimes uses the looped curtain convention in his group backgrounds. His work varies considerably, he makes great use of semi-transparencies to show differences in dress fabrics. One of his labels is headed with the Royal Arms and runs thus : ' Hamlet, | Profile Painter to her Majesty and the Royal Family, | No. 12 Union Street, Bath. | Takes most striking Likenesses on glass or Paper by a sitting of one minute only. | Price from 7s. 6d. to £1. | Ladies and Gentlemen waited on if required.' (Plate 95.)

There is an example at the Victoria and Albert,[1] and five were in the Wellesley collection dispersed at Christie's. In a MS. letter quoted in a catalogue of Messrs. Maggs, Rossetti refers to Hamlet.[2]

In Aris's *Birmingham Gazette*, 26 September 1785, he advertises ' From Abroad ', being the most singular artist in this Kingdom. Striking likenesses taken in 1 minute at 2s. 6d. Shaded and coloured, to 5s. and in full length for 10s. 6d. Also in Jackson's *Oxford Journal*, 18 June 1785.[3]

HANCOCK. Painter, 6 Clare Street, on label at the back of a silhouette portrait of a young man

[1] Rep. M. Knapp, p. 116.
[2] Rep. Nevill Jackson, *History*, xxxi.

[1] No. P. 67, 1924. [2] No. 449, 19291. 274.
[3] B. Long, *Miniaturists*, p. 187.

looking left. Painted on card, white stock and frill, high roll collar, about 1814 to 1820.

'A great variety of choice Prints, Drawings for hire or sale, price ten shillings and sixpence to one guinea per quarter or from sixpence to three shillings and sixpence per week, according to the value. The Money to be paid at the time of subscribing and the value deposited; and if the things are soiled or damaged, to be paid for accordingly. Prints, etc., Frames and Velvet colours and all Kinds of Drawing materials to be had of Mr. Hancock, of the best quality.

'Mr. Hancock drawing master No. 6 Clare Street. Terms vary in different towns. At Clifton 6 Lessons £2 2 0, At Bristol 8 ditto. £2 2 0, At No. 6 Clare Street ditto. £1 1 0, Ditto. 14 ditto. £2 2 0, At the Academy Two Hours and 2 Lessons per week —The first Half Year £4 4 0. Ditto. second ditto £3 3 0.

'Mr. H. will not engage for less than Half a year, neither allow for lost Time, nor take for less than the Time engaged, nor the number of Lessons specified.

'Private Scholars not to have less than 2 lessons per week.'

HANDRUP. 1913. Died 1931. A Danish cutter of portraits and fancy subjects, worked chiefly in London and achieved excellent likenesses which he touched with white chalk or gold paint. He also worked at book illustration and cut genre pictures. He cut in three layer black paper, and mounted on card with his name embossed at one corner. His charge was 1s. 6d. for three portraits (*see* Moderns).

His death in 1931 was caused by a motor accident within a few yards of his salon in Oxford Street, London.

HANK. 1770. Example in the collection of the late Mr. Francis Wellesley, now dispersed.

HANKES, MASTER. 1828. An English prodigy. Cutting and afterwards bronzing. In 1828 he went to America, travelling from South to North through the country; on a full-length portrait of Commodore Preble, which is signed, his label runs: 'Gallery of Cuttings. Cut by Master Hankes with scissors.' This is in the possession of the Maine Society of Portland, U.S.A.

An example was shown at the Exhibition of the Maryland Society of Colonial Dames of America, held January 1911. A portrait of Miss Henrietta Moffet belonging to Mr. and Mrs. Whitridge. In the *Salem Annals*, by Felt, we are told: 'In 1828 Master Hankes as the successor of the celebrated Master Hubard, is advertised as capable of delineating every object in nature or art, with extraordinary correctness. This he did by means of paper and scissors, merely looking at the object represented. It took him but a few minutes to give an exact bust of any person he saw. His full-length portraits are rare, one is in the Essex Institute, Mass. At Con-

cert Hall, where his talent was fully and successfully tested, was the Papyrotamia, a curious collection of paper cuttings. Admission 25 cents. In this department of art several young women of Salem have greatly excelled.'

Hankes seems later to have joined forces with Hubard, that other English prodigy who had landed in New York in 1824 and was showing examples of flowers, trees and other cuttings at Julien Hall, Milk Street. Admission entitled the visitor to a striking likeness of himself cut in a few seconds without the least aid of any drawing or machine, &c. How long the partnership lasted is not at present known, probably he was the 'other prodigy who possesses the same rare talent' and who worked in another room when Master Hubard was too busy to attend to all his clients. At any rate in a *Charleston Courier* advertisement[1] appears: 'Will open this Evening at seven o'clock. The Papyrotomia or Gallery of Paper Cuttings. The only Exhibit of the Kind in the World. Executed by Masters Hubard and Hankes in a style which has astonished the first artists in Europe . . . will be exhibited in Mr. Lege's Room, Queen Street, between Church and Meeting Streets. Admittance 50 cents, children are only charged the price of a likeness, namely 25 cents.' Likenesses of horses and dogs are taken, one learns from a long list of the usual details.[2]

The exhibition was open for fourteen weeks, ending with an evening for charity, Society for Promoting the Gospel amongst Seamen. Afterwards the show was removed to Baltimore.

HARDING. Cutter, Henry Street, London. 'Cut in paper by Mr. Harding' on the silhouette of Mr. Lawless, Irish Agitator, in the National Portrait Gallery, London, printed after a cutting by Harding.

HARGRAVES. Fl. 1813. Painted on plaster, gilding added.

HARRADENE, RICHARD. Died 1838. Signature on silhouette at Victoria and Albert Museum[3] from the Desmond Coke collection sold at Sotheby's July 1931 (rare), painted on card.

At the back is a printed label which reads: 'Profiles and Miniatures | By R. Harraden, | Drawing-Master, South-side of Great St. Mary's Church, Cambridge. | Proprietor and Publisher of the Views of Cambridge and Oxford, the Statue of Sir Isaac Newton, &c., &c.' | The label is inscribed in brown ink: 'From a sitting at Cambridge July 5, 1802.' Indian ink on card. Oval $3\frac{7}{8}'' \times 3\frac{1}{16}''$.

Information supplied by the late Mr. Basil S. Long, Keeper Print Department, Victoria and Albert Museum.

HARRINGTON, MRS. SARAH. 1775. 131 New Bond Street. Cut portraits hollow. These white

[1] *Courier*, 10 January 1828.
[2] *Conn.*, Miss Martin, Vol. 74, p. 93.
[3] No. P. 51, 1931.

paper cavities were usually placed on black satin or paper. They are seldom signed. Mrs. Harrington also painted on silk and cut with scissors. She was in Leeds in 1780 and advertises, 'Royal letters Patent approved. Profilist to the King (George II). 2s. 6d. likenesses.

'N.B. Wanted to exchange a genteel house in the vicinity of Kensington Gardens for one in London.'

There was a lady's portrait with high dressed hair in the Wellesley collection. 'Mrs. Lythall by Mrs. Harrington, circa 1775. Cut with scissors.' (Plate 64.)

Her work has a delicacy and chic unmatched by any other cutter except the Frenchman Edouart, and she never shows the rigid defect of machine cutting.

She advertises, 'To complete the many Favours that Mrs. Harrington is honoured with, it becomes necessary to shorten the Hours of Attendance which in future can only be from Twelve to Four o'clock during which time the most striking Likenesses will be taken at 2s. 6d. by Virtue of his Majesty's Royal Letters Patent granted to Mrs. Harrington by the King for her improved methods of obtaining the most perfect Likenesses in one minute. |

'Specimens of the first Personages and most distinguished Nobility may be seen as above.'

She applied for a patent for the protection of her inventions concerning 'Artists' Instruments and Materials', for the new and curious method of taking and reducing shadows with appendages and apparatus never before known or used in the above art, for the purpose of taking likenesses, &c., in miniature . . . so as to procure his or her shadow to the best advantage either by the rays of the sun received through an aperture into a darkened room or by illuminating the room. . . .'

The shadows (as also the likenesses) are cut out and placed upon black or other coloured paper or any dark body. The late Captain Desmond Coke found an advertisement of 1782 : 'Mrs. Harrington returned from Bath to Mr. Henderson's, chymist No. 131 New Bond Street, takes the most Striking Likenesses at 2s. 6d. each by virtue of His Majesty's Royal letters Patent granted to Mrs. Harrington by the King for her improved and expeditious method of obtaining the most perfect likenesses in one minute. Specimens of the first Personages and most distinguished Nobility may be seen as above. Attends daily from Eleven to Three only.'

In 1782 the portraits of Admiral Lord Howe and the Right Honourable Lord Shelburne painted on silk by Mrs. Harrington were exhibited at 131 New Bond Street.

In 1775 she advertises in the *Oxford Journal*, 1 July 1775 : 'The Lady who takes Miniature Profiles, in the Bond Street (Oxford) Letters patent granted to her.'

It was from one of Mrs. Harrington's profiles that the Wedgwood medallion portrait of Maria Edgworth, the authoress, was taken, Mr. Edgworth writes for 'twelve portraits done in white on pale blue (jasper) from a Profile by Mrs. Harrington '.[1]

HARRIS, C. Portraits of man and girl and of two women with signature ; at Knole, Sevenoaks, in Lord Sackville's collection.

HARRIS, T. 1827. Cutter. Very delicate work in black and gold with elaborate detail. An example William IV, $4\frac{1}{2}''$, belonged to the late Captain Desmond Coke.

HARRISON, A. H. 1916. St. Louis, Missouri.

HART, CHARLES HENRY. American writer and research worker. Author of *The Last of the Silhouettists*, &c., d. 1928.

HART, E. Painter. Signature on example. Painted on card in black and bronzed, in the possession of Mrs. Middleton, Canterbury. Late eighteenth-century work.

HASLEWOOD, LAURA. Genre cutter. Signature on a small cutting representing a man watering a shrub.

HASSELBRUN, ELSA. 1913. A Dane. Copenhagen. Illustrates Hans Andersen's writings.

HASSELRUS, ELSIE. Modern, illustrated with fifty silhouette cuttings, *Shen of the Sea*, by A. B. Chrisman.

HAWKINS, ISAAC. Englishman. Fl. 1803. Wrote from London to Chas. Wilson Peale in Boston, U.S.A., describing a stencil method of duplicating silhouettes, which he uses. Hawkins was naturalized in the United States—he made a machine of which 'any steady hand in a few moments could produce a correct indented outline'. He was an assistant of Charles Wilson Peale at the Museum in Philadelphia.[2]

Hawkins's machine was used by Henry Hervé in London and is described as taking 'correct likenesses in Miniature' on his label.

HAYD, H. Painted silhouettes.

HEINEMANS. Fl. 1763. Cut a silhouette of Goethe.

HEINRICH, ERNST. Fl. 1780. Cut the portrait of Countess Salm Proshan. Also painted silhouettes. A Conversation picture by him is mentioned by Herr J. Leisching in which The Lady sits knitting by a table where her three grandchildren are also seated. There are two dogs in the picture which is dated 1780.

HENNING, CHRISTOPH DANIEL. Born 1734. Painter, engraver and silhouettist. He was also an art dealer and held a municipal appointment in Nuremberg in connexion with the decoration of the town.

HENSEL, F. C. Cut twelve silhouettes to illustrate Grimm's Fairy Tales, published under the title *Aus Märchenland*.

[1] *Life of Maria Edgeworth*, by the Hon. Emily Lawless.
[2] Martin.

HEPFORD. 1913. Silhouettist in colour; cutter, using methods which tend towards plastic effects.[1]

HERBERT, M. In 1761 Horace Walpole writes to Sir Horace Mann and asks him to 'thank the Duchess of Grafton for the découpure of herself', her figure cut out in card by M. Herbert of Geneva —query, Hubert, Jean (*q.v.*)? (Plate 14.)

HERVÉ, A. 1840. Painted Profiles, 145 Strand. Signed in clear cursive lettering. He painted usually full length, using dark grey and black for contour and decoration. He applied gold sparingly. A miniature size portrait framed in a locket was sold by Messrs. Puttick & Simpson in October 1931.

HERVÉ, CHARLES. Artist, 172 Oxford Street, on a cut paper silhouette of a lady in Early Victorian dress. It is profusely bronzed; in the collection of the author. There is also an example of fine brushwork on plaster in the collection of the late George Stoner. Hervé's label is stencilled: 'Hervé Miniature Painter, 143 Strand.'

He has many addresses. In 1835, 172 Oxford Street, the year in which above portrait was cut; in 1828, 21 Paradise Place; 1841, 248 Regent Street; 1847, 193 Oxford Street; 1848, 392 Strand; 1855, 210 Oxford Street; 1858, 256 Oxford Street. He exhibited twenty-seven miniature portraits at the Royal Academy between 1828–58.

A silhouette of Sir Walter Scott by Hervé was shown at the Royal Amateur Art Society's Exhibition, Lowther Lodge, Kensington Gore, March 1902, No. 108.

HERVÉ, HENRY. 1801. Miniature painter, profilist and jeweller, 12 Cheapside and at 23 Bond Street, near Conduit Street. In the album collection of the late Andrew Tuer are two labels: 'Correct Likenesses in miniature taken by Hawkins's Patent Machine, by which he has taken the likenesses of upwards of 10,000 Persons. Profiles taken and cut out in paper 2*s*. 6*d*. each completed in Five minutes. *Miniatures from one Guinea upwards.* H. Hervé wishes the public to understand that besides sketching the Profile outline, this Machine is the only one that makes a complete Drawing of every Feature of the Face and in any View, by which means Likeness is certain; but for the further satisfaction of the Public, he pledges his word, that he will return the Money if the Likeness is not good. | Profiles painted on Plaster of Paris, glass, ivory, &c., in a superior manner, and reduced to the sizes of Rings, Brooches, Lockets, &c. |

'*Profiles of all descriptions copied accurately.* Persons leaving their names can have any number of Copies without the trouble of sitting again. |

'N.B. H. Hervé makes it a rule not to allow any Person to have the Profiles of any Lady or Gentleman, till he is satisfied, the Parties themselves have no objection. Great variety of Rings, Brooches, Lockets, &c., for Profiles and Miniatures. Jewellery of all descriptions on the lowest terms.'

This second label is on portrait of a lady looking left.

His full-length portraits, about 9½ inches, are very attractive, details are worked on to the black paper cutting in white, grey and a denser black, a shadow is often washed on to the ground and bronzing used sparingly.

In Sidney Hand's *Signed Miniatures*, 1925, an example of Henry Hervé's coloured miniatures is shown facing page 10.

He exhibited at the R.A. 1813–16, where his address is given as Great Russell Street, where also Charles Hervé and Francis Hervé lived; both were artists.

In the possession of the late Lady Mount Stephen were two fine portraits by Hervé painted at the underside of convex glass, and filled in with a pinkish cream coloured composition; these were sold at Sotheby's, July 1933.

I have a fine full-length Hervé, a portrait of Mary Grantham, *née* Withers, my mother's eldest sister.

HESSELL, LEONHARD HEINRICH. Born 1757, at St. Petersburg. Painter of silhouettes and engraver, he invented a machine to take silhouettes by daylight 'which he called the Hesselich Treffer'. Later he worked at stipple engraving in England.[1]

HESSEN, DARMSTADT CAROLINE LANDGRAVINE. Died 1774. Fl. 1759–65. Cutter. Fine early examples, some of the earliest in Germany. Life-size original shadows in the possession of the Grand Duke of Hesse-Darmstadt.[2] The Landgravines lived at Bouchsweiler and Darmstadt.

HILLS. Painted silhouettes and touched with gold lines, Cambridge, mid-nineteenth century.

HILMERSON. Silhouettist. Has illustrated the works of Pushkin, the Russian writer. Exhibited 1909, 1910, Blanc et Noir at the Academy of Art at Leningrad, now called the State Academy of Art.

HODGSON, MR. 33 Tavistock Street, Covent Garden. Advertises his 'miniature profiles' and miniatures. 'Miniature Profiles 4 for 2*s*. 6*d*., or in a carved and gilt frame for 3*s*. Miniature Painting from 1 to 2 guineas.' *Morning Post*, 8 December 1774.[3]

HOERNER, GRETA VON. Cut silhouette scenes for the shadow theatre.

HOERNIG. German. Cutter. Fl. 1780 and later at Darmstadt and Homburg. Fine examples in possession of Dr. Jacobi are signed and mounted on brown background.

HOERSCHELMANN, ROLF VON. Cut fantastic figures and groups in quaint angular style for use

[1] *One Hundred Silhouettes*, Ed. Beyer, Vienna and Leipzig, 1913.

[1] J. Leisching.
[2] Information, Dr. Braüning-Oktavio, Ph.D.
[3] Buckley.

in shadow plays. His work has been published for private circulation.[1]

HOLLAND, MARY. Cutter, 1770. Juvenile cutter whose genre work at 10 years old is attested by Mrs. Mary Ann Davis, Senior.

HOLLAND, WILLIAM LANGFORD. Fl. 1777–87. Miniature painter and silhouettist. Was trained at the Dublin Society of Drawing Schools and won prizes in 1774 and 1776, also obtained a medal in 1779. He exhibited three crayon drawings at the Society of Artists in William Street, Dublin, in 1777, the only occasion on which his name appears as an exhibitor. He worked in Dublin for some time at 12 Suffolk Street, doing small miniatures in profile painted in water-colour on glass, backed up with white satin. For these he charged seven shillings. In 1786 he advertised from 146 Capel Street : ' most striking likenesses from one to five guineas each,' and a new invention : ' profiles à la Marlborough painted on glass, being the invention of a foreign gentleman who has brought this art to a perfection never before known, in this or any other country : one sitting only being necessary and time not more than ten minutes. Elegant gilt frames furnished : price of both frames and profiles being so moderate as half a guinea.' In 1787 Holland was practising in Kilkenny as a ' Miniature painter in profile à la Marlborough '.[2]

Commander M. A. Jamieson owned nine portraits in silhouette of one family by Holland, on several of these the price £5 5s. was written in the space left for that purpose on the labels. This fact is interesting as showing the high estimation of silhouettes by the public at the end of the eighteenth century, in that they were willing to pay prices equal to those charged for coloured miniatures.

Holland's silhouettes are rare, of fairly good quality but rather messy.

HOLLANDS. Fl. 1788. 50 Oxford Street. Book- and print-seller. Also taught profile taking. ' Likenesses on glass executed from half a crown to a guinea, frame included.' Advertisement : ' Lessons in Profile taking given by Mr. Hollands, Book and Print Seller, 50 Oxford Street. Profile likenesses highly finished in Shade, Ladies and Gentlemen who may wish to acquire the pleasing art of taking profile likenesses of their friends, may, in a few lessons, be made as perfect as the first profilist in Europe, though totally unacquainted with drawing. Terms 2 guineas.'

HONEYWELL, M. A. MISS. Fl. 1809–48. American. Born without arms she cut silhouettes holding the scissors with her teeth, the paper being supported on a table. She was at Barnum's old Museum, Anne Street, New York City, also at Camberville, U.S.A. She is mentioned in Felt's *Annals*

[1] Rep. M. Knapp, ps. 92, 93, 94.
[2] Strickland, Vol. I.

of Salem as cutting watch-papers and fancy pieces. Her price for profiles was 25 cents, children half price ; they are usually signed ' Cut without hands by M. A. Honeywell '. Sometimes they were bronzed. The work is naturally clumsy, but marvellous that it could be done at all.

HONIGSMANN, R. Painted silhouettes in Indian ink.

HOOKER, SIR JOSEPH DALTON, G.C.S.I., C.B., D.C.L., LL.D., P.R.S., F.L.S. 1817–1906. Botanist and traveller. Author of *Botany of the Antarctic Voyage*, 1847–60, *Flora of British India*, &c., &c. Whilst Regius Professor of Botany in University of Glasgow 1841 was appointed first Director of the Royal Botanic gardens. He brought his *Portraits of Botanists* with him, of which he writes : ' Mine is the only extensive collection and is very valuable '. It consists of chalk drawings, engravings, lithographs and silhouettes, of which there are eleven examples (*see* Miss Everitt).

HÖPFNER, L. J. 1743–97. German professor in Giessen. Some examples of his work together with the silhouette chair or stool and the original stork's beak or pantograph which are still owned by the family, were exhibited at the Exhibition at Leipzig in 1914. Höpfner was a friend of Goethe and together they produced silhouette portraits, some of which were used by Lavater for illustrations in his work. Höpfner had many hobbies and was a skilled craftsman in glass cutting, the making and supplying of household implements, and it is said that he could take the life-size, whole-length figure in silhouette with his machine. Few of these have survived ; there are three in the Goethe National Museum, and others at Frankfurt in Goethe Haus.

HOUGHTON, S. Was working in 1785. Painted on ivory and plaster. Probably a partner with Bruce, at one time his pupil. His label is almost identical with that of Houghton and Bruce, but no address is given. His miniature work for jewellery seems important, as unlike most silhouettists he mentions it first.

' *Profile Shades*, executed in a peculiar style whereby the Likeness is admirably preserved and reduced so small as to set in Rings, Pins and Bracelets, Lockets, &c. by S. Houghton. |

' *N.B.* He keeps the original drawings and can therefore supply all these he has once taken with any number of copies. Any having shades by them may have them copied and reduced, the Likeness is preserved and dressed in the Modern Taste.'

This label is on a beautiful portrait of a girl in my possession, 3½″ × 2½″ sight measurement. His work is very fine, mostly dense black, but the hair and muslin frills transparent black. (Plate 93.)

HOUGHTON AND BRUCE. Late eighteenth century. Profile shades, South Bridge Street, No. 31 (Edinburgh) on a man's head painted on plaster,

elaborate gold bordered glass, from the collection of Evelyn, Duchess of Wellington now in the possession of Miss Martin, New York. There are two others in the Buccleuch collection of miniatures at Victoria and Albert Museum and two lent by C. Stewart Bilton, Esqre., painted in Edinburgh. (Plate 95.)

John, youngest son of Hew Stewart, Governor of Fort Marlborough, painted in 1785, and Elizabeth, youngest daughter, born 1773. Both these fine examples are painted on plaster and signed beneath the bust, they are framed as lockets.

Houghton was, like Lovell, a pupil of Miers. Bruce, whose name comes second, was a jeweller and framer and the pupil of S. Houghton.

HOWARD, EVERET. Circa 1820. Itinerated in New England, U.S.A., cut hollow by machine and made a few miniature examples all black, his work is unimportant.

HOWIE, J. Painter, 65 Princes Street, Edinburgh. Portrait and miniature painter. Stencilled label. Painted the silhouette of Gilbert Burns, brother of Robert Burns, poet, now in the Scottish National Portrait Gallery. Also a portrait of a gentleman looking left, painted on card, in the Victoria and Albert Museum. Label entire, No. P. 5, 1926.

HUBARD, WILLIAM JAMES (Master). Free-hand Cutter. Born 1807, died 1862. Beginning to cut portraits at the age of 12. An advertisement in a Norwich paper, January 1823, runs thus :

'Extraordinary Development of Juvenile Genius. Just arrived at Mr. Critchfield's, cutter, Market Place, Norwich. *Master Hubard,* The celebrated little artist who, by a mere glance at the face ! and with a pair of common scissors ! ! not by the help of a Machine nor from any sketch with Pen, Pencil or Crayon, but from Sight alone ! ! ! cuts out the most spirited and striking Likenesses in One Minute— Horses, Dogs, Carriages, in short every object in Nature and Art are the almost instantaneous productions of *His Talismanic Scissors.*

'Likenesses in Bust 1s. Two 1s. 6d. | Young children 1s. 6d. Two 2s. | Full length 5s. Two 7s. 6d. | Families attended at their houses ; terms extra, if less than seven in number. | Master H. may be seen from 11 in the Morning until 4 and from 6 until 9 in the Evening.' (Plate 97.)

There comes a puff from the Editor in the same sheet : 'We cannot avoid expressing our gratification at the continued success which seems to attend that interesting little artist Master Hubard, whose astonishing abilities, persons of all classes seem to be eager to put to the test. We do not hesitate to pronounce Master H. the greatest phenomenon of art that this city ever witnessed, and we look forward with confidence to the time when his talent will display itself as conspicuously in the use of the pencil as it now does in the use of the scissors.'

Again under date 6 February 1823 : 'Master Hubard's stay in Norwich is prolonged until Wednesday next. Those who are desirous to witness his wonderful Delineations, and at the same time obtain correct Likenesses of themselves, or any favourite animal are requested to call at Mr. Critchfield's, Market Place, Between the hours of Ten and Four on or before Wednesday, 12th inst., which will positively be the Last Day of his stay in Norwich.'

Such advertisements are characteristic of many others in the same vein.

This silhouettist, travelling from town to town, named his headquarters 'The Hubard Gallery' wherever he worked. He was at 109 Strand when he, at an earlier age than that of Frith which is shown as our Frontispiece, cut the portrait of little Princess Victoria, afterwards Queen, and six members of the Parker family, finely bronzed.

At the age of 17 he landed in New York where his address was 24 Coney Street ; here his charge was 50 cents. He uses no signature, his mounts are impressed at the left corner, Hubard, or Hubard Gallery, and I have found a stencil label with the same words on the wood backing of a large group of five of his figures in a room.

Sometimes Hubard used faint colour. In the collection of the late Mrs. Andrews a soldier had a dull red uniform. At the back of this portrait was his Strand address.

In the *Bury Post*, like Charles of an earlier date and Adolph of Brighton, 'drops into rhyme' on the subject of Hubard's portraits.

A lover's address to the profile of his departed mistress, cut by the celebrated Master Hubard :

'Sweet shade of my Anna while on thee I gaze The big rolling tears from mine eyes . . .' &c.

Three other verses are written in this strain. The last begins : 'Oh, Hubard, thy scissors to nature were true,' &c.

At Newmarket, 29 December 1822, Hubard advertises. 'Likenesses in Bust 1s., Two 1s. 6d., Children 1s. 6d., Two 2s., Full lengths 5s., Two for 7s. 6d. Families attended in their houses. Likenesses faithfully copied. Frames in great variety.'

In Hubard's original trade sign.[1] The letters are cleverly done in water colour and comic figures twine themselves on the upright lines. This interesting relic was in the Desmond Coke collection, now owned by Rev. G. T. Morse.

A portrait of a colleague, by Hubard, dated 1832, was shown at the Royal Amateur Art Society's Exhibition at Lowther Lodge, March 1901. No. 1483.

At Bristol, Hubard took the portrait of a street matchseller and used this silhouette in his advertisement. A copy is to be seen in the Library of the

[1] Rep. *Art of the Silhouette,* Desmond Coke.

National Portrait Gallery, London, as well as one of Mappen, the bill-poster of Sheffield.

Hubard advertises 'Family groups, Landscapes, American views, may be viewed gratis, by visitors for Likenesses'. This points to the fact that he returned to England after his work in America. However, he eventually went back to America, and joining the Confederate Army, was killed in Richmond, Virginia, by the explosion of a shell which he was filling. For details of American travels *see* American chapter.

An important pair of portraits by Master Hubard are of President and Mrs. Franklin Pierce; they are full length and bronzed. Name of the artist as usual embossed. Owned by Miss Mary Martin, U.S.A.

HUBERT, JEAN. 1721–86, of Geneva. Cutter. One example of his series of Voltaire was published in the *Illustrated London News*, 9 June 1860, under the title 'La Silhouette decoupee'. (Plate 14.)

Hubert was a friend of Voltaire, and doubtless the silhouettes were made while the great man was unaware that his portrait was being taken. One shows him with arms outstretched, apparently gesticulating as he talks; in another he stands with folded arms, and determined chin very much in evidence. Both were cut at the Château de Ferney pais de Gox en Bourgoyne par Geneve, 4 April 1761.

In 1860 these portraits were in the possession of Mrs. John Henderson, together with several letters from Voltaire written to George Keate during 1757 and 1771.[1] (*See* Herbert, M. (*q.v.*))

HÜBNER. 1797. On a fine painted silhouette of a child belonging to Madame Nossof, Moscow.[2]

HUDSON, MRS. Fl. 1796. On the back of portrait painted on convex glass and filled with wax. Label: 'Models in wax and striking Likenesses in Profile or in colours Executed in a superior style of Elegance and Fashion by Mrs. Hudson from Pall Mall, London.' On portrait of Thomas Surg, January 1796, in the possession of Miss Martin, New York (*see* Dictionary).

This artist was born Miss Chilcot of Bath, daughter of Henry Chilcot, goldsmith and jeweller of Greek Street, Bath. See *Bath Chronicle*, 8 December 1774: 'Continues to take Likenesses as usual in their own hair for Rings, Lockets, Bracelets, at 28 Newhall Street, Birmingham.'

Aris's *Birmingham Gazette*, 27 September 1779; 'By Mrs. Hudson from late Secard's, Pall Mall. Likenesses in Miniature Profile from 5s. 6d. to 10s. 6d. each. Modelling in wax.'

Aris's *Birmingham Gazette*, 21 December 1795; 'So eminent in taking profile likenesses upon glass . . .' 'Has taken over 150 in Birmingham,' *Coventry Mercury*, 4 April 1796.

Another example has the label: 'Hudson, Mrs. | Painter of profiles, | face black, ornament lace, &c., brush and pen work'. Also painted miniatures in colour. | Label oval in husk and ribbon frame. 'Models in wax and . . . or in colours. Executed in a superior Stile of Elegance and Fashion by Mrs. Hudson from the late Secard's, Pall Mall, London.'

This label is on a portrait of Elizabeth Kenwrick, wife of Rev. Thos. Cox, great-great-grandmother of T. S. Cox, late A. C., Deritend, Birmingham.

Hudson's signature is on the portrait of a gentleman looking right, in dress of late eighteenth century, painted on glass in the collection of the late Mr. F. Wellesley, now dispersed.[1] (Plate 96.)

HULM. Eighteenth century. Signature on scarf-pin with miniature silhouette.

HUMMEL, L. Viennese artist cutter, present-day. She has made and published drawings for Andersen's Fairy Tales, *What the Moon Told*, and for the poems of Miss R. Fyleman. In the opinion of a writer in the *Studio*, January 1927: 'She translates a feeling of colour with her simple black and white art.'

HUNT, MRS. LEIGH, 1822. Cut Byron's silhouette in white paper during his stay at Pisa. She wrote to an American friend: 'After tea I sometimes sit at my window snipping away at black paper, I have done the silhouettes of many friends, also comic pictures of acquaintances.'[2] (Plate 96.)

The Byron portrait has been reproduced in lithograph.

HUNTER, THO., of Edinburgh. This name with date, 1798, aged 84 years, is cut in white paper. Beneath an elaborate shield on which is a lion rampant. There is finely cut mantling and a crest, boar's head chained, and the motto 'Courage sans peur'. This work measures $4\frac{1}{2}'' \times 8''$ and is unusual on account of signature cut in a piece. Some of the heraldic effects are obtained by pricking, enclosed in a decorative border of almost exciting rhythm. In my own possession.

Other examples of his work are in the Victoria and Albert Museum, E. 115, 1928; E. 116, 1928. These were presented by Queen Mary and are dated 1786. On one is the Lord's Prayer in cut lettering surrounded by a simple scroll border, square chequer ground fills the space reaching to the outer border on a similar cut paper sheet, similarly signed and dated, is the Church Creed. These examples measure $4\frac{1}{2}''$, and were pages in a book given by Mrs. R. Hughes at the age of 71 to 'my dear daughter Mrs. Frederick Gyd'.

HUPP, OTTO. Born 1859 at Düsseldorf. Cut heraldic designs using the folded method, thus

[1] Thiem and Becker. *Allg. Lexikon der Bildenden Künste*, Vol. 18, pp. 9–12.

[2] Rep. Nevill Jackson, *History*, LIX.

[1] Rep. Plate XL, *One Hundred Silhouettes*.

[2] Nevill Jackson, *History*, LI.

obtaining two sides alike. He worked not only with scissors but also with knife, punch and gauge, and thus secured a variety of effects.[1]

HUS, R. W. Fl. 1653. A South German, probably from Augsburg. A remarkable volume of cuttings in black and white, 1653–4, were first seen at the Silhouette Exhibition in Berlin in 1905. They were again shown at the Leipzig Book Exhibition in 1914, and are now in private ownership.[2] One example shows the procession at a peasant's wedding, in three tiers ; beautiful cuttings of St. Francis preaching to the birds, twenty-five different kinds of birds being shown in a two-inch group. On another page are heraldic emblems and landscapes with black on white, and white on black effects. The folded method is sometimes used.

Signature enclosed in a ribbon is *Pax cum Dev. R. W. Hus, 1654.* Some beautiful examples from this collection are shown in shadow and scissor pictures by Herr Martin Knapp in his book *Three Centuries of Silhouettes.* Hus is the only German cutter of the seventeenth century whose name is known.

HUSTON. 1844. Painter, 14 Dean Street, Brighton. On a portrait of a lady looking left, full length in garden. The hair is tinted brown, the cap and fichu shaded white, full crinoline skirt, black with black shining lines.

H. W. H. On an engraved portrait of George III are the words : ' Drawn, Engraved and published by H. W. H. 24, Clerkenwell Green, London.'

The silhouette portrait is in the dot and line method ; behind the star frame are sun-rays. The Royal crown and sceptre on a cushion beneath, has roses, oak leaves, &c. Beneath are the words : ' His Most Gracious Majesty King George the Third, Who by the Blessing of Almighty God This Day, October 25th, 1809, Enters the fiftieth or Jubilee Year of his Reign in the Hearts of His Loyal Subjects.'

I

ICHIYEISAI YOSHI KU. 1824–95. Japanese artist who worked in silhouette. Two examples of his shadow prints show a cray-fish and red shell fish, gold fish and carp in silhouette. A portrait of the actor Onoge Takanojo in colour and with silhouette is one of a series entitled ' Mako no tsuki Hana no Sugata-ye '. (A flower form picture before a real moon.) Reproduced in *History of Silhouettes* by the author. There are twelve of the portraits, the conventional forms in colour, with the black profile beneath, the subject usually actors as women ; they are catalogued in the work on Japanese prints by Mr. Lawrence Binyon. The silhouette seems an

eminently suitable expression in Japanese art, for only in Japan has the vulgarity of confusing the spirit of elimination with meanness, been overcome.

ISENBURG, CARL FRIEDRICH LUDIG, MORITZ, PRINCE VON. 1766–1820. Fl. 1785. Painter in silhouette, signed and dated. His work, showing hair and fine detail in lines in the English manner.

There are fine examples in the collection of the Grand Duke of Hesses-Darmstadt.[1]

J

JÄGER, LOTTE. 1823–91. Cut portraits and very delicate flower studies in naturalistic manner. In *Deutsche Schatten und Scherenbelder* a portrait of Justinus Kerner is shown, 1853 ; a wreath of flowers surrounds the head and verses are written beneath. Her flowers are graceful, but not botanically correct. Her *Travel Shadows* was published in 1811.[2]

JAHANCKE, SACHS. Cutter, 1887. ' The Rope Walker ', and other designs are her work.

JANARY, H. DE. Circa 1790. Painted on ivory, silhouette process reversed, white on coloured ground, resembling cameos.

Two fine examples in the collection of the late Lord Aldenham. Written at back : ' H. de Janary to be heard of at 32 Lower Thornlough, Bedford and London.'

JARVIS, J. WESLEY. Born England 1789, died New York 1839. Nephew of the preacher. It is said that he was the first to bronze with gold in America. He also painted on glass in New York, and in the southern States ; he was a roistering man, notwithstanding his relationship to the great Wesley. He made a good deal of money and spent it very quickly. Sully considers ' he would have been a fine artist, had he studied anatomy '.

Joseph Wood, water-colour artist, was at one time his partner. They lived together in Park Road, New York.

Jarvis invented a machine for drawing profiles on glass, the outline being drawn on one side was blacked on the other, backed with golf leaf. These portraits became very popular and Jarvis made excellent profits, which he squandered as soon as earned. Jarvis also modelled in clay.

In June 1809 he concludes an advertisement by advising those who wish to have portraits of their deceased friends [3] ' should be particular to apply in time enough, before interring them '.

JASTRAU, GUDRUN. Cutter, b. 1901. At a show in London this clever artist exhibited portraits, decoration and genre pictures. Her methods include examples of great delicacy and others of massive treatment. (Plate 80.)

[1] Rep. M. Knapp, p. 73.
[2] Information, Dr. Braüning-Oktavio, Ph.D.

[1] Information, Dr. Braüning-Oktavio, Ph.D.
[2] Rep. M. Knapp, p. 57. [3] *Long Island Star.*

JAY. Ipswich. *Vide* list in *One Hundred Silhouette Portraits* selected from the collection of the late Francis Wellesley.

JEFFRESON. Early nineteenth century. Cutter and painted on card, used profuse bronzing. ' Modern style of executing Likenesses by a machine constructed on unerring Principles '—Advertisement in a Canterbury newspaper. ' Mr. Jefferson from London, Profilist to the Principal Nobility and Gentry in the Kingdom, Respectfully informs the Ladies and Gentlemen of Canterbury and its vicinity, that he executes Striking Likenesses in Gold Bronze tint. A Style admired and approved of by the Principal Artists and Amateurs in the Kingdom, and as they are become so very fashionable the public can never have a better opportunity than the present or obtaining correct likenesses. A variety of specimens will be exhibited by Mr. Jeffreson at Mrs. Websters, Palace Street as Mr. Jeffreson's stay will be only two or three days. An early application is requested of Ladies and Gentlemen who may be pleased to honour him with their commands. Terms three shillings. Ladies and Gentlemen waited upon at their own houses, no likenesses to be kept unless approved. A large assortment of fashionable frames for sale.' This advertisement is on the portrait of John Williams Esqre. of Bagshot. (Plate 97.)

There are two examples of Jeffreson's work at the Victoria and Albert Museum. Mrs. Kingston, a widow, No. 17, 1928, taken at Midhurst, and a man cut in red brown paper, heavily bronzed, No. P. 18, 1928. London address : 4 New Street, Strand. Label on a miniature $1\frac{1}{2}'' \times 1''$.

JOHNSON. On a silhouette portrait of Frederick of Prussia is this signature : ' 1s. Johnson del Alderton suff : ' The King is mounted on a horse decorated with strange arabesque patterns, the saddle, uniform and horse-cloth are in full detail, only the profile of the King is all black.

JOLIFFE. Painter on underside of flat glass. His work is very rare, though examples may have been attributed to other silhouettists, for his label is still rarer.

The only example of his work I have heard of has an ornamental border and garlands round the portrait. His date is probably the second quarter of the eighteenth century, for Thomas Gray the poet had a friend who sent to him in 1758 ' An ode to Mr. Joliffe who cuts out Likenesses from the Shadow at Whites.'[1] The kindly Gray has little to find fault with in the lines, and his friend, Rev. William Mason, explains that Mr. Joliffe is a bookseller's son in St. James Street, who takes profiles by candlelight, better than anybody. All Whites have sat to him, not to mention Prince Edward.

At first his price was only half a crown and now

[1] See *Notes and Queries*, Vol. 149, No. 16, 17 October 1925.

it is raised to a crown, and he has literally got above a hundred pounds by it. Alas that the late enthusiastic collector, Major Desmond Coke, did not live to know that his mystery is solved.[1]

JOHNSON, T. Harrogate. Painter on back of flat glass. Label : ' T. *Johnson,* | Harrogate. | Takes Miniature Profiles on glass. | Those who please to favour him with their commands, may depend on the most striking Likenesses. |

' N.B. He keeps the shades by him so that any friend by sending a line may have whatever copies they please.'

This label was on the shades of a lady and a young girl in the Desmond Coke collection sold at Sotheby's July 1931.

JONES, EDWARD. Born 1775, died 1862. Studied at the Dublin Society's Schools. Exhibited portrait drawings and miniatures at Dublin 1800–21. Some of his portraits were engraved for the *Methodist Magazine*. In 1816 his address was 6 Chatham Street, Dublin ; about 1820–4, 7 Chatham Street, Dublin, when he was secretary to the Hibernian Society of Artists. In an account of drawings sent to the Exhibition held in Dublin at Allen's in Dame Street, he was referred to as ' a rising genius though but a lad '. His silhouette portrait is reproduced on Pl. XXXV in Strickland's *A Dictionary of Irish Artists*.

Jones retired in 1827 and died at 16, Charlemont Mall, Dublin.[2]

JONES, F. P. Cut hollow by machine and frequently added lines of head-dress or laces on the edge of the portrait. Worked in New England. An example of his work is owned by the Pennsylvania Historical Society.

JONES, GREGORY. Made the profile portrait of Sir Frank Dicksee, P.R.A., for the silhouette portrait frieze in the club-room of the St. John's Wood Arts Club, 1925.

JONES, JOE CRANSTONN. 1926. Of Augusta, Georgia. A blind and crippled youth of 16 who in 1926 was advertised as cutting ' Silhouette pictures of landscapes and animals he had never seen '.

JONES, T. H. Fl. 1752. Advertisement in the *Northampton Mercury*, 30 December 1752 : ' Shading Likenesses in Miniature Profile, on an entirely new plan and with great improvements. Taken in one minute by Mr. Jones, Artist and Drawing Master, from the Royal Academy, London. That no person may be deprived of their own friend's likeness, they will be done at so small a sum as 2s. 6d. Nothing required unless the most striking likeness is obtained. Specimens may be seen each day from 12 till 7 at Mr. Balaam's, Sadler, Northampton.'

In 1790 Jones advertises his newly invented

[1] Information, Mr. Perkins.
[2] Confessions Colie, p. 182.

reflecting mirror ; he is then at Reading. His addresses in London are : 32 Judgate Street ; 7 Coventry Street, Leicester Fields ; 168 New Church, Strand. In 1798, 293 Oxford Street. In 1800, 4 Wells Street. In 1781 he is described as ' the Artist from Bath, 270 Oxford Street, 2s. 6d. frame included ' (see Machines).

In the *Manchester Mercury*, 29 July 1783, he advertises : ' Artist and Drawing Master from the Royal Academy, London. Likenesses in Miniature and Profile to represent the whole Drapery and in particular the head-dress. Taken in 1 minute at 2s. 6d. each. Visits Manchester.'

JORDEN, RICHARD. Fl. 1780. Painter on card and flat glass, usually mounted with card back, beautiful bold work. All black with little detail.

A fine portrait of Mrs. Grosvenor by Richard Jorden is illustrated in *One Hundred Silhouettes* from the collection of the late F. Wellesley, Esq., J.P., p. xiv. In this the characteristic density of his work is well shown. Brother of W. Jorden below.

JORDEN, W. Fl. 1783. Painter on flat glass. Very fine bold style with little detail and no shading. Six specimens ' from the " family friends " collection of the late Lady Shaftesbury ' are in the possession of the author ; these include portraits of William Bray, 1736-1832, historian of Surrey ; Maria Dickons, *née* Poole, 1770-1833, well-known London singer ; Frederica Duchess (Landgrave) ; David Bishop, Esqre ; a son of Rev. Samuel Holworthy of Croxell, Derby ; portrait of a lovely unnamed lady, with beribboned cap. (Plate 97.)

The finest example I have examined is amongst the King's Portraits at Windsor Castle. Queen Charlotte sits in a cane-back chair with cabriole legs half concealed by her hooped skirt. The lower hem is lace-trimmed, lace adorns her throat, and there are ruffles at her wrists. She holds the little dog by one paw and with uplifted finger admonishes him. She wears a great feather-trimmed hat of the period. A beautifully painted vase of flowers is placed on a table near. The picture measures $9\frac{1}{2}'' \times 8''$, and the dense black combined with elegant lightness is remarkable. (Plates 9, 97.)

JOUBERT. Name on silhouette of a boy cut in ornamental engraved mount. Printed below the portrait is ' Fait par Joubert, peintre en miniature '. In the Knole Collection. Possibly the name is that of Joubert who published the *Manuel de l'Amateur d'estampes*.[1]

JOYE. Circa 1812. Painter. Worked at Salem, Mass., U.S.A. His signature is on a silhouette portrait in Indian ink. His advertisement gives the address ' opposite the Salem Hotel ', where he took profile portraits.[2]

[1] Nevill Jackson, *History*, p. XLVII.
[2] E. S. Bolton.

K

K. Signature on minute portrait of a lady in the Wellesley Collection, now dispersed. It is mounted with floral border and framed as a locket. The work is French in character. Plate XLIX in *One Hundred Silhouettes*.

KAFFKA, J. C. Actor at the Royal Electoral Theatre, Saxony. He composed an operetta called *The Apple Stealer*, on which was a portrait in silhouette of a young man signed J. C. Kaffka.

KAG, G., alias **WIRER.** Scissor worker, photographist, miniature painter of the City of Oxford. In 1877 this artist also worked at Scarborough.

KEATING, G. Cutter. He took engraved pictures as his models and cut in black paper the engraved designs of Morland[1] and other workers, making his cut paper copy the same size as the engraving and mounting it on card. An example in the collection of the late Captain Desmond Coke shows ' The Angler's Repast ' after Morland, size $19'' \times 16''$.

KELFE, MRS. L. M. LANE. Fecit 16 April 1785, Bath. On the portrait of a man E. A. Girling, black profile, uniform in grey relief ; by means of an advertisement it is learnt that this silhouettist was a woman ; example in the possession of Captain Desmond Coke is reproduced in *Art of the Silhouette*, Plate V. The advertisement concludes thus : ' Specimens of 160 different Profiles, glass, satin, enamel, shaded and plain, may be seen at her apartments. No. 20 Duke Street, St. James.' This is one of the rare instances when enamel is mentioned as a medium in silhouette work. (*Cf.* Plate 97.)

There is an interesting example painted on card, at the back is ' M. Lane Kelfe fecit, Oxford, 1784 '. The portrait in my own possession is of my great-uncle Reverend John Gatliff in ' Oxford dress '. The mortar-board cap of the student is worn over the wig with its tied queue ; neck frill and high stock is worn. This John Gatliff was the brother of Samuel Gatliff, London merchant, whose portrait, painted by one of the early American painters, Gilbert Stuart, is now at the public gallery at Philadelphia and highly prized. In our family records are the words : ' Samuel went to America, married M. Griffin.' (Plate 97.)

Gilbert Stuart also painted the portrait of Mrs. Samuel Gatliff, with Elizabeth, the eldest of their four daughters, in her arms. This portrait is considered by the late Mr. Hart, the American antiquarian, to be one of the finest of Stuart's portraits : her father Samuel Griffin was also painted by Gilbert Stuart ; he married Betsy Braxted, whose grandfather signed the Declaration of Independence—so I almost feel American through my great aunt—E. Nevill Jackson, *née* Gatliff.

[1] Rep. *The Art of Silhouette*, p. 200.

KELLNER, Christopher Michael. 1741. Cutter. In a stag-hunt, perspective is achieved by means of superimposed papers. In the National Museum at Munich, *vide Miniatures and Silhouettes*.[1] I have a superb specimen in white paper: subject—Moses watching the flocks of his father-in-law Jethro, he is in the act of putting his shoes from off his feet and the burning bush is in front of him. Trees, shrubs, birds and beasts stand out and are enclosed in a delicately lovely border of conventionalized fruit and flowers ¾ inch wide. Cut in the paper in Old German is the text illustrated—Exodus, chapter iii—and the name Christopher Kellner, 1741.

This is the most elaborately cut-work landscape I have examined; it is in my own possession. Supremely fine workmanship, and gives us the name and date of the earliest known cutter after Hus.

KEMPTON, W. Name on profile shade of 'Francis, late Duke of Bedford' taken at Ampthill Park, in the National Portrait Gallery, London.

KERN, Yselin Elias. 1753-1814. Basle. Freehand cutter, in whose family a collection of 700 examples of his work is still preserved. On one of the folios containing the specimens are the words: '*Collection de Silhouettes decoupé par Elie Kern Fils commence dans l'Année 1779.*' His miniature work, unlike that of most silhouette artists, was not reduced to the desired size by mechanical means, but was cut free-hand in the minutest size for rings, brooches, &c. Occasionally he pricked from the back to give raised effect to jewels, combs, &c.

A very charming example is in the possession of Professor Paul Ganz-Kern at Basle. A lady in eighteenth-century dress is shown in a cut frame with garlands, a vase above, candles at the sides are held in elaborate stands attached to the frame, all cut in black paper.[2]

KERR, L. L. Circa 1850. Painter. Signature on a beautifully painted pair, full length, on card in the Rosetti manner, with well-painted backgrounds in wash. A portrait of Lady Alice Hill with view of Hampstead background, another of a lady seated at a piano with view of Italy at window, very fine work.

In 1865 Mr. John Moore Napier lent to the Miniature Exhibition at Victoria and Albert a 'Portrait of a Lady in the Character of the Muse Polyhymnie', painted on ivory in 1830 by Lady Louisa Kerr.

Two silhouette portraits by Lady Louisa Kerr are recorded on p. 11 of the 1905 *Catalogue of Portraits*, &c., belonging to the 4th Earl of Liverpool.[3]

KERRY, R. and W. Artists. A stencil mark on two silhouette portraits painted in black and colour, the interior decoration of the room being also in colour.

K.H. 1854. Finely cut piece in bold design peacock and foliage, probably by an amateur. In possession of the author.

KINDERMANN, Johann. 1809. Silhouette on gold ground. Biblical subject, colours in landscape.

KING, William. 1805. Of New England, U.S.A. 'Taker of profile likenesses, respectfully informs the ladies and gentlemen of Portsmouth that he will take a room at Col. Woodward's on Wednesday next, and will stay ten days only, to take profile likenesses. His price for two profiles of one person is twenty-five cents, and frames them in a handsome manner with black glass, in elegant oval, round, or square frames, gilt or black.' Advertisement in *New Hampshire Gazette*, 22 October 1805: 'Price from fifty cents to two dollars each.' (Plate 59.)

King cut hollow, using a machine. Sometimes his portraits are on embossed mounts.

Advertisement in the *New Hampshire Gazette*, U.S.A., Tuesday, 22 October 1805: 'William King, Physiognotrace, Respectfully informs the ladies and gentlemen of Portsmouth that he has taken a room at Mr. William Gray's Boarding House in High Street, where he purposes staying a short time to take *Profile Likenesses* with his new invented patent Delineating Pencil, which for accuracy, excels any machine before invented for that purpose.

'He reduces to any size from the shadow; therefore the person is not incommoded with anything passing over the face (see Schmalcalder, Chapter V) nor detained over six minutes. The correctness of his profiles is well known, he having taken over eight thousand in Salem, Newburyport.' Did he get one of the redoubtable 'Lord' Timothy Dexter we wonder?

William King's time was six minutes for taking a portrait, and he sold copies of that of George Washington, as mentioned in the Diary of William Bentley. If only he had taken the extra care to keep an account and naming his portraits, a valuable pictorial record of citizens of New England would now exist, but, alas, he had not the methodical mind of the Europeans Edouart, Sideau, and Anthing.

King was a cabinet-maker by profession, and Mr. E. H. Keyes, who has written much of his history,[1] considers that so original a genius as King should be better known. 'An ingenious mechanic but full of projects and what he gains from one he loses in another.' On King's handbills two silhouette portraits appear, obvious reproductions of machine cuts.

On 24 June 1806, he advertised: 'William King takes profile likenesses at the next house to Concert Hall in Hanover Street, Boston.' He also travelled in Halifax, Nova Scotia.[2]

[1] Max von Boehm. [2] Rep. M. Knapp, p. 31.
[3] *Miniaturists*, B. Long.

[4] Published in *Antiques*, September 1927, by Mr. Homer Keyes.
[5] Library of Congress, Washington.

There must be hundreds of these portraits in the possession of New England families in their 'Elegant Frames', the signature King or W. K. should easily be found. He eventually disappeared, leaving a note saying that he was about to drown himself.

KNIGER, HEINRICH. Painted black profiles, colour on clothes and accessories. A series of bell-ringers and town-criers has his signature.

KOCH, F. R. 1779. Name on girl's head in operetta.

KOERTEN, JOHANNA VAN. Paper cutter, fine white medallion. Subject: Virgin with St. John, in Victoria and Albert Museum.

KOLL, M. 1880. Produced posters in drawn silhouette work.

KONEWKA, PAUL. 1840–71. One of the best known silhouettists of the nineteenth century. When a child he amused himself by cutting out white paper patterns and toys. When 11 years old he cut illustrations for *Uncle Tom's Cabin* and later the principal figures in Goethe's *Faust*.

Though Konewka entered the studio of a sculptor in Berlin and was also trained in painting, he did not succeed in these arts and remained a brilliant silhouettist. His best known published pictures are 'Pages from Faust', 'Midsummer Night's Dream', 'Falstaff', and other Shakespearian characters.

Konewka had to transfer on wood and stone in order to obtain reproductions of his work, and in many of them this process has spoiled their delicacy; he often added tendrils and other fine lines with a pen. His brother-in-law J. Trojan wrote the text for many of Konewka's pictures and has also written his biography and enumerated all his work. He had a host of imitators, but in his own line there has seldom been a more skilful cutter. His signature is usually K.[1]

KORINTHEA. 600 B.C. Daughter of the potter Dibutades. According to Pliny this lady was the first lady silhouettist or portraitist of any kind of whom we have any record; she traced the shadow of her lover's profile when he was leaving her in Corinth and thus produced the first portrait directly from Nature's outline.

KRUGER, PAUL. Austrian cutter, in London 1930.

KUNST, FREDERICK. Cut silhouettes.

KUNST, THEODOR. Cutter, began when 12 years of age.

L

LAHRS, MARIA. 1878. Born at Königsberg. Cutter of landscape and genre pictures. Collaborated with Wolff in decorating a café; the scheme has been published in *Die Woche*, Vol. 42, 1909.

[1] Rep. M. Knapp, p. 74.

'The Shepherdess' and 'Man in Repose' are important examples of her work.

LAMBERT. 1809. Painted on flat glass. Woman looking left belonging to Mr. Holworthy.

LANGERVELN, H. 1820. Signature on an example in the collection of the late Mr. F. Wellesley.

LANGERWELD. 1802. Painted in a $5\frac{1}{2}'' \times 7\frac{1}{2}''$ size.

LANSKOY, A. In 1782–3, at the time when the visits of Anthing and Sideau had made the art of the silhouette fashionable at the Russian court, Lanskoy cut many silhouettes; amongst them was the profile of the Empress Catherine which he describes as *en négresse*. This profile was used as the model[1] of the Empress on the silver roubles coined in 1783.

LASSE. Signature on portrait of Emperor Paul of Russia as a child, in possession of Madame Nossof, Moscow.

LAVATER, REV. JOHN CASPAR. Zurich. His *Essays on Physiognomy* are largely illustrated with silhouettes; he considered this type of portraiture the most suitable for examination of the contours of the head. 'It is the justest and most faithful, when the light has been placed at a proper distance, when the shade is drawn upon a perfectly smooth surface, and the face placed in a position perfectly parallel to the surface . . . it is faithful, for it is the immediate impress of nature, and bears a character of originality which the most dextrous artist could not hit, to the same degree of perfection in a drawing from the hand.' I quote from the translation by Rev. C. Moore, LL.D., F.R.S., published in 2 vols. 1794.

Such praise of the silhouette continues for many pages and black profiles of well-known painted portraits by such artists as Michelangelo, Van Dyck, &c., of the skulls of animals, of criminals, imbeciles, and every other type of man, woman and child. The deduction drawn from the contours are described at great length. Characters are classified according to the formation of the forehead chiefly, but every feature is made to play its part and tell the character of the subject in this 'gallery of physionomies and characters'.

Lavater stayed with the Goethe family, the poet himself was an enthusiastic taker of silhouettes. Lavater and his draughtsman Schmoll took the portraits of all the members of the Goethe family; these were afterwards severely criticized, and their inclusion of some of them, but not of all, in the great work on the 'Knowledge and the Love of Mankind' became the subject of acrimonious correspondence.

During his travels Lavater collected hundreds of portraits, many of them of subjects who hoped to have a fine character awarded to them, and Lavater

[1] *Recueil de la Société historique impériale de Russia*, Vol. XXIII, pp. 247, 262.

was able to gather handsome subscriptions for the publication of his book.

For other aspects of Lavater's life and work there are many sources available.

LEA, of Portsmouth. Signature on a portrait painted on convex glass of Admiral Sir J. Lawford. Lea's technique is unusual, the face is not dead black but is painted with stipple and dot like an engraving, so that every feature is depicted with contour. The effect is of semi-transparency as in the drapery of Mrs. Beetham. His beautiful work is rare. There are two fine examples at the Victoria and Albert Museum given by the late Mr. Desmond Coke: one a naval officer looking right, No. P. 149, 1922, and a lady looking left, P.146, 1922.

Of the four in my own collection the portrait of an old man is much the finest, strong character being expressed in the modelling of the features. I have only seen two examples of women's portraits. Any example of this artist's work adds great distinction and value to a collection. (Plate 98.)

LEON. Modern free-hand cutter using several folds of paper. Worked in Regent Street, 1934. (Plate 76.)

LE PAGE, Charlotte. Working in 1800. Cut profiles and bronzed; she also painted coloured miniatures on ivory. Fine examples of her work are signed and dated, being portraits of Le Page, Rev. R. L., Rector of Panfield, 1767–1810; Mrs. Le Page; a self-portrait; Amelia Le Page, and Uncle Le Page. Good work.

LESLIE, H. 1910. Free-hand cutter. ' On the West Pier, Brighton. | Artist Silhouettist. | Full Length 3 copies 5s. | Heads only 3 copies 2s. 6d. | Coloured portraits 3 copies 7s. 6d. | Gilding heads 6d. extra. | Figures 1s. extra.'

Mr. Leslie attended the School of Art in Sheffield after leaving Rugby School, on coming to London he received training at the Slade School. He keeps ' Record Books ' and has 10,000 autographed portraits in them; he also cuts group pictures and beautiful fancy subjects. (Plates 76, 77.)

His records were begun on the West Pier, Brighton, many years after Gapp's work came to an end on the old Chain Pier.

At the end of Leslie's advertisement—' All my Silhouette Portraits are drawn from life and cut out of paper with scissors, without the aid of photograph or any other mechanical device whatever.' He had a successful exhibition at 14 Brook Street in 1932, showing many original examples such as ex-libris with heraldic devices, crests, humorous pictures, and life studies with coloured paper backgrounds: of his floral studies ' Wisteria ' was purchased by Her Majesty Queen Mary. His brochure, freely illustrated, is interesting.

LETTON, R. Circa 1808. At his Wax Exhibition used a machine cutter, afterwards touching his sil-

houette portraits with colour or bronzing; his bust-line is very distinctive with its sharp arm and shoulder curves. ' Mr. Letton Respectfully informs the Ladies and Gentlemen that he takes Profile Likenesses in the neatest manner. The superiority of his machine to those in use and extensive practice, enable him to give correct profiles; he respectfully assures those ladies and gentlemen who will favour him with a call, that his whole endeavour will be to please: and for the small sum of 25 cents they may depend on receiving two correct profiles or no pay will be required.

' He paints them in colours and shades them in gold. All attention paid to those that wish to have them framed. He constantly keeps a handsome assortment of Profile Frames for sale, oval or square, black or gilt. Families may be attended in their own houses at the same expense.' [1]

This handbill has on it the profiles of a man and a woman, and also states particulars of wax works and other attractions of Letton's Show with a list of wax figure groups. It is in the possession of Mr. George D. Seymour at Newington, Conn., U.S.A.

LEWIS. 1808. Profilist signature on the portrait of Mr. J. Cunliffe of York in the possession of Mrs. Fleming. A robust and sturdy figure painted in black and well defined but subdued colour, painted background.

LIGHTFOOT, Mrs. M. Fl. 1785. Label on two painted silhouettes on plaster. ' Perfect Likenesses in miniature profile, taken by | Mrs. Lightfoot, Liverpool, | and reduced on a plan entirely new, which preserves the most exact symmetry and animated expression of the features. | Much superior to any other method. Time of sitting one minute. |

' N.B. She keeps the original shades, and can supply those she has once taken with any number of duplicates. |

' N.B. Those who have shades by them may have them reduced and·dressed in the present taste. All orders addressed to Mrs. Lightfoot, Liverpool, will be punctually dispatched.'

This label printed in oval form to fit the frame gives the information that if one possessed a home-made wall shadow outline one could send it to Mrs. Lightfoot for ' reduction and dressing in perfect taste ' and there need be no sitting before the professional artist.[2] In some old newspaper reports her probity is impugned, but as a silhouettist we can record that Mrs. Lightfoot's work is very charming. She used more solid black than most of the workers except the Jorden brothers. She has a very marked characteristic, namely a thin shadow or secondary outline beyond the body drawing on the bust-line. ' Likenesses in Miniature Profile. Will be here

[1] Rep. Mrs. Van Leer Carrick.
[2] Rep. Wellesley, XXVII.

(Edinburgh) in a few weeks from Glasgow.' *Caledonian Mercury*, 18 September 1786.[1]

LINCOLN, P. S. Signature on several of the portraits in the collection of Mr. Montague J. Guest. Sold at Christie's, 11 April 1910.

LIND, James, M.D., F.R.S. 1736–1812. Physician to the Royal Household at Windsor, he was a dilettante scientist, astronomer, traveller, and printed various little books, printing also profiles ' with a rolling press, from a piece of Paper cut out and blacked on both sides on a Dabber '.[2]

Two profiles could be rolled off at the same time, and he counted that he had thus created 20,000 portraits of King George III at the age of 40 in 1778, such an assertion being written at the back of one of his profiles.

Under date 26 November 1785, Fanny Burney gives a not very flattering opinion of his medical skill, thinking him ' a better conjuror than physician '.

Some of Dr. Lind's profiles were reduced by Tiberius Cavallo (*q.v.*); in a letter to Dr. Lind dated 3 March 1792, he writes : ' Herewith you will receive two of the contracted profiles, but I have not yet been able to make a good job of the third.' Correspondence with regard to ' thick paper mentioned later as suitable for the reduced profiles when used as block for reproduction ' indicates that Dr. Lind made the original life-size shadow portraits, they were reduced by Cavallo on to thick paper and returned to Dr. Lind for printing reproduction.

Many examples may be seen in the Banks' Collection in the Print Room, British Museum, mostly dated from 1792, including King George III and Queen Charlotte, Hume the historian, Mrs. Delany, Benjamin West, P.R.A., Solander the Swedish naturalist, Sir Joseph Banks, de la Lande the French explorer, George Brudenell Montagu, 1st Duke, whom Lind would meet at Windsor, and many others.[3]

LISTER. Amateur. Father of Lord Lister. Cut the portrait of his distinguished son at the age of 13. Reproduced in the *Life of Lord Lister*, 1821. His portraits of the whole family, six sons and five daughters, together with finely painted silhouettes of the great discoverer of the principle of antiseptic dressing in surgery, are in the Wellcombe Medical Museum, Wigmore Street, on continual loan.

LLOYD, A. E. Chain Pier, Brighton, where the ' Towers ' were used for the sale of petty merchandise and toys, or were occupied by silhouettists. Second half of nineteenth century. Lloyd's portraits were cut out of black paper and bronzed with gold.

LOCKE, M. Fecit 1843. Signature on full-length portrait of a lady holding a book, in the possession of Mr. T. R. Hall.

LOEKSI. A Polish cutter. Itinerated in Ireland, holding exhibitions in the cities he visited. Advertisement on an example in the Wellesley collection.[1]

LOESCHENKOHL, H. 1780, of Vienna. A copper-plate engraver who published silhouette portraits of the celebrities of his day and also large pictures in silhouette of important scenes.

In an almanack for the year 1786 were fifty-three silhouette portraits, described by Mr. J. Leisching as divided into groups : ' Nature and Art ' (amongst this section is the name of the poet who composed the words for Mozart's ' Magic Flute '), ' Art and Harmony ' (in which division are the silhouettes of Mozart, Gluck, and Haydn), and ' Song and Artistic Acting ' (when many female lights of the Viennese stage appeared). These silhouettes were also printed and sold separately to admirers of the performers.

Well-known fellow-citizens were outlined by Loeschenkohl's graving tool, and quickly reproduced.

At the death of the Empress Maria Theresa (1780) Loeschenkohl issued a large oval picture in silhouette. The dying Empress, with bowed head, is in a chair, Joseph II kneels at her right, holding her hand, Leopold stands before her, court officials are in the background, one takes down her dying words. On this picture are the words : ' To be had of Loeschenkohl in Vienna, Shop 488 in the Market Place.'

LONGINATE. 81 Margaret Street on printed silhouette of Granville Sharp (anti-slavery enthusiast), born 1734, died 1813. Published by L. Nichols & Co., December 1818.

LORD, Philip. 1814–40. Cutter. Born in Newburyport, Mass. His known work portraits are all full length, cut out of black paper free-hand and mounted on gold or silver ; a grey wash background is usually added. On the back is written : ' Cut by Philip Lord, Profilist.' Several examples are in the collection of Rev. G. T. Morse, Mass. Lord itinerated in New England, U.S.A., 1840.

LOSSE. Signature on a beautiful portrait of the Emperor Paul of Russia as a youth, in the possession of Madame Nossof, Moscow.[2]

LOUISE, Queen of Prussia. Cut figures and other forms for the shadow theatre.[3]

LOUTERBURG, W. 1798. This silhouettist made a sketch of George Washington at Christchurch, Philadelphia, when Washington took his last leave of Congress. It was in Indian ink. Washington[4] presented it to the wife of Major De la Roche, aide-de-camp to Lafayette. I have in my possession an original copy of *The Times* in which is printed : ' Address of President Washington on his resignation.'

[1] Buckley.
[2] ' A Forgotten Group of Profilists,' by F. Gordon Roe (*Apollo*, vol. XXII, no. 131).
[3] *Ibid.*

[1] *One Hundred Silhouettes*, Francis Wellesley, J.**P.**
[2] Rep. Nevill Jackson, *History*, LXXII.
[3] *Children's Toys of Bygone Days*, Karl Gröber.
[4] Information from Library of Congress, Washington.

His admirable periods fill 2½ columns, the other items in the paper and advertisements are most intriguing.

LOVELL, Thomas. Fl. 1806. Painter. 'A pupil of Miers. | "Thomas Lovell" (from Mr. Miers). | Profile Painter, Jeweller and Miniature framemaker. | 32 Bread Street, Cheapside, London, | engages to take Likenesses in Profile to reduce and copy old Shades or Sketches for Rings, Locketts, Frames, &c. |

'N.B. By preserving the original Draught he can supply Duplicates without an after sitting, Mourning rings and every article in the Jewellery line.'

So apt a pupil was Lovell that it is hard to distinguish between some of his portraits and those of his great teacher. Lovell painted on plaster. I have never seen an example of his work on card, nor have I seen any but dead black filling, like Miers' early Leeds work, but without the shadowy hair and laces of the ladies. Probably many examples of Lovell's work whose labels have been destroyed are now thought to be by Miers. (Plate 98.)

LOW, William. 1840–50. Worked at Dublin and at Belfast (dates above) as a miniature painter and profilist.

LOWE. Circa 1840. (*See* Percival, *Cutting by Machine*.)

LUBBERS, W. Signature on an example in the collection of the late Mr. F. Wellesley, J.P.

LYNASS, Master. Cutter. Small square label 'Cut by Master Lynass in 20 Seconds without drawing or machine' on the back of portrait of a man looking left, in possession of the author.

M

MACKENZIE, Laura Muir. 1806. Died 1828. Cut subject pictures in black or white paper. The album pieces of the period, her grouping and tree work is good but by no means of first quality. She is buried at Dale Vine Vault, near Dunkeld. Several examples of her work are to be seen at the Victoria and Albert Museum.

MACKINTOSH. Nineteenth century. St. Andrew's Street, Edinburgh.

MACLISE, Daniel, R.A. 1806–70. Born at Cork. Historical painter. Amongst his drawings bequeathed to the Victoria and Albert Museum by Mr. Foster there are two heads in black silhouette and two cut silhouettes. These are interesting as, notwithstanding the estimation of his works during his lifetime, his fame now rests on his portraits and the two great historical pictures in the House of Lords. Of his portrait of Charles Dickens, now in the National Portrait Gallery, Thackeray wrote: 'the

real identical man, Dickens, the inward as well as the outward of him.' His very slight connexion with our subject make such words of special interest.

MAHALL, Georg. In a Conversation picture two men and a lady sit at a table; two girls are entering the room, holding a flower garland, beneath is written: 'Dedicated to Herr Fraz Bachmann by his friend Georg Mahall.' First decade of the nineteenth century.

MAIDEN, I. Profilist. Stencil label on a portrait painted on card dated 1817.

MANDERER, E. Illustrated a child's book in silhouette.

MANNER & HILL. 2 Wardour Street, London. Cut with a patent machine, profile portrait with glass and gilt frame 1s.

MANNERS, W. H. 1830. Miniature painter. Painted the silhouette of Sir Thomas Swinnerton Dyer, R.N., 1770–1854. He exhibited a 'Portrait of a Gentleman' at the Royal Academy in 1830; his address was then 286 High Holborn. (Plate 99.)

MAPLETOFT. A Fellow of Pembroke College. Cut a black shade of Thomas Gray the poet, 'taken after he was 40'. In the Strawberry Hill Collection a profile of the poet was described as 'Mr. Thomas Gray etched from his shade by W. Mason'. Mr. George Sharf in the *Athenæum*, 24 February 1894, considers it a happy idea to make use of the silhouette for producing a more accurate portrait. 'The black shade of the poet preserved at Pembroke College directly inspired the best known portrait of Gray by Basire.'

MARDEN, F. Profilist. Fl. 1830. On a portrait of a woman painted in olive green on card; there is another earlier record of this artist's work on the portrait of a woman tinted with gold, circa 1820.

MARIA THERESA. Two white paper cuttings appeared in the Brünn Exhibition attributed to the Empress.

MARIE, Féodorovna, Grand Duchess. Cut silhouette of portraits of her friends and contemporaries at the Court of Catherine II. Her method was to cut in 'pierre dure' and outline this cutting on glass.

MARKOW, General. Cut a large number of silhouette portraits in Russia of his contemporaries at Court. This collection is preserved with the engraved portraits of Monsieur M. P. Daschkow.[1]

MARTIN, William. Painter and profilist of King Street Park, Stockport. Is mentioned under 'Painters, Portraits, &c.' in the *History, Directory and Gazetteer of the County Palatine of Lancaster*, Vol. II, 1825.

MARTINI, Viger. On painted silhouette of Blondin dancer and a fine series of personages of the French operatic stage in Paris, including Varain Lefage the dancer, and many others. Martini's

[1] Information from *La Cour de l'Impératrice Catherine II*, Vol. I, pp. 22, 23.

work is on a 4″ × 5″ cartridge paper, black and grey Indian-ink effects very bold and clever. In the Library of the National Portrait Gallery, London.

MASON, W. Profile painter and print-seller, Cambridge. Label on portrait of Ed. Daniel Clarke, LL.D., Professor of Mineralogy, Cambridge, in the National Portrait Gallery, London. He died 9 March 1822, aged 53 years. (Plate 99.)

In a later label Mason describes himself as painter to H.R.H. Duke of Sussex; the Royal Arms appear on the label. An example was in the possession of the late Henry Jerningham. A silhouette portrait cut by Mason was printed by him mounted in an elaborately engraved frame. The profile is surrounded by a laurel wreath, a bishop's mitre above, books piled below, beneath the words 'Herbert Marsh, Bishop of Peterborough, d. 1839'. The figure is in black gown and cambric bands with mortar-board cap.

Mason's activities extended to other crafts such as the resilvering of looking glasses and mirrors, and the making of frames.

His silhouette work is usually heavily bronzed.

MAY, PHIL. 1864–1903. This brilliant black and white artist occasionally worked in silhouette, giving to each portrait his inimitable touch of good-natured caricature. Several specimens were in the possession of Captain Desmond Coke, one signed Phil May, 88 Paris Chat Noir. A portrait of the Polish poet Mickiewicz is reproduced in *Art of the Silhouette*, Pl. XL.

MAYER, JOSEF. Signature on silhouette in black, painted on flat glass, gold ground. His signature read in a mirror has been noted as an example.

MAYER, STEPHANUS. 1813. Signature on a portrait painted on glass, gold ground.

MEGIT. Circa 1840. Cutting by machine. *See* Percival.

MENZEL, ADOLF. 1815–1905. A cutter of the stencil type of portrait, popular in the middle of the nineteenth century, in which outline and contour were obtained by cuts, and when the portrait was held between the light and the wall, the contour shadow was thrown. This type of portrait was cut in black and in white paper. There are examples of Menzel's work in the National Gallery in Berlin, and many of them in the Print Department, Victoria and Albert Museum.

MENZEL, C. B. Glass-worker and decorator of goblets and other vessels, ornamented with black silhouettes, signed and dated, with gold background.

He lived in Warmbrunn. Fl. 1780–90. Examples are preserved in the Hohenzollern Museum, Berlin. Information Dr. H. Braüning-Oktavio.

MERCK, JOHANN HEINRICH, 1741–91. Kriegsrat, Darmstadt. Friend of Goethe. Painted and cut silhouettes. Wendt worked for Merck in pro-viding the full-size shadows. Correspondence with Lavater and important information, *see* H. Braüning-Oktavio, *Silhouetten a.d. Wertherzeit*, 1926.

MERRYWEATHER. Profilist, second half of nineteenth century. Label on the back of cut silhouette of a girl in black paper, bronzed. Portrait of Bishop of St. Davids, full length, in possession of Mrs. Green, Boston, Mass.

METCALF, ELIAB. Born 1785, died 1834, New York. He was a silhouette cutter and a portrait painter in miniature and in oils. In 1807–8 he was in Guadeloupe, afterwards went to Canada and Nova Scotia. He studied drawing in New York in 1810. Ill-health necessitated his going to New Orleans in 1819, and he visited the islands of St. Croix and St. Thomas. Afterwards he lived in Havana, but continued to visit New York each year.[1]

METFORD, SAMUEL. 1810–90. Painter. Born of Quaker stock in Glastonbury, Somerset. Went to America about 1834, and became a naturalized subject of the U.S.A. Worked in New England and elsewhere. He returned to England in 1844, and with the exception of two years in America, 1865–7, spent the remainder of his life in England, mainly in Somerset.[2] Two full-length seated figures, The Hon. Davis Dagge, 1842, and Hon. Nathan Smith, are in the possession of Mr. Leonard Mayhead, New Haven, Connecticut. (Plate 57.)

Metford's father was Joseph Metford of Glastonbury. In 1801 he married Elizabeth Rawes. Many of Metford's silhouettes are to be found in Scotland, they are generally full length and occasionally on lithographed backgrounds. The hair and cap or bonnet is often touched with grey water-colour and bronzing is freely used. He signs S. Metford or Sam'l Metford. His family groups are much prized. His work is not very rare.

MEWES, MAGDEBURGH. Signature on an example in the collection of the late F. Wellesley, Esq.

MEYDELL, BARONESS EVELINE VON. German. Present day. Cuts black-paper portraits after laborious drawing, two or three sittings of several hours required. Price, many pounds per portrait. Works in America. Also does landscape work very finely in miniature and paints on glass with gold leaf backing. Good work. In her girlhood she cut silhouettes at her father's castle in Livonia, and her scissors have stood her in good stead in exile. (Plate 79.)

MEYER, S. 1813. A fine head of a man by this artist was exhibited at the Maehren Crafts Museum in 1906.

MIERS, J. Miniature profile painter from Leeds visits Edinburgh,[3] *Caledonian Mercury*, 18 October 1786.

[1] T. Bolton.
[2] Mr. H. Stewart Thompson, *Conn.*, May 1926.
[3] Buckley.

In *Newcastle Courant*, 27 March 1784, Miers advertises while visiting Newcastle-on-Tyne, 1784 and 1788.

In 1788 he charges 6s. to 10s. 6d. each, according to the *Newcastle Courant*, 6 September 1788.

In *Manchester Mercury*, 4 January 1785, he is at Cateaton Street; he stayed till 7 January, when business in Leeds called him away. In the same paper, 11 July 1786, he announces that he takes Shades from 10 to 1, and from 2 to 5 each day, time of sitting 2 minutes, finished in elegant gilt frames or reduced upon Ivory to set in Rings, Pins, Lockets, Bracelets, at trifling expense.

On 18 July, and 8 August 1786, ' Correct likeness of Mrs. Siddons copied and sold with her permission '. No fewer than four of these have passed through my hands; one I had the pleasure of presenting to Mr. Siddons the actor, the great-grand-nephew of the divine Sarah.

MIERS, JOHN. 1758–1821. Painter. The extreme beauty of the work of Miers and the large number of examples which happily remain both on card and plaster of Paris make the study of the life of this artist of the utmost importance. The span of his days exactly coincides with the heyday of supreme success in silhouette work. All facts we can gather from advertisements, labels and examples of his portraits are valuable. (Plates 8, 16, 101.)

He was the eldest son of John Miers of Quarry Hill, Leeds, a painter, whether of pictures or the utilitarian house painting and decorating I have at present no evidence to show. The mother of the Profilist died 28 May 1767. Miers himself was married at the Leeds Parish Church, 3 January 1751, and very soon after began business apart from his father, buying the goodwill and premises of a fellow-townswoman. Both in the *Leeds Mercury*, 3 April 1781, and the *Leeds Intelligencer*, 10 April 1781, he announces himself as ' Successor to the late Mrs. Walker, Painter, in Lowerhead Row, Leeds, late an eminent and ingenious painter of this town '. His newspaper advertisement runs thus:

' John Miers Junior,[1] Painter, Gilder, &c. Near the Top of the Lower-head row Leeds (successor to the late Mrs. Walker). Begs leave to inform his Friends and the Public That he intends to carry on the above Business in all their various Branches on his own account, and hopes by his Assiduity and utmost endeavours to please, to merit a continuation of the Favours of all those who please to honour him with their Commands, which will ever be gratefully acknowledged by Their obedient and humble Servant J. Miers Junior. Likewise sells Wholesale and retail all sorts of Paint, &c. which he is determined to prepare in the best Manner, and sell at the most reasonable Terms. Profile Shades in Miniature, most striking Likenesses drawn and

[1] *Leeds Mercury*, Tuesday, 6 March 1781.

neatly framed, at 2s. 6d. each, a second Draught from the same Shade 2s. (Plate 101.)

' Elegant oval Picture frames of various sizes at a very low Rate.

' N.B. The House below the Old Assembly Room in Kirkgate, late in the possession of John Rowley to be Lett. Inquire as above.' (This last points to the house painting and agency as part of the business.)

The following is of this period, at present the earliest known engraved label; it is on the back of a lady, which I found in York in 1911.

Label: ' J. Miers, | Painter and Gilder | at the Golden Oil Tarr, Lowerhead Row, Sells on the most reasonable Terms All Sorts of Oils and Colours, &c. for Painting. |

' Also oval Picture Frames of various sizes. |

' N.B. Profile shades in Miniature. Speaking Likenesses drawn and framed at 2s. 6d. each.' *Leeds.*

The second label is similar in all particulars except that the price is raised to 3s. An example fixed on the back of a portrait of a gentleman, all black, on plaster is in the possession of Mrs. Andrews, Bournemouth.

The third label, the last I have found that he used while still living at Leeds, read thus:

' Jno: Miers, | Lowerhead Row, Leeds. | Takes the most perfect Likenesses in Miniature Profile in one Minute, on an entirely new Plan. Allow'd Superior to any other. |

' N.B. He keeps the original Shades of all he takes, therefore any Person may have more copies by applying above. |

' Persons having Shades by them reduced to any size and dress'd in the present taste.'

In September 1783, Miers visited Newcastle-on-Tyne. His address there was at Mr. Bellows's, Glover, High Bridge.

In the local press appeared the following:

' Most striking Likenesses Taken in one Minute upon an Entire New Plan J. MIERS desires to return his sincere thanks to the ladies and gentlemen of Newcastle for their favours conferred upon him in the Multiplicity of Business he is engaged in and desires to inform them that through the Encouragement he has had and the particular Desire of a Number of Families who had not an opportunity of Sitting to him last week, he is induced to stay the Remainder of the week and positively no longer.

' At Mr. Bellows, Glover, High Bridge, where he takes the most perfect Likenesses in Miniature Profile on a much improved Plan, that in point of Likeness and Elegance exceeds every other Profile that have yet appeared. He humbly solicits those who please to favour him with their Commands that they will take the earliest opportunity as they may depend upon a perfect Likeness in an elegant gilt Frame and glass at 5s. each, or reduced upon ivory for Rings, Pins, or Bracelets at the same price. (Plates 30, 32, 34.)

' N.B. Ladies and Gentlemen having shades by them, Living or deceased Friends may have them reduced to any size. The Likeness preserved and dressed in the present Taste.'

A copy of the circular he issued at Newcastle appears in *Notes and Queries*.[1] It seems to be a notice which he could use at any town he worked in and might be called his travelling notice, it only differs from the above in the addition of ' Orders at any time address'd to him at Leeds in Yorkshire will be punctually dispatched.'

He was in Manchester, October 1784. Liverpool 1785, Edinburgh 1786.

Thus the result of research up to 1788 when Miers came to London, is four labels, all on portraits beautifully painted all black on plaster, untouched with bronze in any single instance. His first and best period.

To what date a label which I call number 5 should be assigned I cannot say, it is the size of a sixpence and has simply : ' J. Miers, Profilist,' and is on the back of a miniature portrait of a man painted all black on ivory, in an inch-long red leather case. It is the only label of any silhouettist I have found on miniature or jewel work.

There is one other small label—I have never seen a second copy—it is small oblong, evidently intended for the leather-case type of portrait, as it is too large for jewels.

This rare label was in the possession of Captain Desmond Coke and may be counted 6th on the list, though no date can be assigned.

The earliest label issued in London I believe to be the one which describes him as ' J. Miers, | late of Leeds, | 162 Strand, opposite New Church '. He removed from Leeds in December 1788, and through a contemporary newspaper cutting we find he lived at the house of a Mr. Middleton, pencil manufacturer (Middleton's trade advertisement printed in 3 colours is in the Banks Collection at the British Museum).

In large cursive capitals first in use 1788–9 until 1791. ' *Miers* | late of Leeds, | No. 162 opposite to the New Church Strand, | London. | Executes profiles on Ivory to set in Rings, Lockets, Bracelets, &c. in a peculiar style, whereby the most forcible animation is preserved in an astonishing manner. |

' N.B. He keeps all the original shades and can supply those he has once taken with any number of Copies.'

This label is on the portraits of George Stevenson, Dean of Kellaloe and his wife Lydia, in the possession of Mr. Low, Bristol.

In his newspaper advertisements of the corresponding period, Miers refers to extensive patronage and high ' the time of sitting is two minutes and the cost varies from 7s. 6d. to one guinea '.

[1] 9th Series, VI, 356.

In May 1791, Miers removed to 111 Strand, and his first label from that address retains the words : ' Late of Leeds ', otherwise identical with above.

Then comes label No. 8, which he was using in 1801. Mr. Lumb writes of 9 portraits belonging to Mr. Ford of Leeds, on which this label is attached (*see below*) and also quotes a Diary of the wedding tour of Mary Ford, in which interesting dates and prices, &c., are given.

' December 27th, 1800, Profile at Miers, M. F. £18 0 0. January 7th, 1801, S. D.'s profile £18 0 0. January 7th, 1801, J. L.'s profile £18 0 0. January 13th, Locket and chain J. Mier's bill £4 12 0. February 9th, Bracelets, profiles, etc. J. Miers' bill £4 19 0. March 17th, 4 Profiles, Miers' bill £3 13 6.'

On this label he first uses the word jeweller.

' Miers, Profile Painter and Jeweller. No. 111, opposite Exeter Change, Strand, London, continues to execute Likenesses in Profile shade in a style peculiarly striking and elegant, whereby the most forcible animation is retained to the minute size for setting in Rings, Lockets, Bracelets, etc. |

' N.B. Miers preserves all the original sketches, so that those who have once sat to him may be supplied with any number of copies without trouble of sitting again. Flat or convex glasses, with Burnished gold Borders to any dimensions, for prints, drawings.'

It is in 1805 that Miers painted a man's profile on ivory and dated it. The only date with signature I have ever seen.

After this label is one headed :

' **MIERS** (in large block Capitals | 111 Strand, | London, | opposite Exeter Change. | Executes Likenesses in Profile in a style of Superior Excellence, with unequalled accuracy, which convey the most forcible expression and animated Character, even in the very minute size for Rings, Brooches, Lockets, &c. Time of sitting 3 minutes. |

' Mr. Miers preserves all the original sketches from which he can at any time supply copies without the trouble of sitting again. |

' N.B. Miniature frames and convex glasses wholesale and retail.' |

At what date Miers entered into partnership with John Field I have not yet discovered. In an old newspaper cutting, 22 May 1831, John Field describes himself as ' artist for Mr. Miers for 30 years '. In Miers's will, which was made 24 August 1820, it is stated that his son William Miers, testator's ' *assistant* ' John Field are to have option jointly and as partners of purchasing the leases of his house and goodwill of his business, shades, apparatus relating to the taking and filling up of profiles, the goodwill to be shared between them.

If they refuse, the trustees are to sell by public auction or private contract. If co-partnership exists between testator, his son William and John Field at

the time of testator's death, deed of partnership to be substituted for preceding clause. Trustees to dispose of remaining stock in trade, household furniture, books, &c.

The *Miers & Field* trade label (illustrated, Plate 92) runs as follows :

' 111, Strand, | London, | opposite Exeter Change. | Profile painters, Jewellers and Seal Engravers and Manufacturers of every description of Miniature Frames, Cases, &c., continue to execute their long approved Profile Likenesses in a superior style of elegance, and with that unequalled degree of accuracy as to retain the most animated resemblance and character, even in the minute size of Rings, Brooches and Lockets, &c. |

'Time of sitting not exceeding five minutes. Messrs. Miers & Field preserve all the original Shades by which they can, at any period, furnish copies without the necessity of sitting again.'

This label was used long after John Miers was dead, either from motives of economy or because the name was a valuable asset. This is proved by the date, 1824, on the portrait of Mrs. Marshall, the lovely bride of seventeen, in my collection, which has Miers & Field label.

Yet another label must be added, the eleventh ; it is a small oblong. 'John Miers, Profilist', obviously for use on small case portraits, the only one I have ever seen, was in the possession of the late Captain Desmond Coke.

John Miers, profilist, died on 2 June 1821, a year after he made his will. His death is thus announced in the *Leeds Intelligencer*, June 1821 : 'On Saturday week aged 64, John Miers, Esqre. jeweller and profiler of the Strand, London, a native of this town.' He was buried at St. Paul's, Covent Garden, London, on 8 June 1821. I have seen the register of his death but have not found his tomb. The stone may be amongst those taken up and placed edge to edge at the side, to make room for the churchyard garden ; further history of the firm will be found under William Miers, the eighth child of John, and under John Field and H. W. Field, and Lovell, one of his pupils. I have only identified Thomas Lovell, but without doubt there must have been many more pupils, together with assistants to fill up the shades, frame, pack and tabulate all the hundreds of original sketches used in the very extensive business.

As to the different styles of painting at different periods, roughly John Miers worked at first in pure black, painting on 2½-inch slabs of plaster or on card, the face dead black, hair, lace, muslins, feathers, shirt frills of the men in soft transparent grey, by thinning the black, not by addition of Chinese white as with many silhouettes. I have in my possession 11 portraits of members of one family (Baker) ; they are all by Miers and give examples of his varying methods ; each has its perfect label belonging to the different years. His portraits have great character and are never simpering or insipid, this quality of character and virile force being equally shown in his work however small. At the beginning of the nineteenth century he began to work in the fashionable gold or bronzing, doubtless made to do so by demand.

Though we may regret his defection from the rarity and beauty of black shadow portraiture in its purity, his bronzing contour method was equally fine, and from examples of the same date in either process we see he continued to work in both styles, so that with the exception of the first period of dead black, we cannot judge the date of an example by the single or double colour process.

I have stated the wording of these labels very fully and their approximate dates because sometimes only a few words are distinguishable on a prized possession, and then if one compares, identification may be made even with a fragment.

I am much indebted to Sir Henry Miers, F.R.S., descendant of the great silhouettist, for information and permission to reproduce the portraits of John Miers, profilist, and his wife Sarah, *née* Rothery, also their son John Miers, F.R.S., botanist, 1789–1879, father of Sir Henry.

MIERS, Joseph, & Co. 144 Leadenhall Street. Published sheets of figures in caricature by Engelmann, Leipzig.

MIGHT, Mr. Machine cutter, advertises : ' Mr. Might and an able assistant cuts exact likenesses, frame and glass included for 1s. at No. 7 Grafton Street. By machine of unerring principles, open 11 till 7.' I have seen no example of his work.

MILDNER, Johann. 1799. Austrian. A gold glass *verre églomisé* worker of Weinsberg, Lower Austria, and Gutenbrunn, used the between glass technique. A superb specimen of his work is in the Imperial Museum, Vienna—a cylindrical goblet of double glass. On the front is the head and shoulders of a man, round the rim a dedication with vine tendrils, inside the rim a motto, at the bottom of the goblet a round picture of two peasants working in a vineyard, a cross in gold and W. in silver. Inside the goblet, below the motto, Mildner fec. Guttenbrunn, 1799.[1]

There are specimens of this type at the British Museum, and a tinted profile portrait signed and dated, 1792, at the Metropolitan Museum of Art, New York, formerly in the collection of Jacques Mähsam, Berlin.

MILES. Profilist, early nineteenth century. On the portrait of a naval officer of 1800 cut all black, with gold buttons, is the following advertisement :
' A new patented silhouette machine Taking Profiles in a very superior manner at Mr. Rodell's, Long Row..

[1] *Gläser des Empire und Biedermeierzeit*, Leipzig, 1923.

'*Miles Profilist*. We beg leave most respectfully to announce to the Nobility and gentry and inhabitants of Nottingham that he has taken apartments for a short time as above. The Principles upon which his Machine is constructed and his extensive Practice, enables him to execute Profiles in a Style of accuracy and elegance, never before attempted in this Kingdom ; and upon Terms so very Moderate, as cannot fail to recommend him to a general public in decided Preference.

'As an object peculiarly interesting to the Curious, this Machine is allowed to be from neatness, the simplicity of its mathematical construction, one of the most ingenious and clever among modern inventions, and is open for inspection to Ladies and Gentlemen ardent of orders.

'Profile from five to ten shillings each, exclusive of Frames. |

'Specimens to be seen at Mr. Stretton's and Mrs. Sutton's, Booksellers and Mr. Mill's apartments ; where attendance is given from 10 to 6. |

'Time of Sitting will not exceed 1 minute.'

On profile of naval officer of 1805, cut black, looking right, with gold ornament, buttons, &c.

MILLINGTON, J. H. High Holborn. Label on a portrait of a lady in the Desmond Coke Collection sold at Sotheby's, July 1931. In this rare example the silhouette is painted, face, dense black ; hair and other detail shaded greyish, earrings, gold.

Label : 'Profile one Shilling taken with the greatest accuracy in one minute by the Patent Delineator, | ornamented with neat gilt edge and fancy border, | equal to those charged 2s. 6d. |

'Executed by J. H. Millington, | No. 205, High Holborn. | The Machine is so simple and unerring in its Principle that the most correct Likenesses are produced. N.B. Portraits and cabinet Panelling, old Pictures carefully touched, cleaned and varnished.'

I have not been able to trace connexion between this silhouettist and James Heath Millington mentioned in Strickland and William's Life of Lawrence, though initials and date coincide.

Another example of Millington's work has face and bust black, no gold neck-frill and cap, white unrelieved.

MILN, G. 1804. Painted full-length black profile portraits with gold lines. Signed G. Miln, 1804.

MILNER, JAMES. End of nineteenth century, 78 Grange Hill Road, Eltham. Pen-and-ink silhouette portraits (*see* Moderns). (Plate 77.)

MITCHELL, J. S. Bath. Cutter. On a specimen, cut in brownish red paper and heavily bronzed, owned by Mrs. Stanton, is the label : 'Mr. J. S. Mitchell, | Profilist, | 17 Union Street, Bath. | Executes Likenesses in a superior style of elegance in Bronze Tints, &c., which contain the most forcible expression of animation which can possibly be obtained by such mode of representing the Human Countenance.'

Another address, 40 Strand, is given on the profile of a man painted on ivory, looking left.

MITCHELL, J. T. Miniatures—'Painted Likenesses finished in the first manner from Three to Five Guineas '. On an example in fine work painted on card, white relief.

This label printed below that of J. Trewinnard, which see.

MITCHELL, JUDITH. 1793. Amateur cutter, born at Nantucket, U.S.A., daughter of a Quaker, wrote poetry, married in 1837. Her portraits were cut in white paper, either solid or hollow cut, the lower bust-line without curves, always square and hard. Descendants are owners of many examples, Mr. Carroll Snell, New York.[1]

MOCHI, UGO. Fl. 1895. Italian, of Florentine family. Artist, sculptor and musician. Cut silhouettes from earliest youth. Portraits, landscape mounted on tinted paper of very large size, studies of birds, panoramic views of Florence. Rome, Arabesque borders, one of his silhouette studies of animals at the London Zoological Gardens was reproduced as a poster for the Underground Railway, London.

MODZALEVSKY, B. L. VON. Russian. Wrote the text of a volume in the Russian language, describing the Members of the Imperial Academy of Science published at St. Petersburg 1908, illustrated in silhouette by Anthing.

MÖGLICH, A. L. Fl. 1784. Nuremberg. Painted or etched silhouette portraits on glass on a gold ground. His finest work was used in rings, jewels, boxes, &c. He itinerated in Nuremberg, Vienna and other towns. His best known portrait is of E. F. A. Knopf, Evangelical preacher in Vienna. Meusel's *Lexicon* says of him : 'He was particularly happy in silhouettes and profiles '.

MOHU, GOTTLIEB SAMUEL. 1792. Glass decorator in silhouette with his father Samuel Mohu, which see.

MOHU, SAMUEL. 1762–1815. Born near Leipzig. Painter on porcelain and glassware. His silhouette portraits on glass are black on gold ground, with decoration such as lace, buttons and orders in gold or silver. His background sometimes includes landscapes and architectural detail, while flowers and foliage are occasionally in colour.

Glassware was sold at Warmbrunn and other towns in Silesia with portraits in silhouette of famous persons and also with medallions decorated and ready for the application of silhouettes of the purchaser's choice, applied in a few hours.

A signed example is in the Metropolitan Museum, New York, a second in the Art Institute, Chicago, both from the collection of Jacques Muksam, Berlin.

[1] Rep. *Antiques*, August 1932.

MOMFROY, John. Fl. 1831. Cut elaborate designs in white paper with a knife.

MORIN, Johnathan. 'Drew this sketch of an honest man, 1795.' Signature on a silhouette of a man in the possession of Mrs. S. Campbell.

MORSE, G. T. Cutter and collector. His profile of Theodore Roosevelt, President of United States, is considered a good likeness. He is an ardent collector and a good friend, and during many years he has spent time and money unsparingly. His judgment is highly esteemed by connoisseurs in America. Rector of All Saints, West Newbury, U.S.A. (Plate 78.)

MORSE, Leonard Becher. Fl. 1783. St. John's College, Cambridge.

MORTON, J. 1827. Artist. On a painted silhouette portrait.

MOSER, K. Vienna. Cutter. Illustrated a book of caricatures in silhouette cut out of coloured papers.

MUELLER, H. 1853. Cassel. Signature on portraits of students.

MULACZ, Olga, of Vienna. Cutter. Illustrated Goethe's *Faust*, &c.

MULLER, Franz Hendrick. Danish. In 1772 he showed to the Danish Court pieces of porcelain he had made successfully, and asked for support in his enterprise in bringing to prosperity the Copenhagen porcelain factory. He devoted his life to this end, in chemical experiment guarding secret processes, &c. The silhouette portrait of his son is on a fine vase now preserved in the Museum at Bergen.

MÜLLER, Lisbeth, *née* von Heintze. Born 1866. Pen-work silhouettes in Indian ink. Illustrated *Hansel and Gretel* and many other works.

MÜLLER, W. 1804–65. Cutter. Düsseldorf. A cobbler who had a natural gift for cutting very small fine silhouettes, both figures and landscapes. So fine are his lines that when reproduced his cuttings resemble pen-sketches. His work is sometimes confused with that of Fröhlicks, who also cut and lived at Düsseldorf.[1] Müller made little use of his talent except as an amusement. In *The Cutting of Three Centuries*, by Mr. M. Knapp, there are two interesting examples of scenes in peasant life shown in chessboard fashion, small squares one above another, all cut from one piece of black paper. Müller lived at the time of the plaster-cast group formula (*see* Fröhlicks), and his work is not easy to distinguish from that of other silhouettists of the Düsseldorf School of Cutting.

Some of his work has been published, and many examples are copied with pen or brush on glass by modern forgers.

One of his addresses was 20 Ratingerstrasse, Düsseldorf.

MURATORI, Signor. Extract from *Art Journal*, 1853 : 'Papyrography is the title given to the art of cutting pictures in black paper. Some specimens that have recently been shown by Signor Muratori are certainly the most ingenious works we have ever seen, they are executed with scissors only.'

N

NEATHER, D. H. 1809. Itinerated as a silhouettist, visiting Leipzig, Halle, Magdeburg, Dresden, and other towns. He studied chemistry and mechanics and invented a shorthand alphabet : he used a pasigraph when taking profiles.[1]

NEBEL, Christian Ludwig. 1738–82. Professor of Medicine at University, Guissen. Fl. 1770. Later descendant, Dr. Nebel Friedberg, owns paintings, cuttings, and the stencils used by his ancestor.[2]

NELLES, S. K. G. Master. 1836. An American. In Felt's *Annals of Salem* this silhouettist is described as 'A lad without arms'.[3] Practice made him more skilful with his toes than the greater part of the country could be with the hands. He excelled in cutting paper likenesses of persons, watch-pieces, and fancy landscapes, &c. He was skilled in archery and shooting and animal cutting, would sing songs and dance a hornpipe. 'Price of admission to his Exhibition 25 cents.' His advertisement is headed by a picture of the afflicted youth.

NEVILLE, J. Fl. 1830. Address : Pool Lane, Brighton, and 393 Oxford Street. Painted bluish white on black. An example painted in two shades of bluish white, gold chain, in possession of Rev. Glenn Tilley Morse. Neville often used the wide neck-frill as decoration, as did his neighbour Crowhurst of Brighton. Examples of each man's work in my own collection show this conclusively. When itinerating Neville used a leaflet advertisement with a silhouette printed on it, as did Moses Chapman in Massachusetts at an earlier date. (Plate 100.)

NEWTON, J. Painted on ivory, fine work.

N.F.M. Initial signature on a cut souvenir or memorial leaf, about 1700. It is one of the symmetrical cuttings obtained by folding the paper and thus obtaining two sides identical in pattern.

NICKLAS, L. 1889. Painter and cutter. Chiefly for book illustration. Her clever frieze decoration has been published in original size. The Death of Pierot, 1913.[4]

NILSON. 1721–88. Augsburg Court painter. A member of the Vienna and Augsburg Academy. Engraved the likeness of the Emperor Josef II in silhouette.

NILSON, Andreas. Father of the above. Silhouette and miniature painter.

[1] Rep. M. Knapp, pp. 62, 63.

[1] J. Leisching.
[2] Information by Dr. H. Bräuning-Oktavio, Ph.D.
[3] Mrs. E. S. Bolton. [4] Rep. M. Knapp, p. 101.

NILSON, Barbara, *née* **BRETTANER.** Painter and cutter. Mother of the above.

NIXON, T. Profile painter in colour, partner of William Bache, machine cutter and painter of silhouettes, working in America. Several of his profiles are owned by the Rhode Island Historical Society, but his work is rare, which is not much to be regretted.

His price ' 2 dollars for good likenesses ' is mentioned.[1]

NOETHER, J. 1776. Signature on an example in the collection of the late Mr. F. Wellesley.

NORMAN, E. G. A. Cut full-length figure, painted white and colour, about 1830. Man looking left. In the possession of Mr. Stuart Johnson. Signature, date, fecit and at corner of card Hubard Gallery written—possibly a pupil of Hubard.

NORTH, Dora. 1907. Cutter. Portrait at Knole of Lionel Sackville, son of Col. the Hon. William Edward Sackville West.

NORTON, Thomas. Artist. Portrait painted in the possession of Mr. Bacon, Worthing.

NOWAK, Anton. Cut portraits and genre pictures.

NUN, of Cambray. Signature on a remarkable example of fine cut work 5½ inches square in thin white paper. Subject an achievement of Royal arms with arabesque decoration and medallions of *œil-de-perdrix* and other lace *motifs*, eighteenth century.

At the bottom is ' by a Nun of Cambray cut with scissors ' 1787.

In the Museum and Fine Art Gallery, Bristol.

O

OAKLEY, H. L., M.B.E. Free-hand cutter. Charges 2s. 6d. for 2 portraits. His work was a regular feature of the *Bystander Magazine* from 1914–18. Was given a sitting by the then Prince of Wales, who was serving as a subaltern in the Guards in France. Major Oakley works frequently in Edinburgh and also cuts landscapes and genre. (Plate 74.)

OCCOLOVITZ, L. Painter. Fl. 1799. Painter on glass, with gold background. On a fine series of family portraits in this style belonging to Herr J. Leisching is the signature ' Drawn by Occolowitz ', 20 February 1799. His work is also to be found in lockets and other jewels.

OLDHAM, John. 1779–1807. Miniature painter, engraver and mechanic of Dublin where he exhibited his portraits. Invented the Eidograph for taking miniature profiles. ' Price 11s. 4½d.' He also invented a machine for engraving bank-notes, which was adopted by the Bank of Ireland. He died in Montagu Street, Bloomsbury, London.[2]

OMERINGH, A. V. Cutter. In 1764 this artist exhibited at the City Art Gallery, Manchester, a large cut paper picture, a harbour scene with sailing vessels.[1]

OPIE, Amelia, *née* **ALDERSON.** Wife of the artist. Cut the portrait[2] of Mrs. Edward Beetham, silhouettist, of 27 Fleet Street. This portrait is now in the possession of Dr. Beetham. It is cut hollow in white paper and laid on black.

OPITZ, Johann Adolf. 1763–1825. Spent many years studying at the Academy, Dresden, and became the fashionable silhouettist of the town.

O'REILLY. Early nineteenth century. Painter. On a silhouette portrait on convex glass in the possession of Mrs. Dickson is a label ' O'Reilly, Portrait and Miniature Painter, Drawing Master '.

ORME, Edward. Printer and publisher to His Majesty, and to His Royal Highness the Prince Regent. The address given in the book by Miss Barbara Anne Townshend is Bond Street, corner of Brook Street, 1815. This book contains an introduction and twenty full-page illustrations, 18½″ × 12½″. These were also sold separately at 1s. each. The book in paper covers cost 5s. My own copy is in boards of marbled paper with brown leather corners and back and handsomely tooled label.

Each picture has beneath it Miss B. Anne Townsend del. M. Dubourg, Sculpt. Published and sold 30 July 1815 by d. Edwd. Orme, Bond Street, corner of Brook Street, London. The book is now very rare and valuable, as so many copies have been mutilated in order to obtain the illustrations.

OSTERMEYER. Painted on glass, gold ground.[3]

OUVRIER, Jean. 1725–80. French engraver. Schenau's painting, 'L'Origine de la peinture à la mode ', and those of Eisen Falconet Boucher, are also engraved by Ouvrier on the same subject.

P

PACKENY, P., of Vienna. 1846–1905. Cut silhouettes in variously coloured papers.[4]

PAGIN. Worked in Oxford Street. Wrote *Treatise*, 1863, which is in the Cambridge University Library.

PAHLY. Signature on two fine silhouettes of officers in the uniforms of the early nineteenth century. In the possession of Madame Nossof, Moscow.

PALMER. Signature on full-length cut portrait of a figure dancing : gold lines added.

PALMER. Early nineteenth century. Cutter.

[1] *Essex Register and Salem Gazette,* 10 July 1810.
[2] Strickland.

[1] See *Antiques,* February 1931.
[2] See Nevill Jackson, *History,* XXII.
[3] J. Leisching.
[4] Rep. Nevill Jackson, *History,* p. LIX.

'Harry Bluff a tar for all weathers' is cut and pen-work added. Signed Palmer.

PANTOGRAPH. An instrument for the mechanical copying of a plan, diagram, pattern, &c., on the same or on an enlarged or reduced scale.

In the seventeenth century it was called a parallelo-gram, a stork or monkey instrument. The Eidograph invented in 1821 is superior.

It consisted of 4 rods perforated at uniform distances jointed together, 2 opposite joints being terminal and constant in position, the other 2 capable of being shifted according to the scale desired. One of the free ends carries a tracing point, and one of the terminal joints a similar tracing point : when one of these points is moved over the lines of the diagram, &c., the other traces the copy required.[1]

PARISEN, PHILIP. In the *New York Daily Gazette*, 2 September 1791, this silhouettist informs the public that he has 'Removed from Queen Street to No. 9 Smith Street, where he continues to take most correct Likenesses in New Profile processes and Black shades. All kinds of Hair Devices made in most elegant style. Likewise all kinds of jewellery executed in the neatest manner, and on lowest terms.' This advertisement is also in the *Thursday Evening Advertiser*, 2 September 1802.

In the *New York Commercial Advertiser*, 17 December 1806 : 'Parisen respectfully informs Ladies and Gentlemen that his hours of attendance at his Painting Room is from 10 o'clock in the morning till 3 in the afternoon.

'Those ladies and gentlemen that please to honour him with their commands, may be assured to have their Likenesses painted to their satisfaction on the following reasonable terms : Miniatures painted from 5 to 15 dollars. Profiles painted with natural colours 2 dollars each. Black shades 25 cents. At his Painting Room No. 58, Chatham Street.'

PARKIN, of Colchester. Worked partly in colour, two examples were in the Wellesley sale.

PARRY, AUGUSTE. 1855. Signature on an example in the collection of the late Mr. F. Wellesley.

PASKIN. Colchester. Painter on glass, usually with wax filling. Label : 'Miniature and Profile painter ; profiles painted in a new and elegant style, producing the effect of aquatint engraving, with the beauty and softness of enamel in imitation of marble, conveying the most perfect likeness.

'In rings, brooches, lockets. Time of sitting one minute. Ladies and gentlemen attended in their own houses if required, by leaving their address at Mr. Good's, hairdresser, 14 Head Street, Colchester.'

PATERSON, J. Gifted amateur, painter, assistant surgeon of the 45th Regiment.

At the Royal United Service Institution, Whitehall, is a small book of 7½" × 9" in which are 'Silhouette portraits chiefly of officers of the 45th Regiment,

[1] *Oxford English Dictionary.*

with members of their families taken from 1818 to 1826, whilst quartered in Ceylon.'

The value of this beautiful authentic record is unfortunately discounted by the absence of names of the sitters. Two wear the red coat, green facings and gold epaulettes of the regiment, others, both men and women, are in black or with white relief.

One only, a lady, is by another hand, whose delicate and beautiful work, is of outstanding merit.

With such well-established provenance one can but deplore the want of further documentation which would have made the little volume of very great value as a record of the regiment.

PEALE, CHARLES WILLSON. 1741–1827. Born in Maryland. Painter, clockmaker, and silversmith, was apprenticed to a saddler at Annapolis, deserting this and other occupations. He studied art at Boston and possibly received some instruction from J. S. Copley. Came to London 1767–9, and was a pupil of his fellow-countryman Benjamin West, returned to America, was in Philadelphia in 1775.

Took part in the War of Independence and painted many portraits of military men, including very many of George Washington.

Established in Philadephia his famous Museum and Art Gallery, where he had a silhouette-cutting machine. It produced hollow-cut portraits to be mounted on black, these are generally stamped 'Peale's Museum' and are rather poor work. His Museum was transferred to Independence Hall in 1802, and there his gallery of celebrities was on view. He helped to found the Pennsylvania Academy of Fine Arts, was married three times and had many children whom he named after illustrious painters. They all painted portraits, marine pieces or land-scapes and doubtless some of them worked the family silhouette machine cutter. (Plates 55, 60, 61.)

There is a portrait of Peale with one of his wives and a daughter in the *Pennsylvania Magazine of History*, 1914.

Occasionally Peale's silhouette profiles are stamped on a curved band round the portrait or 'Museum' is stamped on the brass hanger.

Mrs. van Leer Carrick writes that Peale cut and painted profiles as well as making them by machine. I have not examined one of these. His silhouette work is being freely faked or, more correctly speaking, forged, as the signature is added.

PEALE, REMBRANDT. Eldest son of Charles Willson, b. in Bucks County, Penna., 1778 ; d. at Philadelphia, 1860. Came to England in 1801, studied for a year under Benjamin West, when his address was 74 Charlotte Street. Exhibited at the R.A. in 1803. Was in Philadelphia in 1804, in Paris 1807. Established a museum at Baltimore and worked at that of his father at Philadelphia.

An advertisement in the *Charleston Courier*, 7 January 1824, announces that he paints miniatures

on ivory, &c., and quaintly adds that the artist ' appropriates the afternoons to cutting profiles and the evenings to Pencilling of them '.

' Four profiles cut for 25 cents. Pencilling ditto. 12½ cents each. Frames 25 cents each at Mrs. Wing's, corner of Elliot and Bay Streets, entrance of Elliot Street.

PEARCE, B. Early nineteenth century. Cutter. Cut the portrait of Duchess of Kent and Queen Victoria ; these cuttings were copied by his son, himself a cutter. On both these silhouettes the St. Leonards address is given, but the father dates his portraits wherever they were taken, as ' Napoleon III by B. Pearce, Hotel des Invalides, Paris '.

Many of the cuttings in the Album Collection of Queen Victoria at Windsor are by Pearce. (Plate 48.)

Information obtained National Portrait Gallery Collection and at Windsor Castle.[1]

PEARS, CHARLES. 1913. Clever black and white artist, makes use of silhouette effects, occasionally with fine results.

PEARSE, JAMES. Portsmouth. Cut Nelson's portrait just before he sailed for Trafalgar. The Duchess of Kent, in unrelieved black, is in the National Portrait Gallery, by James Pearse.

PELHAM, T. Painter. On trade label ' Miniature painter to H.R.H. Princess Augusta '. Child in a large hat painted on convex glass in the possession of Miss Martin, New York. His address at Bath was 15 King's Mead Terrace ; in London 21 Elizabeth Street, Islington, and 8 Buckingham Place.

He exhibited six miniature portraits at the Royal Academy between 1832 and 1836.

PENZOLDT, E. 1892. Sculptor, Cassel and Munich. Free-hand cutter of profiles, fine bold work with much movement.[2]

PERCIVAL. Circa 1840. Cutting by machine. A newspaper advertisement headed by a silhouette of a man in mortar-board and gown, beneath ' The Collegiate taken in Dublin '. ' For a short time only you may have an Exact Likeness, a Frame and glass included for one shilling in one minute at No. 7 Grafton Street, by a Machine of unerring principles by Messrs. Percival and Lowe, with Mr. Megit and able assistance. Being the same artists who took so many thousands of Likenesses last Season in Dublin, Cork and Limerick. Miniatures at Moderate Charges. Open from 11 till 7 o'clock.' From original handbill.

PERKINS, GEORGE. Circa 1855. Amateur cutter of Salem, Mass. Made many replicas especially of the silhouette portraits by W. H. Brown. I have never examined any original work done by him.

PERRENON, P. H. Fl. 1780. Publisher and bookseller, of Munster, his name is known in

connexion with a copper-plate engraving of three boys in silhouette. One is asleep and the other two hold a candle so that the shadow of the sleeper is shown. This is the Frontispiece of *A Detailed Treatise on Silhouettes*, by an anonymous author, published by Perrenon in 1780. Later he published his second volume on the same subject, also anonymous, it is called *Description of Boumagie*, and treats of the art of reduplicating silhouettes by means of a piece of flat tin, linseed oil and pine-soot ; such are the ingredients of the ink, a rolling-pin was the press.

Many rules are laid down as to pose of the sitter, disposition of light, advice as to materials, size, finish and ornament. Then follow instructions as to gold glass silhouette taking.

These books are very rare, the treatise should have eleven copper plates and 258 pages.

PERRY. Cutter. Worked at Coney Island, New York, 1911. (Plates 76, 78.)

PETHER, GEORGE. On 9 March 1933 was sold at Sotheby's a silhouette of ' Thomas William Sadler by his uncle George Pether '. Poor work, formerly in the possession of Mrs. G. Johnston.

PFEILHAUER. Fl. 1796. At the Linz Museum there is a picture, black figures on flat glass with gold background. Eight musicians are standing in a room, their music and instruments in their hands, they are in uniform with tricorn hats and tied wigs. It is signed ' made by Pfeilhauer, member of the Choir '.

PHELPS, W. Working 1788. Painted in black and colour on glass, plaster and on card with prepared surface. His work is rare and very fine. Treatment of the hair is distinctive, various colours are laid on and dark lines added.

Label : ' W. Phelps, | Miniature Profile Painter, | at Mr. Wilson's, Watchmaker, Drury Lane, opposite Long Acre, London. | Takes the most exact Likenesses either upon glass or a Composition perfectly *White* which will keep its Colour. |

' N.B. He preserves the original shades and can supply those he has once taken with any number of duplicates. | Those who have shades in their possession may have them copied, the likeness preserved, and dressed in the present taste by applying as above.' (Plate 100.)

This label was on an example owned by Mr. Martin Baxter on which was written, ' This Shade was taken November 1788 '. A similar label was on one in the Desmond Coke Collection sold at Sotheby's, July 1931, and one in the possession of the Hon. Humphrey Pakenham, three in my cabinet. Phelps usually introduces colour, in painting his portraits he uses apple green, blue or mauve in the ladies' dresses, and the lace or muslin fichu of the ladies' is invariably buff colour, as he cut from buff-coloured paper. Much pouched in front and with a leaf *motif* embroidered. The shirt-frills of the men are also buff colour. An elaborately puffed head decora-

[1] Rep. *Conn.*, December 1932. Chap. Albums.
[2] Rep. M. Knapp, p. 103.

tion (see *History of Silhouettes*, p. x) was probably kept in his studio for use of sitters, as I have found several portraits with the same style. On page xlii Wellesley's *One Hundred Silhouettes* the portrait of a child is reproduced in black and white, only other such examples may be verified by the treatment of the curls.

The distinctive buff colour is only found in the examples on card, as Phelps cut out of buff paper, pasted it down, and then worked up hair, coloured dress details, &c., leaving the buff paper to show unpainted on frills of men, and muslins of women.

The white plaster painting is therefore without this effect. A fine black and white lady with hat and upstanding feathers, bows and tassel is in the Victoria and Albert Museum. Rare and very fine work.[1]

In the possession of Sir Henry Sutcliffe Smith is the portrait of an officer in coloured uniform, cravat and wig. On the back is written : ' Taken by W. Phelps, March 1790,' it measures $3\frac{1}{2}'' \times 2\frac{3}{8}''$ oval.[2]

The three portraits I possess by Phelps in colour are, I think, the most beautiful amongst the thousands in my cabinets, though not the most correct, as shadow portraits should be black only. (Plate 11.)

PHILIPP, FELICIEN. 1883. Pomeranian sculptor and black paper cutter. His ' Erl King ' is a remarkable study of wind and speed shown with restricted medium.[3]

PHILIPS. Circa 1800. Profile painter, 3 Star Alley, Church Street. Written signature and address at the back of the portrait of a man. Black painted on card with fine gold line work.

PHILLIP, JOHN. 1787. Painted black on tinted card. Probably an amateur.

PICK, G. Cutter. King Edward VII at Marienbad, Carlyle, and others are amongst his portraits in the Knole Collection.

PLATER, MRS. Circa 1790. Painter. Portraits of a lady and gentleman, painted on oval porcelain : these are in the possession of Mrs. Benbow.

Label : ' London | . . . Informs Ladies and Gentlemen | correct Likenesses in Profile upon an entirely new machine improved plan, | any size at 5 minutes sitting, and finished in superior (. . .) upon Paper or Ivory at 6s. to 10s. | each at Mrs. Platers, Bull Ring, Kidderminster. | Where specimens may be seen . . . and gentlemen can have Profiles of all description accurately (. . .) to any number without the Trouble of Sitting | (. . .) Will wait upon any Person who may Honour (. . .) our House At Shortest Notice.'

Fairly good work.

[1] Nevill Jackson, *History*. *Lady in High Hat*, also Phelps, P.
[2] Reproduced in *By-paths in Curio Collecting*, by Arthur Hogdon.
[3] Rep. M. Knapp, p. 88.

PLEASANTS, JAMES H. Late nineteenth century. Cutter. Itinerant, visited Boston 1904, where he cut portraits in a shop in Boylston Street.[1]

PLOCK, CHRISTIAN. 1809–82. Pupil and fellow-worker of Westbrecht. Cut comic scenes which were published with verses in *A Volume for Youth*. In his own funeral procession birds walk beneath the coffin, on which is his knight's helmet ; cats, dogs, thurifers and priests also appear.

POCCI, FRANZ GRAF VON. 1807–76. Munich. Wrote a play for the shadow theatre and book illustration.

POKORNY, *fec.* Signature on woman's head and shoulders *églomisé*, with blue ground.

POLE, THOMAS, M.D. Born at Philadelphia 1753, d. 1829. A Quaker, lived at Bristol from 1802, where he had an extensive medical practice. During his leisure he painted landscapes, architectural subjects, and drew miniatures and shadow portraits in Indian ink.

In the *Bristol Times and Mirror*, 30 January 1925, a description is given of drawings in Indian ink and sepia by this clever amateur silhouettist. They are signed T. Pole, M.D., Delin. 71 Bristol, 1st month, 1825.

POLK, CHAS. PEALE. 1767–1822. Nephew of Chas. Wilson Peale. Born in Maryland. Polk painted on glass. ' C. P. Polk fecit ' is his signature on silhouette portraits of Madison and Galtalin preserved by the American Antiquarian Society, Worcester, Massachusetts. This is interesting as being one of the very few native-work glass portraits of America. Polk also painted portraits of men noted in the American Revolution, at one time he held office under Government, and it is said that he painted 50 portraits of Washington without a sitting.

POULETT, LUCY. Countess Poulett, first wife of the 4th Earl Poulett of Poulett Lodge, Twickenham, was an amateur cutter. She cut a remarkably clever series of silhouettes of children in minute size, described by the collector Andrew W. Tuer in the Leadenhall Press C.C. These cuttings were loosely placed in a book of blank leaves bound in contemporary citron morocco leather, lettered on the front M.G. To some examples the artist has written a verse and to others a date, the earliest 1796, the latest 1806.

Between two of the leaves is a piece of black paper, on the reverse or white side, being written J. Poulett, Twickenham, Middlesex, and on another piece of paper the name Lucy is cut out in silhouette.

The Earl Poulett himself wrote to Mr. Tuer to inform him that they were the handiwork of his first wife.

POWELL, SAMUEL. Mayor of Philadephia, friend of George Washington. ' Made a silhouette portrait

[1] Information from Library of Congress, Washington.

from shadows cast by a lamp,' we are told by Mrs. E. S. Bolton. This portrait is now owned by the Pennsylvania Historical Society. (Plate 59, and Chapter IV.)

PREETORIUS, E. Cutter and painter, illustrated many books in silhouette. His Don Quixote is in the Shrovetide Volume of *The Book Worm*, 1913.

PRINGLE. Newmarket. Signature on the silhouette portrait of a jockey cut out of red-brown paper.

PRISENER. Fl. 1784. Cutter. His profiles were mounted on elaborate engraved mounts.

PROSOPOGRAPHUS. Huddersfield. ' The Automaton Artist ', a machine drawing the Likeness in one minute in black for 1s., Coloured 7s. 6d. upwards. Open from 10 to 8, Huddersfield.

A London advertisement runs thus : ' Unparalled Mechanical Phenomenon, now exhibiting at No. 161 Strand, opposite the New Church, *Prosopographus*, The Automaton Artist. The Public will probably be startled when it is stated that a Lifeless Image is endowed by mechanical powers to draw Likenesses of the Human Countenance through all its endless variety, yet it is no exaggeration to say that this beautiful little figure, not only traces an outline in less than one minute, but actually produces more perfect resemblances than any living artist can possibly execute, and as the automaton neither touches the face nor has the slightest communication with the person, whilst sitting, they are scarcely conscious of the operation, &c., &c.

' Visitors for One Shilling each, not only see the figure perform but are entitled to their own Likeness, or if not inclined to, may receive a copy of any of the Likenesses exposed.'

PROSSER, M. R. Painter on glass. George III and Queen Charlotte portraits in Victoria and Albert Museum, London.[1]

In this the process is reversed, black ground, gold beneath glass, the heads are laurel crowned. A motto encircles the portraits.

PULHAM, E. B. 1819. Cutter. Signature on an example in the collection of the late Mr. Francis Wellesley.

PYBURG, Elizabeth. Fl. 1699. Probably from Holland. According to the assertion in *Harper's Magazine*, June 1882, Mrs. Pyburg cut the profiles of King William and Queen Mary.

PYLE, Howard. Book illustrator in silhouette, U.S.A.

Q

QUENEDEY. 1756–1838. Frenchman. He made profile portraits, cutting by means of a profile machine ; he improved Chrétien's apparatus (see p. 90), and cut thousands of portraits which he

usually coloured.[1] There are 28 great cases of these that are all named, besides 7 folios of unnamed examples in the Bibliothèque Nationale, Paris. At one time he worked in collaboration with Chrétien, but eventually left him and set up for himself in 1789. Engraved Physionotrace outlines were sometimes coloured, sometimes filled in black in the manner of a silhouette. He itinerated in Brussels and Hamburg, and his work numbers no fewer than 12,000 in the Bibliothèque alone. (Plate 56.)

QUIETENSKY, E. M. A Russian who cut silhouette profiles of theatrical characters.

R

RACKHAM, Arthur, R. W. S. Modern artist, used silhouette decoration with beautiful effect in his illustration of *Æsop's Fables, Cinderella,* &c.

RAPER. ' Taken by Mr. Raper's Pantograph ', appears on the black and gold silhouettes of Enoch Wood and his wife in the possession of Mrs. van Leer Carrick.

RAYNER, *fecit.* 1808. Signature on the painted silhouette of a boy, the property of Madam Nossof, Moscow.

READ, Mrs., *née* **BEETHAM,** Jane. Eldest daughter of Edward Beetham and Mrs. Isabella Beetham, the important silhouettist of 27 Fleet Street.

Jane Beetham was a pupil of Opie, who became so attached to her that in 1796 he divorced his wife, hoping to marry her, but she married a rich lawyer many years her senior.

It was her daughter, the eccentric Cordelia, who bequeathed valuable property to the Brompton Consumption Hospital, where the portraits of the Beetham family may be seen.

Mrs. Read's label runs thus :

' *Aqua-tinta Profile Likenesses.* | Likenesses painted on Ground Crystals, in a New and Elegant Style, producing the Effect of Aqua-tinta Engraving, on a beautiful Transparency, | and requiring only one Minute's Sitting | by Mrs. Read. | Portrait and Historical Painter, | 72, Lamb's Conduit Street, London.' Printed inscription from the back of P.131–1931, in the Victoria and Albert Museum.

The work of this silhouettist is of great beauty ; she paints at the back of glass in black, thinned to express light and shade. She makes use of background such as foliage and sky effects in a manner adopted by no other silhouettist whose work I have examined. Examples of her skill are very rare. She fills at the back with pinkish wax ; one in my own cabinet is the only other I have seen.

I am indebted to Dr. Beetham for information.

REBOTIER, Mary Esther. Cutter of subject

[1] P. 124, 1922.

[1] Rep. *Conn.*, March 1926, Miss Martin.

pictures : some of her work was exhibited at the Medici Gallery, Bond Street, February 1935, in the collection of Dr. John Johnson, printer to the University of Oxford, in his collection of valentines, cut and lace papers.

REDHEAD, H. Eighteenth century. Painted on glass to resemble a stipple engraving, card back, not wax filled. His work is very rare.

' By Mr. Redhead, Upper Norton Street, Fitzroy Square, London, 1791 ', is written on back of Mr. and Mrs. Dales of Woodhill Farm, Beverley, Yorks, which I obtained from Mr. A. Dales Todd, grandson. Redhead's work resembles that of Lea of Portsmouth with stipple engraving touch, but Readhead's faces are dense black. An example of a man's portrait is in Wellesley's *One Hundred Silhouette Portraits*.[1] These are the only examples I have seen.

REHSENER, MARIE. German. 1840–1917.

REINHOLD. Cutter. Black paper.

REINIGER, LOTTE. Modern. Cuts silhouette forms inspired by the figures of shadow theatres of the East, particularly in India and Java. Her medium of black paper reinforced by thin lead sheets at joints, the figures are cut out, heads, arms and legs hinged with fine wire so that they are movable. The finished figures were placed on glass plates 18 inches distant from each other, they were lighted from below when exhibited at Victoria and Albert Museum in 1936. The camera pointed downwards as each actor was propelled across the stage. Storm effects were obtained by use of clouds of steam and sandheaps rolled like waves. *The Adventures of Prince Achmed*, her most important work, took three years to accomplish. Over a quarter of a million photographs were taken, 80,000 of which were used in the production on the screen.

REPOLD, WILLIAM. 1885. Berlin. Silhouettist. Illustrated Hans Andersen. Illustrations distinguished by dark masses uncut. ' The Professor ' and ' Model Incarnation ' from the *Wars of the Peasants*, &c. *See* M. Knapp, 1916.

REYNOLDS, SIR JOSHUA. 1723–92. To describe the great portrait painter and President of the Royal Academy as a paper cutter, would overstate our case, but the fact that there exists an example of a paper cut picture, or rather a paper relief picture signed ' J. Reynolds, September 30th, 1739 ' and duly authenticated as the work of the great artist when 17 years of age, entitles me to include the name with that of other paper cutters.

In the catalogue of a fine art exhibition held at Derby sixty years ago, No. 2 was an interior in relief with full-length portraits of Mrs. Reynolds and her daughter, Frances, by J. Reynolds. It was owned by Mr. Llewellyn Jewett and showed Miss Reynolds standing by a tripod table, whose pedestal seems to be on a lower level than the floor on which the lady is standing. Frances Reynolds stands before her mother, flower-basket in hand, and a small dog is by her side, behind her is a side-table, with cabriole legs. On the wall is a picture with formal landscape, next to it a raised label with heraldic mantling bearing the name of the artist and date ; farther to the right is an archway with rosette border showing a pastoral scene, the same rosette *motif* decorates the foreground in two tiers. The whole is in cut and embossed paper which is now the colour of old carved ivory.

On a label at the back is the name ' Llewellyn Jewitt ', a printed label and a note in ink beneath, ' Sir Joshua Reynolds' portrait of mother and sister cut out of paper at the age of 17 '. We know that the artist entered the studio of Thomas Hudson a year later, what more likely that at a time when simple media were used and paper cutting was the rage, from His Majesty to his humblest subjects, that the clever-fingered student should try his hand at the modelling of his mother's and sister's portraits by means of the art which Mrs. Delany was exploiting.[1]

RICHARDSON, DOROTHEA. Paper cutting. This artist models small birds in wax and cutting minute shreds of paper in feather forms, colours the finished bird with extraordinary accuracy. Her greenland Falcon on a small marble block rough hewn, is a fine example : the bird has on jesses and hood and measures only an inch and a half.

Her group of black-headed gulls is another fine example of this delicate paper cutting craft. Some of this group are mounted on wires and remain poised over rock and water. Exhibited at the Walker Gallery, 118 New Bond Street, May 1936.

RICHTER, *fecit*. 1780. Signature on bust portrait with landscape and figures, probably a memorial picture. He painted on glass, gold leaf or silk background.

RIDER AND BAZING. 1800. 408 Strand, facing the Adelphi is given as the address of the firm. Painting on glass.

A very fine example of the work of one of the members of this firm is illustrated in the book of *One Hundred Silhouettes* from the collection of the late Mr. F. Wellesley. The hair is executed in the manner of Mrs. Beetham, but details of dress are in denser black on the glass. Plate XXXI.[2]

RIDER, L. T. | Profilist, | 1789. 85 Long Acre. | Label : ' Profile Likenesses | taken in miniature and finished on convex glasses with an elegant gold border which makes them equal to the finest Enamel, and which for beauty and likeness, is not to be equalled in Europe. | Also Miniature Portraits. Prints or framings mounted in the above manner in Convex Glasses by a Method entirely new and known

[1] Plate XI.

[1] Information by Mr. J. Kyrle Fletcher. Rep. *Conn.*, October 1931.

[2] Wellesley. Plate XXXI.

to no one in England but himself, is thought worthy of a Place in some of the first private Cabinets in the Kingdom and is much sought after by the curious.' From label at the back of a specimen owned by the late Mr. George Stoner.

There is also an advertisement where Rider claims, like several others, to be ' the inventor of gold borders on convex glass, which gives a painting, print or drawing the effect of fine enamel.'

A second address is 408 Strand, facing the Adelphi, on an example once in the Wellesley Collection, and a third, Temple Bar.

Rider's work is excellent, use is made of transparency in the hair and drapery, the face alone being completely black, he sometimes paints smaller examples on plaster about 2 inches.

In the collection of the late Lady Mountstephen was a specimen signed beneath the bust-line, ' J.R. first ' scratched in the black shadow.

RIDLEY. Circa 1797. Essex. Painter of bust profile of Miss Jay, the only known example of the work of this artist, now in U.S.A. The little girl has short straight hair and dainty neck frill ; the bust-line is unusual.[1]

RIGG, Mrs. 1764. Cutter. Two examples of cut paper work were exhibited by this artist at the Free Society of Artists in 1764.[2]

RISSO, Signor, from Italy. *Leeds Mercury,* 26 November 1776, ' begs leave to inform the Nobility and gentry and others That he is just arrived in this Town and will take striking Likenesses, Profiles in Miniature and that everyone may be able to indulge themselves with their own or Friends' Likenesses, he will take them off at half a crown each and at 5s. framed and glassed.[3] Time of sitting only 3 Minutes. His lodgings are at Mr. Hicks in Briggate. His stay will be but a few Days.' [4]

I have never seen an example of the work of this silhouettist.

In the *Newcastle Chronicle,* 18 July 1778, he advertises : ' Hath taken profile likenesses in Miniature in most of the Towns of England.'

He visited Newcastle-on-Tyne, in 1778. ' Price 2s. 6d. each, framed and glazed 3s. Sitting only 3 minutes.'

RITZSCH. 1788. Cut battle scenes in white paper.

RIVIÈRE. Cut silhouettes in coloured papers, which have been published as book illustrations in *L'Enfant prodigue, Scènes Bibliquen en 7 Tableaux* and *La Marche à l'Etoile.*

ROBERTS, H. P. Painted on flat glass. An oval of black with pierced holes and gold put behind is a speciality of his frame work.[5] He used several patterns in his painted inner frames, from two

portraits at Knole. Sometimes the black glass portrait was placed on a white silk back. This artist used a good deal of gold and transparencies in the dress. Occasionally he has the looped curtain convention in the background. His hair effect, obtained with strokes of the brush, is very distinctive ; it is well shown in a portrait from Ebford Manor sale, May 1934, Woodbury, Devon.

ROBERTS, Madie. 1918. Cutter at Hastings. Advertises as ' Elected Queen of the World's Fair ', San Francisco, Cal. She cut the portraits of many cadets of the Air Force in training at Hastings during the Great War (*see* Moderns). (Plate 81.)

ROBSON, William. Profilist, &c. 1 Burleigh Street, Sunderland, on portrait of Reg. Geo. Stephenson, M.A., in possession of Rev. G. T. Morse, U.S.A.

RODE, B. Fl. 1797. Court silhouettist at Berlin. In the Hohenzollern Museum is a large picture representing women and children crowning the bust of Prince Frederick Karl ; it is called ' Grief at the Tomb ', beneath ' Dedicated to his widow ', 28 December 1796, B. Rode inv et del 1797.

ROGERS, of Millbay, nr. Plymouth, painted on much-rounded glass, so that the portraits are almost egg-shaped. Example in Victoria and Albert Museum unsigned. The glass is backed with white compo. His second style is painted on glass which is afterwards backed with white silk. White effects are freely used for collars, ruffs, fichus, &c. In this type the glass is only slightly convex (*see* No. P.130, 1922, P. 133, 1922, Victoria and Albert Museum). At the back of the first is a printed card which reads ' Drawing Taught by Mr. Rogers. | Cattle Landscape & Portrait Painter from the Royal Academy London | No. 3 . . . Grove Millbay Ply : | Bowden Printer '.

Possibly the silhouettist was related to Philip Hutchins Rogers, 1794–1853, a landscape and marine artist born at Plymouth.

ROGERS, Holdron. 1914. Cutter.

ROGERS, James C. 1914. Cutter. Germantown, Pa., U.S.A., and Philadelphia.

ROGERS, Sally. Armless paper cutter. In the *New York Commercial Advertiser,* 15 April 1807, appears the following : ' Mr. Savage of No. 166 Greenwich St. has prevailed on Miss Sally Rogers to remain till 1st of May at his house for the purpose of gratifying visitors by her singular mode of using a pair of scissors in cutting paper, cloth, &c., holding them with her mouth alone, being deprived of both her hands. Her work will bear much criticism. She is here, as in Boston and other places, visited by persons of rank and information who have found her person and features agreeable and extraordinary. I hope Ladies and Gentlemen who wish to see her works may be gratified any day from 9 till 10 o'clock, Admission 25 cents.'

ROLAND. Paris. Signature on an example in the collection of Mr. F. Wellesley, now dispersed.

[1] *See* Carrick. [2] The late Basil S. Long.
[3] *Antiques,* February 1931. [4] Buckley.
[5] Rep. Pl. xiv, Wellesley.

ROSENBERG, Charles, or Carl Christian. 1745–1844. Was probably born in Hanover. When he was fourteen years of age he came to England as page to Queen Charlotte and was later employed as King's Messenger by both George III and George IV. He is so listed in Rider's *British Merlin*, 1829.

In the pedigree of the Rosenberg family he is described as ' a painter of miniatures and silhouettes '. I have not yet found a coloured miniature by him, but as with the wonderful coloured miniature by Rosenberg's contemporary Mrs. Beetham which has recently been discovered, so one may be found by Rosenberg at any time.

Under King George III Rosenberg was called His Majesty's profile painter, and being so closely engaged with the Court circle, he had opportunities of executing the shadow portraits of every member of the Royal family. Sometimes by himself, sometimes in collaboration with one of his sons, he engraved several of these Royal portraits in aquatint, either from paintings of his own, or from portraits of other artists.

Of Carl Christian Rosenberg himself there is a fine life-size portrait painted by his eldest son, Thomas Elliot, 1790–1835, showing him as a handsome man between fifty and sixty years of age, dressed in the Court or Windsor uniform. The canvas bears in the corner a representation of his greyhound badge as King's Messenger ; the badge has the heraldry and the name of George III.

In 1790 he married Elizabeth Woolley at Bath Abbey. I have found no fewer than three different Bath addresses, namely : 14 The Grove at North Parade, Bath, this in the *British Directory*, Vol. II, 1793 ; and ' At Mrs. Barclay's ', Ye Temple, Bath. Before his marriage in 1788 he was working at Cheltenham, and at Ramsgate at a date I have not yet identified.

One label shows slight variation : it is smaller in size, doubtless made to fit the back of the small brass frame, and printed on bluish-green paper with palm-leaf printed border ; a third type also on bluish paper has a wavy line edging. The examples of his work that I have examined have all been in their original frames.

Rosenberg's labels are rare, and a collector will do well to study the technique of well-authenticated specimens. Painting on the back of flat glass, his touch is much more hard and definite than that of his contemporaries, Charles, Hamlet, or Mrs. Beetham ; resembling that of the brothers Jorden in blackness and general effect. His words on the label ' in imitation of Stone ' are difficult to interpret, but at any rate they keep in our memory his density and hardness. Many fine examples are in the collection at Windsor of Royal Portraits in Silhouette (*see Conn.*, Oct., Nov., Dec., 1932).

In my own collection is a remarkable group in the same genre, in which, under the title ' Church, State and Constitution ', are shown the portraits of Cornwallis, Archbishop of Canterbury, King George III, and Lord Loughborough, Lord Chancellor, in State robe and with the embroidered bag with the great seal. There is much gold in the lace and embroidery in this example ; it was purchased at the sale at Wroxton Abbey on the death of Lord North.

Sir Henry Sutcliffe Smith also owns several examples of this fine type of Rosenberg's work.

Rosenberg, alone of the profilists working in England, occasionally backed his profiles with coloured paper of a rose tint ; possibly in reference to his own name ; in this backing he emulated the German workers of the same period, doubtless remembering the custom from his youth in Hanover.

An easy test of a genuine Rosenberg may sometimes be made by removing the glass portrait from the apparently white backing, when a faint pink outline will be found in exact shape of the portrait. The dense black on the glass having preserved the original colour of the backing, while all exposed to the light has faded.

One of his labels is headed by the crown : ' By their Majesties Authority | Mr. Rosenberg | of Bath, | Profile Painter to their Majesties and Royal Family | Begs leave to inform the Nobility | and Gentry that he takes most striking | Likenesses in Profile, which he Paints | on Glass in imitation of stone | that will never fade. | Time of 1 Minute. | Price from 7s. 6d. to £4 4s. Family Pieces, | whole lengths in various Attitudes. | N.B. Likenesses for Rings, Lockets, | Trinkets and Snuff Boxes.' |

This is the example which is in the Banks' Collection.

An advertisement in the *Bath Chronicle*, 1 November 1792 : ' Mr. Rosenberg of Bath, Profile painter to their Majesties, North Parade, Bath, takes the most striking likenesses in the Etruscan and anti-Etruscan methods. Time of sitting 1 minute, and the price 7s. 6d. to 1 guinea.'

In an equestrian portrait we see one of the popular Jubilee productions of George III on horseback ; the background is interesting as it gives the Colet Tower at Windsor, with the roof as yet unspoilt by restorers. This picture is all black, in another variant the lips are tinted red. Stadler was the engraver, 1810. An equestrian portrait of the King was issued in aquatint by Colnaghi.

At Windsor a wonderful record of different members of the Royal Family is to be found, all by Rosenberg. George IV, then Prince of Wales, greets his uncle the Duke of Mecklenburg-Strelitz with raised hat. A row of 8 notabilities of the Court show up finely all black beneath an unusual leafy roof, this is of unusually large size, 26″ × 19″. The Royal brothers are represented, and one sees on the extreme

left[1] the aptness of the pet name of 'The Slice' in the willowy form.

Later, there is the bent figure of the ageing King George III, leaning on his stick and nearing the end of his life ; the spectacled portrait when blindness threatened to overcome him. In looking at this, one forgets many facts and sees only with sympathy a man bent with physical infirmities. For the guidance of those who listen to ignorant nonsense by supposed experts, let me add that Rosenberg is one of the fine artists who never touched a pair of scissors, doubtless his dense black favoured the notion of black paper ; it is the brush alone that Rosenberg wielded.

Coke writes, comparing the characteristics of master workers, of the *fineness* of Mrs. Beetham, the *dignity* of Rosenberg, the *character* of Edouart. It has been said that Rosenberg is most successful with men, but who shall say it when confronted with the oval containing the portraits of the four daughters at Windsor, with their court dressed heads and single bloom and bud of carnation, which becomes almost a formula. His work on convex glass is rare.

Rosenberg shows to perfection all the essential features of the Conversation, the members of the Royal Family assembled in their natural home surroundings, no sensationalism, no fashion plate, just seemly, every-day representation—to use the old name, a 'family piece'. He lived to a great age, to attend the command at Kensington Palace, where the baby Princess Victoria was his sitter ; she was very fond of the old man and called him 'Rosie', unable to manage his long and unusual name.[2] (Plates 29, 36, 44, 102.)

ROSSITER. 1810–11. Was collegian in Hanover, U.S.A. Studied law, made profiles, also in colour. Painted a series of portraits, one numbered 18 is in the collection of Mrs. van Leer Carrick.

ROUGHT, W. Fl. 1800. Of the Corn Market, Oxford. Painted on glass. 'One minute sittings from 5s. to 10s. 6d.' On portrait of a woman in the collection of Mr. A. B. Connor. His work is generally on convex glass. Captain Desmond Coke possessed an example where five portraits are painted in one picture : father, mother and three children. 'An undergraduate' is at the Victoria and Albert Museum, P. 131, 1922.

A large picture painted on glass by Rought shows George III, Queen Charlotte, their six daughters, Charlotte, Augusta, Elizabeth, Mary, Sophia, and Amelia ; they wear full skirts and feathered hats and hold up small parasols.[3] A manservant is behind carrying more parasols. This picture was given by the Queen to her bedchamber woman, Mrs. Gwen. It is illustrated in the *One Hundred Silhouettes* from

Mr. Wellesley's beautiful collection ; it is now at Windsor in the Royal Collection. (Plate 47.)

ROUSE, G. 1755. Advertisement : ' Gentlemen and Ladies pictures drawn in Indian ink in a small oval at half a guinea each with frame and glass by George Rouse at the Bridge Ward Coffee House, under the Piazza on London Bridge. He waits on gentlemen and ladies at their own houses if required.'[1]

ROUSE, J. M. Cutter. Painted bronzed gold, 1820. An example in the collection of Mr. Kilner.

ROWLANDSON. 1756–1827. The painter and caricaturist occasionally painted silhouette portraits in the style so popular in his day. A rare example,[2] formerly in the Wellesley Collection, now in the possession of Sir Henry Sutcliffe Smith, shows ' The Lieutenant of the Tower of London ' ; it measures $5'' \times 3\frac{3}{4}''$.

ROY. Circa 1786. One of a group of Frenchmen who, during the last half of the eighteenth century, used a profile cutting and tracing machine called a physionotrace, an example of which can be seen at the Bibliothèque Nationale, Paris. An assistant of Chrétien (*q.v.*)[3]

ROSEN. Fl. 1796. Russian silhouettist. Signature on two fine portraits in the possession of Madame Nossof, Moscow. The silhouette of the lady is a dignified and beautiful example of the art of the silhouettist at its best.

In my own possession a signed portrait of a man painted on glass, wax-filled, framed in a locket.

RUDOLPH. Fl. 1794. Painted gold glass pictures, silver introduced as relief, subjects—hunting scenes.

RUNGE, PHILIPP OTTO. 1777–1810. It was in silhouette cutting during his childhood that Runge the painter first showed his artistic talent ; at first he copied the work of his elder sister and applied it to the illustration, in white paper, of his toys and games.

When his fame as a painter was acknowledged he continued to make souvenirs in silhouette for his friends. He cut portraits and figures in stencil and made landscape cuttings with slight contour. During his walks in the country he cut outlines of the flowers and trees, conversing on many subjects as he worked. Some of his work has been collected and published in Germany. An example cut, and with Indian-ink embellishment on green ground, is in the collection of Herr Kippenberg, Leipzig, No. 1718. It is signed P.O.R. Hamburg, 1800. Runge is a brilliant exponent of action in his cuttings of animals ; he said that his scissors were but an extension of his fingers.[4]

[1] *See* Plate 36.
[2] Information from Mr. Kruger Grey, great-grand-nephew.
[3] Example in the Royal possession.

[1] Desmond Coke, *Confessions of an Incurable Collector*, 1928, p. 189.
[2] Rep. p. 302, *By-Paths of Curio Collecting*, by Arthur Hogdon.
[3] Martin, *Conn.*, lviii, lxxii.
[4] Rep. M. Knapp, pp. 38, 39.

RYDER, T. Fl. 1789. Advertisement : ' Any lady or gentleman in the country by taking their own shade can have reduced for 3s. 6d. rings in the new method which has the effect of topazes.' Possibly the same as T. Rider.

S

SACKETT, Ackerley. 1914. Describes himself as ' Cuttist '. Germantown, Pa., U.S.A.

SAINT-MEMIN, Charles Balthazar Julien Févret de. Born at Dijon, 1770, d. 1852. Soldier, artist and amateur watchmaker and carpenter. Emigrated to America 1795. Engraved profiles in miniature and used a physionotrace, afterwards reducing his portraits by pantograph. These were generally coloured but sometimes filled black. M. de Valdenuit was his assistant, and his signature occasionally appears with that of Saint-Memin, ' Vnt. & S.M.'

For the life-size portrait in black crayon on a pinkish background together with the copper plate and a dozen proofs, Saint-Memin charged thirty-three dollars, according to M. Guiguard, his biographer.

The Saint-Memin family returned to France in 1814, and the artist was eventually appointed curator of the Museum at Dijon, soon after the accession of Louis XVIII.

His portrait of George Washington is barely half an inch in diameter. It was the last portrait taken before the death of the President, and was produced, engraved, for placing in mourning rings, lockets, &c., on the death of Washington the following year. Saint-Memin lived in America about twenty years, and it is computed that he made over 800 portraits.[1] An advertisement in the *Intelligencer* found by Mr. Henry Erving of Hartford, Conn., runs thus : ' Likenesses Engraved. The subscriber has the honour of informing the Ladies and Gentlemen of the cities of Washington and Georgetown that he has again returned to his former lodgings in Washington for the purpose of taking likenesses. In order that those who are desirous of sitting may not be disappointed, He takes the liberty of suggesting that his stay in the city will be very short. St.-Memin, Washington, 8th November 1804.'

SANDHEGAN, M. Painted on glass and on card. Address : Marlborough Street, Dublin.

SAVAGE, Edward. Assisted Daniel Bowen in establishing a museum in New York City, later went to Boston and opened the Columbian Museum, which was destroyed by fire in 1803.[2]

SCHAEDER, K. Fl. 1799. Painted on glass, gold background.

SCHAEFFER, Johannes David. 1631. A parch-

[1] Martin.
[2] Information Library of Congress, Washington.

ment cutting gummed on to black canvas. At the top is a motto in honour of the person fêted, a mountain where a triumphal procession passes, is the subject, the four evangelists, with their emblems, lead the car. Johannes David Schaeffer, 1631, is below, but whether this is the signature of the cutter or name of the person fêted, is not quite clear. This parchment cutting was published in an Article ' Black Art in Swabea ', by Gustav E. Pazaurek in *Westerman's Magazine*, 1909, and is of great importance on account of its early date.

SCHARF. Black-cut silhouette on blue ground, end eighteenth century.

SCHATZMAN, J. D. 1779–89. Signature on a book of profiles set in engraved borders, formerly owned by Captain Desmond Coke.

SCHELYMAC, I. W. 1779.

SCHENAU. 1737–1806. Painter of ' L'Origine de la Peinture ou les portraits à la mode ', showing a lady's shadow being traced on a paper. This work was engraved by J. Ouvrier. Schenau was a name assumed by Johann Eleazar Zeissig.[1]

SCHILLENBURG, Johan. Eighteenth century. Painter of black profile portraits. Signature on an example in the possession of Miss M. Martin, New York.

Schillenburg, with Schmoll, was the maker of the chair and screen for silhouette portrait taking illustrated in Lavater's *Physiognomy*.

SCHINDLER, Albert. 1805–61. Engelsburg. Draughtsman of the antique ; some fine silhouoette portraits by him were shown at the Troppan Miniature Exhibition.

SCHLEEFSHEIM, Otto. Heraldic cuttings done mostly in the folding method illustrated in Vol. IV of *Scissor Play*, 1914.

SCHLIESSMANN. Modern Viennese black and white artist. His profile of Paderewski is in the Warsaw National Gallery.

SCHMALCALDER, C. Invented a profile machine patented in 1806. Describes himself of Little Newport Street in the Parish of Saint Ann, Soho, in the County of Middlesex. Mathematical and optical instrument maker, he declares that with great labour and study he has invented a Delineator Copier, Proportionometer for the use of Taking, Tracing and Cutting out Profiles, as also copying and Tracing Reversely upon Copper, Brass, Hard Wood, Card, Paper, Asses Skin, Ivory, Glass, to different Proportions directly from Nature. Landscapes, Prospects or any object standing or previously placed perpendicularly, as also Pictures, Drawings, Prints, Plans, Caricatures and Public Characters.

The instrument was made of copper or brass and some wood, a telescopic pole carried a fine steel tracer, a ball and socket joint facilitated its movement according to the movements of a rod passing over

[1] Rep. by G. Biermann, *Barock u. Rokoko*, 1914.

the features of the sitter. His head would rest on a piece of wood lined with leather. If desired a cutter could be used instead of a tracer which if 'fixed to the rod will cut out the profiles'. (Plate 65.)

For a verbatim account of the invention see Machines. Royal Letters patent for 14 years' duration were granted by His Majesty King George III on the 29th day of December in the 47th year of his reign, and were sealed and delivered by the within named Charles Schmalcalder.

SCHMID. Fl. 1795–1801. Vienna. Has been called the 'busiest Silhouettist in Austria'; as he signed and dated much of his work there are many well-authenticated specimens. So explicit is he that on the back of one portrait is 'Schmid Dessinateur en Silhouette lives in Eisen No. 927, 3rd landing'.

He worked on glass and his jewel pieces are very lovely; he often places a delicate spray and signs beneath 'Fecit Schmid Vienna'. On a locket described by Mr. J. Leisching beneath a gold laurel crown there is a semicircular frieze of black female figures with blue foil beneath. The Gratz Museum of Arts and Crafts has portraits by him dated 1796. For two years after that he was court silhouettist to the Schwarzenberg family. Schmid also painted small landscapes. At present no work by him is known dated later than 1801.

There is a beautiful patch-box in the Lazarus collection of miniatures in the Metropolitan Museum, New York, with two heads, signed by Schmid.

Sometimes he uses coloured foils beneath his glass portraits.

SCHMOLL, Georg Frederick. Fl. 1770. Draughtsman. He took many of the silhouette portraits used by Lavater as illustrations in his great work on the study of physiognomy. It was Schmoll who cut those portraits of Goethe, his father, mother and other members of his family, which were afterwards the cause of dispute between the Poet and Lavater. Schmoll travelled with the Zurich divine during the Rhine journey when silhouette portraits were taken of many important people, not only for examination of their qualities but also to interest them in the great work on Physiognomy.

SCHNEIDER. 1779. Publisher of a small volume of operettas by C. F. Bretzner. On the title-page of each set of words is an engraved silhouette of the composer.[1]

SCHOPENHAUER, Luise, Adela von. 1797–1849. Cut silhouettes to illustrate fairy-tales. Her work was much admired by Goethe.[2]

A scissor-cut example in white paper on a light blue ground is in the collection of Herr Kippenberg. On it in her handwriting are the words: 'In Memory of Weimar. Think of me sometimes, 1815.'[3]

[1] J. Leisching. [2] *Silhouttenbuch*, ed. Kroeber, 1913.
[3] Kippenberg, *Sammlung*.

SCHREINER, Christopher. Eighteenth century. Inventor of an instrument of the pantograph type, for the reduction of mathematical drawings; it was afterwards employed in reducing life-size shades.

SCHROTT, G. *fec.* Signature on black profile portrait on glass, gold and black in the Crafts Museum, Maehren, Austria.

SCHUBRING, G. Cut silhouettes for illustration.

SCHÜLER. 1795. Cassel. In the *Annals of Modern Theological Literature and Church History*, there are three black profile portraits signed 'Schuler fec Cassel'.

SCHÜLTNER. 1843. Cutter. A fine example of two ladies, mother and daughter, sitting at work at their writing-tables, is illustrated in the silhouette chapter by Mr. M. v. Boehn.

SCHUTZ, Franz. Fl. 1751. Frankfurt-am-Main. Landscape painter and silhouettist.

SCHUTZE, Fritz. 1838–1914. Bavarian sculptor who lived chiefly in Rome, where he cut many portraits and genre pictures. His 'Mounted Shepherds of the Roman Campagna' is full of animation.[1]

SCHWAIGER, Hans. 1906. Prague. Cut and painted profiles in silhouette.

SCHWALZER. Artist, 256 Tottenham Court Road. Address on a cut portrait of good quality.

SCHWIND, Moritz von. 1804–71. Cut figures in black and white, sometimes in caricature out of thick packing paper; these were used for wall decoration.

In Vol. VII, *Educative Art Magazine*, many of his cuttings are illustrated. Seven examples in black and white mounted on red are in the collection of Herr Kippenberg, Leipzig, 7721.

SCOTFORD, Baron. Born 1884, Kansas City, America. Cutter. Address: 129 Regent Street, London, 'works with scissors alone'. 'People must bear in mind that his work is executed on the spur of the moment and with scissors alone, making it seem impossible to produce the excellent likenesses which one always receives.'

In an interview issued in pamphlet form, Mr. B. Scotford says: 'I keep a dozen pairs of scissors in use. Six sheets of black paper are folded together, the black inside. Then the outline is roughly sketched on the white side, and the six silhouettes are cut at one operation.' (Plates 77, 81.)

His story of cutting the portrait of King Edward VII runs thus: 'It was at the American exhibition at Earl's Court that a gentleman came into the room to have his silhouette done; after I had completed it he said, "People say I am something like the King. Do you think so?" I said, "Yes, you are a little like him." ... Later I saw a large crowd following this gentleman. "Who is that?" I enquired. "That is the King," was the answer.'

[1] Rep. M. Knapp.

Mr. Scotford studied at the Art Academies of Chicago and New York, and completed his studies in Paris under the Swiss artist, Steinland.

SCOTT, J. M., A.R.M.S. 1911–16. Painted profile portraits in Indian ink with slight gold decoration, also full-length figures painted all black. She exhibited at the Royal Hibernian Society's Academy.

SCRIVEN. Engraver. (*See* G. Atkinson.)

SCROOPE, G. 1824.

SCULLY, J. C. Cutter. Portraits in shade on a packet of three well-cut portraits containing Daniel O'Connell, M.P., Richard Lalor Shiel, M.P., John Lawless, Esq. 'All the above were cut for me from the living subjects by a clever English Artist, J. C. Scully.'

SEAGER. Circa 1834. Cutter, North Street, New Bideford, U.S.A. His price was one dollar for portrait profiles bronzed. He was born in London and visited Canada as well as the United States. He taught drawing and painted miniatures as well as silhouettes, was in Halifax, N.S., in 1840, and in Boston 1845–50. An example of his work is in the Essex Institute, U.S.A.[1]

S. E. B. Cut portraits with gold painted lines. Initials signed on a finely cut and bronzed full length portrait of a man looking left, he wears a wig, full skirted braided coat, and holds a tricorn hat in his hand. There is great delicacy in the work. Of a very unusual type.

SEIDL, C. End of eighteenth century. Jewel painter in black profile. Signature ' C. Seidl, fecit ' on male head in locket, *églomisé*.

SEIGNEUR. Cutter. A silhouette of Gibbon the historian and two of Monsieur and Madame de Sévery were lent by Miss Adam to the Royal Amateur Art Society's Loan Exhibition, March 1902, at Lowther Lodge, Knightsbridge, London.

SELDENECK, W. L. F. VON. 1766–1827. Painter of Karlsruhe. An example of his work is now in the possession of the Grand Duke of Hesse-Darmstadt. Occasionally Seldeneck used a kind of fixing fluid which gives a surface like silk.

SEVILLE, F. W. 1821. Lancaster. Free-hand cutter. Handbill : device with shield in corner on which are the Savile arms. He worked at a large room adjoining the Merchants' Coffee Room, Market Street. We are informed by advertisement : ' Striking Likenesses cut with common Scissors in a few seconds without either Drawing or Machine, or any other aid, but by a mere glance of the Eye ! ! by *Mr Seville*. Full length Figures, Animals, &c., &c., cut in any attitude. Profiles faithfully copied.[2] Plain Bust 1s., Two of the same Person 1s. 6d., Elegantly Bronzed 1s. each extra. Frames in great variety on sale. Attendance From 11 till 1 from

3 till 5 and from 6 till 9 o'clock. Families attended. *One Shilling* full length 5s. or two of the same 6s. 6d.

He worked also at Carnarvon and at Mrs. Dixon's Long room, White Hart Inn, Old Flesh Market, Newcastle ; at Mrs. Strong's, near the post office, North Shields, April 1820.

Seville used labels coloured brown and pinkish.

SEYMOUR, MRS. Eighteenth century. Cutter. A head of the King of Poland, a landscape, a squirrel on a bough, are some of this artist's subjects, which were mostly in vellum cut with scissors. She also made heraldic devices and executed very minute work, such as the Lord's Prayer, with signature, date of month and year ' in the compass of a silver threepence '.[1]

SHAKESPEARE. At the Shakespeare Gallery in London silhouettes were cut by machine during first half of nineteenth century.

SHEPHERD, J. On 9 March 1933 was sold at Sotheby's a silhouette of Mrs. M. Robinson by J. Shepherd. Poor work.

SHERMAN, BEATRIX. 1933. Cutter. Her portraits are chiefly full length and autographed by the sitter. Worked for many years in New York, 15 East 26th Street, New York City.

SHERRIFFS. Caricaturist. Uses silhouette method in portraying character studies of persons on the stage and of topical importance. His work may be found in *Sketch, Bystander,* &c., 1832–3. One dimensional.

SHERWILL, MRS. LUCY, *née* Lind. Free-hand cutter, only daughter of Dr. Lind. A series of silhouette portraits were presented by her second son, Lieut.-Colonel Walter Stanhope Sherwill, to the Society of Antiquaries of Scotland in 1877. Amongst them are bust portraits of George III, Queen Charlotte, Princess Amelia, Dr. and Mrs. Delany, and many other persons of distinction, including the only known full-length portrait of Thomas Gray, 4½ inches in height, turned right : it represents the poet in his later years.

Mrs. Sherwill's method ' cut with scissors without any other instrument ' differentiates her work from that of her father, Dr. Lind, whose method was the printing of reproductions.

SHIELD. Signature on cut black paper silhouette portrait of Washington, now in the Library of Congress,[2] Washington, U.S.A.

SIDEAU, F. P. Fl. 1782. Frenchman. During 1782–4 he lived at St. Petersburg. Four valuable collections of his cut and pen portraits are known to exist, their value being greatly enhanced by the fact that the names of the sitters are written beneath most of the shades. At the back of each portrait is a short description of the titles and social honours, this is written in another hand. The great

[1] Rep. Carrick, p. 116.
[2] *Conn.,* April 1911.

[1] Basil S. Long, *Miniaturists.*
[2] Information Library of Congress, Washington, D.C.

Catherine II is herself amongst the distinguished members of her court. Each is pasted on an ornamental mount engraved with the imperial Eagle, laurel wreath, flags and other insignia, suitable for the subject of royalty ; other portraits of aristocrats, not of the blood royal, are on mounts engraved with floral swags, ribbons, and husk decoration.

There are four different albums, more fully described in the chapter on Albums. On one of these collections is inscribed : ' Contemporains de Catherine II Don de Nadine Alexandrovna Wadkovskoy, 1860.'

The fourth collection of Sideau's work is, or was, at the Hermitage Imperial Museum at St. Petersburg.

Besides cutting, Sideau worked with pen and Indian ink ; at the time of his visit to Russia, Anthing was also at work, and amateurs indulged in the cutting of shades there, as in other capitals during the second half of the eighteenth century. The Grand Duchess Marie Féodorovna was herself an enthusiastic worker.

Sideau also made important group pictures, one in which Catherine II, the central figure, shows twelve other figures grouped round her.

There is a peculiarity in Sideau's bust portraits, which makes them easily identified. The line of the arm is carried considerably below the bust line.

His portraits have been engraved, the two volumes *La Cour de l'Impératrice Catherine II ; ses Collaborateurs et son Entourage*, containing 189 silhouettes, has been published, and is a valuable record.

SILBERATH. 1769. A hunting scene with this signature and date is in the collection of Herr Kippenberg at Leipzig, Cat. 7715.

SILHOUETTE, ETIENNE DE. 1709-67. Amateur cutter. The silhouette took its name, but no more, from Louis XV's miserly finance minister. He was born at Limoges on 8 July, and received as good an education as could then be obtained in a provincial town, studying such books on finance and administration as he could obtain. After travelling in Europe he settled in London, and studying our finance system determined that France should have an equally sound one. On his return to France he became attached to the household of Marshal Nivelles, was appointed Secretary to the Duc d'Orléans, the son of the Regent, who shortly made him Chancellor. At this time costly wars and other extravagances were depleting the Treasury of France, and finance ministers were succeeding each other rapidly.

Silhouette had always preached economy and a section of thinking men gathered round him, determined to straighten the finances of the state ; he was backed by the powerful Pompadour, and through her influence was elected Contrôleur-Général 1757. It is said he saved the treasury 72 millions of francs before he had been in office

24 hours. ' This is the more remarkable,' naïvely comments the old biographer Muhand, ' because many of his relations were amongst those whose salaries he cut down.' Economies in Louis XV's household expenditure resulted in many masterpieces of the goldsmith's art being sacrificed in the melting-pot. A proposal to introduce a novel system of banking led to his downfall. After eight months in office he retired to his country estate and for the rest of his life he interested himself in its economical administration and, as a pastime, the cutting of silhouettes, with which he decorated the walls of his house at Brie-sur-Marne.

SINTZENICH. 1779. Engraver of black profile portraits.

SKEOLAN, P. Cutter. Halifax address, 16 Waterhouse Street, Halifax, on a group of four full-length figures and the profile of a man tinted gold. His advertisements when he travelled, announced in the local press that his profiles are ' faithful, elegant and characteristic, accuracy guaranteed '.

SKRYMSHER. 280 Holborn. Name and address on an example in the collection of the late Mr. Francis Wellesley.

SLAMM, G. H. 1890. Sculptor. Illustrated La Fontaine in sixty silhouette pictures, published in Heidelberg.

SLEIGHT, H. 13 Elkerington Road, Gainsborough, Lincs. Invalid cutter. He has illustrated cut scenes from Dickens's novels in cut work, and sometimes cuts in gold and silver paper.

SMITH. | ' Portrait Painter in oil, | original Portraits, Landscapes and Historical Paintings copied in the exactist manner. | Miniature Pictures and Profiles &c. | No. 95 Newman Street near Oxford Street.' | Of this silhouettist's work I have found no example with the exception of the miniature head of a woman above the frame decoration of his interesting label. Later example of his label gives his address as 40 Oxford Street, the corner of Newman Street. Both these labels are in the Banks Collection at the British Museum.

SMITH, J. Miniature profiles by J. Smith, Hair and Pearl Worker, North Bridge Street, Edinburgh. Painted profiles on plaster. *Caledonian Mercury*, 26 July 1788.[1]

SMITH, OBI. Cut portraits of Portier the French comedian in character. Described as ' friend of Portier '. (Plate 103.)

SMITH, T. Edinburgh. Label : ' Striking Likenesses in Miniature Profile, | taken by | T. Smith, Edinburgh. | Reduced on a plan entirely new, in which the most exact symmetry and animate expressions of the features is preserved. |

' Time of sitting 1 minute. | The original Shades are kept and those once taken, can be supplied with any number of duplicates, such as have shades by

[1] Buckley.

them may have them copied or reduced any size and dress, with present taste hair and pearl work. | Rings, Lockets, Brooches executed to any pattern or design.' (Plate 103.)

SMITH, W. Hawke. Painted. Signature beneath the bustline on portrait of a man, date about 1825. Fine work.

SMYTH, Mrs. Edward. 1836. 40 Strand. Painted on card. Example in possession of Mr. Stanley Bacon. Man painted on card, touched with grey, signed beneath the bust 'Smythe '.

SNIPS. The name used by a paper cutter of the 'seventies and 'eighties, who worked chiefly at Portsmouth, Southsea, and Portsea. Examples of full-length portraits of officers of the Royal Navy and other ratings are to be found with this signature.

SOLLBRIG, J. G. 1765–1815. Miniature painter and silhouettist, popular in Dresden in the year 1794. He was a pupil of Casanova and at one time lived in Danzig.[1]

SPECHT, Ernst Christian, of Gotha. Made a machine using glass for taking profiles by daylight, and reflectors for reducing the size of a portrait.

SPECKBERGER. Vienna and Paris. Gold glass silhouette profile portraits.

SPORNBERG, W. A Swede. Practised 1793. Painter on convex glass in an original manner, reversing the process he painted in black all over the surface of the glass, leaving the profile untouched, then drawing in fine lines, the hair and features, and indicating lines for the dress, he overlaid the whole at the back with red pigment. Such portraits usually have an inner framework of black lines and simple devices of Greek inspiration, so that his work is sometimes called in the Greek manner; this is overlaid with red, so that the colour shows up the pattern. He frequently signed also in black lines 'W. Spornberg invemt. Bath'. or 'W. Spornberg fecit, Bath ', the lettering taking the same line as the painted frame. In the Knole Collection I examined no fewer than eight portraits, all members of the Anstey family, ancestors of the late Lady Sackville, taken at intervals during twenty years. Neither colour nor method vary in these examples; one of these is now in my possession. His addresses registered on one of these portraits is 5 Lower Church Street, or 5 Bond Street, Bath. Mr. Wellesley owned five all-black portraits by Spornberg without red relief. A fine one is illustrated in *One Hundred Silhouettes*, the Wellesley Collection, Plate XXXII. In this example is a heavily draped and fringed curtain with tassel above the lovely figure of a lady. These all-black portraits without red pigment at the back are extremely rare.

His label, of which I have seen one example only, is practically unique; it runs thus, and is about 2 inches square :

[1] J. Leisching.

| ' Bath. | Mr. Spornberg. | Miniature painter. | 2 Lilliput Alley, Bath. | Profiles painted on glass in the neatest manner. | Name of Printer Hazard.'

I have also seen a Conversation piece two full-length figures, an old man seated with stick in hand, evidently speaking to his son who stands before him. This also is all black, and the same curtain drapery as above described is on this picture.

The late Mr. Stoner owned a ring by Spornberg, and Mrs. Dickson has a beautiful double locket; both these miniature examples have red grounds.

Another address of Spornberg is North Parade, Bath, in plain block lettering.[1]

His work is very rare and valuable, and much prized by collectors. (Plates 38, 62.)

STAMMHAGEMANN, Gertrude. 1890. Cutter. Her work is strong, specially shown in the sixty illustrations for La Fontaine's *Fables*.

STANZELL, *fec.* Signature on male silhouette portrait *églomisé* in the Crafts' Museum, Maehren, Austria.

STARCKE, F. C. A., of Weimar. Fl. 1780. Took full-size shadow portraits, many of which are preserved at the Goethe Museum, Tiefurt, and Darmstadt. It is known that Goethe in 1780 spent a sum for 9 silhouettes life-size copies for bust portraits he received.

Starcke offers his services for adapting the sketches of his clients to the more convenient size and form, by means of the pantograph. His Groups and Conversations are interesting. That of the Ducal family of Goethe is now in the Goethe Museum.

(*See also sub* Goethe).

STEELL. Fl. 1781. Advertisement in the *Northampton Mercury*, 8 October 1781 : ' Mr. Steell most respectfully solicits those inclined to honour him by sitting, to be immediate, as his stay will be so short. Likenesses in Profile.' 22 December 1781 : ' Mr. Steell having been sent back to Northampton to wait on some families in the neighbourhood, and being informed that several ladies and gentlemen have applied during his absence, takes this opportunity of acquainting the public that he purposes stopping for about a week at Mr. Mawley's in Mercer's Row, where he hopes those who are inclined to honour him will apply.'

STEWART, Rev. Joseph. 1806. Worked at a museum opposite his Episcopal Church at Hartford, Connecticut, and advertised that the place was open except the evenings before and after the Sabbath.

His price was 12½ cents. for each profile. He specially desired ' the patronage of gentlemen sailing for foreign parts '.

STOOKE, James, of Bristol. 1830. Painter on convex glass, white wax filling. Sixteen examples are in the Bristol Fine Art Gallery, together with the

[1] *Lives of the Painters*, p. 121, E. Shepard.

indenture of James Stooke, the younger son of James Stooke, portrait painter of Bristol, who was apprenticed to a coach-builder, Philips of Bristol, in the year of our Lord one thousand eight hundred, for a term of seven years, during which time the said James Stooke must not frequent taverns nor play at dice nor contract matrimony. After these seven years of prohibitions James Stooke is to have the sum of four shillings given to him towards purchasing his freedom of the City of Bristol.

The silhouettes, which are not very good work, are portraits of various relations : father, mother, grandfather, wife, sons John and James, daughters Emma and Sarah, great-aunt Elizabeth, &c.

A characteristic of his work is a small sprig or group of dots which he places on muslin caps, fichus, &c. An example is to be found showing this in the Holborne Museum, Bath.

His descendants are still living at Bristol.

James Stooke also worked in London ; an example of his portraits has on it ' Barbican '.

STORR, James. 1812.

STREUBEL, Bernardine. Signature on a cutting of a stag dated 1800 in the possession of Miss D. Coates.

STREVBEL, Caroline, of Clemnitz. 1913. Landscape and portrait cutter. Examples : ' View of Joordem, Holland ', ' Reflections in Water ' and ' Portrait of Professor Wolff of Königsberg '.

STRÖHL, Hugo Gerard. 1851–1919. Austrian.

SUMMERDAY, Mrs. | Draws cats and dogs in Indian ink. | Old Cavendish Street, Cavendish Square, London. | Price £1 1 0. |

SUTHERLAND, Dr. Cutter. An interesting series of subject pictures are cut. They are fully described on each card and signed. The subjects are mostly of a technical description, such as bleeding a patient, cutting off limbs, &c. Death represented by a skeleton takes an important part. There is great animation, and the subjects are largely caricatures.

T

TAPP, F. Cut silhouettes out of black paper. Red background. Used as frontispiece of a cookery book, end of eighteenth century.

TAYLOR, ' from Bath '. On a pair of painted portraits ' The Twins '.

TAYLOR, Isaac. Born at Lavenham, Suffolk, 1787, d. 1865. Lived at Colchester and Ongar, and was trained in his father's business as an engraver. He painted miniatures and silhouettes, wrote on philosophical subjects, and invented various mechanical contrivances.[1]

The only example of his work that I have examined

[1] *Dic. Nat. Bio.*

is the crayon portrait in the National Portrait Gallery, London.

TEMPLETOWN. In the Folios of the Print Room, Victoria and Albert Museum, are genre subjects, domestic scenes inscribed ' Copied by Mrs. Wigston from Lady Templetown's designs '.

TERSTAN, A. T. Fl. 1787. Painted fine portraits in black and colour, enclosed in floral frames, one signed A. T. Terstan fecit, 1789, is at Knole.[1]

THACKERAY, Wm. Makepeace. 1811–63. Novelist and artist. Cut self-portrait, signed W. M. T.

THARP, Captain. 1913. Cuts genre subjects, birds and animals.

THOMAS, R. 83 Long Acre. Label : | ' Warranted Likenesses taken by Patent machine, at 1/- each | by R. Thomas, | 83 Long Acre, | in a way superior to those taken by any other Artist at 2s. 6d. each. | Bordered by real Burnished gold paper on rich gold grounds : are therefore fit to hang in any room, without the additional expense of a frame.'

Advertisement without example of the work in the Library of the National Portrait Gallery. ' Mr. Thomas is enabled to make this liberal offer to the Public in consequence of an order he has received from a Gentleman of eminence to procure 50,000 different Profiles of the human countenance for a Treatise on Physiognomy.' Printed by W. Calvert, Great Shire Lane, Lincoln's Inn Fields.

THOMASON, I. Was working 1787–92. Painted silhouette portraits on glass and plaster. He worked for ten years in London, Cheshire, Lancashire, and Staffordshire. In March 1790 he went to Ireland and remained three years in Dublin, one of his labels being dated from that city.

In the *Dublin Chronicle*, 16 March 1790, he advertises that he has come to Ireland with the intention of settling in the city ; his addresses there were 25 South Great George Street, and later 33 Capel Street. Like most silhouettists, he occasionally painted shades from a miniature or oil painting and while in Dublin he is known to have done at any rate one portrait of George Washington then being much talked of. This example is now at Sulgrave Manor, original home of George Washington's family. (Plate 52.)

In an advertisement of 18 May 1790, *Dublin Chronicle*, it is announced that ' As one main object of settling in Dublin is to accommodate country patrons he (Thomason) hath something new and particular to propose. Any number of ladies and gentlemen, not less than three, desirous of getting studies, but do not come to Town, may, by directing a line as above, have such instructions sent as will enable even those who do not draw, to take correctly each other's shades from life, which may be sent to be finished in

[1] Rep. Nevill Jackson, *History*, p. 18.

Town, and they may rely on having the same justice done them and every mistake as particularly rectified as if present on the spot without any additional charge whatever.'

Thomason left Dublin in 1792,[1] notwithstanding his determination to settle in Ireland. He dates his farewell advertisement from 33 Capel Street, and ' Returns his most grateful acknowledgments to the public for the extraordinary encouragement given him. He informs them that he has determined to leave early in May and therefore requests those who wish for good likenesses not to let slip an opportunity, that perhaps will never return, also requests those who have any shades left with him to send for them, and that all old shades wanted to be reduced may be sent to him as his departure is positively determined on.'

A fine example of Thomason's work on plaster is in the possession of Mr. D. Dickson. Two on glass, backed with wax, are in my own collection. (Plates 15, 52, 103.)

Thomason's work is very fine, all black with transparencies of thinned black, usually found in oval brass frames. He uses his trade label freely. | ' Perfect Likenesses in Miniature Profile | Taken by | J. Thomason | on a particular plan and reduced to any size which preserves ye most exact symmetry and animated expression of ye Features. | Superior to any other Method. | Set in elegant gilt Frames 6s. 6d. only. | Likenesses set in Rings, Lockets, Pins, &c. He keeps ye original Shades and can supply Those he has once taken with any Number of Copies, | reduces old ones and dresses them in ye present Taste.| [2]

' N.B. Time of sitting from Ten to Two and from Two to Five in the Evening when each Person is detained 2 Minutes only. | All orders Post paid will be duly attended to at No. 25 South Gt. George Street.' | (Plate 103.)

Thomason was a follower of John Wesley and is said to have painted a Shade of the preacher from life.

He advertises in the *Leicester and Nottingham Journal*, 9 June 1787, ' Likenesses in Miniature Profile '.

THOMPSON. Dublin. Painted on plaster.

THOMPSON, John. 1809. Painter in oils, miniature and silhouette cutter and painter. He left Kingston, Jamaica, in 1809 and worked in Halifax, Nova Scotia. An advertisement in a local paper states that he had ' returned to accomplish his tour of British America '.

THONARD. Cut silhouette groups and family pieces between 1790 and 1820. Sometimes worked in dark olive green with bronzing.

THYLMANN, Karl. Cutter. Delicate and sensitive work is shown in his seven silhouette illustrations

of scenes in the Life of the Virgin. Worked with Hoerner.[1]

TIPS, K. 1891. Studied in Baden, received a medal for his silhouette work in 1914. Dr. Dusel wrote of him as ' The Master of Modern Silhouettists '.

TODD. Early nineteenth century. Machine cutter. Itinerated. An album with 2,000 examples of his work is owned by the Boston Athenæum. He cut in two sizes, 2½ inches and also 1⅝ inch. His signature is a stamp ' Todd's Patent ' with rosette ornament. The fact that he wrote the name of his sitter beneath the bust-line [2] gives interest to work which is mechanical.

TÖPFFER, Wolfgang. 1766–1849. Cutter. A tailor of Geneva. Did some portraits, notably one of his wife, Marie Dubouchet in peasant costume, but worked mostly in genre subjects and caricature. Country scenes, horses, hawking, &c.[3]

TOROND, Francis. 1743–1812. A French refugee of Huguenot descent. Painted likenesses, profile shades, miniatures, &c. He heads his advertisement : ' *Les Portraits en Passant*.'

Before 1784 he worked at Bath. Afterwards at Berwick Street, Soho ; 18 Wells Street ; 3 Princes Street, London. We do not know his real name ; the one he worked under was assumed for trade purposes. He painted all black and also in colour. I have seen portraits of the usual bust-size, single, full-length figures with graceful accessories, and there are religious pictures, but his chief forte was family grouping to make those charming Conversations which were fashionable during the last quarter of the eighteenth century. An example presented by Mrs. Alec Tweedie is in the Victoria and Albert Museum. The Sitwell family group was exhibited at Sir Philip Sassoon's Exhibition 1932.

I have been able to identify six of his trade labels or cards.

1. ' TOROND. Drawing Master, Berwick Street, Soho.' This card is ornamented with a female profile in an ornamented engraved frame and is dated 1786.[4]

2. ' TOROND. | Drawing Master, Wells Street, Oxford Street.' | In a medallion with garlands and architectural details. Both these examples are to be seen in the Banks Collection, British Museum, D. 2. 3716.

3. ' TOROND. | Drawing Master, | 18 Wells Street, Oxford Street.' | Garland and architectural ornament.

4. A small oval, ¾ inch, generally found on the front of his Conversations : | ' TOROND | 18, Wells Street ' | in an oval husk wreath-frame.

5. This label may also be found without the husk

[1] Strickland.
[2] *Dublin Chronicle*, March 1790 ; May 1792.

[1] Rep. M. Knapp, p. 95. [2] Rep. Carrick.
[3] Rep., see D. *Band Bovy Peintre Genevois*, 1804, Vol. II, p. 91.
[4] Banks Trade Label Collection, Brit. Mus.

ornament and with the words : 'Likenesses taken singly or in groups in the genteelist taste.'

6. 'TOROND. | Drawing master, | 18, Wells Street.' | His pupils are properly instructed in Indian ink, Chalks, or Water Colours, Flowers, Ornaments, Landscapes and Figures ; from Drawings, Models or Nature, according to their different profession. |
| The Nobility and Gentry attended at their Houses as usual, 1786. |

I have also found twenty advertisements of his work in contemporary news-sheets, but they do not add materially to our knowledge of his personal history nor his work, which is as fine and more varied than that of other silhouettists of the mid-eighteenth century. Flowers, birds, domestic animals, furniture, and household equipment are wrought with the utmost delicacy ; a silver tea-service and porcelain cups, ladder-back chairs, and early chippendale tables add charm to his domestic scenes in silhouette ; with his animals, he is less successful.

His work places him amongst the first six of the eighteenth-century shadow workers. (Plates 39, 41, 102.)

The late Captain Desmond Coke owned many fine examples, purchased from a descendant ; these were unfortunately all destroyed by fire in 1919, making Torond's already rare work still harder to find : the collector who owns an example is fortunate.

Captain Coke writes of Torond's work : ' He was a master of decorative effect and each of his compositions is a separate delight.'

An interesting group is in the possession of the Hon. Humphrey Pakington, his ancestor Sir George Baker, Physician to George III seated with his family, 28″ × 16″, oval label 18 Wells Street.[1]

Mrs. A. M. Walker Ballards, Wickham Bishops, Witham, Essex, owns a profile bust-size with small oval label, address : 3 Princes Street, Leicester Square. This is at the back of the portrait of a lady looking left, high dressed hair, elaborate gauze fichu. The words are : ' Likenesses taken singly or in groups in the genteelist taste by Torond, No. 3 Princes Street. Drawing and Painting taught at home and abroad.' As usual a dotted ornament outlines the oval.

TOUFFROY. Painter to the King of Poland, &c. Painting on glass either portraits or history, ' in which kind of painting he surpasses all that was ever done before. Short time to stay in England at Mr. Moullet's, Milliner, Little John Street, Golden Square.' [2]

TOWNSHEND, BARBARA ANN. Cut single figures and groups in black paper. A collection of these was published in paper covers by Edward Orme,

publisher to His Majesty and to His Royal Highness the Prince Regent, and single sheets were sold at 1s. each ; the complete book is now very rare and valuable as many copies have been destroyed to obtain the picture sheets.

The title-page runs thus : ' Introduction to the Art of cutting groups of Figures, Flowers, Birds, &c. In Black Paper by Miss Barbara Anne Townshend, London.'

The introduction to the only letter-press runs thus : ' In the Art of Cutting Out, it is difficult to render assistance to the young artist by instruction, but a few rules may afford improvement by being observed. When a group of figures are to be cut, after designing the subject in the mind, cut the general outline in a rough manner, and correct and finish them afterwards ; flowers on the contrary, must be carefully, and exactly cut out first, the fibres and open parts to be done after the leaves and blossoms are formed . . .' Miss Townshend advised free-hand cutting, as drawing the designs takes greatly from the merit of cutting . . . she concludes, ' In this work, every style of cutting is introduced that may be useful to those who wish to learn the art.'

TREWINNYARD. Mid-nineteenth century. Painter. Label on an example in the collection of Rev. G. T. Morse : | ' Profiles | of every Description taken in the most correct Manner on Ivory, Glass, Composition or Card, and cut out by | J. Trewinnyard, | No. 40 Strand. | Those on Ivory are in the most approved Stile ever yet offered to the Public, as the Features and Complexion are obtained as well as a correct outline. |
| ' Miniatures painted by Mrs. A. Trewinnyard Warranted Likenesses and finished in the first stile from 3 to 5 guineas. Cheap and elegant Frames and Glasses.' |

Another label (on a fine example painted on card, is printed above that of J. T. Mitchell, which see) as follows :
| ' Of every description a most correct manner on Ivory or composition or card by | J. Trewinnyard, | No. 40 Strand. | These on Ivory are in most approved style ever offered to the public as the Features and complexion are obtained as well as correct outline.' |

TURNER. 1782. Published a silhouette portrait of Queen Charlotte of Great Britain, 1782, opposite the Church, Snow Hill. In the National Portrait Gallery.

TURNER, MRS. Circa 1840. Cutter. Address : Upper Gallery Western Entrance, Old Bond Street. Poor work.

TUSSAUD, J. P. 1823. ' Son of the great Madame Tussaud Respectfully informs the nobility and gentry and the public in general that he has a machine by which he takes profile likenesses. Price 2s. to 7s. according to style. Biographical and descriptive sketches of the whole length composition

[1] Rep. Conversations Chapter.
[2] *Public Advertiser*, 2 January 1765. Buckley.

figures and other works of art forming the unrivalled collection of Madame Tussaud, &c.'

In *Notes and Queries*, 6th series, V, it is said that Tussaud sometimes mounted his portraits as groups and drew buildings and scenery as backgrounds.

U

UNGER, Johann Frederik G. Berlin. Cut in wood. Reduplicated silhouette portraits, by means of a printing press mentioned in *Bon Magie*, one of the earliest books of instruction in profile taking.

Circa 1790, mentioned by Professor M. Knapp, and is possibly identical with above. He is described as a wood-carver and silhouettist who executed shadow portraits and also made woodcut portraits of small size from life-size outlines supplied by clients.

UNKLES. Early nineteenth century. Lithographer. Worked in Cork at 26 South Mall. He executed the illustrations in Lindsay's *View of the Coinage of Ireland* published in Cork in 1839, and also the lithographed backgrounds used by Edouart for his full-length silhouettes. These were signed Unkles and Klasen, and appeared in the *Treatise on Silhouettes* published in 1835.[1]

URICH, R. Signature on engraved mount.

V

VALDENUIT, M. de. Assistant of Saint-Memin in the process used by that artist. Valdenuit's silhouette portraits are signed ' Vnt. & S.M.' or ' Drawn by Valdenuit and Engraved by St.-Memin '. He went to America about 1793 and after living in France returned to America, dissolving his partnership with St.-Memin in 1797. Fine examples are in the Corcoran Gallery, New York.

VALENTINI, Ernst. 1759–1820. Painter and silhouettist. Was originally a bookseller in Frankfurt, and practising drawing and silhouetting in his leisure hours, he gained sufficient encouragement to throw up his bookselling and go to study in Italy, where he cut silhouette portraits in Turin, Milan and Florence ; he also painted miniatures and eventually became court painter at Detmold.

VALLÉE, Jean François de la. 1785–1815. Painter. French *émigré* who, after correspondence with Washington and other statesmen, went to America, intending to establish cotton mills in Virginia. He was not successful and kept a boarding-house in Philadelphia for some years, eventually settling in New Orleans in 1815. (Plate 55.)

He painted miniatures,[2] one of General Jackson

[1] Strickland. *Treatise on Silhouettes*, by Edouart.
[2] Mantle, Fielding.

is known : he also painted silhouettes, that of Washington at the age of 63, at one time in the possession of the late Mr. Charles H. Hart.

VALLOTON. Obtained silhouette effects by woodcuts and lithographs in two shades.

VARNHAGEN, von Ense. A skilful amateur. Married Adela Schopenhauer, also a silhouettist. Author and friend of Goethe.

VECCHIO. Circa 1790. Painted on plaster, Dublin. He did fine work, which is rare.

VENIMORE, C. Signature on a fine portrait of an ecclesiastic, painted on flat glass in dense black. Date about 1778. At the back is printed ' C. Venimore, Wallingford ' in cursive lettering. I have never seen another example of this artist's work.

VERNON, Catherine. Cutter of flowers, village groups, animals and decorative *motifs* ; very fine work. First half of the nineteenth century.

VESPRE, Mr. Painter on glass. Advertisement in Felix Farley's *Bristol Journal*, 29 May 1756, and *Daily Advertiser*, 3 February 1775.[1]

To be sold two paintings on glass by the ingenious Mr. Vespre.

VIDEKI, Ludwig. Salzburg.

VOSS. Second quarter of eighteenth century. German. Friend of Lavater, Goethe, and his circle.

W

WAGNER, Gebhardt. Draws silhouette portraits in caricature.

WALCH, Jean Baptist Nicolas. Fl. 1773. Silhouette of Mozart and his sister seated at a piano as a child. Cut out of small pieces of silk of various colours, gummed on card.

WALKER, G. 1820. Cutter. Label : | ' Artist, | 43 Lord Street, Liverpool.' | Stencil label, bronzing. Average work.

WALKER, J. Eighteenth century. Trowbridge. Painted on card, white relief.

WALLE, Gustav. 1912. Cutter. Studied at Royal Academy of Design at Stockholm. Practised at a studio in Fifth Avenue, New York. Cut portraits with cut or slashed white lines with flamboyant decoration. Examples reproduced in *The World Magazine*, 28 April 1912, p. 5.

WALLER, H. and J. Names mentioned as silhouettists by Mr. Weymer Mills. No details given.

WALLSON. Signature on silhouette portraits in the possession of Mrs. Young, Bromley.

WALTER, H. and J. Signature stencilled on an example in the collection of the late Mr. F. Wellesley, also in collection of Mr. G. T. Morse, U.S.A.

WALTERS, Hand J. Circa 1848. Signature on portrait of a lady full length, cut, bronzed and with white decoration. Poor work.

[1] Buckley.

WALTHER, Luise, *née* von Breitschwert. 1833. German cutter. Afterwards embellishing her work with her pen. Some examples show stiletto marks at the back, to emboss or raise the paper. She was well known in Würtemberg, and several albums containing portraits cut by her are known to exist.[1]

WARREN. On a cut portrait of a man looking left and slightly bronzed, in the possession of Major Howell; address of artist, Victoria Gallery, Warwick, 1832.

WASS, John. 1822–76. Cornhill, London, February 1823. On portrait of a lady wearing a frilled lace collar and high comb, in the possession of Mr. Alfred Doxey Wass, generally paints in greyish black with heavy shiny black lines on card.

WATKIN. Fl. 1801. Windsor and Bath. Cut paper profiles. Signature on portrait of Nelson's mother, also on portraits of Nicholas Brooking,[2] a family taken in Devon. He also painted on card with white and gold relief; of this type is the Duke of Clarence, afterwards William IV, in Victoria and Albert Museum, P. 162, 1922. Presented by the late Captain Desmond Coke. (Plate 103.)

WATKIN. Signature with date 1760. On portrait painted on card of a man in a wig and cocked hat.

WAUGH. Fl. 1835. Of N. Carolina, U.S.A.

WAY, Mary. 1811. Portrait and miniature painter from New London, Connecticut, advertises that she ' takes Likenesses upon Ivory and glass . . . if not approved, return without charge. Her paint room is at 95 Greenwich Street. Hours from 11 till 3.' *New York Evening Post*, 14 December 1811.

WEAVELL. Signature beneath bust-line on a portrait of a man finely painted on card.

WEDGWOOD, Josiah. 1730–1795. Cutter on the authority of Miss Meteyard, the biographer of the great potter. We are told that the young Josiah was an adept in the art of cutting out with scissors, designs in paper, when attending as a day scholar a school kept by one Blunt, in a large half-timbered house in the market-place of Newcastle-under-Lyme.

The cuttings represented ' an army at combat ', ' a fleet at sea ', a house and garden, or a whole pot works and the shapes of the ware made in it. Those cuttings when wetted were stuck along the whole length of the sloping desks, to the exquisite delight of the scholars, but often to the great wrath of the severe pedagogue.[3]

WEINRAUCH, J. C. Circa 1786. Fine pen-and-ink work with wash. Signature on a 12″ × 8½″, elaborate interior walls, furniture and decoration of the period, lady playing a guitar, music in front on finely carved stand. Bamberg, 1786, in the possession of the author. Very fine work. (Plate 13.)

WELLINGS, William. Fl. 1785. Painted bust profiles of which I have one example, and full-length figures in conversation pictures. A fine example of one of these groups is at Colchester Museum, another is at the Victoria and Albert Museum, given by the late Captain Desmond Coke.

Wellings lived, for fourteen years, at 3 Tavistock Row, he then advertises his removal in October 1792.

' Mr. Wellings, Miniature Painter. Removed from No. 3 Tavistock Row, to No. 26 Henrietta Street, Covent Garden, The Original Person that introduced the so much approved and admired Light Shades in the Profiles, thereby giving them an Elegance of appearance, and expressing the Drapery and Dress in a style totally peculiar to himself alone, and has had the honour and happiness to meet with the approbation and patronage of the first Personages and greatest judges in the three Kingdoms during the fourteen years of his residence at Mrs. Sledges in the above street. He most respectfully informs the nobility and gentry and the Public in general that he will continue to Paint Portraits in miniature, for Lockets, Bracelets, Rings and Fausse Montres, in whole lengths, coloured or black, shaded or plain. Blocks, Busts, Conversations, &c., &c., in the most elegant manner. Specimens to be seen by applying above. Theatrical Portraits finished in any character required on a few days notice. N.B. Large Shades reduced to any size.'

The late Mr. Basil S. Long in his *British Miniaturists* considers that William Wellings the silhouettist is probably identical with the artist Wellings who exhibited a miniature from a London address at the Royal Academy, 1793, numbered 399 in the Catalogue. (Plates 40, 103.)

The British Museum has an engraved portrait after Wellings.

The late Mr. F. Wellesley, *One Hundred Silhouette Portraits*, reproduced a Conversation by Wellings, Plate XXI, depicting William Pitt, aged 21 ; the portrait, which is painted on paper, is dated 1781.

WELLINGTON, W. Painted on card in reddish-brown. Also cut black paper with white details in brushwork. ' Formerly of Trafalgar House.'

WENDT, Johann W. Fl. 1780–92. Cutter. Worked at the time when Lavater laboured to read the soul from the features in Silhouette. Wendt's work is generally (when reduced from the shadow) placed on a green background. Fine examples are in the Erbach Castle Museum, Weimar, and at Darmstadt it is interesting to find that he was paid 1 florin for each portrait. These he sometimes drew and painted, always pasting on green. Further information can be found in *Das Silhouettenbuch des Count De Franz von Erbach*, 1785, ed. K. Morneweg, Leipzig, 1923.

[1] Rep. M. Knapp, p. 58.
[2] Rep. Nevill Jackson, *History*, LIV.
[3] *Life of Josiah Wedgwood*, Meteyard.

WEST. 1811. Advertisement : 'Miniature and profile painter from London, respectfully informs the ladies and gentlemen of Derby and its environs that he has taken apartments at Mr. Price's in the Market Place, where he intends for a short time practising the above art, and where specimens may be seen. Mr. West requires only two short sittings, and will reduce the likeness with the greatest exactness, to within the compass of rings, brooches, &c. Miniatures from two to six guineas. Profiles taken correctly in one minute by means of his portable machine. The construction and simplicity of this instrument render it one of the most ingenious inventions of the present day, as it is impossible in its delineation to differ from the outline of the original, even by the breadth of a hair. Profiles on card, in black, 5s., in colour, 10s. 6d. ; on wood, in colours 1 guinea and upwards. Attendance from ten in the morning till five in the evening.

'Mr. West never permits a painting to quit his hands but what it is a likeness.'

A fine portrait of a man looking right, with colour detail, signed 'West, 1789', in the collection of Sir Henry Sutcliffe Smith, may possibly be the work of this artist. He also owns two small portraits, black faces, coloured hair and clothes, each signed 'West', formerly in the Wellesley Collection.

WEST, WALTER J., R.W.S. Painted a series of six figure and animal groups, which were lithographed, the edition limited to 100, each is signed J. Walter West, quv. et Del, or with initials. The subjects : 'Coal Rations', 'The Milk Express', 'A Diet of Worms', 'Little Fly', 'The Riding School', 'Market Day'.

WESTON. 149½ Bowery, New York.

WESTON, MRS. Signature on four portraits painted on paper in the collection at Knole.

WHEELER, JUDGE CHARLES B. Cutter. Buffalo, New York. Subject pictures : 'Off to the Hunt', 1909 ; 'Going to Market', 1909.

WHEELER, J. 1793. Signature on the silhouette portrait of a coachman in elaborate livery in the possession of the late Captain Desmond Coke, possibly by Windsor silhouettist below.

WHEELER, T. 1794. Windsor. Label : 'Profiles on glass that will not wash off or on paper that may be sent in a letter any distance without injury. | Price 5s. Frames 2s. | If not approved likenesses no payment required. | By T. Wheeler at Windsor, 1794.' | Following these words written in ink on a portrait owned by Mr. Hames, | 'Ladies and gentlemen waited on at their own Houses at any Hour, and it would prevent loss of Time, if the Head-dress was adjusted previous to his attending. | A striking likeness of the King for sale.' |

Example inscribed 'Dear Lady Frances, Windsor, 1794', and another 'Miss G. A. Vyse, T. Wheeler fecit August 1st, 1810' described by Mr. A. Hames.

'The Great Gatehouse, Kenilworth' *The Times*, 4 April 1936.

WHITCOMB, J. H. Cut hollow. Signature on portrait of W. M. Matthews, American, early nineteenth century. (Plate 60.)

WHITE. Paper cutter and photographer. Label : 'Photographic Portraits—Paper cuttings &c. | Taken by | *Mr. White* | at his Gallery (daily) Queen's Terrace, opposite the Royal Hotel Blackpool | Likenesses faithfully copied | open from 7 a.m. till 7 in the evening | ' 1855 on the back of a photogroup of the Boys family in the possession of Mrs. Schofield, Ripon, Yorks. This is an interesting example of the overlapping of silhouette and photography, the same artist practising both processes.

WHITE'S. On some silhouette portraits cut in London about 1850 is to be found a stencil label : 'Cut with scissors at White's.' These portraits are generally full length, there were several in a 'parcel' sold at Sotheby's, July 1931. One example is in the Library of the National Portrait Gallery, London.

WHITING. Profilist, Salem, Mass., U.S.A.

WHITTLE, E. Fl. 1830. Artist. Stencilled signature on cut profile portrait of a man with gold lines. 'Cut with scissors, Mr. E. Whittle' on portrait of a lady, black paper, gold touches, in possession of the author. Fine bronzing.

WICHE, J. 1806. Profile bust looking left in the possession of the author. Label gives address : 'No. 12 Beech Street, Barbican. Profile Painter.'

He paints on card with a good deal of relief obtained by thinning his black paint, rather than using body colour.

WIEDEMANN, OTTO. 1869. Painter. Groups. His work is decorative and well balanced in composition.

WIFFEN, J. H. Signature on a printed silhouette portrait of a youth in neck-frill and cut-away coat is the name, Frederic James Post of Islington. The lad holds a Greek Testament in his hand. Born 1819, d. 1855.

WIGSTON, MRS. Amateur cutter. In the Victoria and Albert Museum are some genre cuttings on which are inscribed : 'Copied by Mrs. Wigston from Lady Templetown's designs.'

WILL, J. M. Signature on an example in the collection of the late Mr. F. Wellesley.

WILLIAMS, HENRY. 1787–1830. Boston, U.S.A. On his machine-made portraits cut hollow he uses his surname only impressed, he also painted. An advertisement in the *Columbian Sentinel* was found by Mrs. van Leer Carrick.

'Correct Profile Likenesses or no pay. Henry Williams will take correct Profile Likenesses with his new machine ; which takes 16 different sizes down to a quarter of an inch ; cut on beautiful wove paper—may have two or four cut for 25 cents—elegantly framed with enamelled glasses from 75

cents to 1 dollar, 1.50 and 2 dollars. Miniatures and Portraits executed upon Ivory ; Portraits in oil and crayons ; profiles painted upon glass ; likewise on Ivory—from 3 dols. to 4 dols. Also glass miniature sittings, for sale, from 10 to 16 and 20 dols.

' Profile Frames for sale, oval, round, square, or circular of various sizes ; by the dozen glass or single, cheaper than can be purchased in Boston.

' N.B. Constant attention from 7 o'clock in the morning until 9 in the evening.'

His address is given as ' Under Boston Museum, North side the market '.

No examples of his work on ivory or glass have yet been found.

WILLIAMS, HENRY. 1787–1830. Born at Boston. He painted coloured miniatures, oil portraits and silhouettes in Indian ink. Dunlap also writes of him as modelling in wax and working with electrical appliances.

There is a silhouette signed Williams in the possession of Mr. D. M. Prouly of Boston and one is reproduced in *Emerson's Journal*, Vol. IV. I believe his signature has to be read through a looking glass.[1]

Williams [2] is given to me as the signature on a cut silhouette on the portrait of an unknown man by the Library of Congress, Washington, D.C. Probably this worker is identical with Henry Williams of Boston.

WILLSON, LESLIE. Modern silhouette illustrator, *The Scorcher's Progress*, &c.

WILLSON, MISS. Painted on convex glass. Signature at the back of portrait of Elizabeth Mitchell. Black head, cap fichu, lace in relief, in the possession of the Rev. G. T. Morse.

WILLTON. 1809. Queen Street, Portsea. Advertisement on an example in the Wellesley collection.

WILSON, A. Fl. 1839. Royal Saloon of Arts. Windmill Hill, Gravesend. Cut paper, established 1839. A quaint picture of contemporary date shows the booth of the artist and his advertising at the Fair.

WINKLER, ROLF. Fine pictorial silhouettist, 1913.

WIRER. (*See* Kay.)

WIRTH, H. 1877. Cutter. Born in Labrador, America. Teacher of painting at the Academy of Art in Königsberg. Bold and massive work with good lettering, genre pictures.

WISE, J. 1796. Cut and coloured slightly. Worked at Wantage.

WISH, R. Signature on portrait of a man, on decorated mount, in the Knole Collection.

WIVELL, A. Pinxt signature beneath bust-line, painted on card of a man looking left, date circa 1814–30. Owned by Mrs. Topham. This artist also cut and bronzed. Good work.

[1] T. Bolton.
[2] Information from Library of Congress, Washington, D.C.

W. J. embossed on card, example in the collection of Miss Mary Martin, New York.

WOLFF, HEINRICH. Fl. 1780. Cut genre pictures and landscapes, his technique is fine, he uses the two effects of white background for black cutting, and black background for white pierced work —in the same picture. His figures are very animated.

WOLFF, HEINRICH. 1875. Drawing master at the Royal Academy of Art in East Prussia. Wrote and illustrated *Tales of a Pair of Scissors*.[1] A characteristic of his work is the use he makes of large heavy black massed background.

WOLFF, ZIMMERMAN ELIZABETH. 1912. Königsberg. Cutter. Her portraits of ' The Sisters ' is a fine example of her work reproduced in *Deutsche Schatten- und Scherenbilder*. Wife of above.

WOLKOFF, BARBARA. 1870. Cutter. Daughter of Count Peter Neiden and Princess Sophie Dondonkoff-Korsakoff. Born at St. Petersburg. Interested in handicrafts in connexion with Princess Obolensky's School for Girls. Lady-in-Waiting to H.R.H. Empress Marie of Russia.

Works on the exact lines of Mrs. Delany, unknowing of this great prototype until she came to England in 1922. Madame Walkoff's flowers in paper mosaic form a complete index to the garden flowers and many of the wild varieties in England ; if delicate gradations of colour are unobtainable in paper this cutter has various ingenious methods of supplying her needs. Her series of flower studies, begun in Russia, have been continued in England since the Revolution, and now, without retouching with paint or any other means, she has formed a very complete portrait gallery of the English flora.

WOOD, JOSEPH. Sometime partner of Jarvis, which see. Advertises as making ' profiles on gold leaf, shadowed by Latebury. Price five dollars.' He also painted on glass and used a machine.

He was born at Clarkstown, Orange County, New York, and worked with great rapidity ; his address was at one time Park Row in Beekman Street. Being introduced to Malbone the miniaturist, he worked at coloured miniatures and eventually severed his connection with Jarvis, with whom he had many carefree adventures.

WOODHAM, J. 1825. Painted on glass, a full-length figure is inscribed ' by J. Woodham, from Milverton, 1825 '.

WOODHOUSE, J. Painted on flat glass. On 9 March 1933, was sold at Sotheby's a full-length silhouette portrait signed J. Woodhouse, Newcastle, 1822.

WOOLLASTON, THOS. Circa 1769. In South Carolina, Harriott Pinchney writes to a friend : ' My dear Miss R——, Thos. Wollaston has summon'd me to-day, to put the finishing strokes to my shadow which straightens me for time.'

[1] Rep. Knapp, p. 80.

WRAY, Mrs., *née* Jeffreys. 1766. Cutter. Her silhouette portrait of Daniel Wray, Esq., antiquarian, was published April 1816, by J. Nichols & Co. Her signature is on several groups of members of the Jeffreys family before her marriage in 1772 ; the figures are full length, and executed with much charm. Silver and china table equipment still in the possession of the family are shown. The late Capt. Desmond Coke told me that a bracket or mantelpiece projecting from the edge of the picture is a peculiarity of her work. This is also used constantly by Torond. Mr. Paget Toynbee records a portrait, also by Mrs. Wray, of Thomas Gray, made in 1762. He is seated with a book on his knees. This portrait is of great value, as it is almost the only authentic full-length representation of Gray ; it is amongst those in the Gosset collection.

WRIGHT, Joseph. Partner with Samuel Brooks (*q.v.*)

WRIGHT, Mrs. Patience, *née* Lovell. Quaker. Modeller in wax and occasional silhouette cutter. Born in New Jersey, U.S.A., 1725. Came to England, held an Exhibition in London 1778. Worked also in France. Her younger daughter married Hoppner, R.A. Captain Desmond Coke mentions her Conversation groups. I have never seen one—Mrs. van Leer Carrick[1] quotes a letter from Franklin alluding to a Shade by Patience Wright : ' I send you the little Shade copied from the great one.'

WYEINANKA. Polish word denoting the coloured paper cuttings which are made by peasants and fixed to the walls and ceilings of their cottages. They are probably associated with pagan symbols for defence from the Evil Eye and take the form of Swastika, small trees, spirals, spiders, wheels, triangles, and crosses.

Y

YOUNG, G. M. 1836. On a full-length portrait in dark olive green, white relief, cap and other detail, in the possession of Mrs. Nickson.

[1] Carrick, p. 20.

Z

ZELL, Maria. One of the nuns of Bavaria, skilful in cutting lace papers which were sometimes afterwards printed with saints or sacred emblems, occasionally emblems of the saints are painted in the cutting such as a hunting scene in a St. Hubert example. A single picture sometimes represented many weeks' labour. White paper was always used.

ZELLER, Cornelia. Cutter of subject pictures.

ZENNER. Late eighteenth century. Amsterdam. Worked in England, exhibited at the Society of Artists of Great Britain, address 1778 at 28 Haymarket, when a drawing of a landscape in metals on glass was his work. He is described as a stained glass painter, and frequently made pictures of views in England. His method is near the *églomisé* process. Greenwich Palace and Observatory, signed Zenner and dated 1802, is in the collection of H.M. The Queen and was exhibited at the Four Georges Exhibition. An illustration of Sadlers Wells Theatre, recently rebuilt at a cost of £4,000, is reproduced in the *Connoisseur*, December 1933. The New River made by Sir Hugh Myddelton in 1609 flows in the foreground.

A beautiful specimen signed and dated shows ladies in full dress and men walking in an avenue, the centre lawn is done in elaborate arabesque pattern, though all the rest is gold the figures are backed with silver, and the sky of wax faintly tinged with blue and grey, the picture measures $7\frac{1}{2}'' \times 3\frac{1}{2}''$.

Another example also signed and dated shows men working on a ship. Roman numerals indicate the depth of the water, a second ship or barge holds a boom with which some experiment is taking place, the sky in this case also is wax of pale grey tints. Both these specimens were in the collection of the late Captain Desmond Coke.

ZIMMERHAKEL, F. A bust portrait in black with yellow mount was signed ' Made August 25th, 1810, by Franz Zimmerhakel ' at the Arts and Crafts Museum, Prague.

ZIMMERMANN, J. G. Cutter. Hanoverian doctor, contemporary of Goethe and Lavater, assisting the latter in taking the portraits in silhouette for the study of physiognomy.

PLATE 82

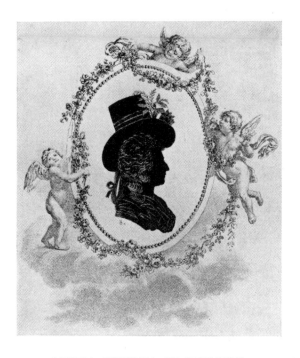

LOUISA AUGUSTA OF DENMARK
BY J. F. ANTHING, 1753

FROM THE 100 ILLUSTRIOUS PERSONS
By special permission of Dr. Conrad Höfer

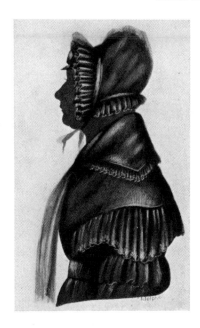

PORTRAIT OF A LADY
PAINTED BY ADOLPHE, SIGNATURE BELOW WAIST-
LINE, TINTED GREY AND WHITE

THE
ORIGIN OF PROFILES.

' Twas love, 'twas all-inspiring love, tis said,
 Directed first a female hand to trace,
 In some Corinthian hall, her lover's face,
As once it fell an evanescent shade
Upon the marble wall ; aye, she pourtrayed
 Each lineament so true, each turn and grace,
 It seemed as though some spell had charmed the
 place,
And stamped the image there ; the enraptured maid
 Enamoured gazed, bewildered to behold
The work herself had done : yet she was there
 The sole enchantress then. Oh ! who that's told
This classic tale would not a *shade* revere?
And each to each fond interchanges make,
For love, affection, or for friendship's sake.

TAKEN BY

MONS. ADOLPHE,

Portrait, Animal, Miniatuıe
and Profile
PAINTER,

NO. 79, KING'S ROAD, BRIGHTON.

RHYMED ADVERTISEMENT OF ADOLPHE
OFTEN USED AS HIS LABEL ON PINK OR
YELLOW PAPERS

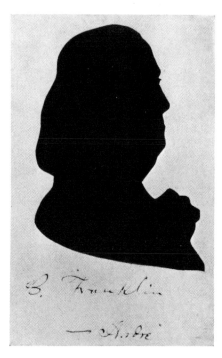

BENJAMIN FRANKLIN
PORTRAIT CUT BY MAJOR ANDRÉ DURING THE
TIME OF GAY SOCIETY IN OLD PHILADELPHIA,
WHICH ENDED IN THE TRAGEDY OF WAR

PLATE 83

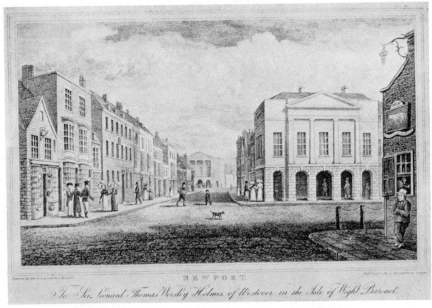

HIGH STREET, NEWPORT, ISLE OF WIGHT

WHERE BUNCOMBE, LODGING AT THE IRONMONGERS (KETTLE ABOVE), PAINTED
HIS FINE SILHOUETTES : PORTRAITS CHIEFLY OF THE OFFICERS FROM THE NEARBY
DEPÔT

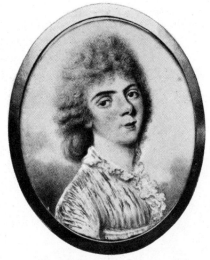

MISS CHAMBERS, DAUGHTER OF CHAM-
BERS, SURGEON OF LONDON HOSPITAL

RARE EXAMPLE OF MRS. BEETHAM'S WORK IN
COLOUR, AFTER LESSONS FROM SMART, WHOSE
INFLUENCE IS SHOWN IN THE TREATMENT OF
THE HAIR, ACCORDING TO THE LATE B. S. LONG

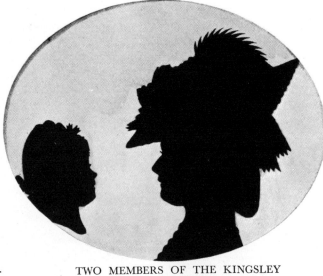

TWO MEMBERS OF THE KINGSLEY
FAMILY

EARLY WORK OF MRS. BEETHAM, WHO CUT
SILHOUETTES BEFORE HER GLASS-PAINTING
PERIOD

STAMP ON THE PAINTBOX LID OF J.
BUNCOMBE, WHOSE WORK IS MUCH
PRIZED BY COLLECTORS

NO PRINTED LABEL HAS YET BEEN FOUND

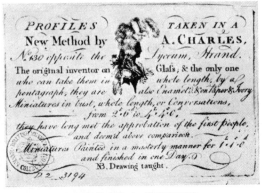

LABEL OF A. CHARLES

Banks Collection

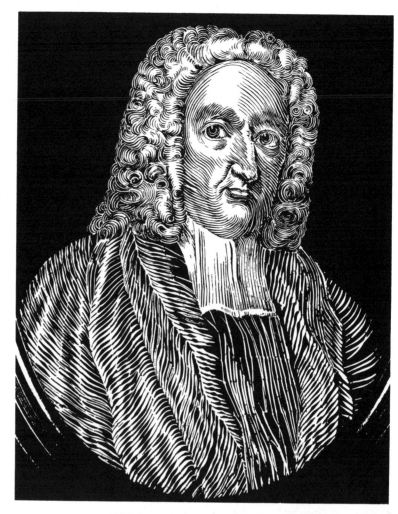

JUDGE JEFFREYS, 1ST BARON JEFFREYS OF WEM, 1648–89, JUDGE OF THE 'BLOODY ASSIZE'. WAS NOTORIOUS FOR HIS BRUTALITY

PORTRAIT SUPERBLY CUT BY NATHANIEL BERMINGHAM, 1774, RARE AND EARLY PIECE

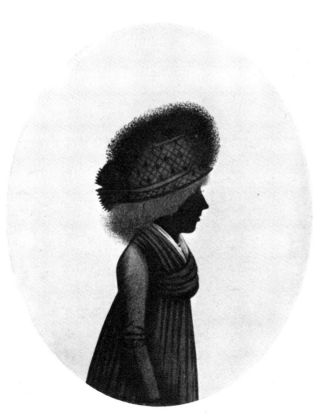

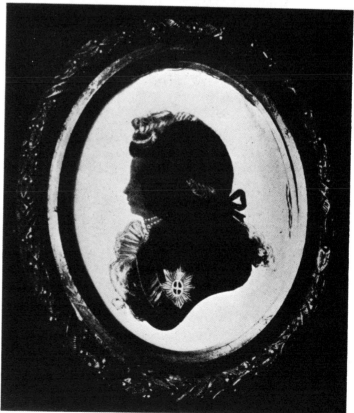

ONE OF THE RARE EXAMPLES OF WOMEN'S POR-TRAITS BY BUNCOMBE

GEORGE III AND QUEEN CHARLOTTE, BY A. CHARLES
In the Royal Collection, Windsor Castle (By gracious permission of H.M. the King)

PLATE 85

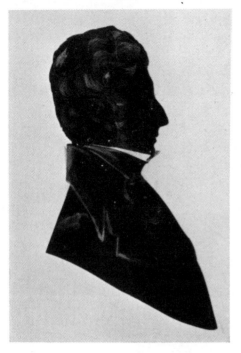

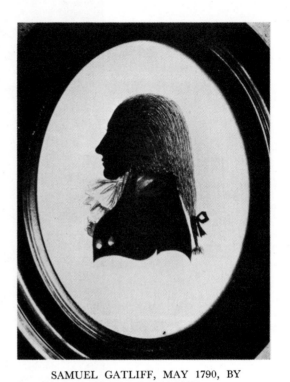

PORTRAIT CUT AND BRONZED BY
BARRETS, 148 HOLBORN BARS

SAMUEL GATLIFF, MAY 1790, BY
J. BUTTERWORTH

MY GREAT-UNCLE'S PORTRAIT BY G. STUART,
TOGETHER WITH THAT OF MY GREAT-AUNT,
NÉE GRIFFIN, ARE NOW IN THE FINE ART
GALLERY, PHILADELPHIA. HER GRANDFATHER,
CARTER BRAXTED, SIGNED THE DECLARATION
OF INDEPENDENCE IN AMERICA. E. NEVILL JACK-
SON, *NÉE* GATLIFF

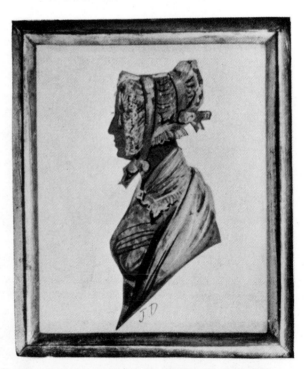

STENCIL LABEL OF MRS. CATLIN, ARTIST
AT THE PAVILION OF ARTS AT THE
BASE OF THE ROTHERHITHE SHAFT,
THAMES TUNNEL

LADY PAINTED ON CARD IN COLOUR
BY J. DEMPSEY

PLATE 86

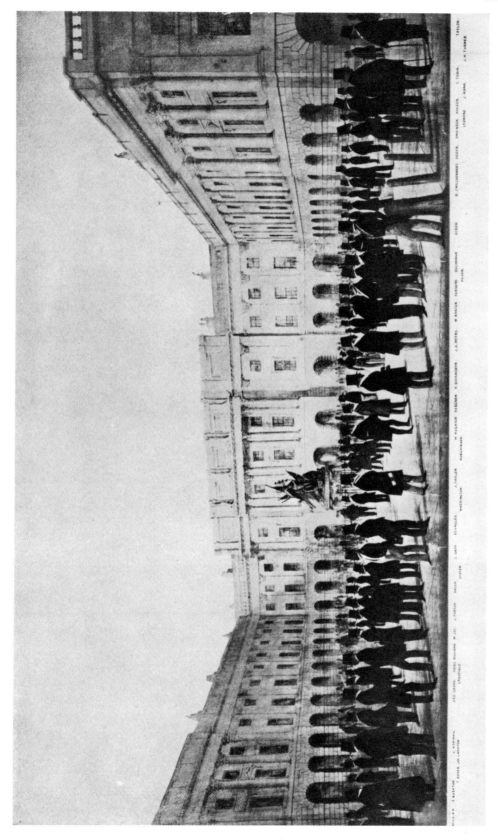

THE LIVERPOOL EXCHANGE, 1840, WITH SILHOUETTES BY J. DEMPSEY, SHOWING IN FRONT THE MERCHANTS' RENDEZVOUS IN CASTLE STREET. THE BACKGROUND IN WATER-COLOURS REPRESENTS THE OLD EXCHANGE BUILDINGS ERECTED IN 1808, AND WAS PROBABLY ALSO THE WORK OF DEMPSEY. DUPLICATES OF SOME OF THE PORTRAITS, TAKEN FROM DEMPSEY'S OWN PATTERN BOOK, IN POSSESSION OF THE AUTHOR

The complete group is here illustrated by permission of Miss Jeffy

PLATE 87

SELF-PORTRAIT OF AUGUST EDOUART IN THE ACT OF CUTTING
THE SILHOUETTE OF LISTON THE ACTOR. NOW IN THE NATIONAL
PORTRAIT GALLERY, LONDON

THE METHOD OF HOLDING THE SCISSORS, AND THE SKILL DISPLAYED IN THE
PENDENT BLACK PAPER FROM WHICH THE FIGURE HAS BEEN CUT, THE REVERSE
SIDE UPSIDE DOWN, MATHEMATICALLY CORRECT, SHOWS THAT THE ARTIST IN
1828 WAS ALREADY SUPREME MASTER OF HIS ART

This is probably the finest example of portrait cutting ever produced. In the possession of
Bernard Nevill Jackson, New York

PLATE 88

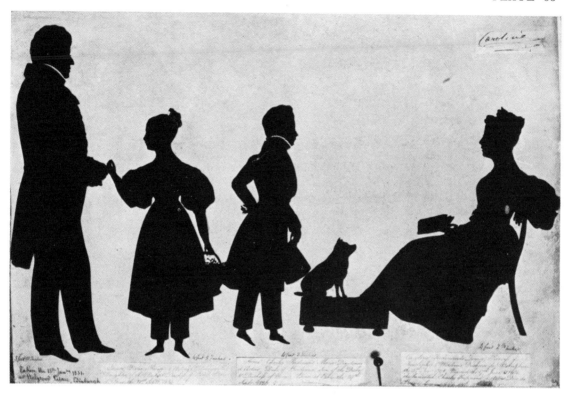

CHARLES X OF FRANCE
DUC DE BORDEAUX, PRINCESS LOUISE, DUCHESSE DE BERRI
CUT BY EDOUART AT HOLYROOD PALACE DURING THE SECOND EXILE, 1832

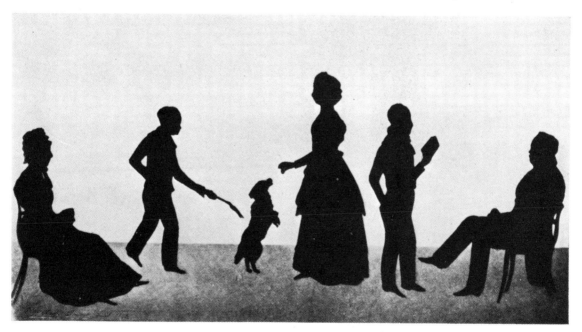

MR. AND MRS. FISK, OF OXFORD, WITH THEIR SONS, MARSHALL AND FRED, AND DAUGHTER,
ELIZABETH PRUDENCE, WHO MARRIED THOMAS JACKSON
CUT BY AND SIGNED 'AUG. EDOUART, FECIT 1828'
In the possession of Miss Emily Jackson

PLATE 89

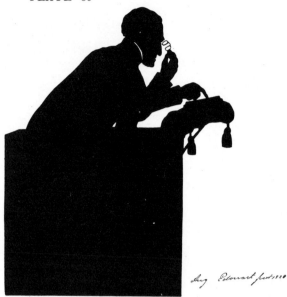

ONE OF THE SERIES OF TEN PORTRAITS
OF THE GREAT PREACHER, DR. SIMEON,
BY AUGUST EDOUART
PRESENTED TO HIS COLLEGE LIBRARY ON THE
OCCASION OF HIS CENTENARY, 1936

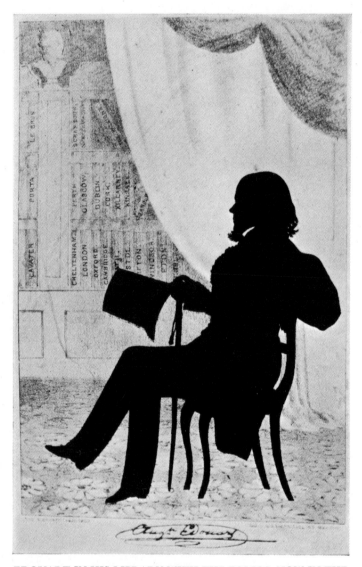

EDOUART IN HIS LIBRARY WITH THE FOLIOS, NOW IN THE
POSSESSION OF THE AUTHOR
IN THESE BOOKS HE KEPT THE DUPLICATE CUTTINGS AFTER NAMING
AND DATING THEM, AS A PHOTOGRAPHER KEEPS HIS NEGATIVES

LORD CHAS. KERR, OF THE 90TH REGI-
MENT, AND PRIVATE THOMAS GRAFTON
TWO OF THE MANY FIGURES TAKEN ON THE
PARADE GROUND AT GLASGOW

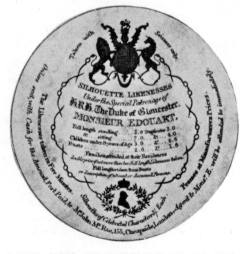

LABEL USED BY EDOUART UP TO 1836.
CHEAPSIDE, HIS ADDRESS IN LONDON

PLATE 90

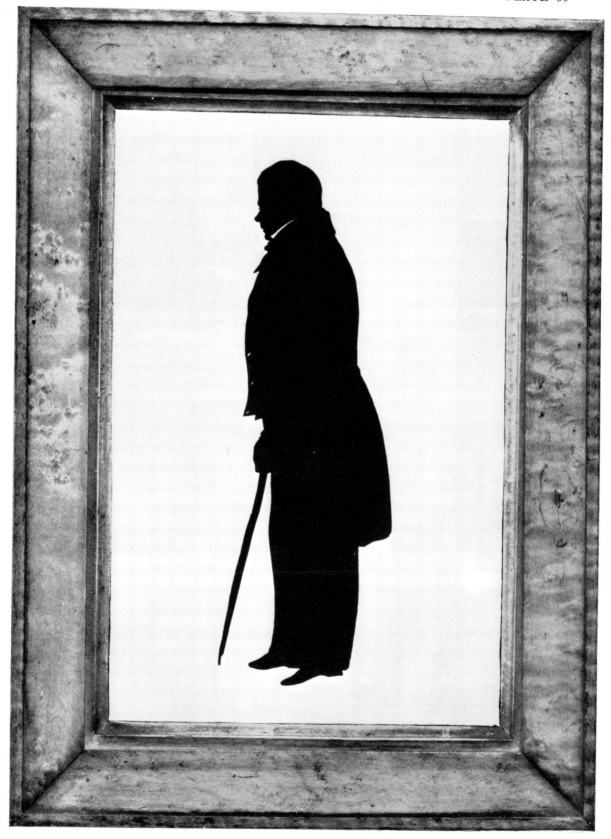

SIR WALTER SCOTT, BART, 1771–1832

THIS PORTRAIT WAS TAKEN BY EDOUART AT EDINBURGH TWO YEARS BEFORE SCOTT'S DEATH AND WAS PURCHASED
BY THE TRUSTEES OF THE NATIONAL PORTRAIT GALLERY, LONDON, IN 1911. THE FRAME, IN BIRD'S-EYE MAPLE, IS
ONE OF THOSE PROVIDED BY THE ARTIST

PLATE 91

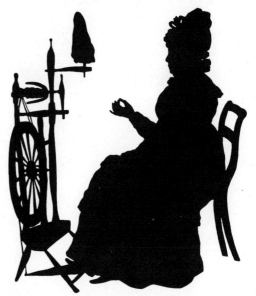

MRS. WILLIAM KEITH
NÉE MARIANNE RAE, FRIEND OF SCOTT,
GODMOTHER TO HIS ELDEST DAUGHTER.
HER HUSBAND WAS ONE OF THE PALL-
BEARERS AT THE FUNERAL OF SIR WALTER

*This is one of the fifty-eight portraits presented to
the Victoria and Albert Museum by the Author*

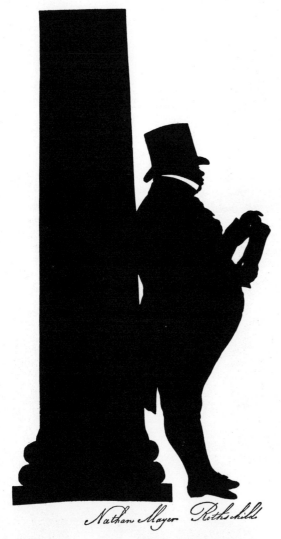

Nathan Mayer Rothschild

PORTRAIT BY AUGUST EDOUART ON THE
OCCASION OF HIS VISIT TO THE ROYAL
EXCHANGE WHEN HE CUT MANY PORTRAITS
OF THE MEMBERS WHICH ARE NOW PRE-
SERVED IN THE LIBRARY OF THE EXCHANGE

PLATE 92

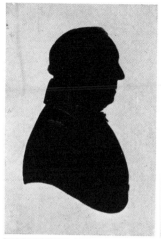
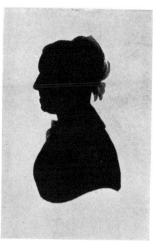

SELF-PORTRAIT OF JOHN FIELD

MRS. JOHN FIELD

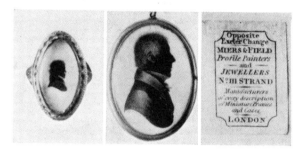

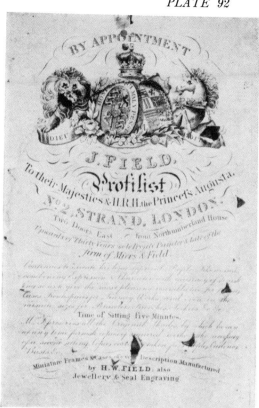

SMALL LABEL USED FOR JEWEL BOXES TO CONTAIN RINGS, LOCKETS, SEALS, ETC., WITH PORTRAITS BY MIERS AND FIELD

TRADE LABEL OF FIELD WITH NAME OF H. W. FIELD, USED AFTER THE DEATH OF MIERS

A single example (locket) of the Silhouette work of H. W. Field is in the Victoria and Albert Museum

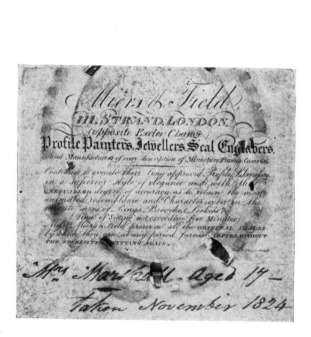

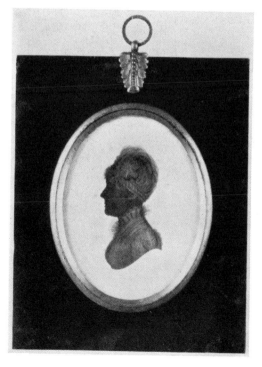

LABEL USED BY JOHN MIERS AND HIS PARTNER, JOHN FIELD, LONG AFTER THE ORIGINAL JOHN MIERS WAS DEAD

PORTRAIT OF A LADY HEAVILY BRONZED, PAINTED ON PLASTER. LABEL, MIERS AND FIELD. ONE OF A PAIR

PLATE 93

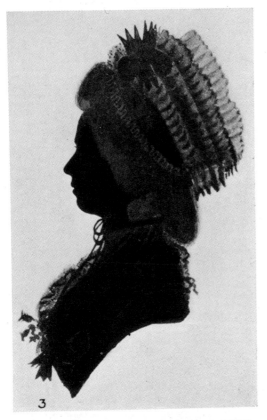

A MEMBER OF THE FRIEND FAMILY
OF TUNBRIDGE WELLS
BRUSH-WORK ON PAPER, BY ROBERT FRIEND,
TUNBRIDGE WELLS
Owned by Mr. Gordon Roe

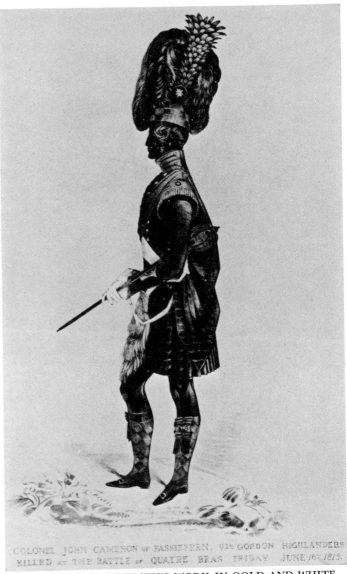

COLONEL JOHN CAMERON of FASSIEFERN, 92ª GORDON HIGHLANDERS
KILLED at THE BATTLE of QUATRE BRAS FRIDAY JUNE 16ᵗʰ 1815.

FINE EXAMPLE OF FRITH'S WORK IN GOLD AND WHITE
ON BLACK CUTTING, SIGNED
Nevill Jackson Collection

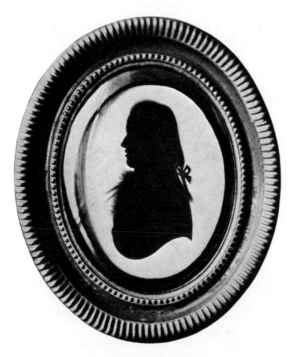

PORTRAIT OF A GENTLEMAN WITH
LABEL, HOUGHTON AND BRUCE
Formerly in the Collection of Captain Desmond Coke

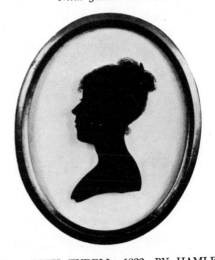

ELIZABETH TYDELL, 1822, BY HAMLET,
OF BATH
*Given to the Victoria and Albert Museum by Captain
Desmond Coke*

PLATE 94

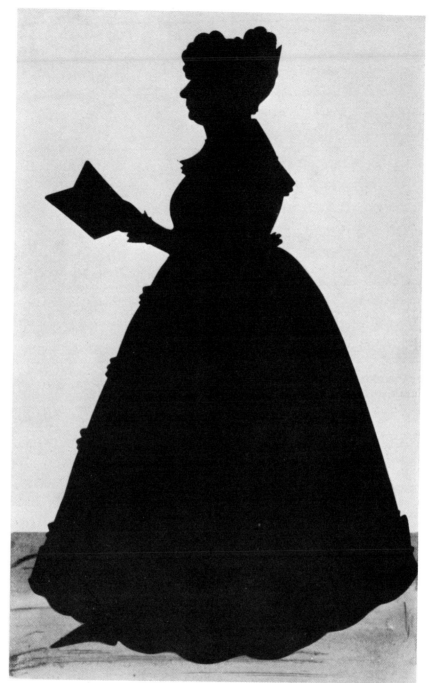

J. GAPP,

Profilist, the original Producer of LIKENESSES from the SCISSORS ONLY, begs leave most respectfully to inform the Public, that he attends daily at SAMPSON's Royal Saloon, Chain Pier, and produces the most wonderful Likenesses, in which the expression and peculiarity of character are brought into action in a very superior style on the following terms :—

Full lengths 2s. 6d. each, or Two of One Person 4s.
Busts 1s. each, or Two of One Person, 1s. 6d.
Ladies and Gentlemen on Horseback, 7s. 6d. each—Single Horses 5s. each.

BRIGHTON LABEL OF J. GAPP, AND AN EXAMPLE OF HIS WORK

PLATE 95

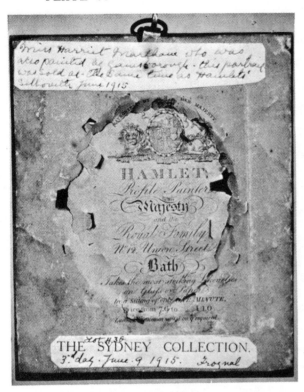

TRADE LABEL OF HAMLET, OF BATH,
HIS PRICES 7s. 6d. TO £1 1s.

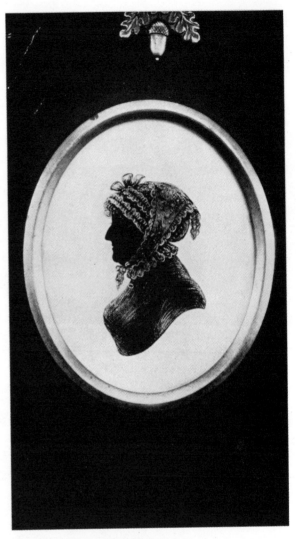

MISS HARRIET MARSHAM, A MEMBER
OF THE SYDNEY FAMILY
PAINTED UNDERSIDE GLASS BY HAMLET, VERY
FINE. THIS LADY WAS ALSO PAINTED BY GAINS-
BOROUGH

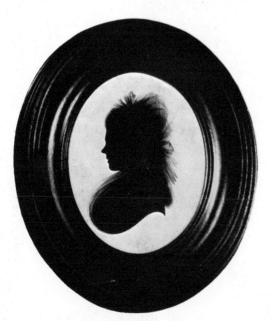

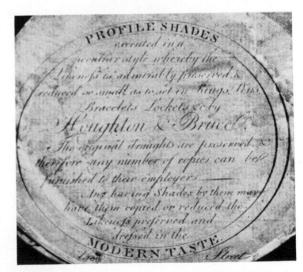

PORTRAIT OF A LADY BY S. HOUGHTON, WHO WAS A PUPIL OF MIERS. HE AFTERWARDS TOOK
AS PARTNER BRUCE OF EDINBURGH (LABEL ABOVE)
In the Collection of Miss Martin

PLATE 96

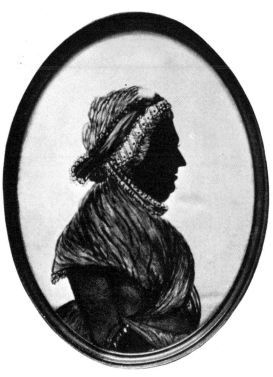

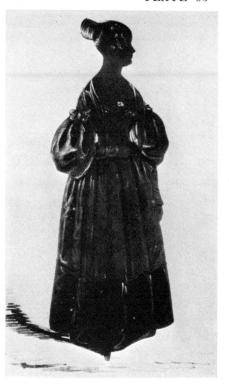

MRS. THOMAS COX, *NÉE* ELIZABETH
KENWICK, BY MRS. HUDSON, OF PALL
MALL, LONDON, 1796
In possession of Mr. T. S. Cox

MARY GRANTHAM, *NÉE* WITHERS,
MY MOTHER'S ELDEST SISTER
STENCIL LABEL, HERVÉ, 172 OXFORD STREET
Nevill Jackson Collection

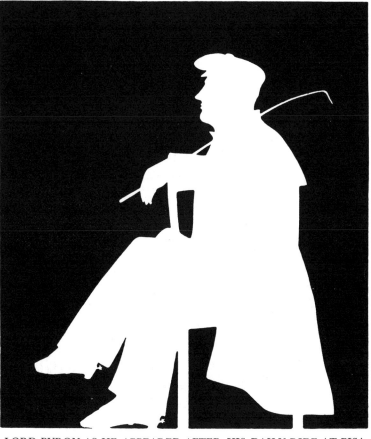

RARE LABEL OF MRS. HUDSON
FROM WHICH WE LEARN THAT SHE WAS A
WAX MODELLER

LORD BYRON AS HE APPEARED AFTER HIS DAILY RIDE AT PISA
CUT IN WHITE PAPER BY MRS. LEIGH HUNT. THIS PORTRAIT WAS
ENGRAVED IN 1828 BY HENRY COLBORN

PLATE 97

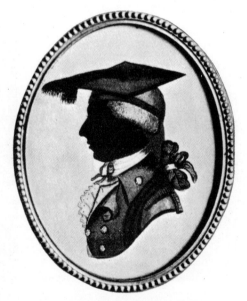

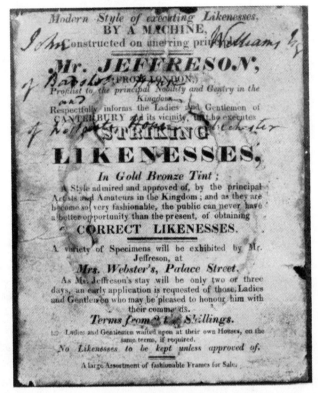

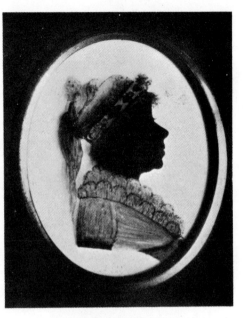

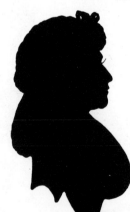

LABEL FOR MINIATURE CUTTING BY
MASTER HUBARD, USED BEFORE HE
VISITED AMERICA

QUEEN CHARLOTTE

PAINTED ON THE UNDERSIDE OF CONVEX GLASS
BY H. GIBBS, 3 INS × 2¼ INS.

*In the Royal Collection, Windsor Castle (By gracious
permission of H.M. the King)*

LABEL OF JEFFRESON

CUT BY MACHINE

*This label is at the back of a portrait of John Williams,
Esq. Profusely bronzed, and is in the possession of
Miss M. Bown*

A LADY

PAINTED ON THE UNDER-SIDE OF
FLAT GLASS, BY W. JORDEN

*From the 'family collection' of the late
Lady Shaftesbury*

'REV. JOHN GATLIFF IN OXFORD
DRESS', BY MRS. LANE KELFE, 1784

BROTHER OF MY GREAT-UNCLE, SAMUEL GATLIFF,
WHO WENT TO AMERICA, MARRIED ELIZABETH
GRIFFIN, AND WHOSE PORTRAIT BY GILBERT
STUART IS NOW IN THE PHILADELPHIA FINE ART
GALLERY. E. NEVILL JACKSON, *NÉE* GATLIFF

PLATE 98

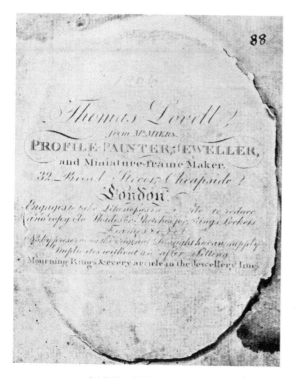

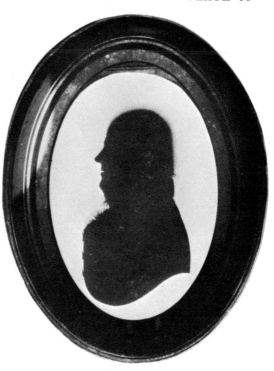

LABEL AND EXAMPLE OF THE WORK OF THOMAS LOVELL, *fl.* 1806
PAINTED ON PLASTER, ALL BLACK IN MIERS BEST EARLY TRADITION, WHOSE PUPIL HE WAS. MOURNING
RINGS ARE SPECIALLY MENTIONED IN HIS LABEL

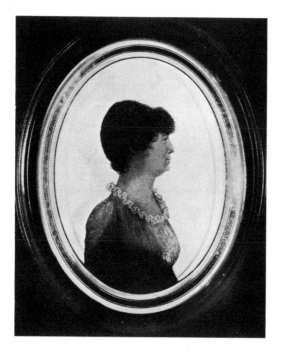

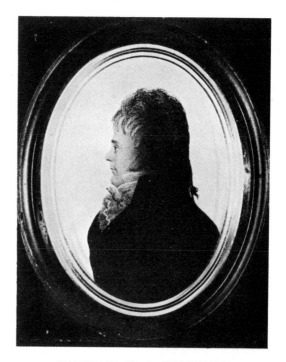

PORTRAIT OF A LADY

PAINTED ON THE UNDERSIDE OF CONVEX GLASS
WOMEN'S PORTRAITS BY LEA OF PORTSMOUTH
ARE VERY RARE. THIS AND THE COMPANION
PORTRAIT ON THE RIGHT ARE THE ONLY TWO I
HAVE SEEN

PORTRAIT OF A GENTLEMAN

PAINTED BY LEA OF PORTSMOUTH, IN THIS
ARTIST'S DOT AND STIPPLE MANNER, RESEMBLING
ENGRAVING ; VERY FINE WORK

Nevill Jackson Collection

PLATE 99

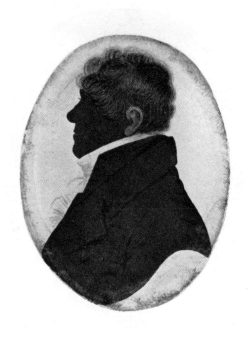

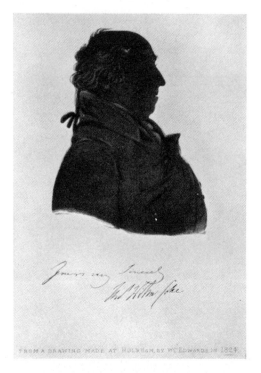

PORTRAIT BY W. H. MANNERS
MINIATURE STUDIO, 288 HIGH HOLBORN,
LONDON

COKE, OF HOLKHAM, BY E. C.
EDWARDS, 1824
IT HAS BEEN USED AS A BOOK ILLUSTRATION

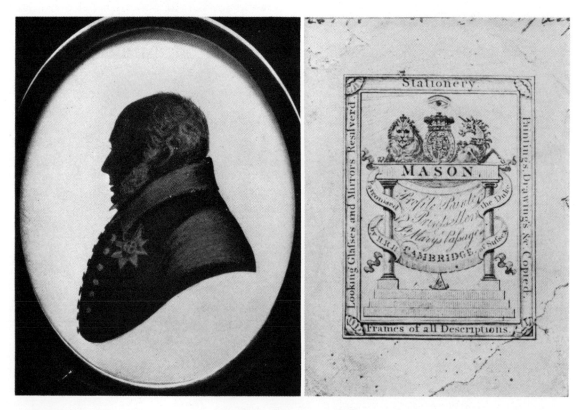

THE TRADE LABEL OF MASON OF ST. MARY'S PASSAGE, CAMBRIDGE, AND AN EXAMPLE OF HIS WORK

PLATE 100

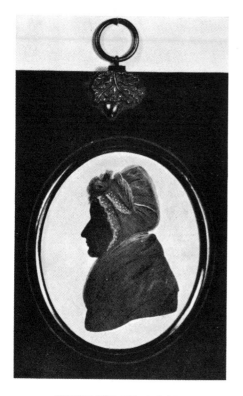

PORTRAIT OF A LADY
PAINTED ON CARD BY NEVILLE, OF BRIGHTON
In the Collection of Miss Martin

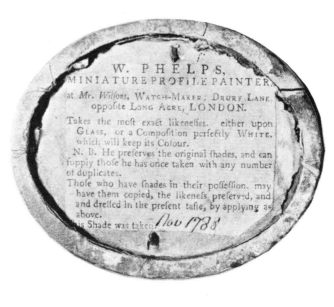

TRADE LABEL OF W. PHELPS, 1788
HIS PAINTINGS ON GLASS ARE SOMETIMES BACKED WITH WAX, HIS
COLOURED SILHOUETTES ARE VERY LOVELY, BUT RARE

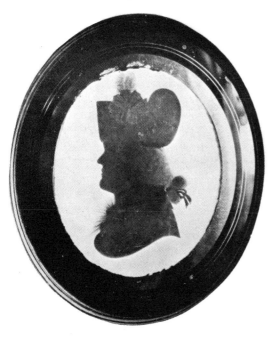

FINE EARLY PORTRAIT OF SIR CHAS. STUART,
1755, BY MIERS. SIR CHARLES WAS
GOVERNOR OF MINORCA
Nevill Jackson Collection

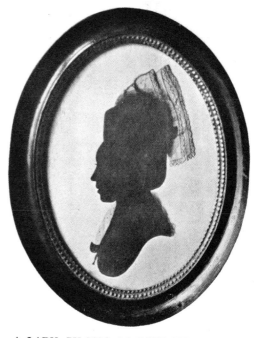

A LADY, BY MRS. M. LANE KELFE, 1785,
FINE WORK
ON HER TRADE LABEL SHE MENTIONS ENAMEL
AS ONE OF THE PROCESSES SHE USES

PLATE 101

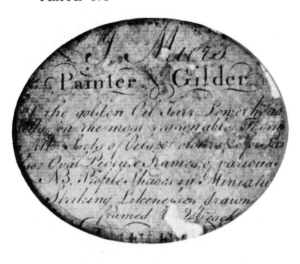

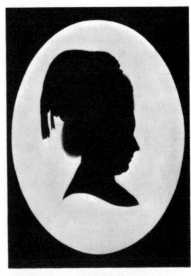

THE FIRST KNOWN LABEL OF JOHN
MIERS, USED FROM 1781, WHEN HE HAD
A SHOP IN LEEDS

A LADY
EARLY WORK OF JOHN MIERS. IT HAS ORIGINAL
FRAME AND FIRST KNOWN LABEL, *SEE* LEFT

Nevill Jackson Collection

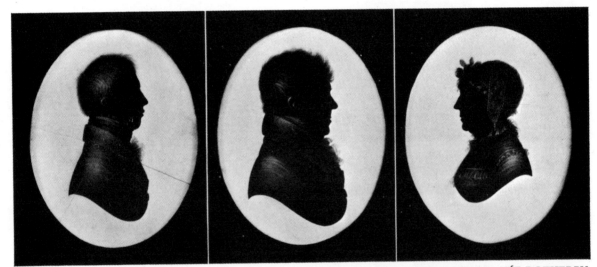

JOHN MIERS, BOTANIST, 1798–1879, SON OF JOHN MIERS, PROFILIST, SARAH MIERS, *NÉE* ROTHERBY
SELF-PORTRAIT

Three portraits belonging to Sir Henry Miers

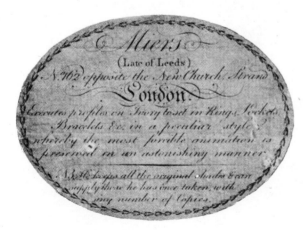

MIERS' FIRST LONDON LABEL OF 1788–91
Nevill Jackson Collection

EARLY LABEL, USED WHEN MIERS
WAS STILL AT LEEDS
Nevill Jackson Collection

PLATE 102

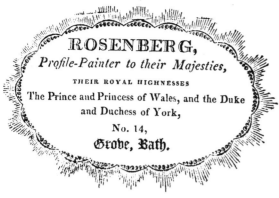

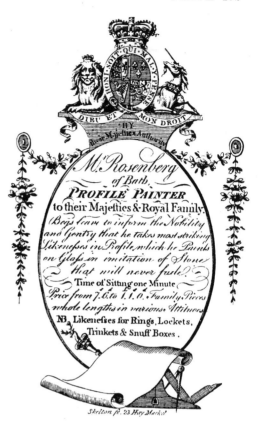

LABEL OF CHARLES ROSENBERG, SILHOUETTIST
AT THE COURT OF KING GEORGE III
PRINTED ON GREY, GREEN, OR PINK PAPER

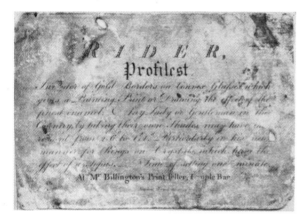

LABEL OF RIDER, 1789, WORKING AT
MR. BILLINGTON'S, TEMPLE BAR
From an example owned by the late Mr. George Stonor

MORE ELABORATE LABEL USED BY
ROSENBERG
From the Banks Collection, British Museum

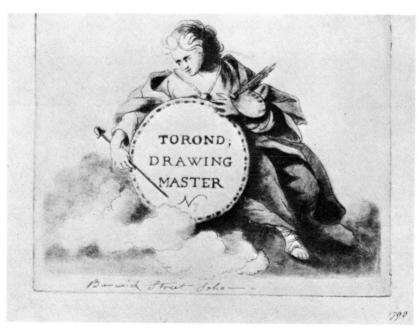

LABEL OF TOROND, FRENCH REFUGEE
From the Banks Collection. This has never been found on a specimen of his work

PLATE 103

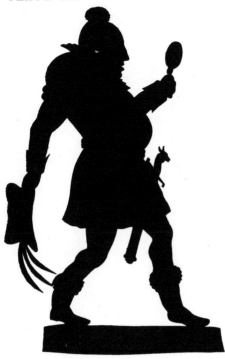

POTIER, FRENCH COMEDIAN
CUT BY OBI SMITH

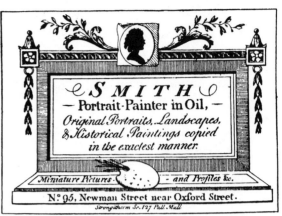

LABEL IN THE BANKS COLLECTION,
BRITISH MUSEUM
No example of this artist's work is known at present

THE TRADE LABEL
OF I. THOMASON,
FOUND ON THE
BACK OF THE POR-
TRAIT OF GEORGE
WASHINGTON
*Presented by Lord Lee of
Fareham to Sulgrave Manor*

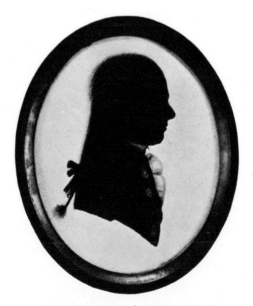

PORTRAIT OF A GENTLEMAN,
BY WELLINGS, 1785
*Fine Conversation Pieces by this artist are at Colchester
and Victoria and Albert Museum*

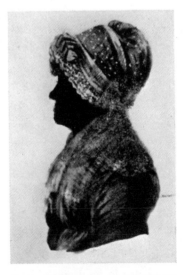

MRS. NICHOLAS BROOKINGS
PAINTED ON CARD, BY WATKIN OF WINDSOR
AND BATH
Owned by Mrs. Young

11016

£6.75

15·11·82